Illuminated Books
of the Middle Ages

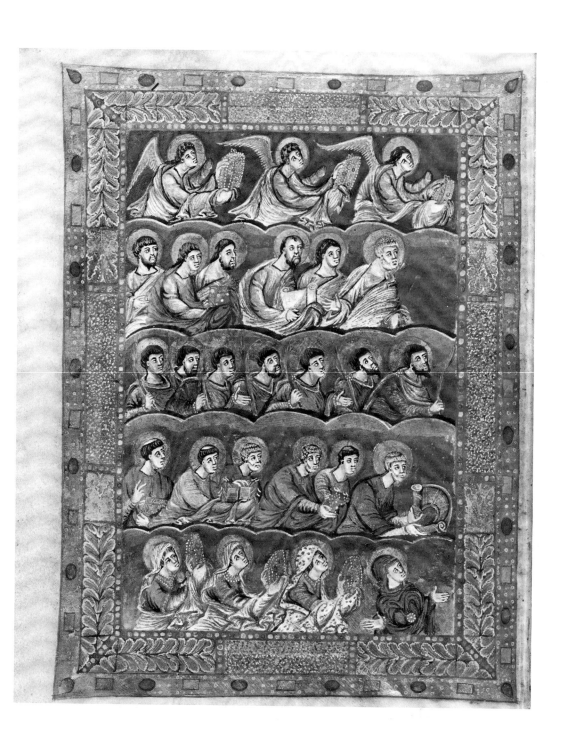

Illuminated Books of the Middle Ages

ROBERT G. CALKINS

CORNELL UNIVERSITY PRESS

ITHACA, NEW YORK

First published 1983 by Cornell University Press

Printed in the United States of America

The paper in this book is acid-free and meets the guidelines for permanence and durability of the Committee on Production Guidelines for Book Longevity of the Council on Library Resources.

Library of Congress Cataloging in Publication Data
Calkins, Robert G.
 Illuminated books of the Middle Ages.

 Bibliography: p.
 Includes index.
 1. Illumination of books and manuscripts, Medieval
I. Title
ND2920.C28 1983 745.6'7'0902 83-5208
ISBN 0-8014-1506-3

Frontispiece: Hierarchy of Heaven Paying Homage. Metz Coronation Sacramentary, fol. 5v (Paris, Bibliothèque Nationale, MS lat. 1141: Photo Bibl. Nat., Paris)

for ann

Contents

Colorplates follow page 32

Preface

Recent exhibitions of medieval illuminated manuscripts have provided the general public with the opportunity to see rare and precious books, often sumptuously painted or bound, to which it would otherwise not have access. The nature and value of these manuscripts, however, require them to be enclosed in glass cases, remote and unperusable. The viewer usually sees an opened book with only two folios visible. Although the decorations displayed may be spectacular, other equally important decorations elsewhere in the volume cannot be seen. Occasionally, the viewer is provided with photographs or color transparencies of other illuminated pages, partially gratifying the desire to see more, but these are usually displayed like paintings hung on a wall. Nevertheless, the very structure that makes it difficult to appreciate fully the book as an exhibited object is also intrinsic to its mode of presentation: it is the open spread of the two-page format, the symmetrical curvature of the two leaves bending away from the center fold, and the visual impact of the text and decoration on the facing folios which constitute the essential aesthetic quality of the bound codex, the book form that has been most prevalent since the fourth century. Although the manuscript presents itself two folios at a time, it is not a static object. One must turn the pages to receive the full effect of its material, format, glitter of decoration, and particular choice of ornament and sequence of illuminations, and to understand how they relate to the special demands of its text and use.

Expensive facsimile editions of many of the most important manuscripts now make it possible to learn what is in them and how they function, textually and decoratively, in a sequential manner. But these facsimiles, like the originals, are usually inaccessible to the general public. More general books either discuss

isolated pages from a large selection of manuscripts or present a popularization of a single well-known example, such as the *Très Riches Heures*. These publications rarely explain to the nonspecialist the various kinds of miniatures and decorations, or the various types of medieval manuscripts and how they work, or how the illuminations relate to the text in which they appear. For the person who does not have an intimate knowledge of a particular kind of text or of a specific manuscript, discussions of illuminations have the effect of presenting them as isolated works of art, sometimes not even calling attention to facing pages of decoration or proper sequences of illuminated pages, totally divorcing them from the context of the book as a whole.

The purpose of this book, therefore, is to introduce various types of medieval illuminated manuscripts as coherent functional objects that were decorated and used in a particular way. Selected examples of these books will be analyzed from the point of view of the aesthetic impact of the manuscript as a whole, of the visual effect of the two-page display of the opened codex, of the relationship of decorative accents to major divisions of the text, and of the sequence of illuminations which builds, as one turns the pages, into an appropriate decorative program for the particular kind of book. The focus will be on prevalent types of religious books used by the Christian church: variant forms of the New Testament, liturgical books used in the celebration of the Mass and Divine Office, and books for the private devotions of the laity. Examples of these manuscripts have been selected both for the magnificence of their decoration and for the representative nature of their texts.

Considerations of type of decoration and its sequential and hierarchical relationship to the text will be interwoven with discussions of the structure and arrangement of the contents of the manuscript. Where relevant, entire sequences and the effect of facing illuminations or decoration and text on two-page spreads have been illustrated. For some manuscripts all the major decorative pages have been reproduced. For others in which the illuminations are copious, selected examples show the treatment of major or unusual texts. Occasionally illuminations and decorative sequences from other manuscripts are shown for comparison, or several examples are discussed to give the reader an idea of the development or variations of a particular form.

While no attempt has been made to present a survey of the development of the styles of manuscript illumination, representative examples from the major periods are used. It may seem that a disproportionate emphasis has been placed upon the development of decoration in Insular Gospel books, but they demon-

strate an important departure from the traditions of late antique book illustration briefly described in the Introduction. Moreover, they show a growing awareness of the decorative, narrative, and symbolic potential of the illuminated word. Since later liturgical and devotional books were ultimately derived from the text of the Bible, and the most important feast days are commemorations of the incidents recounted in the New Testament, the early appearance and use of narrative miniatures in biblical manuscripts are explored in some detail. These set the stage for developments in books for the Mass and Divine Office. The large illuminated Romanesque Bibles, generally derivative from the earlier examples, are not discussed in detail, but they, their more fully illustrated Gothic counterparts, and a number of other special kinds of texts are briefly described in the last chapter.

No attempt has been made to resolve the controversies surrounding some of the manuscripts discussed here, but references to important scholarly works are given in the notes. While these notes have been kept to a minimum, they present, for each chapter, an introduction to the bibliography of the relevant kind of manuscript and associated problems. The Bibliography at the end of the book is therefore in alphabetical order to facilitate easy reference. The contents of each manuscript discussed in detail, showing the relationships of the illuminations to the divisions of the text, are given in the Appendixes.

For discussions of the nature, use, and structure of many medieval liturgical books, I acknowledge my debt to a small and now unavailable exhibition catalogue by John Plummer published by the Pierpont Morgan Library in 1964, *Liturgical Manuscripts for the Mass and Divine Office,* and to materials provided by James John which served as a point of departure. *The Study of the Liturgy,* edited by Cheslyn Jones, Geoffrey Wainwright, and Edward Yarnold, provides a useful introduction to the subject, and Andrew Hughes's invaluable *Medieval Manuscripts for Mass and Office: A Guide to Their Organization and Terminology* contains a detailed and technical analysis of the textual components of liturgical manuscripts. Richard Pfaff's *Medieval Latin Liturgy: A Select Bibliography* is useful for its critical introduction and wide-ranging bibliography.

I am extremely grateful to Mosche Barasch, James John, Susan Shedd, Susan Straight, Philip Webber, and Mara Witzling for their many helpful suggestions. I am also indebted to the following for providing me with dimensions of the text areas in the manuscripts in their care: François Avril, Bibliothèque Nationale, Paris; Hermann Hauke, Bayerische Staatsbibliothek, Munich; Lilian M. C. Randall, Walters Art Gallery, Baltimore; and Wil-

liam Voeckle, The Pierpont Morgan Library, New York. All photographs are reproduced with the kind permission of the owning institution. I am especially indebted to the Samuel H. Kress Foundation for making it possible to increase the number of color plates.

ROBERT G. CALKINS

Ithaca, New York

Illuminated Books of the Middle Ages

Introduction: From the Earliest Bibles to Byzantine Manuscripts

Books produced during the Middle Ages, before the perfection of printing with movable type by Johannes Gutenberg in the mid-fifteenth century, were all handwritten and are therefore called manuscripts. The study of these books requires the expertise of many specialists: paleographers who analyze the development of various forms of script, liturgical and literary historians who examine the text and its variations, codicologists who investigate the structure and physical makeup of the book, and art historians who study the decorations, usually small painted pictures. These illustrations are often called miniatures, not because of their size but rather after the minium or orange lead used in their preparation and in the writing of red-ink headings or rubrics. Actually, the miniatures may constitute only a small proportion of the ornament in a manuscript, for frequently the text also contains decorated letters and penned calligraphic flourishes and is surrounded by elaborate borders. All of these elements are present in varying proportions in what is called an "illuminated" manuscript. In the narrow sense the term illumination refers to any ornament to which gold, silver, or bright colors have been added. In many medieval manuscripts, these illuminations take on a major function in relation to the book, whether as symbolic ornament, iconic representations of holy personages, or pictorial narration accompanying and elaborating the text. The scale or lavishness of this decoration is usually determined by the importance of the text it opens, major divisions having elaborate ornament, and lesser subdivisions having less obtrusive accentuation.

The form of handwriting or script and the motifs of decoration and styles of painting in miniatures went through various stages of development during the Middle Ages, but the basic format and structure of the book was established by the late antique–

early Christian period.[1] The earliest form of the book that was easily portable in the classical world was the scroll or rotulus.[2] It was usually made of sheets of papyrus, which were glued together and contained columns of text. As the reader followed the text, he unrolled it from one side and rolled it up on the other, the direction depending on the language: scrolls containing Hebrew, which is read from right to left, would have unwound from left to right; those containing Greek and Latin, which are read from left to right, would have unwound from right to left.

Papyrus, a paperlike substance made from a reed that grew in the Nile Valley, was fragile, and scrolls were awkward formats because the reader had to rewind to find a particular place in the text. By the end of the first century A.D., however, it was discovered that if the skins of animals, usually calves or lambs, were properly scraped and cured they would make an excellent sturdy, durable, and flexible surface upon which to write. This parchment or vellum was cut into sheets and folded down the middle to form two folios (a bifolio), which could then be inserted with others and bound with other gatherings or quires by being sewn along the crease into a binding. The result was the codex (plural codices)—the book form that we still use today.[3] (Parchment was occasionally used in scrolls and papyrus sometimes in codices.) Codices could contain considerably more text and were significantly easier to use than scrolls. In the Middle Ages, the leaves, when they were numbered at all, were foliated, that is, each was numbered on only one side; the convention of numbering both sides of the leaf (pagination) was widely adopted only well after the invention of printing. When speaking of a foliated manuscript one must distinguish between the right-hand or front surface (recto of the folio) and the left-hand or back surface (verso of the folio). The increasing use of the vellum codex coincided with the increasing demand for Christian texts, and as a result the codex became the prevailing form of the medieval book.

The Bible, particularly the New Testament, was the principal religious text of the Christian Middle Ages in Europe and the source of many different compilations of passages for various liturgical purposes. Originally, of course, the Bible had existed as two disparate parts, a Hebrew Old Testament, consisting of books written between the eighth and second century before Christ, and a Greek New Testament written in the first century after Christ.[4] The contents of both parts varied considerably well into the first centuries of the Christian era.

A concerted effort was made by the Jews to standardize the Judaic tradition of the Old Testament after the destruction of the Temple in Jerusalem by the emperor Titus in A.D. 70. In order to restore the authority and preserve the purity of the text of the

Old Testament, the order of the books and the language of their texts were carefully compiled and codified between A.D. 70 and 100. This standardized "Massoretic" or canonical text has survived practically unchanged from that time until the present day.

The oldest surviving Hebrew texts of the Old Testament known at present are the fragments of the Dead Sea Scrolls found in caves near Qumran, which are thought to date from between 200 B.C. to A.D. 70.[5] Before their discovery in 1947, the oldest known Hebrew texts were believed to date from the ninth century after Christ. Thus this significant archeological discovery provides the earliest examples of the uncodified, pre-Massoretic text of the Old Testament.

Until the discovery of the Dead Sea Scrolls, surviving Greek translations of the Old Testament predated those known in Hebrew. In the third century B.C., legend has it, seventy-two scholars at Alexandria translated the Hebrew books into Greek in seventy days, thereby lending to this version the name "Septuagint." Two fourth-century copies of this translation have survived, the Codex Sinaiticus (now divided between Leipzing and London, British Library, MS Add. 43725), and the Codex Vaticanus in the Vatican Library. Both of these manuscripts also contained books of the New Testament.

Other fragmentary remains attest to the variety of compilations of biblical texts at an early date in the Christian period. Fragments of papyrus codices found in the Fayoum district of Egypt in 1930 (some for a while in the Chester Beatty Collection and now in scattered collections) were believed to date from the first half of the second century to the fourth century A.D.[6] The earlier ones contained texts in Greek predating the Septuagint. Most of these fragments contained Old Testament texts in Greek, but there was also a copy of the New Testament containing the four Gospels and the Acts of the Apostles. The oldest fragment of the New Testament is a passage from the Gospel of St. John now in the John Rylands Library in Manchester.

Major impetus for the production of an integrated Bible as a Christian book was generated by the studies and translations of the Old Testament by Origen of Alexandria (d. 253). He provided a six-column parallel translation in Greek alongside the Hebrew text in an edition known as the Hexapla. Using manuscript sources first at Alexandria and then, after 231, at Caesarea in Palestine, he based his translations on newly discovered and more authoritative versions of biblical texts.

Constantine's Edict of Milan in 313, which decreed that Christianity be given equal status with other religions in the Roman Empire, removed the fear of persecution for the Christians. Although he was not baptized a Christian until on his death bed in

337, Constantine nevertheless threw the weight of imperial patronage behind many Christian enterprises, commissioning the construction of new vast basilicas for Christian worship and also the writing of fifty copies of the Greek Bible in vellum codices for his new capital at Constantinople. Although probably not part of this imperial commission, the fourth-century Codex Sinaiticus and Codex Vaticanus nevertheless reflect this new burst of production of the Bible for Christian purposes.

The next major event in the development of the Bible in Western Europe was the translation of the text into Latin. Portions of the New Testament had been translated from the Greek into Latin by the early second century, and these translations served as the basis for further variations. In an effort to resolve inconsistencies in these "Old Latin" (*Vetus Latinum*) versions, as they are now often called, Pope Damasus commissioned St. Jerome in 382 to undertake a revision of the Latin text. Insofar as he was able, Jerome turned to what he considered the most authoritative Greek texts, most of which belonged to the Alexandrian family. In the case of the Old Testament, he made a new translation directly from Hebrew sources. The resulting compilation was the Latin Vulgate Bible, which gradually became the basis for most of the Biblical texts in the Middle Ages.[7]

The Bible, particularly the New Testament, also served as a source of passages that were excerpted and arranged in a variety of sequences in separate volumes to suit the developing ceremonial needs of the early Church. As the rites for various sacraments became formalized, these texts in specialized liturgical books became more standardized, although they were continually subjected to further variations throughout the Middle Ages.

The Gospels were frequently written as a separate book to be used in the liturgy because lessons were read from it by the deacon during the celebration of the Mass. Originally these lessons were simply read from the chapters of the Gospels in the order that they were written, special passages being singled out only for the most major of feast days, such as Christmas and Easter. After the seventh century, however, it became the custom to assign specific passages to particular feast days. This practice necessitated the numbering of subunits of the chapters and the compilation of a Gospel list or capitulary with the number and the opening and closing words of the lesson. This list provided the order of the lessons to be read during the entire liturgical year. The numbering of these sections is believed to have been done by Ammonius and was used by Eusebius, bishop of Caesarea, in the fourth century, to compile a concordance of similar passages in the four Gospels in tabular form. The prefacing of the text of the Gospels with these canon tables, as they are called, soon became

a common practice, and was adopted by St. Jerome in his revision of the Latin Gospels.

Because the Gospels were used as a liturgical book, a variety of specialized permutations was created. All four Gospels were combined and condensed in a continuous narrative or harmony, called the *Diatessaron*, by Tatian in the second century. Various readings in the four Gospels were intermixed and arranged according to the sequence of lessons throughout the liturgical year in books called evangelistaries, Gospel lectionaries, or pericopes. The Epistles were excerpted and arranged according to the liturgical order of their readings in epistolaries, and, at an early moment, the Psalms from the Old Testament became a separate entity as the psalter. Representative examples of major stages of this development and specialization are discussed in the following chapters.

The early surviving texts of the Bible such as the Codex Sinaiticus and the Codex Vaticanus contain no major decorations or miniatures. A fifth-century Greek Bible, the Codex Alexandrinus (London, The British Library, MS Roy. I.D. V–VIII), does, however, manifest a late antique tradition of providing penned decoration around explicits or colophons at the completion of each of its books.[8] It also shows a predilection for increasing the size of beginning letters of sentences which was gaining in usage in secular manuscripts of the late classical period.

A major tradition of diagrams and narrative illustration did exist, however, in the scientific and literary texts of the classical period. Usually inserted in the columns of text in scrolls, they served as one of the sources of inspiration for the miniatures of the codex. Kurt Weitzmann had explored in detail these early illustrations and their transformation when adapted to the format of the codex folio.[9] Although only a handful of early illustrated literary codices survive, such a manuscript as the early fifth-century Vergilius Vaticanus, containing fragments of the *Georgics* and *Aeneid* of Vergil (Vatican City, Biblioteca Apostolica Vaticana, Cod. Vat. lat. 3225), may be representative.[10] It has framed miniatures (Pl. 1), usually set within the text area, but sometimes occupying an entire page. Stylistically the miniatures approximate the effect of the monumental mosaics or wall paintings of ancient Rome, containing effectively modeled three-dimensional figures placed within convincing architectural or landscape scenes. The frame enhances this spatial effect by defining a "window" through which we observe the scene—an effect that was reintroduced to book illustration in the Renaissance and still dominates the modern book. In some later miniatures this illusionistic style is supplanted by flatter, more patterned figures and more diagrammatic and spaceless settings, as in the miniatures of

1. Aeneas, Fatula, and Dido. Vergil, *Aeneid*, fol. 36v (Vatican City, Biblioteca Apostolica Vaticana MS Vat. lat. 3225: Photo Biblioteca Vaticana)

19

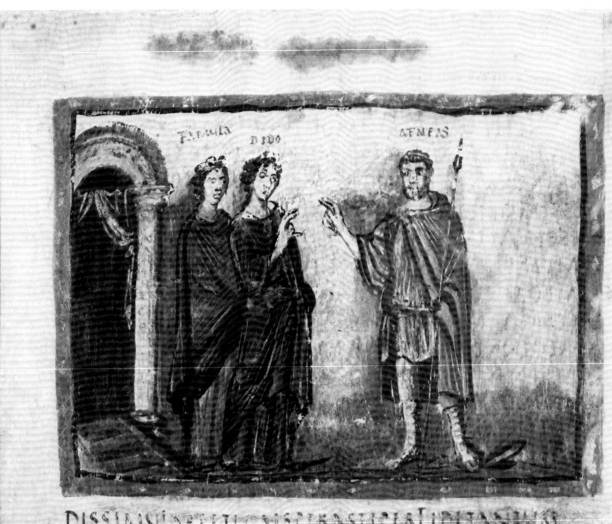

a late fifth-century copy of Vergil, the Vergilius Romanus (Vatican City, Biblioteca Apostolica Vaticana Cod. Vat. lat. 3867.[11]

An antique tradition of unframed miniatures also appeared in the early literary codices. Not only do some of these unframed scenes appear in the title miniature of the *Eclogues* in the Vergilius Romanus, but also in later manuscripts produced during the ninth century in the Carolingian Empire and the tenth century in Byzantium, presumably copied after late antique prototypes. For example, a Carolingian Physiologus or bestiary now in Bern (Burgerbibliothek, MS 318), containing sketchy miniatures of animals set against the parchment, is believed to have been copied after a fifth-century manuscript, while a tenth-century Byzantine copy of a herbal, the *De Materia medica* of Dioscurides (New York, The Pierpont Morgan Library MS M. 652), with beautifully executed paintings of botanical specimens set against the vellum page, closely reflects the magnificent early sixth-century Byzantine copy now in Vienna, which in turn was based upon earlier prototypes.[12]

The earliest surviving example of the adaptation of the narrative miniature to a Christian biblical codex is the set of six leaves of the fourth- or fifth-century Quedlinburg Itala fragment, containing illustrations to the Book of Kings (Berlin, Staatsbibliothek Preussischer Kulturbesitz, Cod. theol. lat. fol. 485) and some accompanying passages of the Old Latin, pre-Vulgate text.[13] Two to five scenes are grouped together in adjacent frames on a single folio, removed from the text, and are painted in the free illusionistic style of the late classical manner. Thus, although the style and narrative quality of these illustrations remain close to classical prototypes, the separation of picture and text allows the illustration to develop a decorative validity and iconographical importance of its own. Three examples will illustrate the developing modes of narrative embellishment in biblical books in the sixth to seventh centuries.

The Vienna Genesis (Vienna, Österreichische Nationalbibliothek, Cod. theol. gr. 31), believed to have been produced in Syria in the sixth century, shows a close affinity with the manner of late antique manuscript illumination.[14] Although the manuscript now consists of only twenty-four folios with miniatures, scholars have conjectured that originally it possessed about ninety-six folios with 192 illustrations. Written in silver uncials upon purple dyed parchment, even in its fragmentary state it is the most sumptuous manuscript to have survived from the early Christian–early Byzantine period before the iconoclastic controversy of the eighth century. All of the miniatures appear at the bottom of the text pages (Pl. 2), reminiscent of some of the pages of the Vergilius Vaticanus, but they are of both the framed and

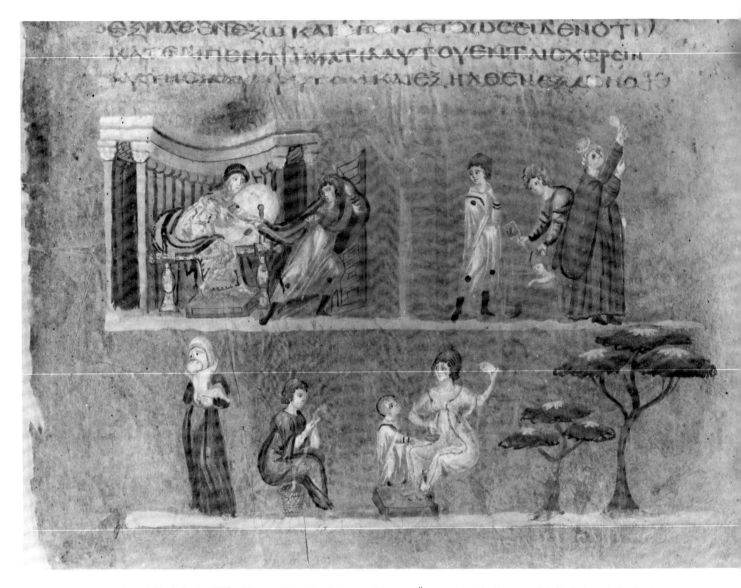

2. Joseph and Potiphar's Wife. Vienna Genesis, fol. 16r (Vienna, Österreichische Nationalbibliothek, Cod. theol. gr. 31)

the unframed type. The text, which follows the Septuagint version, is frequently abbreviated, and the accompanying miniatures have been shown to contain incidents and figures not mentioned in the text of Genesis. Thus in one of the most remarkable miniatures in which Joseph struggles away from the persistent advances of Potiphar's wife, leaving his garment in her hand, an enigmatic lady in blue at the right examines a string. She is thought to be the astrologer mentioned in Jewish commentaries who foretold that Joseph would become the father of the children of Potiphar's wife. In the second scene below, the women and

children perhaps reflect that at the time of this incident none of the men of the household were present. Since most of the figures depicted in these scenes appear to be based upon popular elaborations of the story, it has been suggested that they were derived from a Jewish paraphrase of the text. The form of this earlier book which served as a model, it has been conjectured, must have been similar to the Cotton Genesis (London, The British Library, MS Cotton Otho B. VI), a sixth-century manuscript believed to have been made at Alexandria which was unfortunately largely destroyed in a fire in 1731.[15] The few surviving fragments show that this manuscript was copiously illustrated with framed miniatures interspersed throughout the text.

A variant of this mode, employing full-page miniatures that sometimes combine several scenes, appeared in another early manuscript, the Ashburnham Pentateuch (Paris, Bibliothèque Nationale, MS n.a. lat. 2334).[16] Believed to have been produced, in northern Africa in the late sixth or early seventh century, it originally consisted of the first five books of the Bible but is now missing Deuteronomy. It now contains nineteen illustrations although originally it may have had as many as sixty-eight full page miniatures. Serving as a frontispiece to Genesis is a full-page table containing the names of the books in Latin and Latin transliterations of Hebrew names enclosed within a curtained arch, perhaps symbolizing an unveiling of the Word. Some miniatures, such as that of the Flood (fol. 9r), occupy the entire page, as in the single illustration devoted to this theme in the Vienna Genesis. Others, such as the story of Adam and Eve after the Fall (Pl. 3), place a variety of incidents in horizontal registers with each scene set against a different colored background. This device for depicting an expanded narrative, perhaps also stemming from the tradition of using two registers of scenes in some of the Vienna Genesis miniatures, was to become a major pictorial element in later Byzantine, Carolingian, and Romanesque manuscripts.

A second system of illustration is found in a Syriac Bible now in Paris (Bibliothèque Nationale, MS syr. 341), believed to have been made in northern Mesopotamia in the sixth or seventh century.[17] In this case miniatures set within one of the two columns of text per page introduce each book of the Bible. Most of these are full-length portraits of the authors, particularly the prophets, a reflection of a long tradition in classical scrolls. Some of the miniatures, however, depict principal figures or incidents in the ensuing book, such as Job seated on a dung heap preceding the Book of Job. Another, before the book of Proverbs, shows an allegorical group of the Virgin and Child flanked by Solomon, personifying the wisdom of the Old Testament, and by Ecclesia,

3. Adam and Eve after the Fall. Ashburnham Pentateuch, fol. 6r (Paris, Bibliothèque Nationale, MS n.a. lat. 2334: Photo Bibl. Nat., Paris)

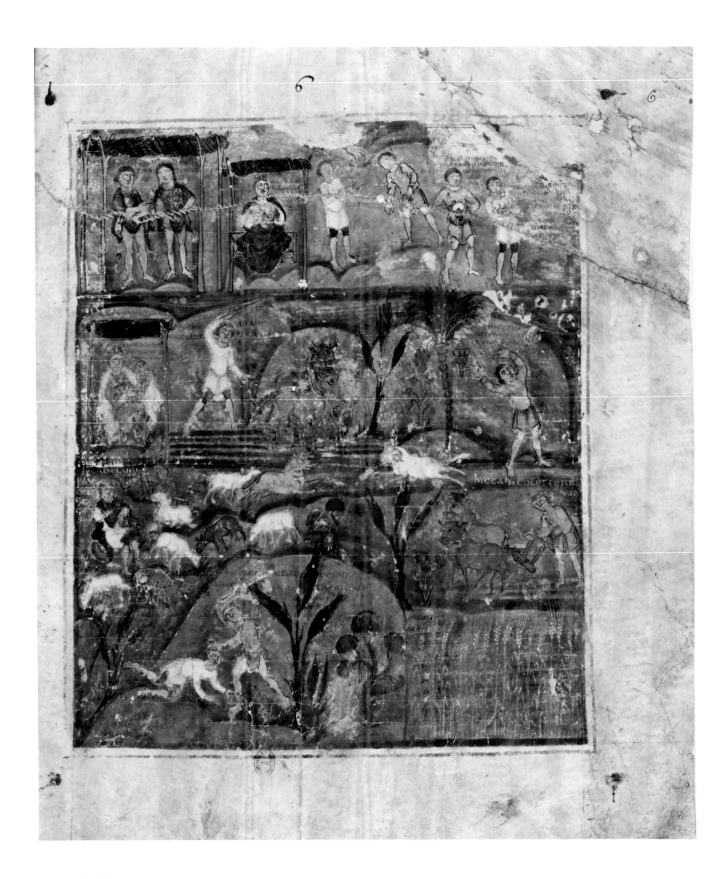

the wisdom of the Christian Church. Although large sections of the text and its illustrations are missing, and only one New Testament miniature, James the Apostle, survives, the variety of types of miniatures suggests that they were derived from several sources. This Bible is the earliest surviving example of a full Bible with a consistent program of illustrations. The practice of opening each book of the Bible with a miniature or, later, of placing the narrative scene in the opening capital letter (historiated initial), continued to be widely used in the later Romanesque and Gothic periods.

As groups of books of the Old Testament, such as the Pentateuch (the first five books) or the Octateuch (the first eight books), were frequently bound in a single volume, the four Gospels, because of their importance for the reading of lessons during the Mass, were also produced as a separate book. Patrick McGurk found that many of the Gospel books of the fifth through the first half of the seventh century soon became uniform in arrangement, appearance, and scribal tradition.[18] The Western Old Latin, pre-Vulgate copies contained only the Gospel texts, while those of eastern Mediterranean origin normally contained a prefatory gathering with the canon tables of Eusebius and a letter from Eusebius to Carpianus explaining their use. When St. Jerome completed his revision of the Gospels, he not only prefixed the Eusebian canon tables from this earlier tradition but also included a letter from himself to Pope Damasus (beginning "Novum opus") explaining his revision and the use of the tables. St. Jerome also wrote a preface, beginning "Plures fuisse," in which he discussed the work of the four Evangelists. These writings of St. Jerome thus became standard prefatory material for the Vulgate versions of the Gospels. A letter from St. Jerome to Paulinus of Nola beginning "Frater Ambrosius" (Pl. 44) and his prefaces to the individual books likewise became standard prefatory material for the Old Testament.

Many of the early Gospel books, however, did not contain miniatures, although some of them did have embellished explicits (colophons) as mentioned above. Thus the Rossano Gospels, in the Cathedral Treasury at Rossano in southern Italy, is of considerable importance, for it is the earliest surviving illustrated Gospel book.[19] Believed to have been produced in Syria in the sixth century, it is written in Greek in gold and silver uncials on purple dyed parchment. Only the Gospels according to Matthew and Mark with twelve miniatures survive. The Gospel of St. Matthew is prefaced by eleven miniatures following not the narrative order found in the text but the liturgical order according to the lessons read during Lent. Old Testament prophets appear with some of the narrative scenes, and their accompanying quo-

4. Christ before Pilate, Suicide of Judas. Rossano Gospels, fol. 8r (Rossano, Archiepiscopal Treasury: Photo Giraudon)

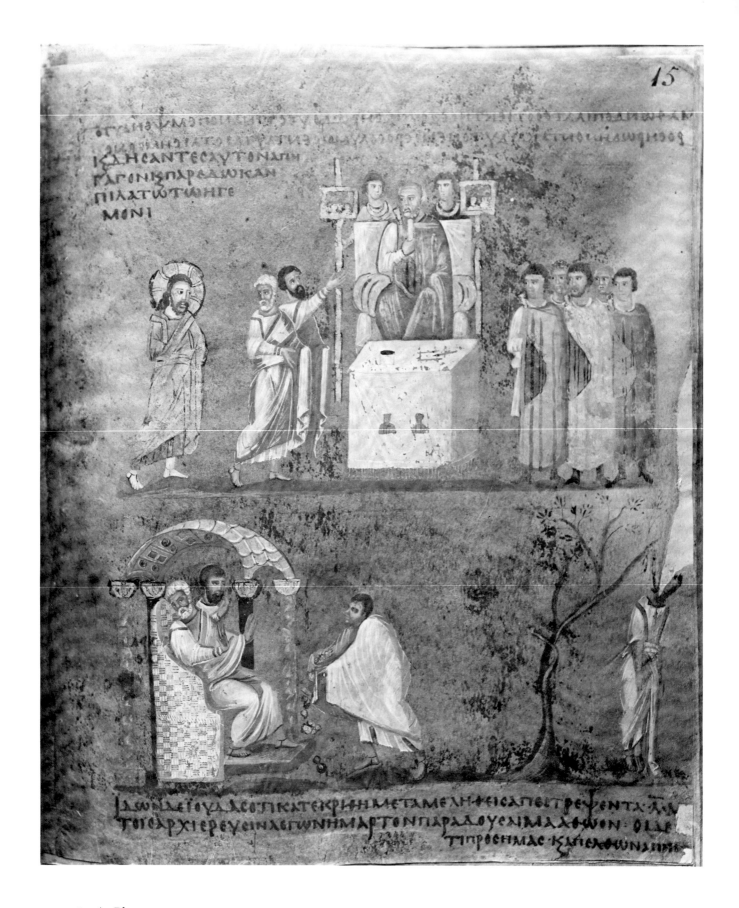

tations assert the relevance of Old Testament prophecies to the events of the New Testament. It is therefore thought that this arrangement is in part derived from an illustrated Lectionary, a book that contained passages from the Bible arranged according to the order in which they were read on the feast days during the liturgical year (see the section below on the Pericopes of Henry II).

The miniatures are similar to many of those in the Vienna Genesis and to some in a fragment of another Gospel book on purple parchment in Paris (B.N., MS suppl. gr. 1286), the Sinope Gospels, in that the miniatures are unframed and are sometimes presented in two horizontal tiers.[20] The folio with Christ before Pilate contains this scene in the upper register (Pl. 4), and Judas attempting to give back the thirty pieces of silver and committing suicide in the bottom scenes. Below another miniature depicting the parable of the Good Samaritan—in which the Samaritan is shown as Christ—Michah, Sirach, and David (shown twice) are represented above relevant passages from their prophecies.

Prefacing the Gospel of St. Mark is a representation of the seated Evangelist poised to write and receiving instructions from a woman dressed in blue (Pl. 5). She is the personification of Divine Inspiration or Divine Wisdom and is derived from the frequent Hellenistic illustrations of the Divine Muse found in classical manuscripts. St. Mark sits within an architectural frame, two marble columns supporting a gold entablature with blue triangular elements at each end and a semicircular lunette with multicolored radii—a flat patterned design perhaps derived from shell-like niches found in late Roman architecture and sculpture. This representation of the enthroned writing evangelist in an architectural setting became a standard miniature prefacing the Gospels in Byzantine and Western manuscripts throughout the rest of the Middle Ages.

In style the Rossano miniatures are also closely related to those of the Vienna Genesis and Sinope Gospels, with softly modeled figures and lively gestures and glances. But the three-dimensional illusionism of architectural elements and landscapes are now giving way to more awkwardly rendered, schematic forms. Thus the Rossano Gospels marks an important link between the naturalism of the classical, Hellenistic style of late antique painting and the more stylized representations developing in the Byzantine east.

Manuscripts produced during the ensuing centuries in the Byzantine Empire continued the developments briefly sketched above, adapting the form of figural art, narrative miniatures, and exegetical juxtapositions to the demands of the developing lit-

5. St. Mark. Rossano Gospels, fol. 121r (Rossano, Archiepiscopal Treasury: Photo Giraudon)

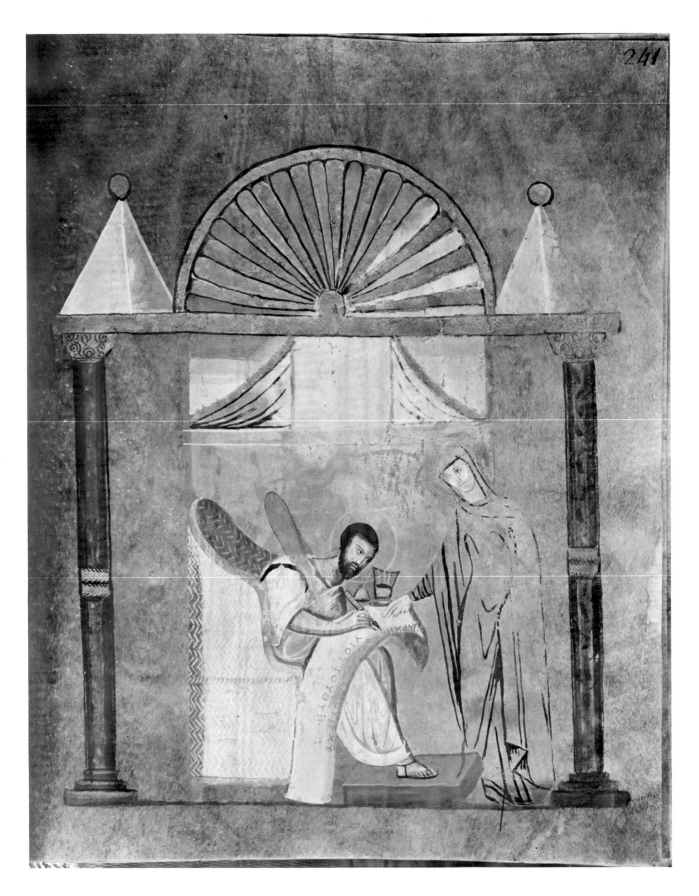

urgy.[21] Although representations of divine personages were forbidden during the tumultuous years of the iconoclastic controversies from 726 to 843, classical traditions of painting survived in illustrations of literary and mythological texts and may have been responsible for the remarkable revival of classical motifs, compositions, and even style in the religious manuscripts of the Macedonian renaissance of the tenth century. The most frequently repeated images were those of the Evangelists. Normally prefacing Gospels or lectionaries, they usually depicted seated Evangelists as in the St. Mark of the Rossano Gospels, although standing types, such as those found in the illustrations of the prophets in the Syriac Bible, were also used. Scholars have also distinguished between profile and frontal portraits, and both of these types found their way into the repertoire of Western manuscripts, as in the Lindisfarne Gospels discussed below.

Narrative miniatures continuing the frieze effect of early Christian illustrations predominate in Byzantine Gospel books, psalters, and homilies or sermons, particularly those of St. John Chrysostom or of Gregory Nazianzus. In some manuscripts such as the Paris Psalter (B.N., MS gr. 139) of the tenth century, full-page miniatures with single scenes closely dependent upon the Hellenistic style preface the text, while in a copy of the ninth-century homilies of Gregory Nazianzus (Paris, Bibliothèque Nationale, MS gr. 510) full-page miniatures containing three horizontal registers and multiple scenes are used.[22] Frequently, particularly in psalters, unframed scenes are placed in the margins adjacent to the relevant texts. Representations of patrons or imperial personages also became frequent. An early example, the portrait of Juliana Anicia, a Byzantine princess, in a copy of Dioscurides' *De Materia medica* dated 512, follows the formula for late antique imperial portraits.[23] Later examples, such as the eleventh-century portrait of Nicephorus III between St. John Chrysostom and St. Michael (Paris, Bibliothèque Nationale, MS Coislin 79), follows an abstract, hieratic style derived from Byzantine icons.[24]

Most of these developments are posticonoclastic and the special forms of Byzantine manuscripts and their illumination fall outside the scope of this book. But the books of the Byzantine Greek world manifest a close continuity with what must have been formulated in the early Christan period and constitute, therefore, the best indications of the nature of these early developments. Byzantine illuminations may also have exerted considerable influence on the development of manuscript illustration in the Latin West, particularly in the Ottonian and Romanesque periods, and therefore cannot be dismissed from any discussion of Western medieval art.[25]

1 / The Insular Gospel Book

*a*lthough Christianity reached the British Isles at a rather early date, its beginnings were tentative and easily supplanted by renewed pagan traditions with the decline of Roman influence. Christianity was established in Ireland by the mid-fifth century. By the sixth century Irish monasticism abounded, and a tradition of book production slowly developed in its monasteries. One of the most remarkable sixth-century Irish monks, St. Columba (St. Columcille, c. 521–597), founded a monastery on the Isle of Iona off the western coast of Scotland in 563 and undertook to convert the Picts to Christianity. In the seventh century the missionary zeal of the Irish was extended to Northumbria in northern England with the foundation of a monastery at Lindisfarne in 635. Eventually the Irish missionaries reached the continent, founding monasteries at Luxeuil in France, St. Gall in Switzerland, and Bobbio in Italy. In the two centuries of its development Irish Christianity followed either the forms of Eastern eremitic monasticism or the precepts of cenobitic monasticism, the tradition in which, it is believed, St. Patrick had been trained. Various Irish customs of worship became formalized into a specific Celtic rite, and variations of this form of worship, prevalent in England, France, and Spain, became the Gallican rite.

At the same time, the Roman form of Christianity was introduced into southern England by St. Augustine. Sent by Pope Gregory the Great in 596, he founded a monastery at Canterbury from which the Roman rite spread northward. The influences of the Roman and Irish churches collided in Northumbria. Some of the differences between the Roman and Irish forms, such as the way in which the date for celebrating Easter was calculated, or the manner of tonsure, led to considerable controversy. The Synod of Whitby was held in 664 in an effort to resolve the dif-

ferences, and the Roman position won. Lindisfarne was taken over by Northumbrian monks who took up the Roman rite, and the Irish monks with their abbot, Colman, retreated to Iona. But the Irish heritage and many Irish traditions persisted in Northumbria, one result of which is the continuing controversy whether the Book of Durrow, perhaps the earliest surviving major monument of Anglo-Irish or Insular book illumination, was produced at Lindisfarne, Iona, or in Ireland.

The four Gospels, comprising a separate entity in one self-contained book, existed in a fairly uniform format from at least the fourth century, and a large number were later produced in Ireland and in Northumbria. The Insular Gospel books of the seventh to the ninth century can be separated into two principal groups, small pocket Gospel books and larger elaborately decorated ones. As Patrick McGurk has pointed out, the pocket Gospels were designed to save space: they contained only the text of the four Gospels without any prefatory matter, but did contain the portraits of the Evangelists or their symbols.[1] Textual traditions manifested by such undisputedly Irish pocket Gospels as the Mulling Gospels in Dublin or the Cadmug Gospels in Fulda, McGurk has noted, were repeated in the larger and more lavishly decorated books produced under Irish influence, such as the MacRegol Gospels now in Oxford and the Chad Gospels now in Lichfield Cathedral.[2]

The second group of Gospels, containing prefatory texts and tables and elaborate decorative pages and introductory initials, marks a significant break with the previous Insular tradition. As scholars have rightfully noted, the Book of Durrow is the first major statement of a new, essentially medieval concept of embellishing the sacred text as though with precious jewels and textiles, as indeed were the wood and metalwork containers for these books (*cumdachs*) and for sacred relics. This form of text decoration was perfected with utmost precision in the Lindisfarne Gospels and varied and developed in the later Book of Kells.

This decorative innovation in Insular bookmaking was not totally unannounced. Enlarged initials and decorative embellishments had been used in the late antique manuscript of the Vergilius Augusteus of the late fourth or early fifth century (Vatican City, Biblioteca Apostolica Vaticana, Cod. vat. lat. 3256).[3] Minimal patterning of colors occasionally occurred within the structure of these initials but their basic shape was not altered. Large initials with decorative pen flourishes springing from the letter into its interior spaces or the area around it were used in the copy of the Psalms in Latin once believed to have been written by St. Columba in Ireland in the mid-sixth century (Pl. 6). This important early Irish book, considered a holy relic, was carried into

6. Initial Q. Cathach of St. Columba, fol. 48r (Dublin, Royal Irish Academy, MS 5n)

battle as a talisman, and is therefore known as the Cathach (battler) of St. Columba.[4] Although its initials were penned, not painted, and their motifs have no direct resemblance to those appearing in the Durrow illuminations, the idea of accentuating an incipit, or opening words, and of occasionally writing the first several letters in a diminishing scale were devices that were developed in the later manuscripts.

A closer antecedent in time and place is the Gospel book now in fragments in three different volumes in the Durham Cathedral Library (MSS A.II.10, C.III.13, C.III.20). Believed to have been produced in the Irish foundation of Lindisfarne in Northumbria about 650, it contains an elaborate column-length decorative panel (Pl. 7) inscribed with a colophon marking the end of Matthew (explicit) and noting the beginning (incipit) of Mark (Pl. 8), which may have followed on the facing folio (they have now been juxtaposed in their present binding):[5] "Finitum est huius aevangelii secundum Mattheum in nomine domini nostri Iesu Christi nunc incipit aevangelium secundum Marcum in nomine Altissimi amen" (Here is finished [the text] of this Gospel according to Matthew in the name of our God Jesus Christ; now begins the Gospel according to Mark in the name of the Most High. Amen). This inscription occurs in the top loop of the design; a Greek text of the Lord's Prayer, but written in Latin letters, fills the two lower loops. This decorative colophon follows the tradition of elaborated colophons prevalent in many of the early Gospel books—usually the only decoration found within them. The decorative motifs of this frame have been shown to be related to interlace forms found on an Irish stele at Fahan Mura, which contains a Greek inscription of the seventh century, and one at Carndonagh of about 675, as well as to those found on an ansate

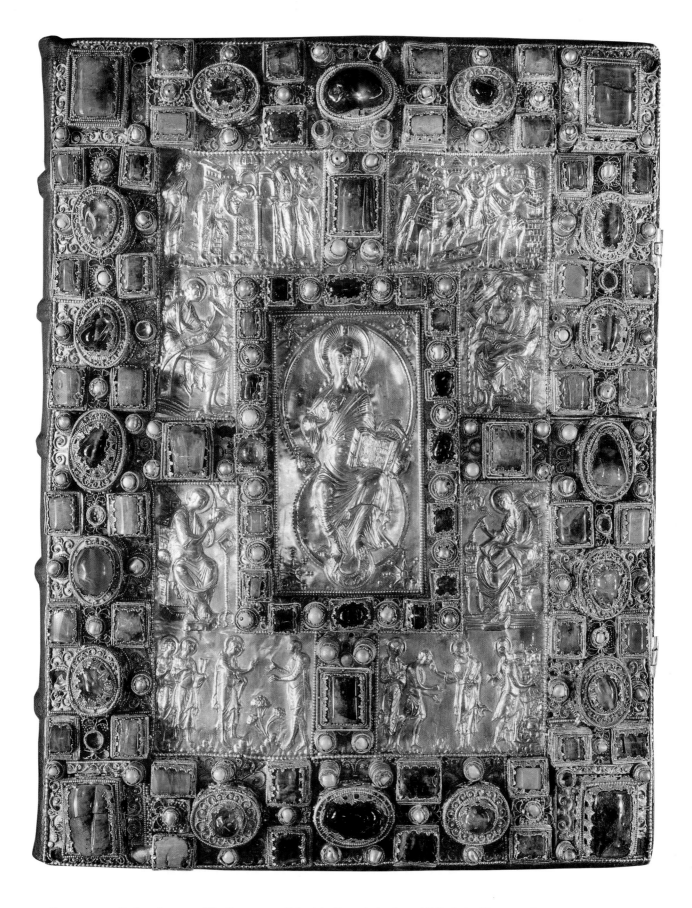

1. Front cover. Codex Aureus of St. Emmeram (Munich, Bayerische Staatsbibliothek, Clm 14000)

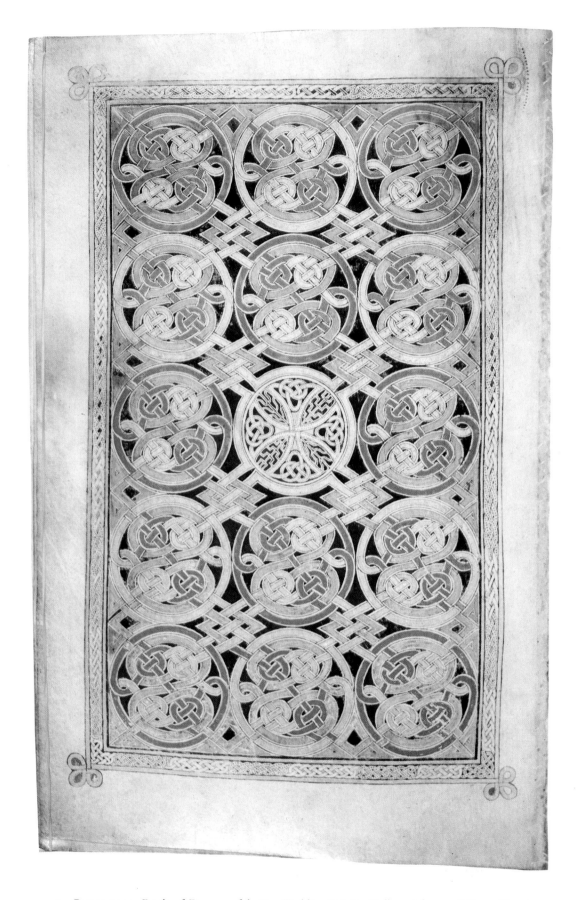

2. Carpet page. Book of Durrow, fol. 85v (Dublin, Trinity College Library, MS 57: Courtesy Board of Trinity College, Dublin)

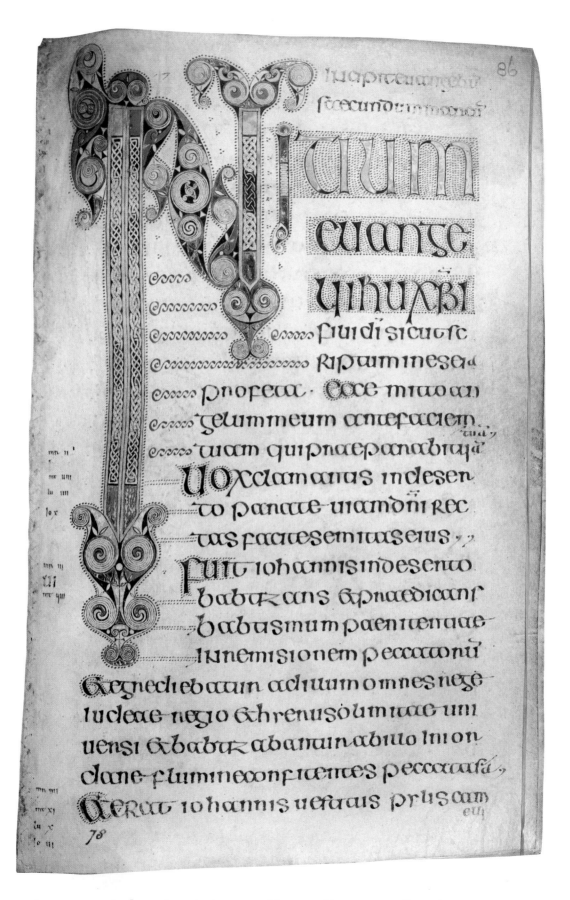

3. "Initium evangelii iħu xp̄i." Book of Durrow, fol. 86r (Dublin, Trinity College Library, MS 57: Courtesy Board of Trinity College, Dublin)

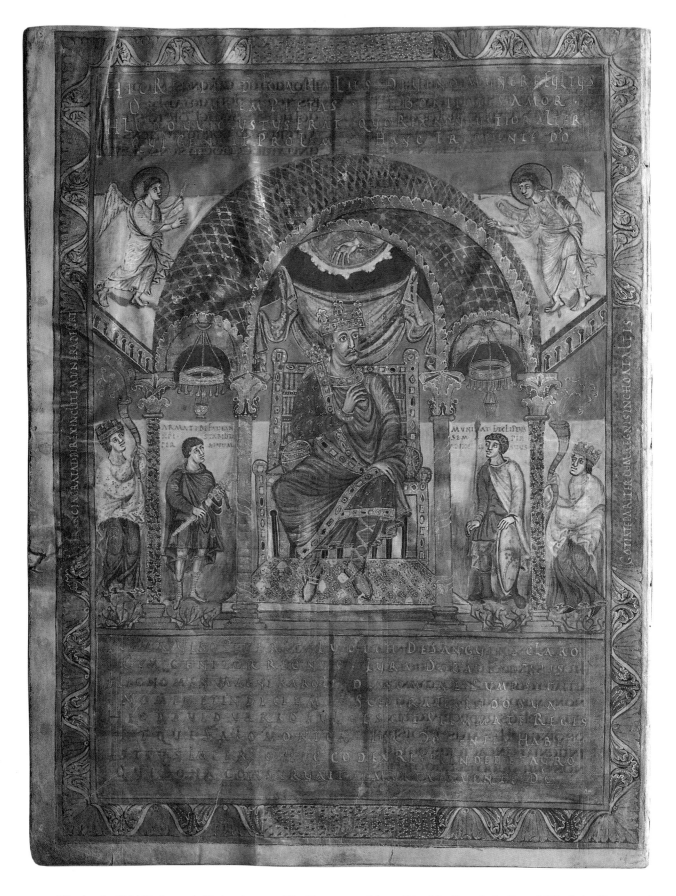

4. Charles the Bald Enthroned. Codex Aureus of St. Emmeram, fol. 5v (Munich, Bayerische Staatsbibliothek, Clm 14000)

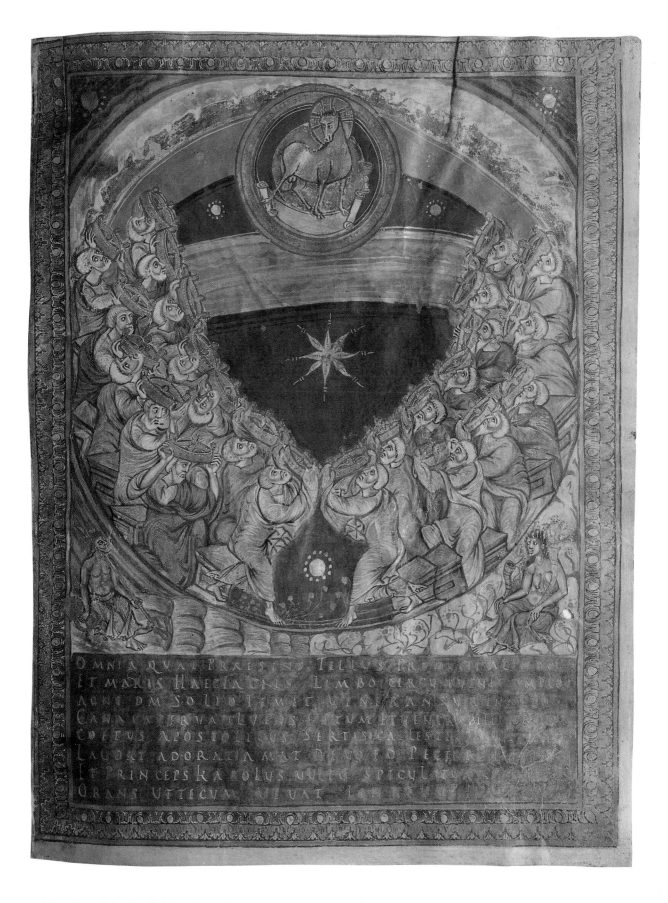

5. Adoration of the Paschal Lamb. Codex Aureus of St. Emmeram, fol. 6r (Munich, Bayerische Staatsbibliothek, Clm 14000)

6. Hand of God. Codex Aureus of St. Emmeram, fol. 97v (Munich, Bayerische Staatsbibliothek, Clm 14000)

7. "In principio erat verbum." Codex Aureus of St. Emmeram, fol. 98r (Munich, Bayerische Staatsbibliothek, Clm 14000)

8. Three Marys at the Tomb. Pericopes of Henry II, fol. 116v (Munich, Bayerische Staatsbibliothek, Clm 4452)

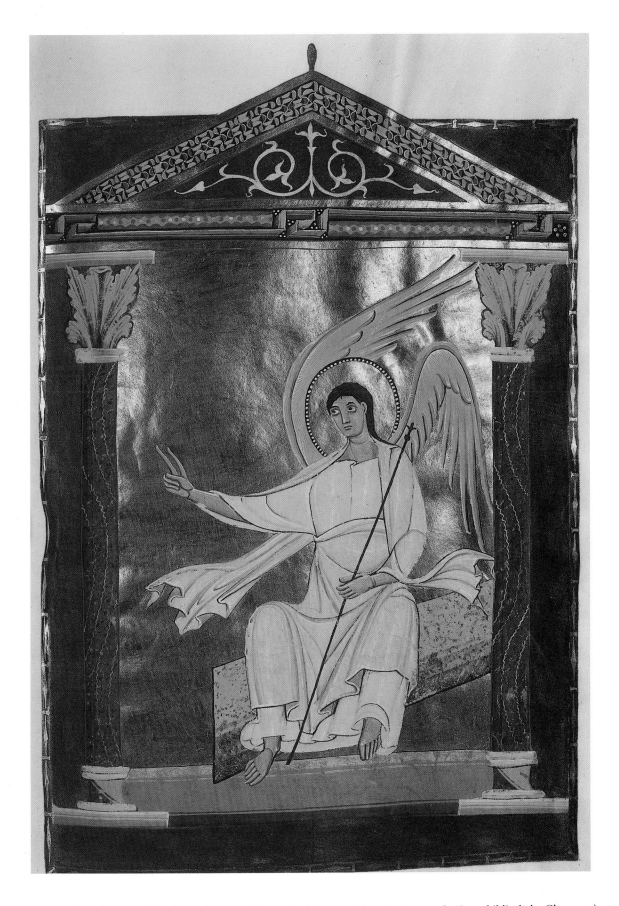

9. Angel on the Open Tomb. Pericopes of Henry II, fol. 117r (Munich, Bayerische Staatsbibliothek, Clm 4452)

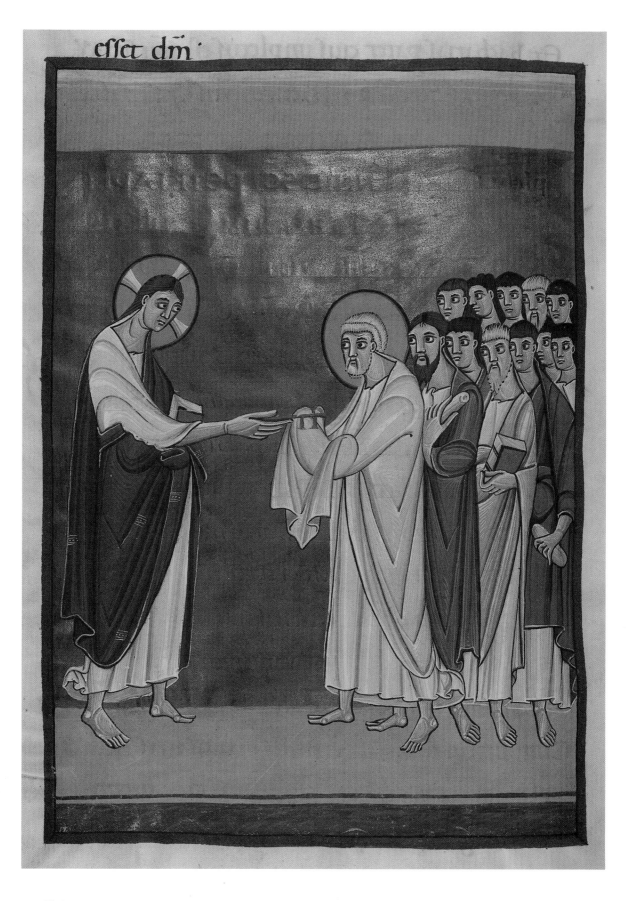

10. Christ Gives Peter the Keys to Heaven. Pericopes of Henry II, fol. 152v (Munich, Bayerische Staatsbibliothek, Clm 4452)

11. "Venit Jesus in partes." Pericopes of Henry II, fol. 153r (Munich, Bayerische Staatsbibliothek, Clm 4452)

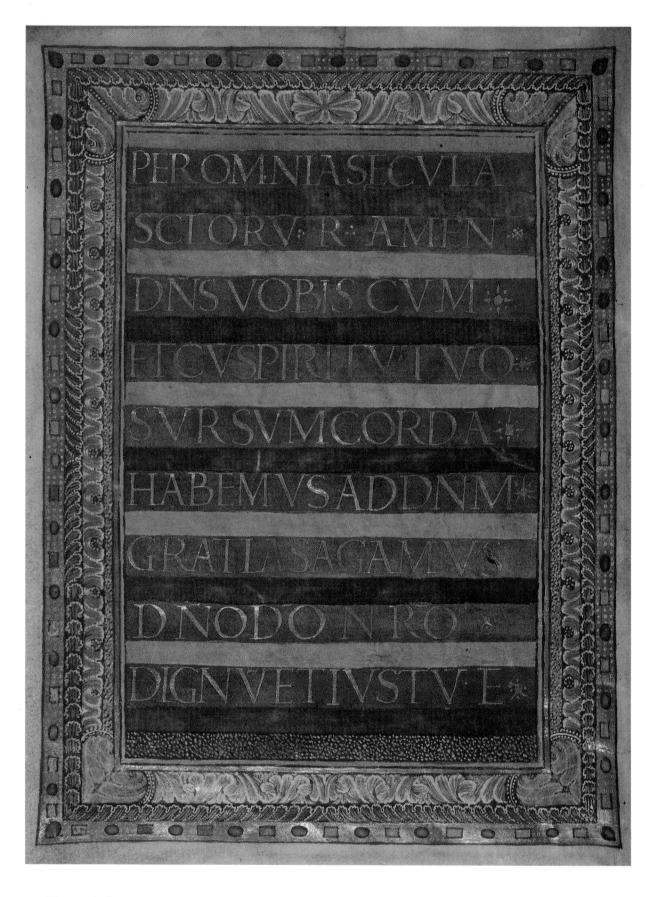

12. "Per omnia." Metz Coronation Sacramentary, fol. 3v (Paris, Bibliothèque Nationale, MS lat. 1141: Photo Bibl. Nat., Paris)

13. "Vere dignum." Metz Coronation Sacramentary, fol. 4r (Paris, Bibliothèque Nationale, MS lat. 1141: Photo Bibl. Nat. Paris)

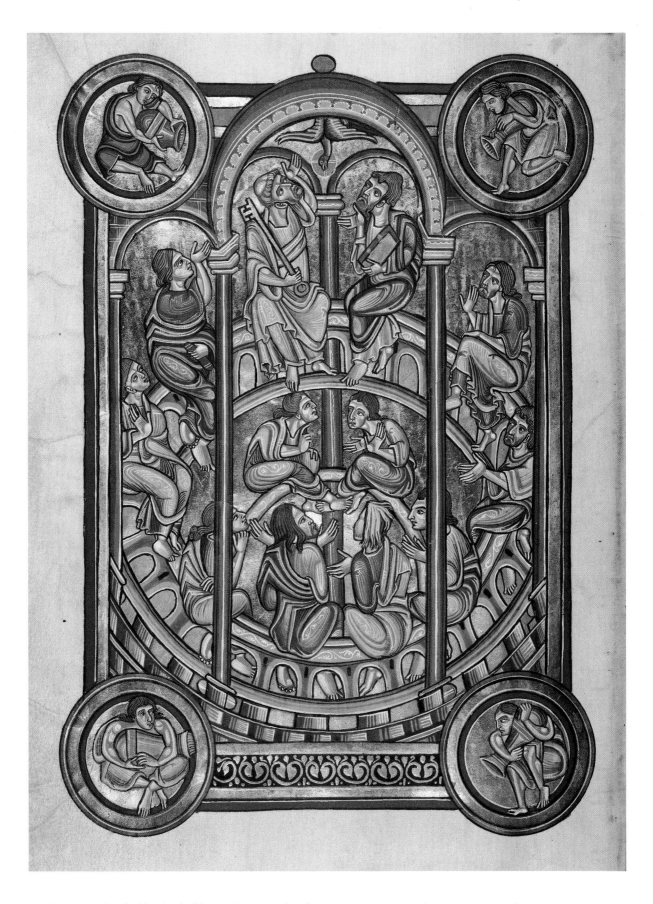

14. Pentecost. Berthold Missal, fol. 64v (New York, The Pierpont Morgan Library, MS M. 710)

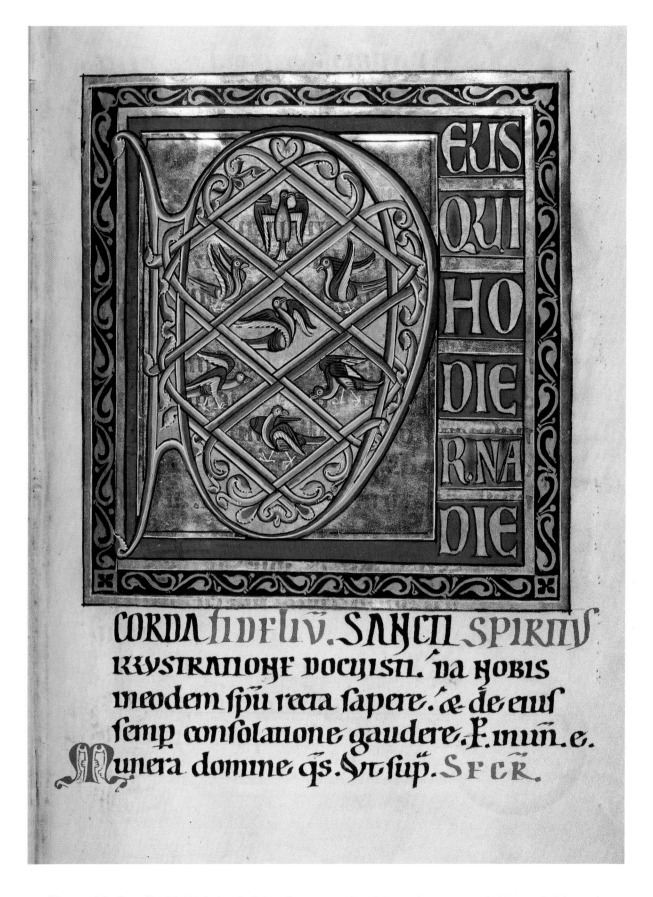

15. "Deus qui hodierna" with Birds Symbolizing the Seven Gifts of the Holy Spirit. Berthold Missal, fol. 65r (New York, The Pierpont Morgan Library, MS M. 710)

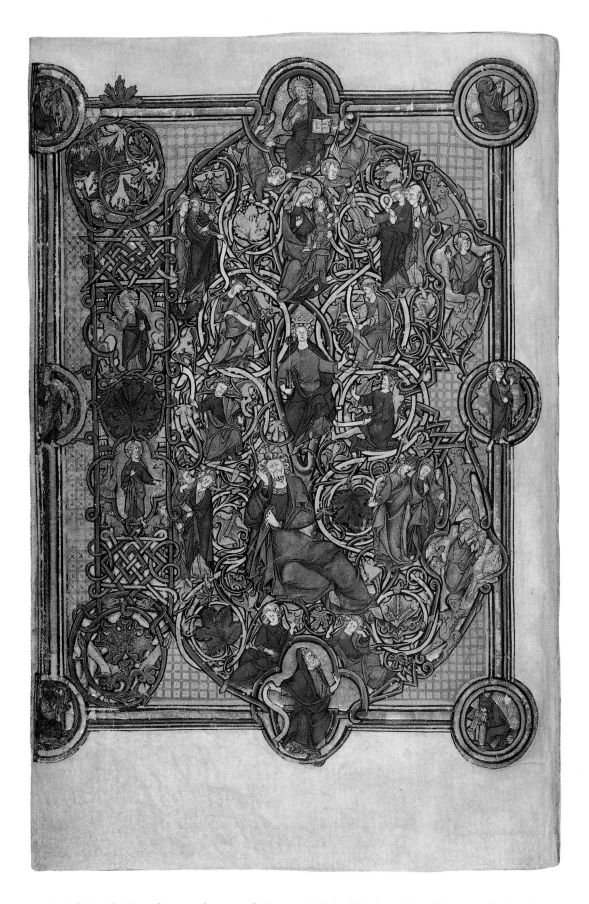

16. Initial *B* with Tree of Jesse and scenes of Creation. Windmill Psalter, fol. 1v (New York, The Pierpont Morgan Library, MS M. 102)

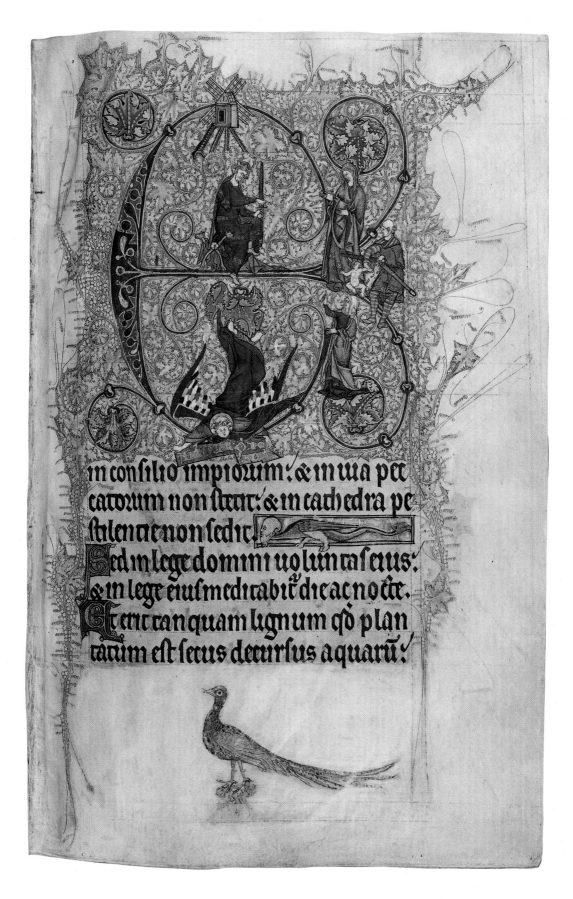

17. Initial *E* with Judgment of Solomon. Windmill Psalter, fol. 2r (New York, The Pierpont Morgan Library, MS M. 102)

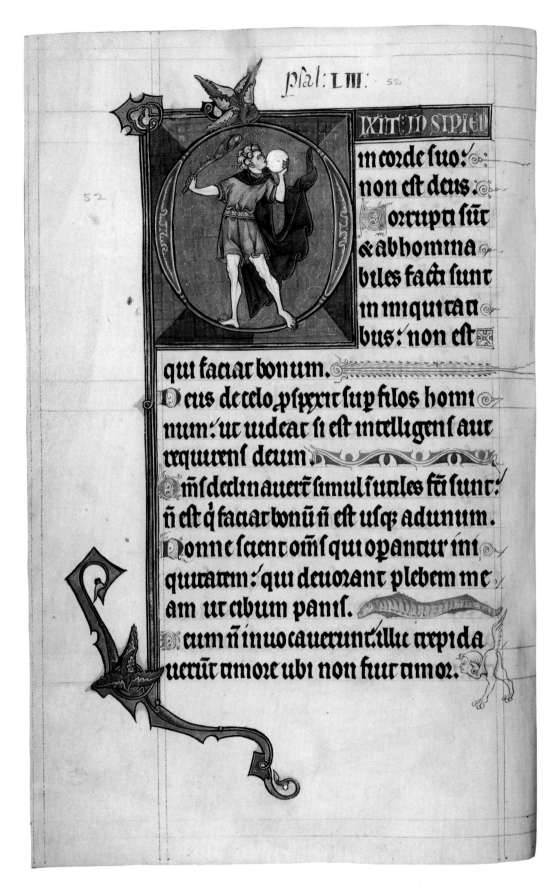

IXIT·IN SIPIEN
in corde suo:
non est deus.
Corrupti sūt
& abhomina
biles facti sunt
in iniquitati
bus: non est
qui faciat bonum.
Deus de celo prspexit sup filos homi
num: ut uideat si est intelligens aut
requirens deum.
Oms declinauerūt simul inutiles facti sunt:
ñ est q faciat bonū ñ est usq; adunum.
Nonne scient oms qui opantur ini
quitatem: qui deuorant plebem me
am ut cibum panis.
Illuc trepida
uerūt timore ubi non fuit timor.

18. Initial *D* with a Fool. Windmill Psalter, fol. 53v (New York, The Pierpont Morgan Library, MS M. 102)

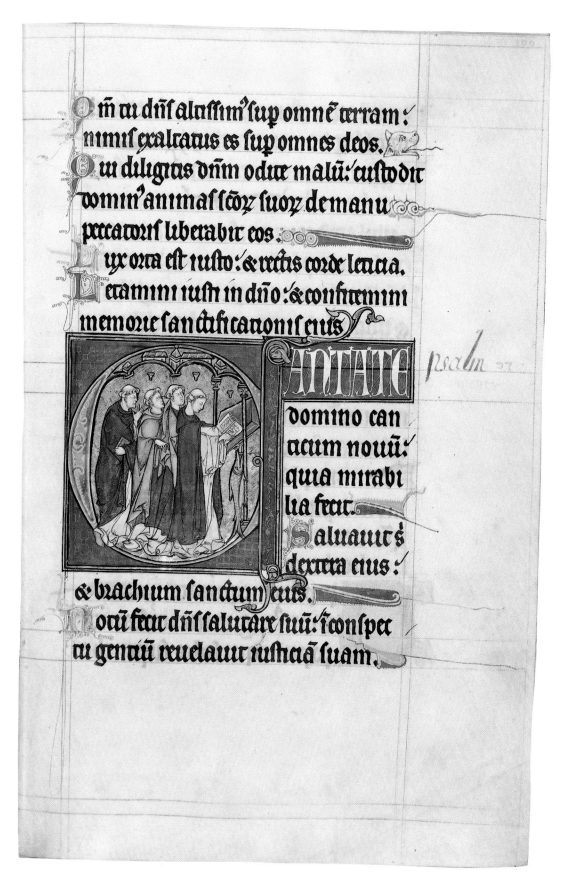

ōm tu dn̄s altissim° sup omnē terram:
nimis exaltatus es sup omnes deos.
Qui diligitis dn̄m odite malū: custodit
dominus animas scōx suox de manu
peccatoris liberabit eos.
Lux orta est iusto: & rectis corde leticia.
Letamini iusti in dn̄o: & confitemini
memorie sanctificationis eius

ANTATE
domino can
ticum nouū:
quia mirabi
lia fecit.
Saluauit s
dextera eius:
& brachium sanctum eius.
Notū fecit dn̄s salutare suū: in conspec
tu gentiū reuelauit iusticiā suam.

19. *Initial C with Singing Monks. Windmill Psalter*, fol. *100r* (New York, The Pierpont Morgan Library, MS M. *102*)

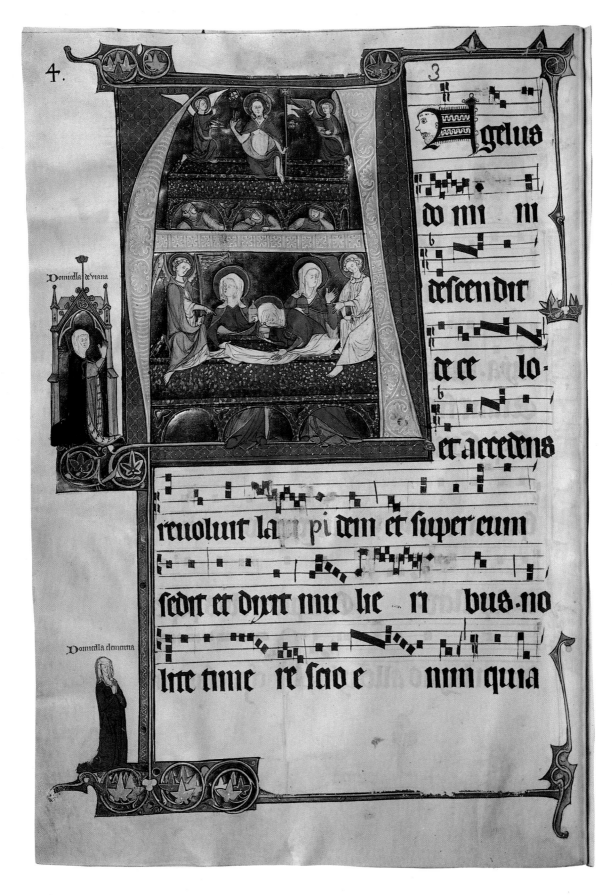

20. Initial *A* with Resurrection and Kneeling Donors in margin. Beaupré Antiphonary, vol. 1, fol. 3v (Baltimore, The Walters Art Gallery, MS W.759)

21. Initial *V* with St. Catherine. Folio from Beaupré Antiphonary, vol. 2 [MS W.760, fol. 182r] (Oxford, Ashmolean Museum)

22. Annunciation. "London Hours," fol. 20r (London, The British Library, Add. MS 29433: By permission of The British Library)

23. Adoration of the Magi. "London Hours," fol. 67r (London, The British Library, Add. MS 29433: By permission of The British Library)

24a. Initial *N* with St. Helen Kneeling before the Cross.

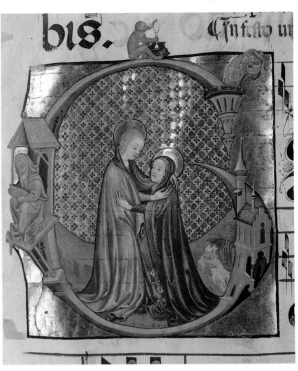

24b. Initial *G* with Visitation.

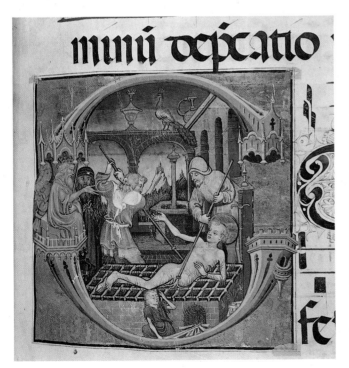

24c. Initial *C* with Martyrdom of St. Lawrence.

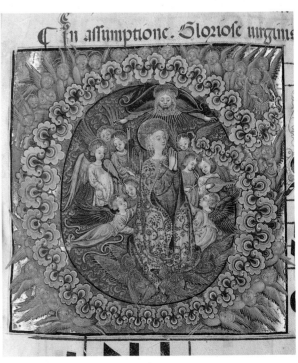

24d. Initial *G* with Assumption of the Virgin.

24. Lombard Gradual, fols. 28v, 45r, 51r, and 54r (Ithaca, N.Y., Cornell University Libraries, MS. B. 50++)

cross in an illuminated Coptic manuscript of the Acts of the Apostles in the Glazier Collection of the Pierpont Morgan Library (MS G.67).[6] The interlaced terminals with scroll and trumpet motifs, long current in Celtic art, had formed the basis of some of the decorative elaboration of the initials of the Cathach of St. Columba.

The facing incipit to Mark, "Inititium [*sic*—it should read *initium*] evangelii" (The beginning of the Gospel), consists, for the first time, of painting initials using not only the device of diminishing letters found in the Cathach but also decorative motifs and effects common to metalwork of the period. This visual relationship of the decorative panel containing the colophon, which Carl Nordenfalk related to motifs on a book binding from the Far East and in Byzantine canon tables, facing the accentuated incipit initials on the opposite folio, sets the precedent for more elaborate juxtapositions found in the Book of Durrow.[7] Although not further elaborated in the Durham Gospels, these facing decorations may have been the genesis of the deliberate planning of two-page decorative spreads in later Insular manuscripts.

The Book of Durrow

The Book of Durrow has been, and continues to be, the subject of considerable controversy, not only over its place and date of origin, but also over the sources for its decoration.[8] It has been suggested that it was made at a Columban monastery near Durrow in Ireland as early as about 650, or at the Columban monastery on the Isle of Iona just after the Synod of Whitby in 664, or as late as about 690 at Lindisfarne in Northumbria. In any event, the Book of Durrow was in Ireland by the beginning of the tenth century when King Flan (d. 916) commissioned a cumdach to be made for it, and inscriptions in the book prove that it was at Durrow by the eleventh or twelfth century. Sources for its decorative motifs and iconographical peculiarities have been said to come from eastern Mediterranean manuscripts and book covers, Coptic manuscripts and textiles of about 400, and indigenous Irish-Celtic and Anglo-Saxon motifs prevalent in the stone carving and metalwork of the sixth and seventh centuries.

As the manuscript is bound at present and published in the facsimile edition of 1960, the folios have been restored to what is believed to be more or less their original order.[9] Examination of the manuscript revealed that it was written for the most part in gatherings of ten leaves, but there was considerable variation,

7. Explicit decoration to Gospel of St. Matthew. Durham Gospels, fol. 3v (Durham Cathedral Library, MS A.II.10: Courtesy The Dean and Chapter of Durham)

8. "Initium" (Incipit to Gospel of St. Mark). Durham Gospels, fol. 2r (Durham Cathedral Library, MS A.II.10: Courtesy The Dean and Chapter of Durham)

diserendit decaelo eraccedens reuoluit
lapidem etsedebat supereum Erat
autem aspectus eius sicut fulgor eius
amentum eius candida ut nix praetimore
autem eius exterritisunt cus-
todes etfacti sunt uelutmortui Respon
dens autem angelus dixit mulieribus
Nolite timere uos scio enim quod ih[e]su[m]
xp[istu]m qui crucifixus est quaeritis Ior
exchino surrexit enim sicut dixit uenite
etuidete locum ubi positus erat d[omi]n[u]s
Ecito euntes dicite discipulis eius q[ui]a
surrexit amortuis etecce praecedit
uos ingalileam ibieum uidebitis etecce
dixi uobis Exierunt ergo demonume[n]to
cum timore etgaudio magno currentes
Er nuntiare discipulis eius Etecce ih[esu]s
currit illis dicens hauete Illae autem ac-
cesserunt ettenuerunt pedes eius et
adorauerunt eum Tuncait illis d[omi]n[u]s Noli-
te timere Sedite nuntiate fratribus
meis ut eant ingalileam ibi me uidebu[n]t
quae cum abissent ecce quidam deor-
todibus uenerunt incuitatem adhun-
tiauerunt principibus sacerdotum om-
nia quae facta fuerant Etcongregati
cum senioribus consilio accepto pecunia
copiosam dederunt militibus dicentes
dicite quia discipuli eius nocte uenerunt
etfurati sunt eum nobis dormientibus
Ethoc audtum fuerit apraeside nostra
debimuset etsecuras uos faciemus atqli
accepta pecunia fecerunt sicut erant
instructi etdeuulgatum est uerbum istud
apud iudaeos usq[ue] inhodiernum diem ---

VNdeceni autem discipuli eius Abierunt in
galileam inmontem ubiconstituerat
illis ih[esu]s etuidentes eum adoraurunt quid-
am autem dubitauerunt etaccedens ih[esu]s locutus
est eis dicens datam mihi omnis potestas in
celo etinterra euntes ergo nunc docete omn[e]s g[entes]
bapdzantes eos innomine patris etfilii et
sp[iritu]s s[ancti] docentes eos obseruare omnia quae-
cumque mandaui uobis etecce eg[o] uobiscum
sum omnibus diebus usque adconsumma
tionem saeculi ::::::::

eruno eum cliuisse · atenna nacoo est epocoo sose sunc

INITIUM
euangelii Ihu Xpi filii
dei sicut scriptum
est in Esaia
propheta ecce
ego mitto ang-
elum meum ante faciem
tuam qui praeparabit
viam tuam · Vox clamant-
is in deserto parate viam
dni rectas facite semitas
eius · fuit Iohannis in
deserto baptizans et
praedicans baptismum
paenitentiae et remission-
em peccatorum et egredie-
batur ad illum omnis Iudaeae
regio et hierusolymitae universi et
baptizabantur ab illo in Iorda-
ne et confitentes peccata sua
et erat Iohannis vestitus pi-
lis cameli et zona pellicia circa
lumbos eius et locusta et mel sil-
vestre edebat et praedicabat
dicens venit fortior post me cu-
ius non sum dignus procumbens
solvere corrigiam calciamento-
rum eius ego baptizavi vos aqu-
a ille baptizabit vos in spiritu
sancto · et factum est in diebus
illis venit Iohannis a Naza-
reth Galileae et baptizatus est
in Iordane a Iohanne et statim
ascendens de aqua vidit apert-
os et caelos et spiritum tamquam
columbam descendentem et ma-
nentem in ipso et vox facta est
ad eum de caelis tu es filius meus
dilectus in te conplacui · et
statim spiritus expulit eum in deser-
tum et erat ibi xl diebus et xl noc-
tibus et temptabatur a satanah
erat q: cum bestiis et angeli mi-
nistrabant ei · Post autem

traditus est Iohannis venit dns in
galileam praedicans euangelium regni
dei et dicens quoniam impletum est tempus
et adpropinquavit regnum dei peni-
temini et credite euangelio et praeter-
iens secus mare galileae vidit simo-
nem et andream fratrem eius mittent-
es retia in mare erant enim pis-
catores · et dixit eis dom-
venite post
me et faciam
vos fieri
piscatores ho-
minum et
pnotinus ne-
licta reab-
 rectas sunt eum
et progresus inde pussillum vi-
dit iacobum zebedei et iohannem
fratrem eius · et ipsos in navi
componentes retia et statim vocavit
illos et relicto patre suo zebedeo in
navi cum mercenariis secuti sunt eum
et ingrediuntur capharnaum et
statim sabbatis ingressus in synagogam
docebat eos · et stupebant sup
doctrinam eius erat enim docens
quasi potestatem habens et non sicut
scribae · et erat in synagoga eorum
homo in spiritu immundo et exclamauit
dicens haec quid nobis et tibi ihu na-
zarene venisti perdere nos scio qu-
ia es sanctus dei et comminatus est ei ihu dic-
ens obmutesce et exi de homine spiritus
immundus et exit spiritus immundus dis-
cerpens eum et exclamauit uoce mag-
na exivit ab eo et mirati sunt omnes
ita ut conquirerent inter se dicentes
quidnam est hoc quae doctrina
nova quia in potestate et spiriti-
bus immundis imperat et oboediunt
ei et processit rumor eius statim in
omnem regionem galilee · et pro-
tinus egrediens de synagoga venerunt
in domum simonis et andreae cum
 ... decumbebat et statim
dicunt ei de illa et accedens ele-
vavit eam adpraehensa manu
eius et continuo dimisit eam febris
et ministrabat eis

Pl. 8 / 35

and some of the decorative introductory pages were on single leaves. Although the text appears to have been written by a single scribe in a fine Irish majuscule hand, Ludwig Bieler concluded from a study of the paleography that the book could have been written either in Ireland during the second half of the seventh century or in Northumbria after the Synod of Whitby in 664 while the Irish influence at Lindisfarne was still strong.[10]

Curious anomalies occur in the text of the Book of Durrow which emphasize its position as a transitional work between the Old Latin, pre-Jerome translations of the Bible and the Vulgate version and between Irish-Gallic and Roman traditions that gained ascendancy after the Synod of Whitby. Although the text of the four Gospels closely follows the Vulgate revisions of St. Jerome, and are in the order established by him, they are preceded by prefatory material stemming from the Old Latin translations of the second century.[11] This consists of a glossary of Hebrew names (see Appendix 1), four summaries (*Breves causae*), four prefaces or prologues (Argumenta), and the numbered capitula in the text. Even the structure of the introductory page with the four symbols of the Evangelists follows a pre-Jerome order, which will be discussed below.

The decoration of the Book of Durrow shows a concerted effort to embellish the text in a coherent manner, creating a meaningful sequence or program of ornament in relation to significant divisions of the book. It is the oldest surviving example of the maturation of this idea. In all, the Book of Durrow contains six full-page decorative panels of abstact geometric and zoomorphic ornament or "carpet pages," four full-page representations of the symbols of the Evangelists, one page containing the symbols of the four Evangelists together, four text pages with major introductory or incipit initials, and other text pages with lesser decorative initials. Although many of the better preserved pages have been illustrated and discussed separately, only the facsimile edition of the manuscript presents the full visual impact of the facing pages of decoration and their relationship to the structure of the book.

At the beginning of the manuscript, before the prefatory material, two decorative pages form an introductory double-page frontispiece (Pls. 9, 10). A carpet page with a double-armed cross set against a field of interlace and framed by panels of similar decoration faces a full-page rectangular frame filled with a diaper design and enclosing a panel with the four symbols of the Evangelists.[12] These four signs, placed in compartments created by the presence of a Latin cross within the central panel, not only symbolize the contents of the Gospel book, but affirm by their depiction together the harmony of the Gospels. Their appearance

at this point is also appropriate for the prefatory material consisting of St. Jerome's letter of transmittal to Pope Damasus explaining his new compilation of the Gospels ("Novum opus"), his revision of the Old Latin text and the use of the canon tables providing the numerical concordance of similar incidents in the Gospels. The four summaries and prefaces, grouped together before the texts of the Gospels, also reiterate the unity of the Evangelists' accounts of Christ's mission.

The second carpet page (Pl. 11), consisting of a panel of circle and trumpet spirals set within a frame of broad ribbon interlace forming linked circles, has been much abused and may be out of place. The top of the interlace frame is missing, and the entire decorative panel was apparently cut out along its outer boundary, sewn onto another parchment leaf, and inserted as a frontispiece facing the incipit of Jerome's letter. J. J. G. Alexander suggested that this page may be the one that is out of place and that it possibly faced the incipit of the Gospel of St. Matthew, which, unlike the other Gospels, does not now have a carpet page.[13] But its placement as a frontispiece to the "Novum opus" (Pl. 12) need not be considered inappropriate. In fact, as we shall see below, a carpet page was used in a similar position in the slightly later Lindisfarne Gospels.

The canon tables are in a simple rectangular format, appearing in penned columns within a frame filled with continuous interlace. It has often been observed that this format suggests an Insular tradition independent of Continental, specifically Mediterranean, influences. Such a columnar format was used in the Echternach Gospels (Paris, B.N. MS lat. 9389) and in part of the canon tables of the Book of Kells.[14]

As though following the inspiration of the decorative lettering in the Cathach of St. Columba, the prefatory initials of the *Argumenta* are two lines high and the letters of the first word decrease in size to the normal one-line height of the continuing text. In the prefatory section of the Book of Durrow, only the *N* of the "Novum opus" (Pl. 12) received major emphasis, its left staff occupying the equivalent of eleven lines. Painted in yellow, filled with spirals and panels of interlace, and surrounded by dots following its outer contour, this initial may be the first in Insular illumination to emulate deliberately the effect of niello and gold filigree metalwork. Its structure is more compact and its interior details more meticulous and sophisticated than the *Ini* of Mark in the Durham Gospels.

As mentioned above, the sequence of decorative pages introducing the Gospel of St. Matthew may have been altered: as the manuscript is now bound, a full-page representation of a man, the symbol of St. Matthew (Pl. 13), faces the incipit (Pl. 14),

9. Carpet page. Book of Durrow, fol. 1v (Dublin, Trinity College Library, MS 57: Courtesy Board of Trinity College, Dublin)

10. Symbols of the Four Evangelists. Book of Durrow, fol. 2r (Dublin, Trinity College Library, MS 57: Courtesy Board of Trinity College, Dublin)

11. Carpet page. Book of Durrow, fol. 3v (Dublin, Trinity College Library, MS 57: Courtesy Board of Trinity College, Dublin)

12. "Novum opus" (Letter of St. Jerome). Book of Durrow, fol. 4r (Dublin, Trinity College Library, MS 57: Courtesy Board of Trinity College, Dublin)

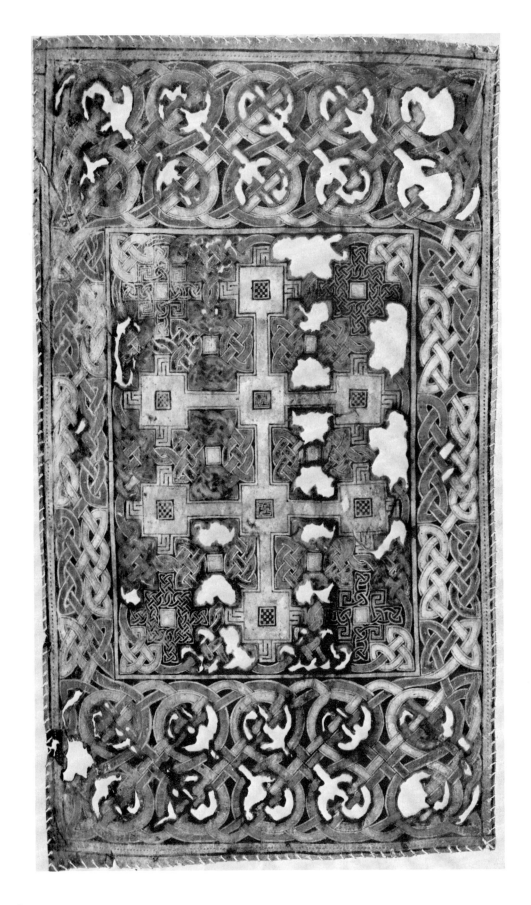

38 / Pl. 9

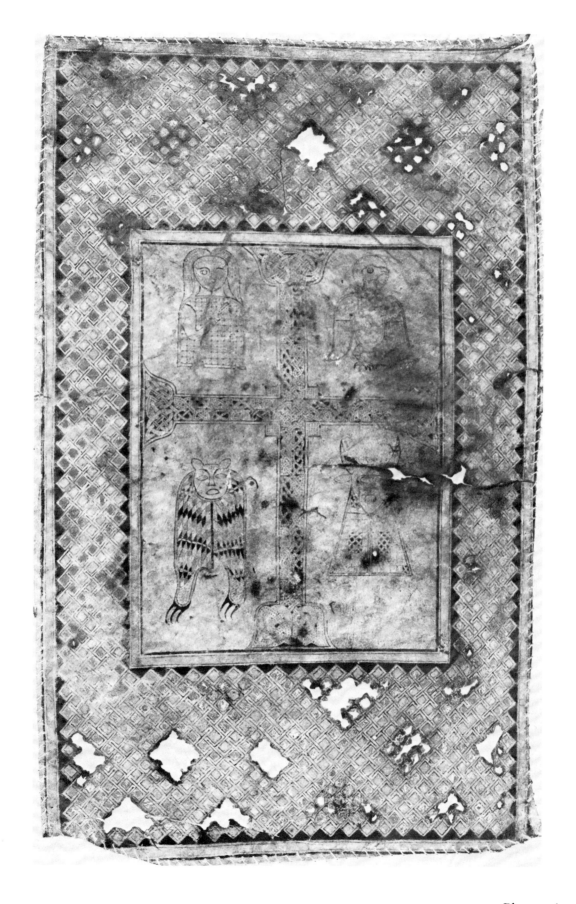

Pl. 10 / 39

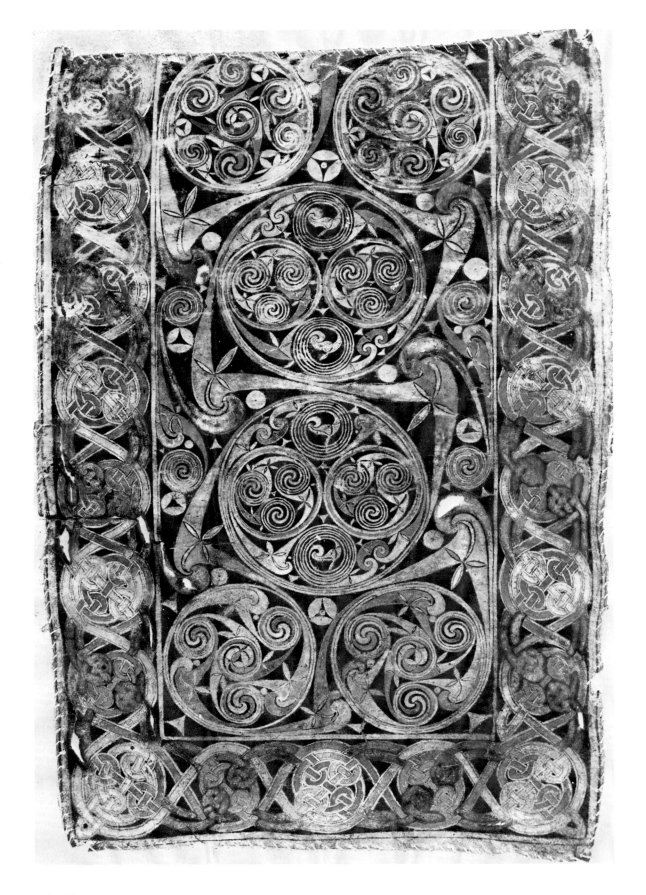

40 / Pl. 11

NOUUM OPU

facere mecogit ex
ueteri utpostexem
plaria scribtura
rum toto onbe dispe-
sa quasi quidam arbiter sedea
et quia inter se uaricant quae
sint illa quaecumgraeca con
seruant uentate decernam
Pius labor sed periculosa
praesumptio iudicare dece
teris ipsum ab omnib; iudicandum
senis mutare linguam et canescente
mundum ad initia retrahe ne par
uulorum · quis enim doctus pariter
uel indoctus cum inmanibus uolumen
adsumpserit et a saliua quam se
mel inbibit uiderit discrepare
quod lectitat non statim erumpat
in uocem me falsarium me clamans
esse sacrilegum · quid ad eam ad
quid mutatis libris addens mutans
ns

Pl. 12 / 41

"Liber generationis" (The book of the generation). It seems likely that a carpet page was originally intended for this position, whether the one opening the book, the one before the "Novum opus," or one that has been lost. Thus the sequence prefacing the Gospel, as for Mark, Luke, and John, would have consisted of a representation of the symbol of the Evangelist on a verso facing a blank recto, and a carpet page on the subsequent verso facing the decorated opening of the text.

In the other three Gospels, this sequence survives. The carpet page prefacing Mark (Pl. 17) consists of a panel of circles of interwoven ribbons surrounding a central circle with a cross made up of interlace. The decorative page facing the opening of Luke (Pl. 20) contains a large panel of interlace and smaller ones of step motifs and diaper patterns. The page facing the incipit of John (Pl. 23) contains a circular medallion with interlace, roundels of step patterns, and a diminutive cross in the center, all framed by panels containing biting quadrupeds and snakes or lacertines. The final carpet page (Pl. 25), consisting of a simple regular design of tightly woven interlace around seven rows of four equal-armed X's, faces the colophon at the end of the book. This page, previously bound at the beginning of Matthew was moved to the position of final carpet page when the book was rebound in 1957, as markings on the folio, perhaps rust from a clasp, suggest that this was its original position.[15] In principle, these decorative pages perform a carefully calculated function: perhaps originally seven in number, they open the book, serve as frontispieces for the prefatory matter and for each Gospel incipit, and close the book. Their role may therefore be more complex than just sumptuous frontispieces, but we shall return to this question after examining the initials, the Evangelist symbols, and the sources for their decorative motifs.

The large ornamental initial letters commencing the Gospels are a further elaboration of the mode of decoration used in the letters of the *Breves causae* and Argumenta and ultimately derived from the tradition of the Durham Gospels incipit and the Cathach of St. Columba. The line of lettering which opens Matthew, "Liber genera" (Pl. 14), is similar to the opening line of the Durrow "Novum opus" (Pl. 12): the *Li* are enlarged and carefully articulated with panels of interlace and spirals, and are painted to look like metalwork. With the slightly smaller *b* these letters reiterate the diminuendo of earlier examples. The remaining versal letters are slightly smaller, but still the height of about two lines of the regular text. The area that they occupy is filled with dots, framing all but the introductory letters as though they were panels of interlace. Although the "Liber" reintroduced the diminu-

endo not found in the "Novum opus," the effect of this decoration is still restrained.

Perhaps one reason for this restraint is that on the following folio we find the lavishly articulated phrase "Xpi autem" (Pl. 15) introduced by two large introductory initials and painted entirely in yellow versal letters. The *Xpi* or "Chi Rho" monogram standing for the name of Christ became the vehicle for increasingly elaborate embellishment, and the example in the Book of Durrow may be the beginning of a remarkable tradition that culminated in the lavish Chi Rho page of the Book of Kells. Since the Gospel of St. Matthew begins with a genealogical listing of the human ancestors of Christ ("The book of the generation of Jesus Christ, the son of David"), the actual narration of the story of the Nativity, or Incarnation, does not begin until Matthew 1:18: "Christi autem generatio sic erat" (Now the birth of Christ was in this wise). Regarded as the true beginning of the Gospel and as embodying the full mystery of the Incarnation, this phrase was given even more elaborate treatment than the actual incipit of the Gospel.

As though realizing the decorative potential in the increasing elaboration of these incipits, the illuminator provided a monumental *In* for the opening lines of Mark (Pl. 18). The *I*, which doubles as the left staff of the *n*, occupies the equivalent of twenty-one lines, the second *i* occupies five, and the remaining *tium* in yellow versal letters occupies three. The first three lines of the text, "Initium evangelii iħu xp̄i" (The beginning of the Gospel of Jesus Christ), are now enclosed in fields of dots, and the areas between the decorative initials and the text filled in with running scrolls and parallel lines of dots. Here is born the idea of a monumental incipit dominating the text but decoratively linked to it. The initials, again articulated as though they were a precious bejeweled piece of metalwork, not unlike the intricate eighth-century Tara Brooch with braided gold filigree, niello trumpet spirals, and panels of interlace, now take on an importance that begins to vie with and balance that of the facing carpet page.

The beginning of Luke is more subdued (Pl. 21), the Q occupying only nine lines, but the diminishing versal letters are filled in with spirals, and the banded letters continue for two lines. Perhaps the reason for the reduced scale of decoration is the presence below on the same page of a second major initial and ornamented passage: "Fuit in diebus Herodis regis" (There was in the days of Herod the king). This text, like that in Matthew, is the actual beginning of the narrative of the Nativity, the opening lines "Quoniam quidem multi" (Forasmuch as many) merely serving as a preamble to the Gospel. But the tradition of accentu-

13. Man (Symbol of St. Matthew). Book of Durrow, fol. 21v (Dublin, Trinity College Library, MS 57: Courtesy Board of Trinity College, Dublin)
14. "Liber generationis" (Incipit of Gospel of St. Matthew). Book of Durrow, fol. 22r (Dublin, Trinity College Library, MS 57: Courtesy Board of Trinity College, Dublin)

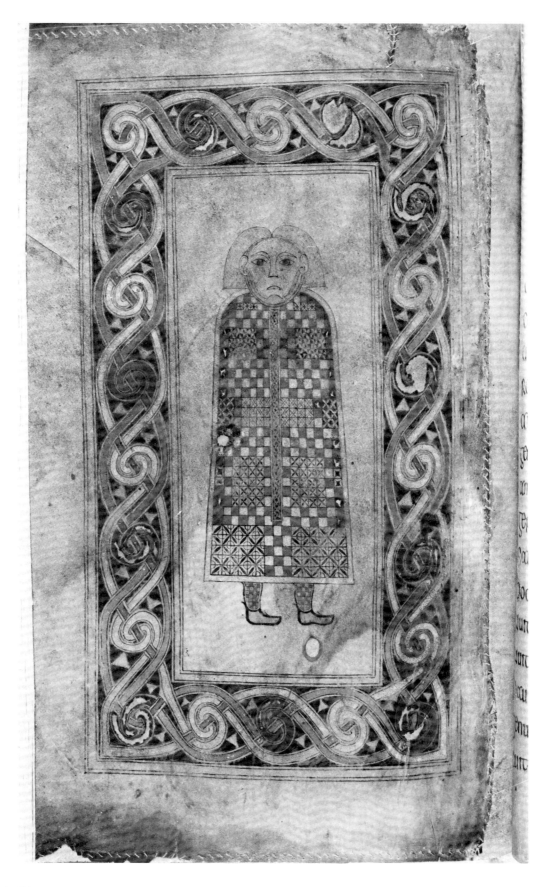

Pl. 14 / 45

ating this text, unlike that of the "Christi autem," enjoyed only a short life perhaps because it did not include the monogram for Christ which inspired Insular illuminators to lavish upon it increasingly elaborate decoration.

The *In* of the "In principio erat verbum" (In the beginning was the word) opening the Gospel of St. John (Pl. 24) received the largest decorative format, occupying the entire page and echoing, in diminishing scale, through six lines of the text. The entire page has now been subjected to the decorative impact of the incipit initials, and this advancement in the concept of the relation of opening letters to the page will result in the framing of the page in the Lindisfarne Gospels and the Book of Kells. Although close in form to the *In* introducing Mark, the terminals of the letters have been enlarged and filled with a greater complexity of trumpet spirals, and within the vertical structure of the capital, the interlace is woven in more varied knotlike forms.

The five pages with the symbols of the Evangelists have been the subject of considerable scholarly inquiry and controversy.[16] While in the full-page representations before two of the Gospels the symbols of the man for St. Matthew (Pl. 13) and of the ox for St. Luke (Pl. 19) follow the arrangement established by St. Jerome, the eagle is used for St. Mark (Pl. 16) and the lion for St. John (Pl. 22), a reversal of the usual pairing. That this transposition is intentional is proven by explicits in the original hand of the text on the rectos of each of these folios referring to the ending of the previous Gospel. This unusual use of the lion for John and the eagle for Mark has been traced to the exegetical writings of St. Irenaeus, a second-century bishop of Lyon. His use of the Evangelist symbols had some currency among the makers of Insular manuscripts, for a similar but verbal rather than representational pairing occurs in the MacRegol Gospels produced in Ireland in the late eighth century.[17] It has been noted that the Durrow symbols have neither wings, haloes, nor books and are thought, therefore, to serve not as symbols or portraits of the Evangelists, but rather as personifications of them.[18] A symbol of the appropriate Evangelist before each of the Gospels functions like book covers that have all four representations together on the exterior of the book.

The question of sources for the unusual pairing of the Evangelist symbols with the Gospels in the Book of Durrow also pertains to the four-symbols page at the beginning of the book, and to the surviving carpet pages. Many sources from diverse regions and different media have been proposed. While it is legitimate to make a distinction between the source for the various decorative motifs contained on these pages on the one hand and the source of the idea of including such pages in manuscripts of the Gospels

15. "Xpi autem" (Matt. 1:18). Book of Durrow, fol. 23r (Dublin, Trinity College Library, MS 57: Courtesy Board of Trinity College, Dublin) 16. Eagle (Symbol of St. Mark). Book of Durrow, fol. 84v (Dublin, Trinity College Library, MS 57: Courtesy Board of Trinity College, Dublin)

nuit iacob iacob autem genuit io
seph uirum mariae de qua na
tus est ihs qui uocatur xps ~

OMNES ergo generationes ab ra
cham usque ad dauid generationes
xiiii et a dauid usque ad trans mig
rationem babilonis generation
es xiiii et a trans migratione babi
lonis usque ad xpm generationes
xiiii.

XPi autem
generatio sic erat
cum esset dispon
sata mater eius mariae ios
eph ante quam conuenirent in
uenta est in utero habens de spu
sco ~

IOSEPH autem uir eius cum esset
iustus et noletet eam traducere
uoluit oculte dimittere eam

Pl. 15 / 47

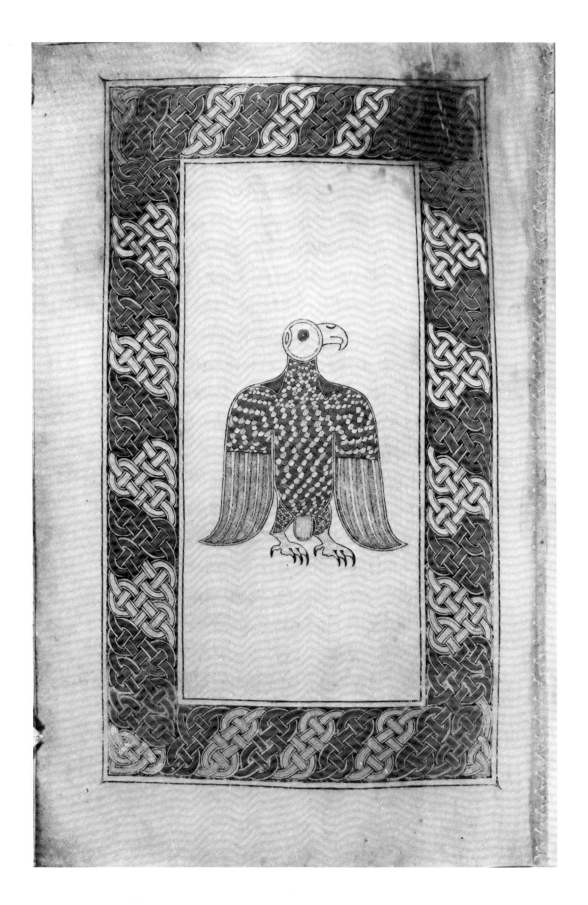

on the other,[19] most scholars have not sought to explain the reasons for the use of these pages and their particular function. Perhaps this realm of inquiry has been considered too conjectural; nevertheless, a careful examination of the possible sources reveals likely underlying reasons for the decorative pages.

The prefatory miniature facing the first carpet page, depicting the four signs of the Evangelists arranged around a cross, is problematic on two levels: the iconographical sequence of the symbols and the reason for the inclusion of such a page. The sequence reads as follows:

Man	Eagle		Man	Lion
Lion	Ox	as opposed to	Ox	Eagle

The first order is also thought to derive from the pre-Jerome tradition of Irenaeus, while the second, following the Jerome tradition, is the sequence found in most other Insular Gospel books.[20] Martin Werner suggested that the source for the earlier sequence, which appears in the Book of Durrow, came from Coptic Egypt.[21] Lawrence Nees has shown, however, that the Durrow four-symbols page (Pl. 10) may reflect an early south Italian book cover, such as one depicted in a fifth-century mosaic at the Catacomb of S. Gennaro, Naples, in which the same sequence of symbols around a cross is represented.[22] Nees also demonstrated that such a representation, repeating the theme of an exterior cover on the inside of the book, may well have served a protective or apotropaic function, preserving the sacred word from the "penetration of evil." Justification for this attitude, as Nees pointed out, may be seen in the talismanic quality attributed to the Cathach of St. Columba, which was carried into battle as protection from defeat, and the curative properties later believed to reside in the Book of Durrow itself, which was immersed in water to provide a cattle cure in the seventeenth century.[23]

This function of the four-symbols page, which serves as an "interior cover" to protect the four Gospels in a symbolic way, may also be attributed to the carpet pages. Discussions of these pages have focused on a variety of possible sources for individual motifs as well as for the general concept of the decorative frontispiece. Carl Nordenfalk suggested that the first carpet page, containing a double-armed cruciform shape set within a field of circlets and braided patterns of ribbon interlace, ultimately derived from a similar frontispiece that he believed was in an early Christian copy of Tatian's *Diatessaron*, a copy of which might have been at Iona in the middle of the seventh century.[24] The surviv-

17. Carpet page. Book of Durrow, fol. 85v (Dublin, Trinity College Library, MS 57: Courtesy Board of Trinity College, Dublin)
18. "Initium evangelii iħu xp̄i" (Incipit of Gospel of St. Mark). Book of Durrow, fol. 86r (Dublin, Trinity College Library, MS 57: Courtesy Board of Trinity College, Dublin)
19. Ox (Symbol of St. Luke). Book of Durrow, fol. 124v (Dublin, Trinity College Library, MS 57: Courtesy Board of Trinity College, Dublin)

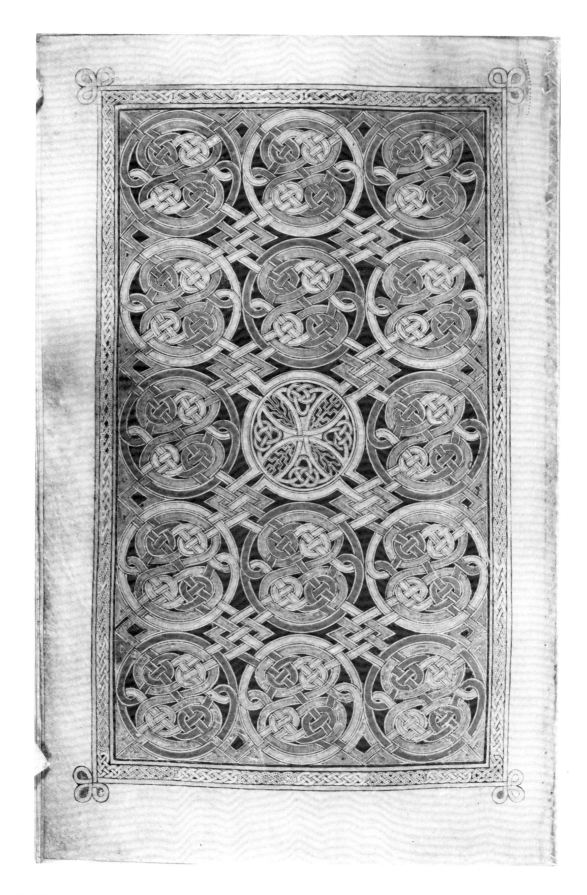

50 / Pl. 17

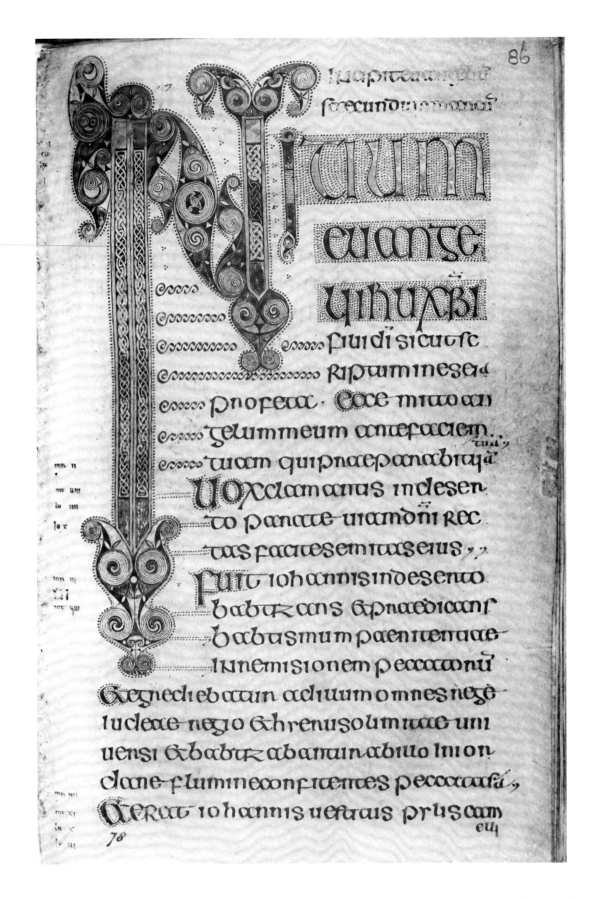

Incipit euangelium
secundum marcum

INI
TIUM
euange
lii hu ihu xpi
filui di sicut sc
riptum ineseia
propheta · ecce mitto an
gelum meum antefaciem...
tuam qui praeparabit uiam
Vox clamantis indesen
to parate uiam dni rec
tas facite semitas eius ;;
fuit iohannis indeserto
babtizans & praedicans
babtismum paenitentiae
in remisionem peccatorum
& egrediebatur ad illum omnes rege
iudeae regio & hierusolimitae uni
uersi & babtizabantur abillo inior
dane flumine confitentes peccata sua ;
Erat iohannis uestitus pilis cam
78 elli

Pl. 18 / 51

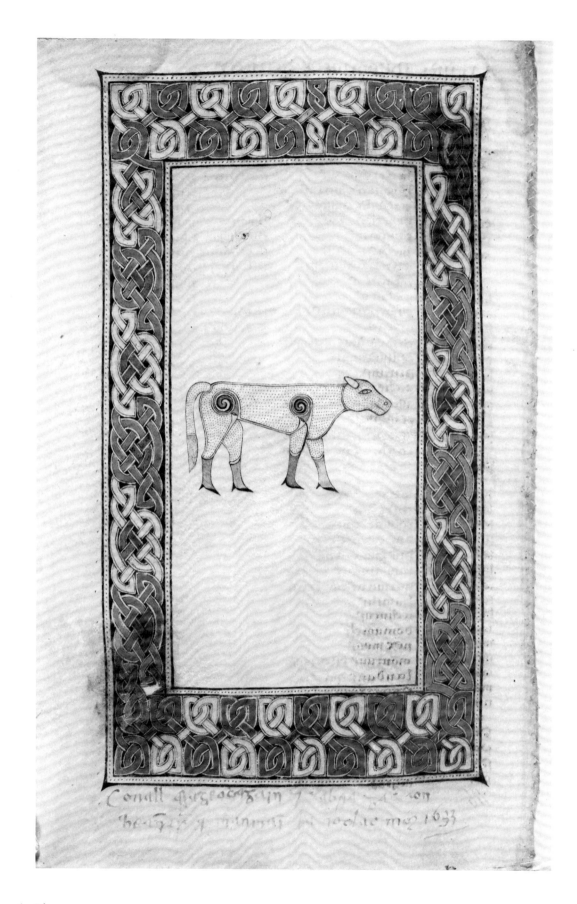

ing example upon which Nordenfalk based his thesis is a Persian manuscript of the sixteenth century now in the Laurentian Library in Florence; the degree to which it can legitimately be said to copy a Syrian *Diatessaron* of the second century is disputed. Indeed, whether the two-armed cross, a so-called patriarchal cross, can really be considered a Christian symbol in this context, or merely, as Meyer Schapiro called it, "an abstract field-filling ornament" is also controversial. It must be recognized that possible sources of inspiration for the decoration of the Durrow pages abound, and to varying degrees the artist may have been consciously or unconsciously influenced by them all.

The cross form, of course, is a universal geometric ornament that had existed concurrently in widely separated cultural centers in the world without any possibility of direct influence. Nevertheless, several examples suggest the possibility of models close at hand. T. D. Kendrick noted that patterns of such motifs were used in Roman mosaic pavement in the British Isles, and their coincidental similarity with the first Durrow carpet page is certainly striking.[25] Cross patterns and interlace ornament were used on the stamped leather bindings of Eastern codices in the sixth and seventh centuries.[26] If such a binding had been taken to Iona or Northumbria by the Gallic bishop Arculf, who may have brought with him a copy of the *Diatessaron* when he sought refuge from storms on Iona on his way back from the Holy Land, as suggested by Nordenfalk, it might have inspired the design of at least the first carpet page.[27] The stamped leather binding of the seventh-century Stonyhurst Gospel, believed to have been found among the grave relics of St. Cuthbert, contains a frame and panels of interlace surrounding a central panel of foliate elements in a spiral on the top cover, and faintly incised step motifs on the lower one.[28] Although dismissed as unlikely sources for motifs found on the Lindisfarne decorative pages, these motifs appear to be more relevant for the bold designs of the Durrow pages.[29]

The designs of the Durrow pages are also similar to those found in fabrics used for holy purposes. Such textile designs would also be appropriate as prefatory ornament, and indeed, similar interlace and cruciform designs can be found in woven Coptic textiles of the third or fourth century.[30] At a later moment in the Middle Ages, fine decorative Byzantine and Sassanian silks were imported to Europe and used as shrouds for saints' relics, as in the case of the Shroud of St. Siviard at Sens Cathedral in France. As an emulation of a textile shroud or cover for the books containing the Word of God, these carpet pages would still have performed an appropriate function prefacing the embellished incipit of the Gospels. The ninth-century Gospels

20. Carpet page. Book of Durrow, fol. 125v (Dublin, Trinity College Library, MS 57: Courtesy Board of Trinity College, Dublin)
21. "Quoniam quidem multi" (Incipit of Gospel of St. Luke). Book of Durrow, fol. 126r (Dublin, Trinity College Library, MS 57: Courtesy Board of Trinity College, Dublin)
22. Lion (Symbol of St. John). Book of Durrow, fol. 191v (Dublin, Trinity College Library, MS 57: Courtesy Board of Trinity College, Dublin)

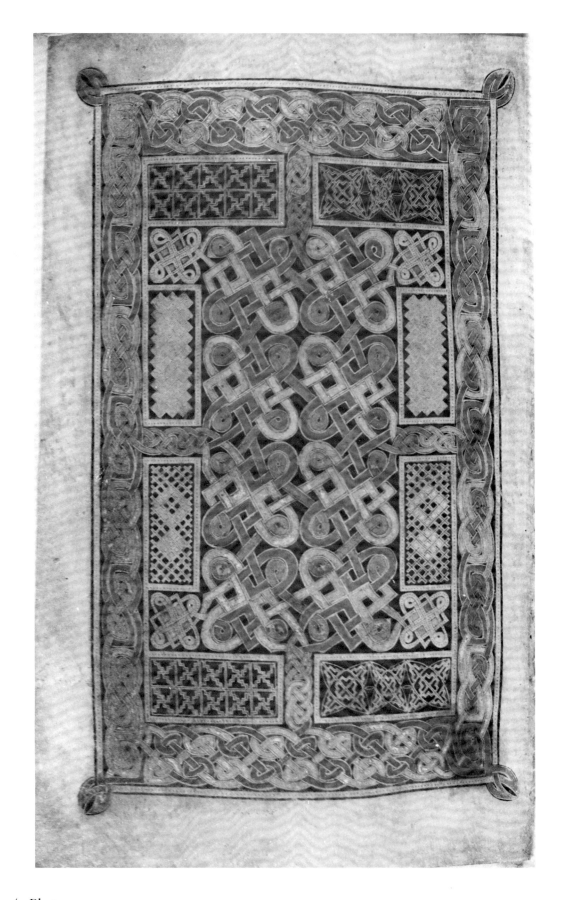

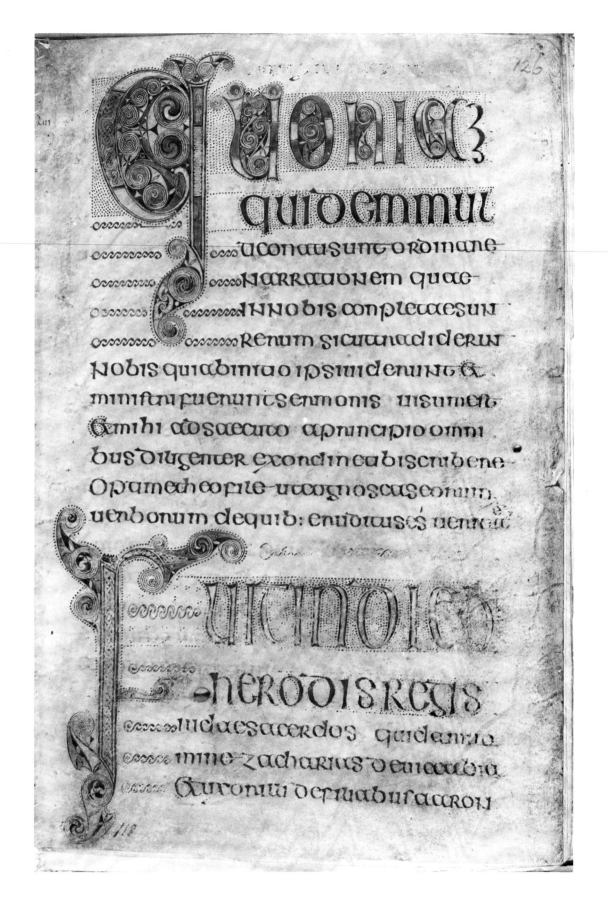

Quoniam
quidemmul
ti conati sunt ordinare
narrationem quae
in nobis conpletae sun
rerum sicut tradiderun
nobis quiabinitio ipsi uiderunt &
ministri fuerunt sermonis uisumes
& mihi adsecuto aprincipio omni
bus diligenter exordine tibiscribere
Optime theofile utcognoscas eorum
uerbonum dequibus erudituses ueritā

Fuit indie
herodisregis
Iudae sacerdos quidano
mine zacharias deuice abia
& uxoriilli defiliabusaaron

Pl. 21 / 55

from Lindau in New York (The Pierpont Morgan Library, MS M. 1) contains, pasted on the inside of its elaborate gold bindings (which probably came from different manuscripts), ninth- and tenth-century Oriental textiles as decorative endpapers. Although they were believed to have been altar cloths previously and were possibly pasted in the bindings as late as the seventeenth century, their effect as an interior shroud for the Gospels is in fact recreated in some ninth-century decorative pages within the manuscript.[31] Painted simulations of similar Byzantine or Sassanian silks precede and follow the canon tables, perhaps performing the same function for this tabulation of the harmony of the Gospels. In the Ottonian period, similar emulations of Near Eastern textiles, painted on two facing pages, prefaced each of the Gospels in the Codex Aureus of Echternach (Pl. 74), now in Nuremberg. It is not known whether textiles were used as endpapers in books of the fourth to eighth century, but Christian and Islamic books were encased or bound in precious silks or satins between the tenth and fourteenth century, perhaps reflecting an older tradition.[32]

The largest repertoire of motifs and many of the closest affinities occur in indigenous works of stone carving and metalwork. The engraved seventh-century stone crosses from Fahan Mura and Carndonagh in Ireland contain similar ribbon interlace, and Pictish stone slabs have similar cruciform shapes set against interlace backgrounds as well as similar elements of abstraction in their representations of the legs of animals—repeated in the lion and calf Evangelist symbols in the Book of Durrow. Even the representational images of the Book of Durrow have been rendered in a barbarian style.

The most striking and numerous affinities are with metalwork. Both in Anglo-Saxon England and in Celtic Ireland, workmanship in precious metals and enamels had reached a high degree of sophistication of technique and design, as manifested by the various seventh-century artifacts of the Sutton Hoo treasure in England and such spectacular eighth-century objects as the Emily Shrine in Boston and the Tara Brooch and Ardagh Chalice in the National Museum of Ireland. Trumpet spiral motifs, ribbon interlace, knot- and plaitwork, and interwoven, biting lacertines were all found in the geometric and zoomorphic designs of barbarian metalwork. Painted panels of stepped patterns framed in yellow in the pages of the Book of Durrow resemble cloisonné enamel and millefiori glass.

Perhaps of all the possible sources of inspiration for the carpet pages, a metalwork cover seems most likely. Broad ribbon interlaces form repetitive spirals on the incised, tin-coated bronze panel of the Domnach Airgid Book Shrine now in the National

23. Carpet page. Book of Durrow, fol. 192v (Dublin, Trinity College Library, MS 57: Courtesy Board of Trinity College, Dublin)
24. "In principio erat verbum" (Incipit of Gospel of St. John). Book of Durrow, fol. 193r (Dublin, Trinity College Library, MS 57: Courtesy Board of Trinity College, Dublin)

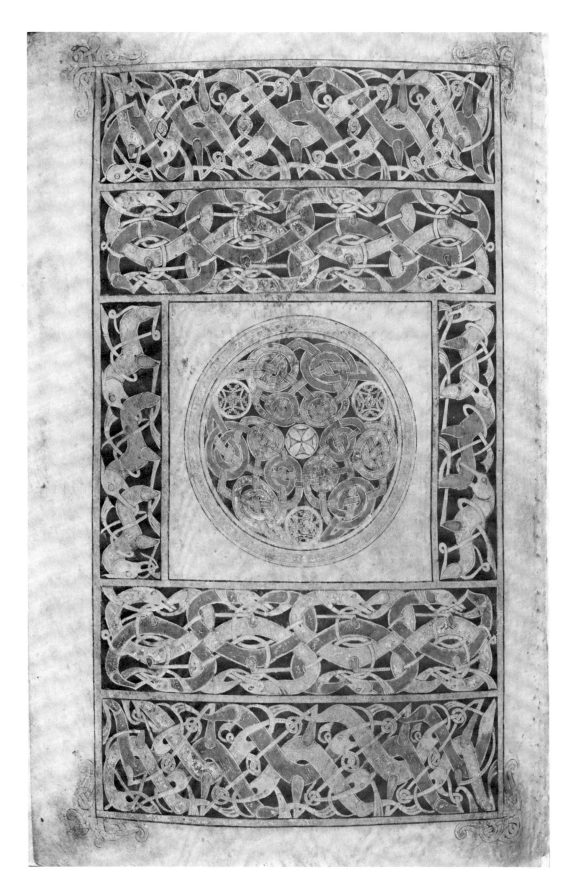

58 / Pl. 23

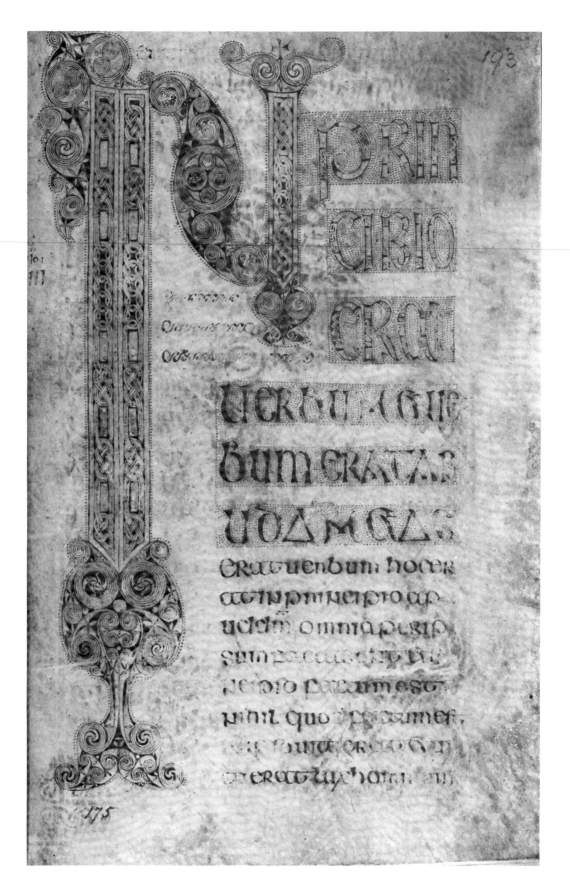

IN PRIN
CIPIO
ERAT
UERBU & UER
BUM ERAT AB
UD & M & & S
ERAT UERBUM · HOC ER
&T IN PRINCIPIO AP
UD DM OMNIA PER IP
SUM FACTA SUNT · ET
SINE IPSO FACTUM EST
NIHIL QUOD FACTUM EST
IN IPSO UITA ERAT ET
UITA ERAT LUX HOMINUM

Pl. 24 / 59

Museum in Dublin. Although it has been set in a mount of considerably later date, this panel is believed to date from the seventh century and therefore may be contemporary with the Book of Durrow.[33] Similar but more complex motifs of interlace spirals occur in the upper and lower registers of the first Durrow carpet page (Pl. 9), around the border of the second (Pl. 11), and in the central roundel of the page facing the incipit to John (Pl. 23). Although only a few book covers from the seventh century have survived, such as those of the Stonyhurst Gospel mentioned above, the practice of making cumdachs or containers for holy books—one (now lost) was made for the Book of Durrow at the beginning of the tenth century—reveals that these books were regarded as holy relics of the Word of God. This attitude is confirmed by the medieval veneration of both the Cathach of St. Columba and of the Book of Kells.

The use of Evangelist portraits can be seen as a logical outcome of a Mediterranean tradition stemming from the classical use of author portraits, and the four-symbols page may reflect an early Christian tradition of book covers as represented in the fifth-century Naples mosaic. The function of the abstract carpet pages of the Book of Durrow, however, still needs to be explained. It is possible that they represent a continuation of a tradition of decorative frontispieces which goes back to early Christian and Coptic prototypes, such as the decorative cross page of presumed eastern Mediterranean origin in the *Diatessaron*, or the concluding page containing an ankh filled with interlace ornament in the fourth- or fifth-century Coptic Acts of the Apostles now in the Morgan Library.[34] In addition, a copy of Orosius's *Chronicon* in Milan (Biblioteca Ambrosiana MS D. 23. sup), thought to have been made in the early seventh century at the Irish foundation of Bobbio in northern Italy, contains a decorative frontispiece with a large rosette and four smaller ones within a rectangular frame.[35] But the Coptic page is similar to the Durrow abstractions only in the talismanic use of a cross and in the details of alternating color and discordant plaiting of its interlace; the Orosius frontispiece only in its alternation of color and in the idea of using an intricate geometric design as a frontispiece: the effect of these two pages is entirely different. Only the lost *Diatessaron* page could be considered a likely and immediate source of inspiration for the Durrow carpet pages, but its existence is highly conjectural.

The intended function of the carpet pages may be inferred, however, from the various sources of their individual decorative motifs and from their overall effect. Whether derived from an early Syriac frontispiece, Eastern textiles, Near Eastern, Coptic

25. Carpet page. Book of Durrow, fol. 248r (Dublin, Trinity College Library, MS 57: Courtesy Board of Trinity College, Dublin)

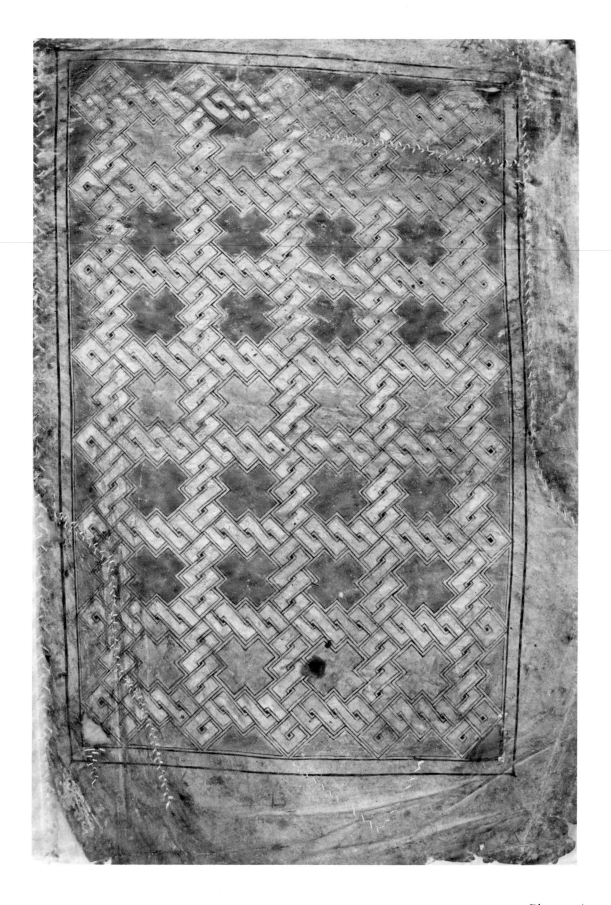

Pl. 25 / 61

and Insular leather bindings, Byzantine silk "endpapers," Insular metalwork bindings or book shrines, or most probably from a composite of some or all of them, it seems likely that the carpet pages were intended to function as "interior covers," opening and closing the entire text, and prefacing the incipits of each of the Gospels. Not only were individual groups of books of the Bible customarily bound separately in the early Middle Ages, but the Stonyhurst Gospel, containing only the Gospel of St. John, was bound in its own incised and molded leather binding. The designs on this cover reflect analogous large but intricate patterns found in the Durrow carpet pages. It is conceivable that other Gospels might also have been singly bound, and that the makers of the Book of Durrow wished to retain the idea of the separateness of each of the texts within the harmony of the whole. In the Cadmug Gospels (Fulda, Landesbibliothek, Codex Bonifatianus 3) a separate quire was used for each Gospel, a structure that reinforces the possibility of such a tradition.

Thus the carpet pages, deriving elements of their designs from all of these sources, seem to function as "interior covers" in the same way that the four-symbols page may have. Whether or not they also combined the connotations of sacred shroud and mystical, even apotropaic, frontispiece,[36] they manifestly emulated the color and boldness of cloisonné enamelwork and the subtle intricacy of niello spirals and filigree interlace of splendid, traditional forms of Insular metalwork. The seeming magical qualities of knots, plaitwork, and interlace indigenous in Celtic art, the containment of zoomorphic lacertines within panels, the rejuvenating order of circles and spirals may all connote the control of chaos and evil. With the occasional explicit, but sometimes implicit, presence of a cruciform design in the center of these complex patterns, we may have the implication of Christian order imposed on the uncertainties, difficulties, and disorder of the terrestrial world. As the incipits are the logos made incarnate and embellished as befits the Word of God, so each of the Gospels may have been prefaced with an interior bejeweled cover and the full-page personification of its author. Appropriately, the entire contents were enclosed in similar painted covers and introduced by a four-symbols page evoking the iconography of a book cover or book shrine.

The Book of Durrow is the earliest surviving manuscript in which all of these ingredients and attitudes come together and are used to articulate a meaningful sequence of decorations in terms of the book as a whole. Some of these developments seem to be experimental, some of the decorative initials are not fully evolved, yet this program of illumination points the way for sub-

sequent sequences of decoration in the Lindisfarne Gospels and the Book of Kells.

The Lindisfarne Gospels

In many respects the Lindisfarne Gospels, now in the British Library (MS Cotton Nero D. IV), is less problematical than the Book of Durrow. A colophon on the last page states precisely:

> Eadfrith, Bishop of the Lindisfarne Church, originally wrote this book, for God and Saint Cuthbert and—jointly—for all the saints whose relics are on the Island. And Ethelwald, Bishop of the Lindisfarne islanders, impressed it on the outside and covered it—as well he knew how to do. And Billfrith, the anchorite, forged the ornaments which are on it on the outside and adorned it with gold and with gems and also with gilded-over silver—pure metal. And Aldred, unworthy and most miserable priest, glossed it in English between the lines with the help of God and Saint Cuthbert.

Although this colophon dates from the mid-tenth century, and was written by Aldred at a time when he and the monks of Lindisfarne were seeking sanctuary at Chester-le-Street from the Viking raids along the coast of Northumberland, its basic substance has never been questioned. The first part of the colophon is believed to have been copied from an earlier inscription on a flyleaf or inside its now missing original cover. It is therefore presumed that the Lindisfarne Gospels was written by Eadfrith either just before 698, when he became bishop and abbot of Lindisfarne, or between 698 and 721, the date of his death, while he occupied those offices.[37]

For those who believe that the Book of Durrow was also produced at Lindisfarne, Durrow becomes an immediate precursor of the style and program of the illuminations in the Lindisfarne Gospels. The structure, contents, and sequence of decorations in both books is similar, but with changes in the Lindisfarne Gospels which give evidence of strong new influences from the Continent. Indications of the coming of age of the innovations of the Book of Durrow may be seen in the greater elaboration and complexity of decorations both in the carpet pages and in the incipit pages.

As in the case of the Book of Durrow, the text of the Lindisfarne Gospels follows the Vulgate translation by St. Jerome. It also contains the prefatory texts derived from the Old Latin, pre-Jerome tradition, but these are now divided and serve as intro-

ductory material before each of the Gospels. By this means the structure of each separate unit of the book became more closely integrated (see Appendix 2).

The basic form and sequence of decorations is similar to that of Durrow. Five carpet pages serve as decorative frontispieces, one to the "Novum opus" (Pl. 26), and one to each of the Gospels (cf. Pl. 30). It is possible that a sixth carpet page terminated the book, as in Durrow, but no evidence of such a page survives. An elaborate cruciform page introduces the book as a whole and faces the prefatory material, which begins with Jerome's letter. Intricate diaper patterns fill a large cross centered in the design. Step patterns, as though executed in cloisonné enamel, fill panels on both sides of the cross, and the residual area is filled with alternate red and yellow knotted interlace. The entire ensemble is framed with a border containing stylized birds, and the corners of the rectangular design are accentuated with interlace and animal-head terminals. Although there is some question as to whether the cruciform page in this same position in the Book of Durrow was in fact intended for it, there is no doubt that in the Lindisfarne Gospels the position was intentional for this folio is an integral part of a bifolio: the other half contains the continuation of the prefatory texts.

The facing "Novum opus" page (Pl. 27) demonstrates that the illuminator and scribe, thought to be one and the same, Eadfrith, bishop of Lindisfarne, was aware of the potential for decorative impact of the entire incipit page.[38] Not only is the introductory N considerably larger than the similar initial in Durrow, occupying almost the entire height of the text area, but all of the first line consists of large versal letters, some with decorative infilling, and the diminuendo of the lettering continues through the slightly smaller penned letters of the second line to the next three lines of still smaller writing to, finally, the bottom line written in the Insular half-uncial of the normal text. The first two lines of text are filled in with stippling similar to that found in Durrow, and the three remaining large lines of text are framed with parallel lines of dots delineating not only the individual lines of text but also the entire incipit block. Only the normal script on the bottom line is excluded.

Decoration has become text and text has become decoration. Here we find the beginning of a statement of equivalence with the carpet page which will be developed in the openings to the individual Gospels. The decorative motifs of the carpet page, particularly the interlace and birds' heads, relate only in a general way to the motifs found in the letters on the top line of the facing incipit. Nevertheless, in its ornamental treatment of the text and its subtle framing, we may observe a growing awareness of the

aesthetic impact of the two-page decorative spread as a major emphasis in the articulation of the opening of the Gospels.

As the "Novum opus" of St. Jerome receives accentuated treatment in the Lindisfarne Gospels, so do other prefatory texts. The preface by St. Jerome ("Plures fuisse") and a letter from Eusebius ("Eusebius Carpiano") have been added before the canon tables: the latter explains how the tabulations of the concordances work. The first line of the text of this letter, occupying part of one of two columns on the page, starts with a large versal capital containing panels of interlace, birds, and a quadruped, followed by three large ink letters and four half-uncial ones, all framed by rows of dots. Similar articulation of the first lines of the text is found in the prefaces and summaries throughout the manuscript.

The incipits of the Gospels continue the decorative letters and script of the "Novum opus" page and develop the idea of the framed text as a display page. The *L* and *i* on the Matthew page (Pl. 31) intersect each other and together occupy the entire height of the text like a fragment of some bejeweled penanular brooch. The *L* also joins with a large flasklike *b* made up of interlace and zoomorph-filled panels and enclosing a field of spirals. The decoration of the letters and the filling of the lines convert the opening passage of the text into a full-page decorative panel. Paneled frames now state the limits of the block of text, reinforced by the irregular panel filling in the residual area at the lower left of the *Li* on the Matthew page and *Q* on the Luke. The *I* of the *In* of Mark and John forms the left frame of the enclosed text. The opening text as a whole, the individual decorative letters, and the frames surrounding the block of writing have now assumed an ornamental equivalence with the facing carpet pages. This is reinforced on some double-page spreads, particulary for the incipit of Mark, where the dominant red and blue interlace on the facing pages creates an effect of tonal unity.

The *Xpi* monogram in Matthew (Pl. 32), in comparison with its first accentuation in the Book of Durrow, has been given major emphasis in the Lindisfarne Gospels. Although the *X* does not occupy the entire height of the block of text, the monogram does take up the entire first line and the remaining four lines of text are written in diminishing scale and framed by a painted border in the manner of the incipit pages. The "Fuit" in Luke, beginning a similar passage about the Nativity, has remained in relatively small scale, the *F* occupying only eight lines of text and the *uit* and ensuing line of text only two lines.

The canon tables (Pl. 28) manifest a different tradition from the simple rectangular frames and columns of the Book of Durrow. A large arch embraces the appropriate number of smaller arches supported by columns, following an architectural tradition found

26. Carpet page. Lindisfarne Gospels, fol. 2v (London, The British Library, MS Cotton Nero D. IV: By permission of The British Library)
27. "Novum opus." Lindisfarne Gospels, fol. 3r (London, The British Library, MS Cotton Nero D. IV: By permission of The British Library)
28. Canon table. Lindisfarne Gospels, fol. 14v (London, The British Library, MS Cotton Nero D. IV: By permission of The British Library)

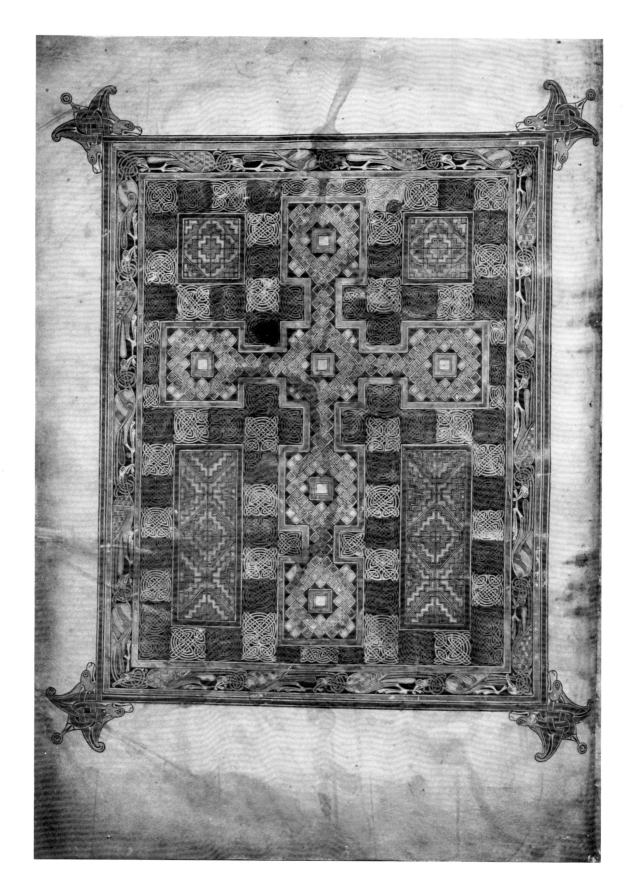

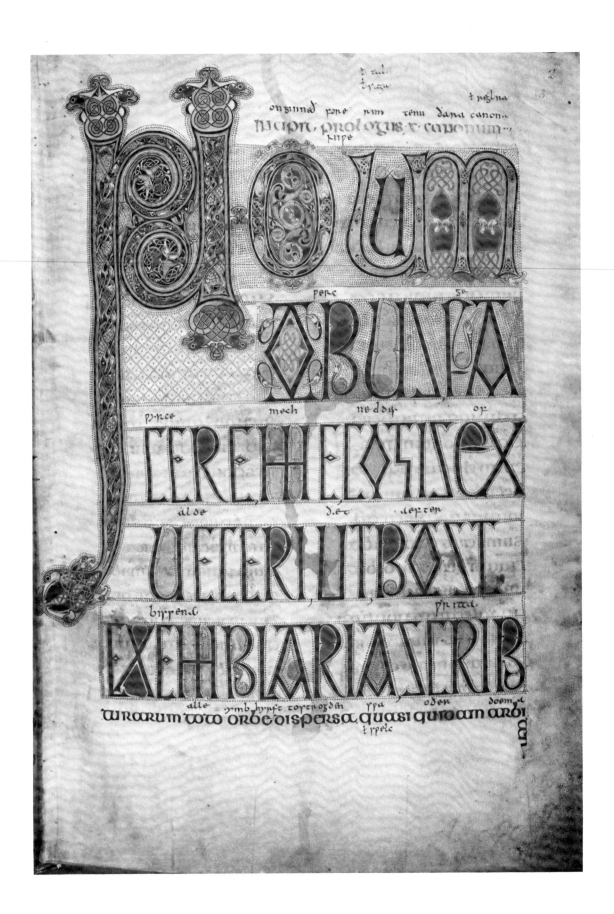

Pl. 27 / 67

in early Mediterranean examples.[39] These arcades are reminiscent of architectural niches or baldacchinos around enthroned imperial figures, a form of architectural symbolism which reinforces their supreme authority. They also recall the openings of triumphal arches. Both connotations may be implied in the painted evocations of these forms in the late antique canon tables, where the arcades enclose the tabulations like an imperial portrait and lead, like a triumphal arch, to a clarification of the relationships within the Divine Text. In the Lindisfarne Gospels, however, in spite of the Continental influence that undoubtedly provided the impetus for this striking design, the architectural properties of the arcades and columns have been transformed into decorative panels containing zoomorphic forms and interlace. The bases and capitals of the columns have been abstracted into step motifs filled with interlace. Architectural elements have become thin framed bands of cloisonné enamel.

Further evidence of a direct influence from Continental, specifically south Italian, manuscripts is found in the exchange of the symbols of the Evangelists in the Book of Durrow for portraits of the Evangelists with their symbols. These occur on versos preceding the carpet pages before each of the Gospels. The representation of St. Matthew (Pl. 29), showing the Evangelist in profile, seated and writing in a codex, is manifestly derived from the same Italian source as the Ezra portrait in the Codex Amiatinus, a massive Bible written and decorated at Monkwearmouth or Jarrow before 716 and now in the Laurentian Library in Florence.[40] This extraordinary book was copied from a now lost Codex Grandior, a large pandect or full Bible, of Cassiodorus, which was brought from Vivarium to Northumbria by Benedict Biscop or Ceolfrith at the end of the seventh century. Three copies of this Italian book were made, two for the twin monasteries of Monkwearmouth and Jarrow, and one that Ceolfrith, abbot of the monasteries between 689 and 716, intended to present to St. Peter's in Rome. The Ezra portrait, which is also considered to be an author portrait of Cassiodorus writing in his scriptorium with the nine books of the Bible arranged on a bookcase behind him, is ultimately derived from the classical tradition of author portraits and it signals the first intrusion of this Mediterranean motif into Northumbrian usage.

The profile Evangelist portrait, used three times in the Lindisfarne Gospels, was also prevalent in Byzantine Gospel books, and since the inscription accompanying these representations reads variations of "O Agios" instead of "Sanctus," they may ultimately derive from an earlier Greek model rather than from one in the Codex Grandior. The final portrait of St. John, executed in a frontal manner, is more consistent with the Western tradition,

29. St. Matthew, Lindisfarne Gospels, fol. 25v (London, The British Library, MS Cotton Nero D. IV: By permission of The British Library)

69

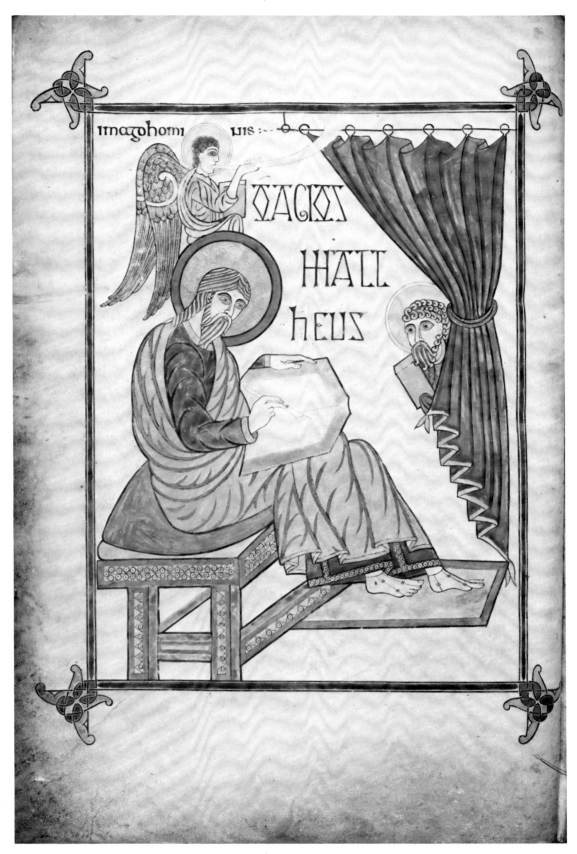

although here, too, the Greek word is used in the inscription. Whether the three profile portraits were also derived from illuminations in the Codex Grandior, from other Mediterranean models, or from a composite of additional sources remains conjectural. Similar problems abound in determining the origins of the full-length, winged forms of the symbols placed with the Evangelists, particularly the trumpeting winged man and lion. The most that can be concluded on the basis of known evidence is that the illuminator may have had access to a variety of sources, both indigenous and imported, and that he may have added to them and varied them for his own purposes. In Continental and Mediterranean manuscripts portraits of the Evangelists normally faced the incipits to their texts, but in the Lindisfarne Gospels, following the arrangement in the Book of Durrow, they face the blank rectos of subsequent carpet pages. Thus if these portraits were in fact copied from a variety of imported models in which the portraits faced the incipit pages, they may have introduced a disquieting note, for in the Insular tradition the carpet page intervened.

Rather than abandon the use of the carpet page facing the incipit, another solution was found to bring the portraits of the Evangelists and their symbols into the proximity of their texts. At the top of each incipit page are rubrics written in gold: "iħs xp̄s Matheus homo" (Pl. 31), "Marcus Leo," "Lucas vitulus," "Johannis aquila." These inscriptions are said to be "roughly contemporary with the first hand [of the text] and the rubrics."[41] Since each of the portrait pages has its own explanatory inscription ("Imago hominis," "O agios Mattheus," and so forth), the golden rubrics are redundant unless we consider them a verbal reminder of the image on the folio before. Perhaps here word and image are considered one: the material inscription invokes, like a painted icon, the spiritual presence of the Evangelist and his symbol at the incipit of his text. To my knowledge, these are the only Insular incipits that have such inscriptions. These rubrics may indicate that the scribe, perhaps Eadfrith, realized the viability of the Insular and Continental traditions and sought by this compromise to reconcile them both. This solution to the problem, however, was not to be repeated.

The two-page spread of carpet page and facing incipit of the Gospels presents an ensemble of intricate and controlled decorative splendor unequaled in Insular illumination. That these were intended as facing decorations is proven by the fact that the carpet page on folio 94v is an integral part of a bifolio containing some of the prefatory texts on its other half, and by the consistency of color and design between that decorative page and the facing incipit to Mark. This arrangement follows not only that of

30. Carpet page. Lindisfarne Gospels, fol. 26v (London, The British Library, MS Cotton Nero D. IV: By permission of The British Library) 31. "Liber generationis." Lindisfarne Gospels, fol. 27r (London, The British Library, MS Cotton Nero D. IV: By permission of The British Library)

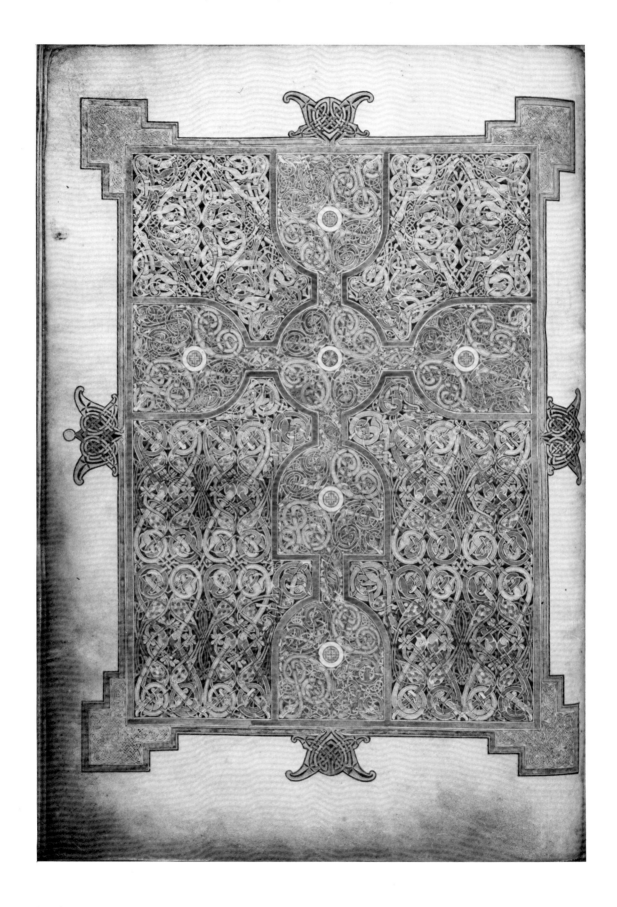

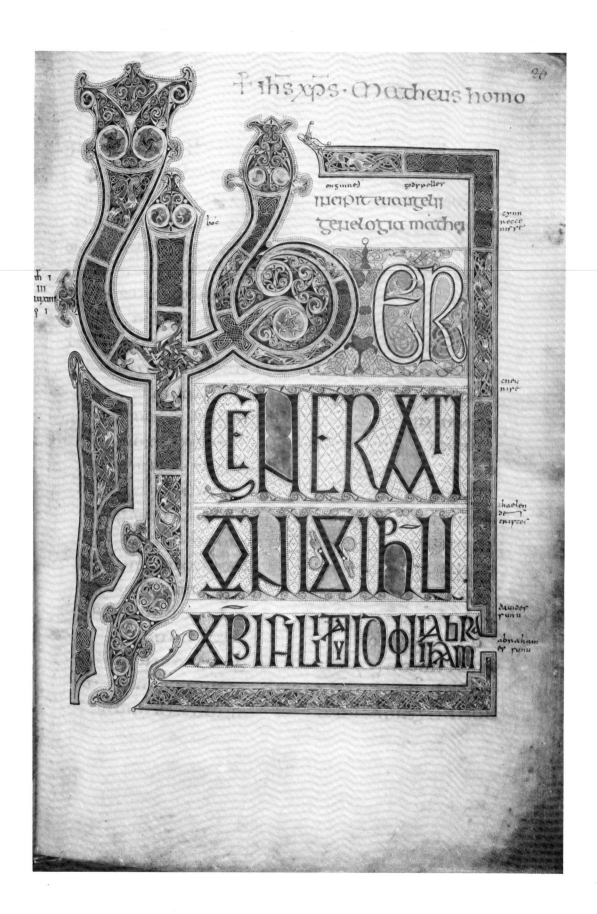

Pl. 31 / 73

Durrow but also the placement in the Lindisfarne Gospels of the first carpet page—a page that, as we have seen, was also an integral part of its gathering—before the "Novum opus." Although the remaining three carpet pages are painted on single leaves inserted into their respective gatherings, we may presume that they also are bound in their intended positions.

The first two carpet pages are dominated by cruciform designs: that introducing the prefatory material made of square segments (Pl. 26), and the one facing the beginning of Matthew (Pl. 30) consisting of bell-shaped forms. Both of these designs are strongly evocative of metalwork covers, the first with cloisonné diaper and step motifs and interlace filigree, and the second with a myriad of interlace forms within the cross set against a field of intertwined but symmetrically controlled lacertines. This second page is not only remarkably similar to a carpet page in the Chad Gospels but anticipates the later design of the metalwork back cover of the Lindau Gospels in the Morgan Library (Pl. 33).

The remaining three carpet pages fragment and abstract the central cruciform shape, a circle with equal arms prefacing Mark, a square with arms and crosspieces before Luke, and a small equal-armed cross with disconnected T-like projections before John. In all cases these pages are meticulously constructed from elusive grid patterns, visible on the opposite side, and are pigmented to give the effect of rich, glowing enamelwork, interlaced filigree, cloisonné lacertines, and niello spirals.[42] These three pages also manifest the most complex relationships between pattern and field, particularly in the ambiguity of the cruciform shapes sometimes apparently laid against a decorative field and sometimes seeming to exist merely as a residual pattern.

On the carpet pages for Luke and John rectangular or right-angled panels of zoomorphs or spirals reiterate similar panels on early book covers. Similar decorations occur on a book cover depicted in a sixth-century icon of Christ Pantocrator now at Mount Sinai and on the metalwork covers of the Gospels of Queen Theodelinda now in the cathedral treasury at Monza.[43] These covers, the back cover of the Lindau Gospels (Pl. 33), and the carpet pages of the Lindisfarne Gospels may all be indications of what the design and detailing of the original lost leather or metal cover of this sumptuous book, referred to in the colophon, may have looked like.

The possibility that in the Book of Durrow the carpet pages were intended to be symbolic interior covers to the text as a whole and to each of its major units is even stronger in the Lindisfarne Gospels. The reference to the Cassiodorian Codex Grandior in the similarity of the St. Matthew portrait and the Ezra miniature of the Codex Amiatinus shows that the Lindis-

32. "Xpi autem." Lindisfarne Gospels, fol. 29r (London, The British Library, MS Cotton Nero D. IV: By permission of The British Library)
33. Back cover. Lindau Gospels (New York, The Pierpont Morgan Library, MS M.1)

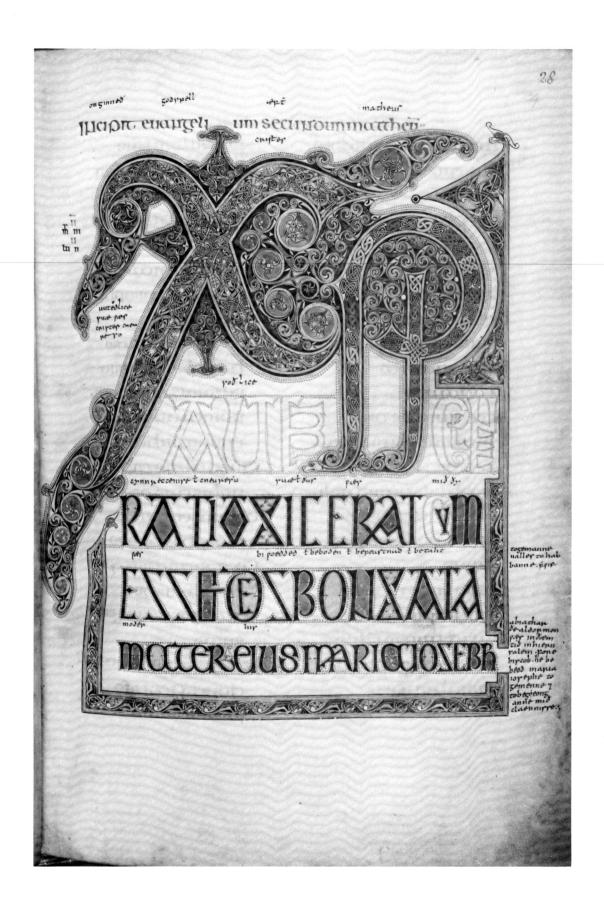

Pl. 32 / 75

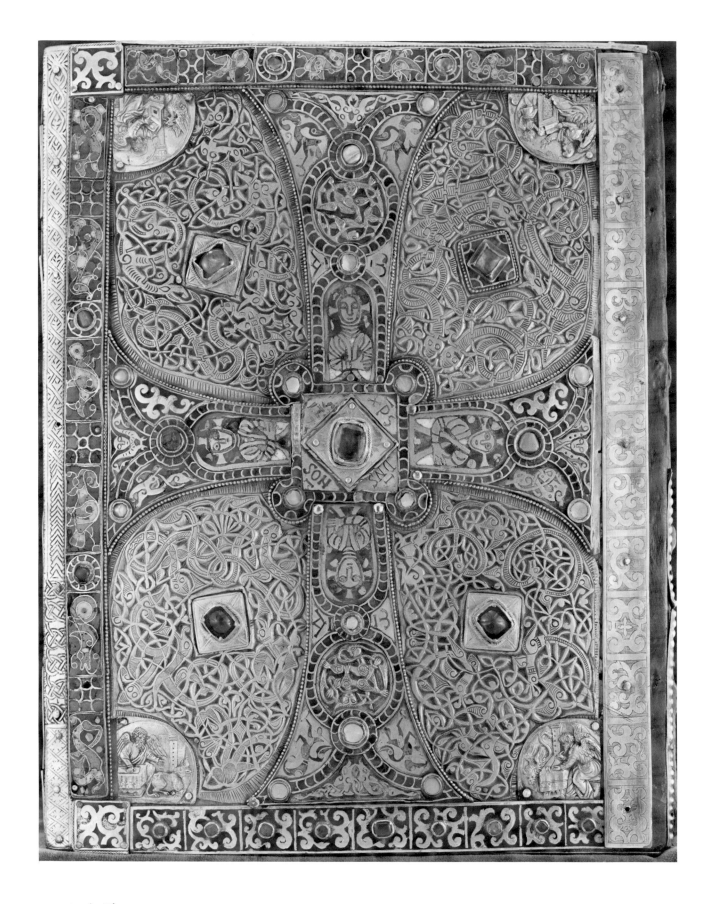

farne illuminator was familiar with that miniature or its proto-
type. He must have been aware, therefore, of the bookcase with
the nine volumes, the *Novem Codices*, into which Cassiodorus
had divided his Bible. The Old Testament volumes have covers
decorated with lozenge motifs, whereas the New Testament has
a Latin cross and the Acts of the Apostles a St. Andrew's cross
or "X." The cruciform motifs in the Lindisfarne carpet pages,
sometimes obvious, sometimes abstracted, recall the Gospel
cover in the Amiatinus miniature as well as the Lindau Gospel
cover, and reinforce the hypothesis that these pages are meant to
function as interior covers. In fact, the pigmentation of the cov-
ers in the Ezra miniature still shows traces of gold, and Cas-
siodorus recorded the special pains he took to provide lavish
bindings for his manuscripts: "We have provided workers skilled
in bookbinding in order that a handsome external form may en-
close the beauty of the sacred letters." He appears to have had
made a model book of designs for covers, for he records: "We
have represented various styles of binding in a single codex that
he who so desires may choose the type of cover he prefers."[44]
The carpet pages of the Book of Durrow and the Lindisfarne
Gospels, intentionally or not, in fact provide such a repertoire of
possible designs. Eadfrith perhaps followed the sense and maybe
even the letter of Cassiodorus's praise of sumptuous book cov-
ers. In addition, with his carpet pages, he emulated the essential
meaning in the Ezra/Cassiodorus portrait of the Codex Grandior
and its copy, for they provide separate covers for each Gospel
and for the whole text, reaffirming the individuality and unity of
the four texts within the whole, as Cassiodorus's nine volumes
were bound separately but grouped together within the con-
taining cupboard of the Amiatinus miniature.

In the Lindisfarne Gospels, the meaningful sequence of in-
troductory decorative pages was retained, developed, altered
slightly, and refined. Continental influences changed the nature
of the canon tables and were probably responsible for the substi-
tution of the symbol portraits by Evangelist portraits accompa-
nied by their symbols. Although the aesthetic effect of metal-
work still dominated, the carpet pages were more manifestly
"cruciform" in their design and more explicitly like some surviv-
ing metalwork covers. Major initial pages became decorative en-
tities in themselves, subjugating opening passages of text to an
ornamented format so that individual letters are distorted and
sometimes ambiguous, oscillating in and out of the patterns that
they constitute. But at the same time that the Lindisfarne Gospels
manifests the highest development of this carefully planned Insu-
lar tradition of decoration and sequence, it also embodies that
tradition's collision with European influences. The resulting ver-

bal compromise on the incipit pages noted above leads, in the next major monument in this style, the Book of Kells, to a major transformation in the sequence of decorative pages.

The Book of Kells

The Book of Kells, like the Book of Durrow, is the subject of much scholarly controversy concerning its place and date of origin.[45] Because its decoration is unfinished in places, it is often thought to have been begun in the Irish monastery at Iona at the end of the eighth century just before the Viking invasions, and to have been continued in Ireland, perhaps at Kells, after the monks fled there. Others have maintained that it was entirely executed in Ireland. Scholars have suggested a variety of dates from the beginning of the eighth century to as late as the end of the eighth and beginning of the ninth century. Many of these arguments depend upon subtleties of paleographical evidence and the possibility of Continental influences, although some would argue that Insular developments influenced similar, later, manifestations on the Continent. In any event, the Book of Kells was at Kells by the twelfth century, when charters pertaining to that monastery were written on some of its blank pages, but it is probable that it was there by the beginning of the eleventh century.

Everyone has agreed, however, that the Book of Kells manifests the most complex form of Insular ornament to have survived. It may have been the manuscript that was seen and described by Giraldus Cambrensis on a visit to Ireland in 1185:

> This book contains the harmony of the four Evangelists according to Jerome, where for almost every page there are different designs, distinguished by varied colours. Here you may see the face of majesty, divinely drawn, here the mystic symbols of the Evangelists, each with wings, now six, now four, now two; here the calf, here the man, here the lion, and other forms almost infinite. Look at them superficially with the ordinary casual glance, and you would think it is an erasure, and not tracery. Fine craftsmanship is all about you, but you might not notice it. Look more keenly at it and you will penetrate to the very shine of art. You will make out intricacies, so delicate and subtle, so exact and compact, so full of knots and links, with colours so fresh and vivid, that you might say that all this was the work of an angel, and not of a man. For my part, the oftener I see the book, the more carefully I study it, the more I am lost in ever fresh amazement, and I see more and more wonders in the book.[46]

The Book of Kells contains a text based upon the Vulgate translation, but with numerous variations. It is therefore not such a pure rendition of Jerome's translation as the Book of Durrow or the Lindisfarne Gospels, but this may be the result of its dependence on different sources. Françoise Henry has rightly pointed out that this book, larger in format than its peers, was probably intended to serve as a magnificent altar book, and this would also account for the increased lavishness of its decoration. It has a number of the usual prefatory elements, but as we shall see, it may have had more of this material which is now missing. The Book of Kells is more like the Book of Durrow than it is like the Lindisfarne Gospels, in that the text of the Gospels in the Book of Kells was kept as an uninterrupted unit by placing the *Breves causae* and Argumenta for all four texts at the beginning of the book. This intent also may have led to a major change in the nature of the prefatory miniatures for each of the Gospels, one which, to some degree, solves the problem created in the Lindisfarne Gospels by the carpet page intervening between the Evangelist portrait and the incipit. In addition, the number of illuminations has been increased, the forms of incipit pages expanded, the number and complexity of interior motifs multiplied, the sequence of prefatory decorative pages augmented, and decorations and narrative miniatures within the text added.

Unfortunately, an unknown number of folios is missing from the beginning of the Book of Kells. These may have contained the "Novum opus" of St. Jerome, the letter of Eusebius, and possibly some preliminary decoration, but we cannot be sure. As it is bound now (see Appendix 3), the volume opens with a page divided into two columns, the left one containing the end of a glossary of names in Hebrew, and the right the painted symbols of the Evangelists. Paired and placed in two frames and oriented sideways so that they face the top of the page, these symbols introduce the canon tables that follow, reiterating the unity of the Gospels as tabulated in its columns.

The canon tables commence on the following verso. The first eight tables of a possible twelve-table sequence are placed within Insular versions of the architectural arcade as in the Lindisfarne Gospels. In addition, they contain within the tympana of the main arch symbols of the Evangelists which A. M. Friend and Carl Nordenfalk believed were derived from the "Beast Canon Tables" of the Carolingian manuscripts of the Ada School of about 800.[47] The enclosing arch is contained within a squared-off frame creating a rectangular format for the overall design, a device found in some Carolingian manuscripts. These frames, as well as the spandrels, arches, tympana, and columns, are filled with Insular zoomorphic and geometric motifs, while the bases

34. Virgin and Child. Book of Kells, fol. 7v (Dublin, Trinity College Library, MS 58: Courtesy Board of Trinity College, Dublin)
35. "Nativitas Xpi in Bethlem" (*Breves causae* of Gospel of St. Matthew). Book of Kells, fol. 8r (Dublin, Trinity College Library, MS 58: Courtesy Board of Trinity College, Dublin)

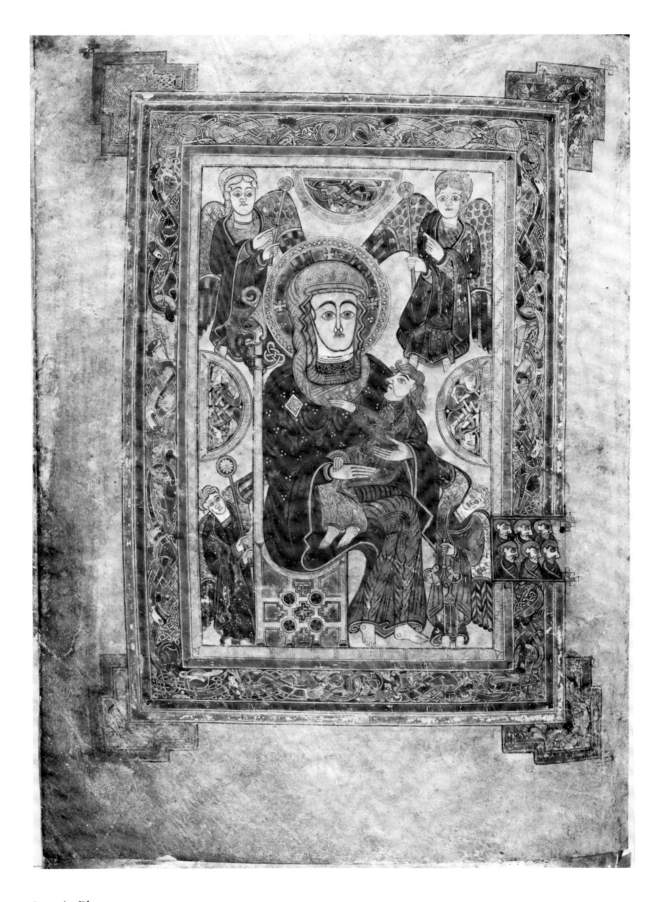

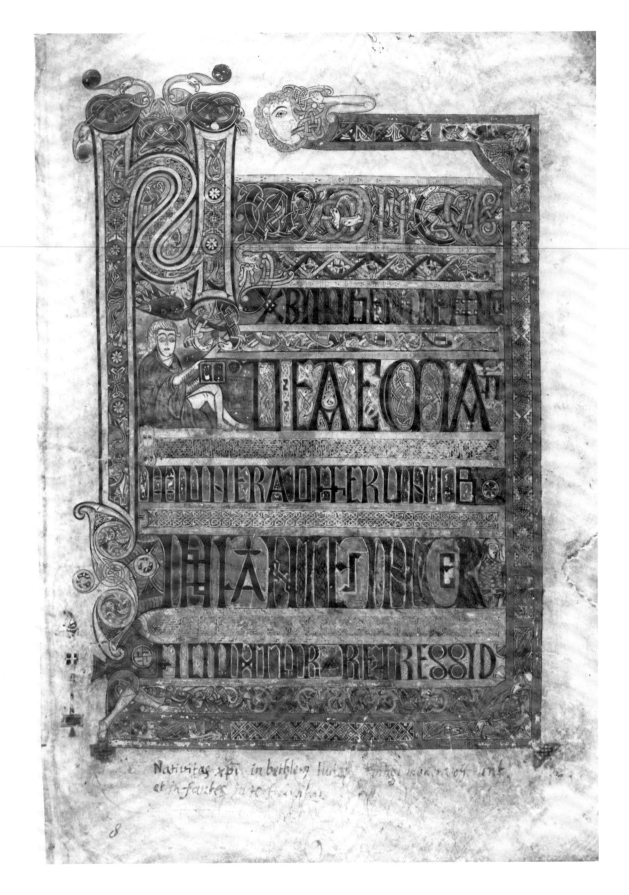

Natiuitas xpi in bethlem iudie
et infantes

Pl. 35 / 81

and capitals of the columns have been transformed into a variety of abstract shapes containing similar ornament. As in the Lindisfarne Gospels, the architectural integrity of the design has been exchanged for a decorative interplay of metalwork-like forms.

Two pages of the tables were never executed, the relationship of some of the symbols to the columns of tabulation is sometimes garbled, the appropriate numbering of the capitula sections in the body of the text has been omitted, and the remaining two pages of the tables abandoned the arcade for a grid system similar to that of Durrow. Whether inspired by Continental prototypes or an innovation that was to influence the Carolingian illuminators, these canon tables are nevertheless both incomplete and useless. It is impossible to know what the circumstances were which caused this disruption.

A full-page miniature of the enthroned Virgin and Child (Pl. 34), an innovation in Insular manuscripts, appropriately faces the incipit of the *Breves causae* for Matthew, beginning "Nativitas Xpi in Bethlem" (The birth of Christ in Bethlehem). It serves as a frontispiece for the entire section of prefatory material. Flanked by four angels in the corners, the Virgin is shown in a curious combination of frontal and profile views. The design is similar to the engraved image of the Virgin and Child on the wooden coffin of St. Cuthbert, now in Durham, and ultimately may be derived either from a Byzantine icon or, according to Werner, from Coptic sources.[48]

The facing incipit page (Pl. 35) is enclosed on three sides by a paneled frame and on the fourth by the prolonged first upright of the *N* and its continuation into a spiral terminal. The six lines of text, alternating large and small, are interspersed with paneled bands filled with painted foliate, geometric, and zoomorphic interlace. A figure holding a book, possibly Matthew, is seated in the third line of the text. The process of heightening the decorative impact of the incipit page first stated in the Lindisfarne Gospels has now reached its culmination: text and illumination are now entirely interwoven, word and ornament merge in a similar ambiguity as pattern and field had in the earlier carpet pages. In fact, the incipit page has now become its own carpet page, for it appears that none other was intended.

Although the first initials and first lines of the remaining *Breves causae* and Argumenta are not decorated on such a lavish scale, they nevertheless have been given considerably more magnificence in color and intricacy than the diminishing letters of the Book of Durrow or the still restrained beginnings of these texts in the Lindisfarne Gospels. The sumptuousness of the major pages reflects the prevailing desire of the illuminators to embellish the Word of God throughout the book, for almost every

page has decorative initials with colored fillings and calligraphic pen flourishes. For this reason, the Book of Kells may be considered the oldest surviving *fully* illuminated book of the Middle Ages.

We may surmise, in spite of the presumed loss of some decorative pages, that each of the Gospels was preceded by a well-thought-out order of illuminated pages. But the kinds of decoration within the sequence has been changed. The ensemble begins with a full-page verso divided into four compartments—rectilinear before Matthew and Mark, essentially triangular before John—each page containing the four signs of the Evangelists (e.g., Pl. 36). Presumably a similar four-symbols page, now missing, began the Luke sequence. With paneled frames and interior cruciform motifs, these four-symbols pages reaffirm the harmony of the Gospels before each text. They also function implicitly as book covers since this arrangement may well be derived from an early tradition of book covers implied by the fifth-century mosaic in Naples referred to above. This iconography also appeared in Irish metalwork, as on the eighth-century plaque of the Soiscel Molaise Book Shrine.[49] In the Book of Kells, the use of the four-symbols page *before* the other prefatory illuminations, where a normal book cover would be if each Gospel were bound separately, resolves some of the anomalies of the arrangement in the Lindisfarne Gospels.[50]

On the following versos, facing the incipits of their texts, are the portraits of the Evangelists. St. Matthew (Pl. 37) and St. John, frontally enthroned, survive; St. Mark and St. Luke are missing. This sequence, of Evangelist portraits facing the incipit page, is one that was gaining currency on the Continent, and this arrangement may be another example of continuing foreign influences on the illuminators of the Book of Kells. Unlike in Durrow and Lindisfarne, however, the proximity of author and Word are now made manifest without the interruption of the carpet page. Yet in style and manner of painting, the Kells portraits are thoroughly Insular, transforming the still recognizable Mediterranean images of the Lindisfarne Evangelists into stylized, flattened forms set within schematized thrones and patterned frames filled with barbarian ornament. Matthew is flanked by small symbols of the other three Evangelists, two small lions on top of the throne, and the ox and the eagle on the cushion, perhaps emphasizing that Matthew and his symbol, the winged man, are one. John is shown alone, but the entire frame surrounding him, with hands projecting from the sides, feet from the bottom, and haloed head, now effaced, from the top, forms a cruciform figure behind him. A representation of the crucified Christ, it may therefore be a personification of the Word, a pic-

36. Symbols of the Four Evangelists. Book of Kells, fol. 27v (Dublin, Trinity College Library, MS 58: Courtesy Board of Trinity College, Dublin)

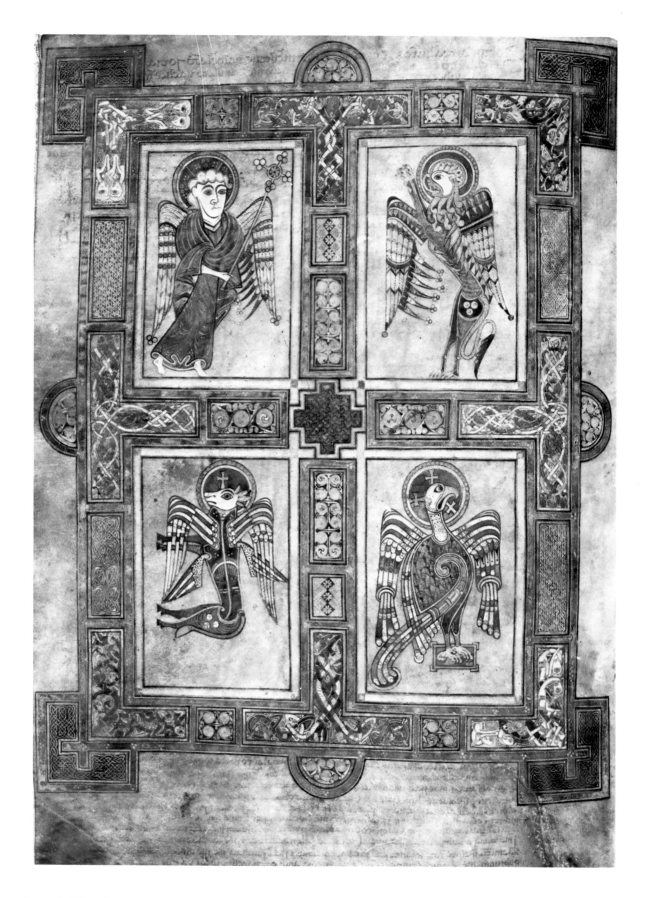

torial evocation of John's phrase "and the Word was God," from the opening verse of his Gospel. Here, the Word is only partially revealed, an implication reinforced by the gesture of John displaying a closed book, with its implicit references to the closed book of the Apocalypse and to the Old Testament allusions to the inscrutable nature of God.[51]

The opening pages of text for each of the four Gospels display even more complex blocks of ornament than does the "Nativitas" page. The beginning letters, in the manner of the Lindisfarne incipits, dominate the entire page but are also interwoven with the opening words so that the integrity of lines of text, still evident in the Lindisfarne Gospels and the Kells "Nativitas" page, are now almost lost. For Matthew (Pl. 38), the *Lib* forms a magnificent jewellike monogram and the *er* is interwoven within the flasklike *b*. "Generationis," broken into three lines, is contained within a small rectangle in the lower right corner, enclosed by an elaborate, multi-banded frame that counterbalances the form of the monogram and implies the rectangular block of text. As a result, the design has the effect of a tightly woven carpet page in which the letters and frame exist in an ambiguous relationship with the ornament of the ground. This ambiguity of text and decoration may therefore imply the mystery of the half-veiled Word.

A standing figure holding a book to the left of the monogram has been thought to be a representation of the donor for whom the Book of Kells was made. Above the *ib* is a half-length haloed figure holding a book, two lions appear on the left slope of the top of the *L,* and an angel is evident to the left of the *L.* The exact meaning of these figures is not clear; if they were intended to be symbols of the Evangelists, the ox of St. Luke is missing.

Given the extraordinary elaboration of these pages, it is no surprise that the *Xpi* monogram in the Book of Kells (Pl. 41) was also given the status of a full-page incipit beginning the narrative of the Nativity in the Gospel of St. Matthew. The great curvilinear arms of the *X* sweep diagonally across the page while the *pi* nestles between it and an angled panel of frame in the lower right corner. The most exuberant and open of the designs in the Book of Kells, it is also the most elaborate manifestation of the Incarnation monogram in Insular art, developing stages of which can be seen in the Book of Durrow and the Lindisfarne Gospels.

Buried within the myriad abstract motifs are some surprisingly well-articulated animals and figures. Two butterflies or moths appear in the dotted field to the left of the crossing of the Chi. Below, along the descending arm, are three angels. At the bottom two cats crouch facing each other with mice perched on their backs. The cats each have caught by the tail mice that are

37. St. Matthew. Book of Kells, fol. 28v (Dublin, Trinity College Library, MS 58: Courtesy Board of Trinity College, Dublin)
38. "Liber generationis." Book of Kells, fol. 29r (Dublin, Trinity College Library, MS 58: Courtesy Board of Trinity College, Dublin)
39. Christ Enthroned. Book of Kells, fol. 32v (Dublin, Trinity College Library, MS 58: Courtesy Board of Trinity College, Dublin)
40. Carpet page. Book of Kells, fol. 33r (Dublin, Trinity College Library, MS 58: Courtesy Board of Trinity College, Dublin)

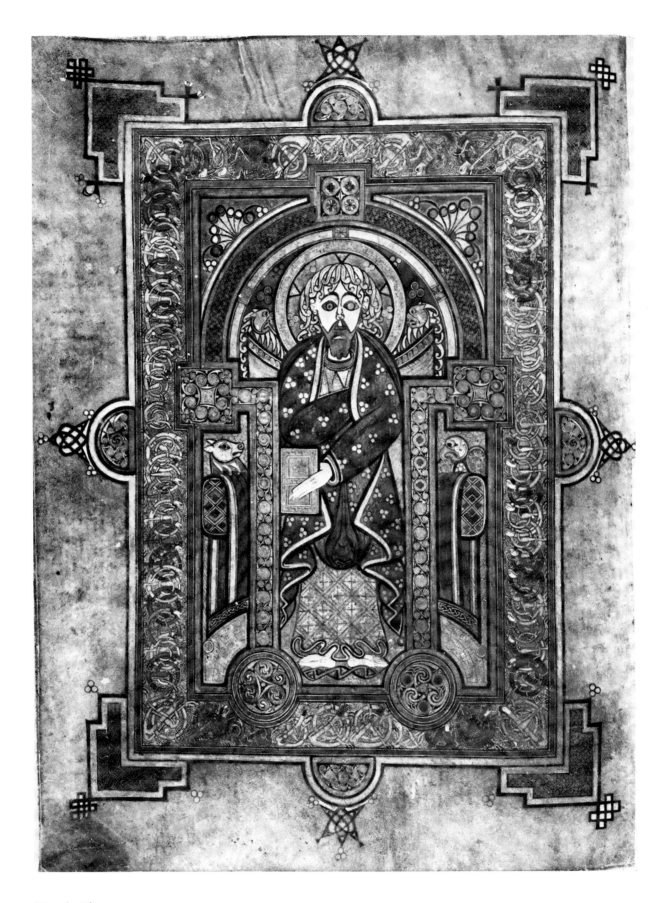

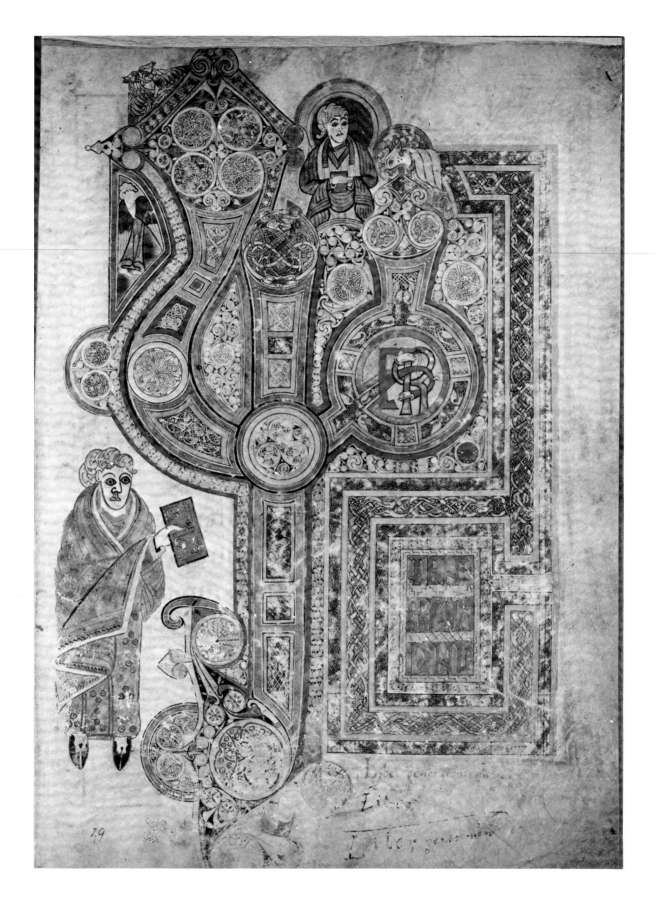

Pl. 38 / 87

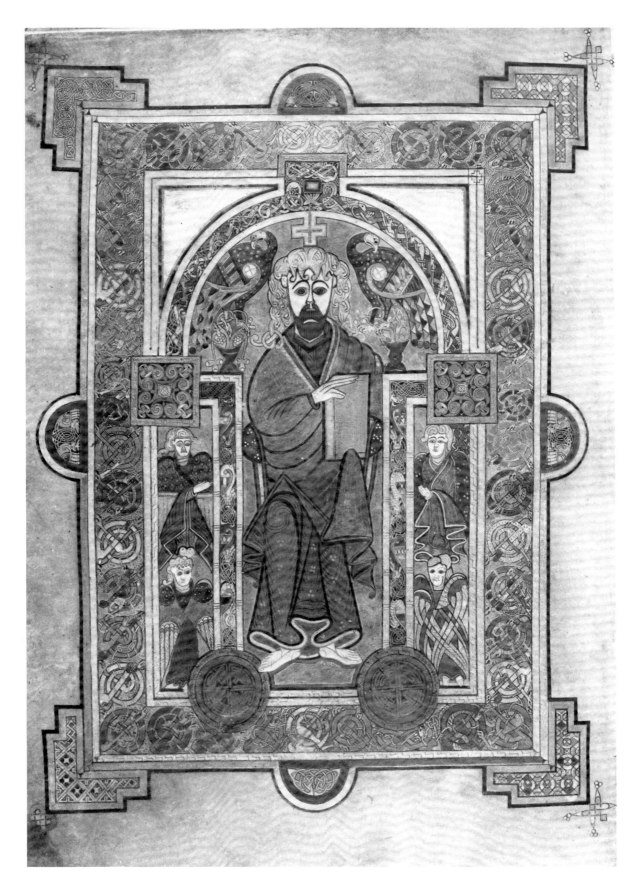

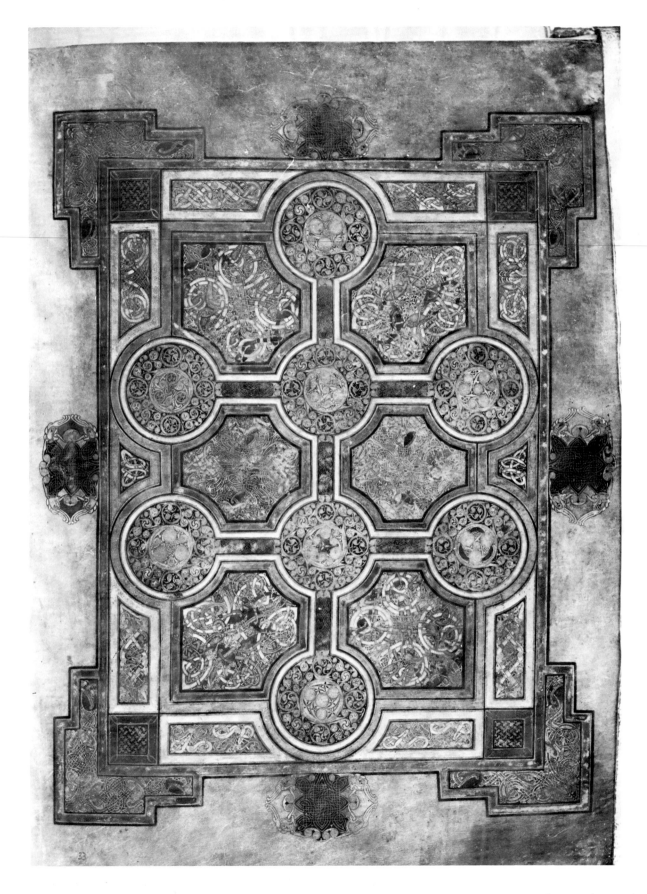

Pl. 40 / 89

nibbling a round object with a cruciform marking, possibly a wafer of the Eucharist. To the right, beneath the rho and iota, a black otter has just caught a fish.

Various interpretations of these animals have been made, dependent upon a variety of sources including convoluted ninth-century Irish exegetical writings.[52] The fusion of the monogram of Christ's name with the cruciform shape of the chi implies both the mystery of the Incarnation in which the Word was made flesh and the sacrifice of Christ by means of the Crucifixion. The fish had been a symbol for Christ since early Christian times, as the letters of the Greek word *ichthys* stood for the first letters of the words in the phrase "Jesus Christ, God's Son, Savior"; and the wafer was a symbol for the body of Christ. Both are also symbols of mystic meals, the wafer of Communion, the fish of the legends of Irish saints who were miraculously brought a fish every day by an otter. The animals at the bottom of the page are of the land and sea, the moths or butterflies above are of the air. The latter are symbols of the immortality of the soul and of the Resurrection, both themes appropriate for the Incarnation page. These remarkable vignettes of real animals and insects signify, in the same way as the intricate and convoluted decoration of the monogram and its field, partially revealed and partially obscured by its decoration, the most significant mysteries of the Irish liturgy: the Incarnation and the Resurrection.

The importance of this page and its symbolic impact is further emphasized by the double-page frontispiece that immediately precedes it (Pls. 39, 40). On the verso of the previous folio Christ in Majesty stands beneath an arcade flanked by four angels. Two peacocks, symbols of the soul, are perched on vines emerging from chalices on either side of his head. This heraldic image of Christ, holding the closed book containing the Logos, faces the only carpet page in the book. The most elaborate of all carpet pages, it contains a double-armed cross punctuated by medallions containing a myriad of niellolike spirals. It is set into a bold paneled frame and against a ground filled with intricately intertwined lacertines. The cruciform motif placed opposite the figure of Christ again states the theme of the sacrifice of Christ, which is also combined with the Incarnation monogram on the following Chi Rho page. Following the tradition of the Book of Durrow and the Lindisfarne Gospels, the carpet page functions as a prefatory cover, as a container of the most sacred word, the name of Christ, like a painted cumdach. In the Book of Kells, however, this intricate and disciplined carpet page, abstract and symbolic in its function, has been reserved for this most sacred sequence of illuminations, and the problems created in the Durrow and Lindisfarne Gospels have been resolved, as we have seen above, in a

41. "Xpi autem." Book of Kells, fol. 34r (Dublin, Trinity College Library, MS 58: Courtesy Board of Trinity College, Dublin)

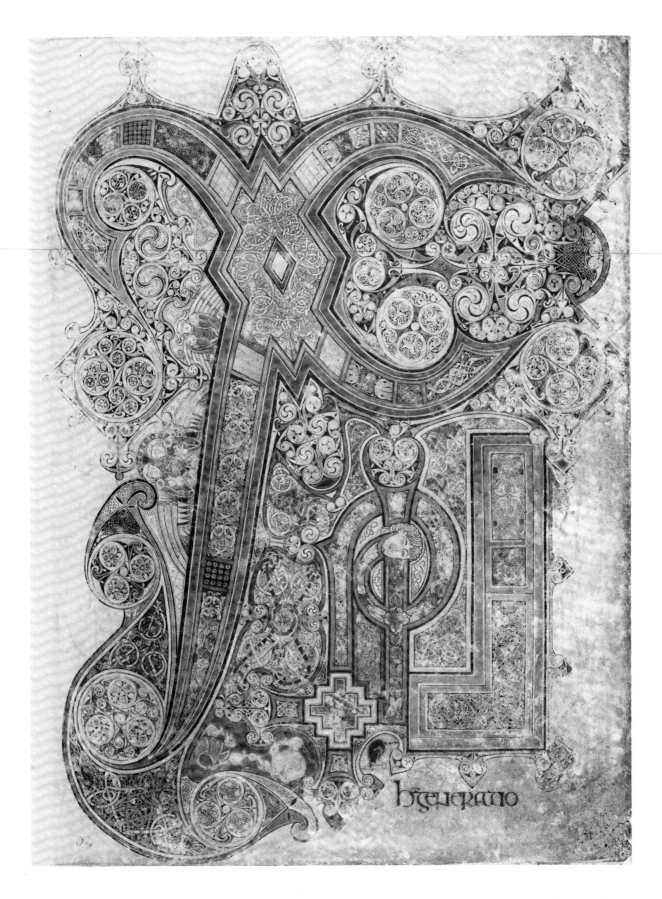

liber gener atio

Pl. 41 / 91

different manner. A similar arrangement occurs in the earlier St. Gall Gospels, where the only carpet page in the book, with a central cruciform motif, faces an elaborate Chi Rho page.[53]

In addition to the sequence of prefatory miniatures before the Gospels and the elaboration of decorative pages associated with the Chi Rho page, the illuminators included a series of narrative miniatures and subsidiary decorations embellishing significant passages of the text. In Matthew, a full-page miniature of the Arrest of Christ and, in Luke, one of the Temptation of Christ introduce passages in the text describing these events. Other texts with elaborated initials suggest that there may have been additional narrative miniatures that are now missing.[54] The surviving narrative illustrations of the Arrest and the Temptation contain evidence that their compositions were derived from Continental examples, but the source for the idea of their inclusion is not clear. Whether an Eastern, Italian, early Carolingian, or lost Insular manuscript inspired the in-text narrative illustrations, the Book of Kells remains one of the earliest surviving examples from northern Europe, standing at the threshold of this tradition.[55]

The Book of Kells therefore marks the fullest development of the Insular tradition of illumination with ornamental frontispieces and illuminated incipits. But it also shows the impact of new ideas, some from the Continent, others perhaps indigenous, which resulted in an expanded program of decoration and a tighter, more meaningful sequence of illuminations. To this were added extensive zoomorphic decoration of initials on most of the text pages and the introduction of what may have been a program of narrative miniatures to illustrate what were considered to be liturgically significant points in the text. Henceforth Insular illumination became less preoccupied with purely abstract ornament and developed a more pictorial emphasis.

2. / The Carolingian Bible

When Charlemagne (742–814) became king of the Franks in 768 he set about consolidating the political power of his kingdom in the area of present-day France and Germany, strengthening the military position of Europe against the Moslems in Spain and virtually rescuing the pope from the threat of the Lombards in Italy. He was concerned not only with the political and military power of his kingdom, but also with the image of his Christian realm in Europe, and therefore had himself crowned Emperor of the Romans in St. Peter's in Rome on Christmas Day, 800. By this device, he created a link with the Roman Christian Empire of the time of Constantine and sought to legitimize this association through the reorganization of Frankish political institutions in the Roman manner. He also emulated what he considered to be Roman imperial images in art and architecture, such as the patterning of his Palatine Chapel of Aachen after S. Vitale in Ravenna. And finally, he encouraged a concerted revival of learning in the monasteries and at the imperial court.

As a result of this last endeavor, a resurgence of book production was a major product of the Carolingian *renovatio*. Monastic and court scriptoria were founded which set about reviving, clarifying, and regularizing the more legible forms of late antique writing. Basic grammar books were assiduously copied and recopied in order that stricter rules for the use of the Latin language be disseminated.

For the art of the illuminated book, the most significant Carolingian innovations occurred in the reform of several modes of script and the return to several classicizing styles of painting in the representation of Evangelist portraits and the architectural framework for the canon tables. Carolingian scribes carefully emulated the square or epigraphic capital letters frequently found

carved on Roman monuments. These bold, monumental letters were frequently used for rubrics on title pages and after decorative incipit initials. Various forms of uncial script were developed, in which most of the letters remained capitals but some ascenders and descenders broke the line of text and the letters *a, d, e,* and *m* appeared in transitional forms approaching those that we now use as lowercase letters. Uncials were often used as subtitles after the quadrata titles and before the body of the text. This device regularized a diminishing hierarchy of script, the Carolingian answer to the Insular diminuendo. A form of lowercase writing was also developed, known as Caroline minuscule. This script was used for the body of the text and provided the basis for subsequent styles of writing until the development of Gothic script at the end of the twelfth and beginning of the thirteenth century.

While many of the visual manifestations of the Carolingian renaissance were nothing more than political propaganda to reassert the authenticity and authority of the new empire, this desire for legitimacy and accuracy also led to attempts to authenticate and codify religious texts, particulary that of the Bible, which had become corrupted since the time of St. Jerome's translation. One of the major accomplishments of Carolingian scholars was the revival and gradual reformulation of the text and decoration of the single-volume Bible or pandect.

Although rare, large single volumes containing both the Old and the New Testament were occasionally produced in Italy and Spain in the early Christian period. The now lost sixth-century Codex Grandior of Cassiodorus (c. 485–580), which was brought to Northumbria by Benedict Biscop or Ceolfrith, was one of these pandects: it served, together with other texts, as we have seen, as one of the models for the Codex Amiatinus made at Monkwearmouth or Jarrow before 716. The illustration of these early pandects, however, seems to have been sparse. In the Codex Amiatinus, the portrait of Ezra/Cassiodorus as scribe revising the books of the Old Testament, a double-page miniature of the Temple of Solomon, and a schema of the divisions of the Bible prefaced the text of the Old Testament, signifying the codification of the Old Law and the site of the Ark of the Old Covenant. A miniature of Christ in Majesty with the four Evangelists and their symbols and a set of canon tables prefaced the New Testament, signifying the New Dispensation.

It remained for the Northumbrian Alcuin of York (c. 730/35–804), who served at the court of Charlemagne from c. 782 to 796, to organize a concentrated campaign of production of at least six pandects upon his retirement to the monastery of St. Martin's at Tours.[1] These early "Alcuin Bibles" were not elabo-

rate books. In those produced by later generations of scribes in the Tours scriptorium under Fridigisus (804–834), Adalhard (834–843), and particularly under Vivian (843–851), however, script, decoration, and a meaningful sequence of miniatures were developed.

Since the early Christian pandects do not appear to have been copiously illustrated, the Carolingian Bibles may have drawn from other sources, for example, volumes of single books or groups of books such as the Rossano Gospels, the now mostly destroyed Cotton Genesis, the Itala Fragments of an illustrated book of Kings, or the Ashburnham Pentateuch, which were more fully illustrated with narrative cycles. Many of these earlier examples introduced either framed or unframed miniatures into the text at the appropriate passage, as in the Vienna Genesis (Pl. 2). Others, such as the Ashburnham Pentateuch (Pl. 3), placed a variety of incidents relating a single narrative, such as the Fall of Man, within large single-page miniatures. In many of the Carolingian Bibles these scenes were placed in horizontal bands separated by frames inscribed with Latin verses or tituli. Scholars do not agree on the origin of this arrangement: some believe it was derived from a lost fifth-century Bible from the time of Pope Leo the Great, others think it was a Carolingian innovation of the school of Tours.

The decorative program in the Carolingian Bibles evolved slowly. An early Carolingian Bible, now in Bamberg (Staatsbibliothek, misc. class. bibl. 1) and generally thought to have been made about 835–843 at Marmoutier, contains only two miniature pages prefacing the major sections of the text.[2] A full-page representation of the Creation and Fall of Man appropriately served as a frontispiece to Genesis and the Old Testament, while a symbolic evocation of Christ, the Lamb of God, surrounded by the four signs of the Evangelists introduced the Gospels. These miniatures simply and directly stated the themes of mankind's fall from grace and the necessity for salvation through the coming of Christ and his sacrifice, implied by the Paschal Lamb, and through the adherence of his Word contained in the Gospels, signified by the symbols of the Evangelists. In the Bibles from Tours, this program was expanded. The Moutier-Grandval Bible in London (The British Library, MS Add. 10546), of about 830–835, contains four full-page miniatures, before Genesis, Exodus, and the Gospels and after the book of Revelation. The Bible examined here, the First Bible of Charles the Bald, contains a fully developed program of eight illustrations, but without the narrative elaboration of the twenty-four frontispieces provided for the Bible of S. Paolo fuori le mura in Rome of perhaps twenty to thirty years later.[3] This carefully worked-out program

of frontispieces and incipit pages in turn influenced developments in the illustration of imperial Gospel books.

The First Bible of Charles the Bald

The so-called First Bible of Charles the Bald (Paris, B.N., MS lat. 1), also known as the Count Vivian Bible after the lay abbot of St. Martin's at Tours, was commissioned by the abbot and presented to Charles the Bald, king of the Franks, in 846. In addition to its eight full-page miniatures, it contains dedicatory verses to the king and visual and verbal references to the divine investiture of his royal authority.

The volume opens with four pages of enframed text written in two columns of gold letters against purple-dyed panels (see Appendix 4). These pages have the effect of simulated consular diptychs and inscriptions—hinged ivory panels with figural representations of consuls, which were manifestations of delegated imperial authority in use in the Byzantine Empire. Although consisting only of text, the effect of these panels is enhanced by their contents—the dedicatory verses to Charles the Bald—and by the presence of two circular medallions—simulated imperial coins—with the inscriptions "David Rex Imperator" above and "Carolus Rex Francorum" below.[4] A similar folio appears at the end of the manuscript, the verso side of which, containing further dedicatory verses, faces a full-page miniature of Charles the Bald enthroned (Pl. 54). The king is shown receiving the Bible from three clerics with veiled hands while Count Vivian, standing next to him, gestures toward them. This appears to be the earliest surviving dedication miniature in a medieval manuscript. Athough these folios are inserted into the first and last gatherings, they function as appropriate prefatory and concluding texts referring to the qualities of kingship and the legitimacy of the regime. These qualities are further alluded to in the other miniatures throughout the manuscript.

The prefatory matter of the Bible proper begins with an unusual miniature depicting the life of St. Jerome (Pl. 42) facing a title page to Jerome's letter to Paulinus of Nola (Pl. 43), which lists the books of the Bible and summarizes their meanings. The narrative scenes, perhaps derived from a fifth-century model, are arranged in three horizontal bands. In the top row St. Jerome is shown departing from Rome for the Holy Land on the left and paying the teacher who taught him Hebrew on the right. The middle register shows St. Jerome instructing four women, Paula, her daughter, and two others who had followed the saint back to

Rome, while a monk records his teachings. On the right two scribes transcribe the books of the Bible into codices from scrolls, perhaps signifying the ancient sources. In the bottom row St. Jerome distributes the completed volumes of the Vulgate to monks who take them off to buildings on the right and the left, the major churches and monasteries of the Western world.

This full-page ensemble of narrative scenes functions, therefore, as an expanded author portrait, emphasizing Jerome's activity in revising and translating a new authoritative copy of the Scriptures into Latin. The presence of this cycle of illustrations in this and in the S. Paolo Bible had an added significance, for it undoubtedly also referred to the activities of Alcuin in establishing the scriptorium at St. Martin's at Tours, undertaking in Carolingian times a similar repurification and clarification of the Vulgate text.[5]

The title page to Jerome's letter to Paulinus (Pl. 43) faces the narrative miniature. With its frame and five horizontal bands of epigraphic capitals set against a purple ground, this page contributes to a monumental two-page spread of decoration. The narrative of the story enhanced by tituli under the bands of miniatures and the clarity and precision of the lettering on the title page dominate. The sumptuous and mystical intricacy of Insular incipits is foreign to this milieu, which reached back to the rational forms of Rome for its authority. On the verso the opening lines of the letter, beginning "Frater Ambrosius," are written in epigraphic capitals in diminishing size (Pl. 44). The large introductory *F,* the full height of the frame surrounding the text, contains medallions with two lions at the top, the hand of God and an ox in the middle, and a seated man with a book at the bottom. These figures appear to be a mixture of Christological and Evangelist symbols.

Four folios after the text of the letter to Paulinus, another framed page with bands of letters for the rubric begins St. Jerome's preface addressed to Desiderius: "Incp pfat Sci Hieronm prbi [Incipit praefatio Sancti Hieronymi presbyteri]" in gold and silver letters shimmers against the purple ground of the horizontal bands (Pl. 45). Although manifesting the same tendency found in Insular art to frame lines of text, the solid colored fields and stark epigraphic capitals show the Carolingian penchant for clarity rather than for the dotted decoration and distorted letters of the Insular tradition. The block of text below is a solid field of purple with golden uncial lettering. The actual text is introduced by a monumental *D* in gold and silver, made up of ten roundels containing the signs of the zodiac. In the interior of the letter, a personification of Sol as a male charioteer, Apollo, appears between the two fish of Pisces, and below, a female figure of Luna,

42. St. Jerome frontispiece, First Bible of Charles the Bald, fol. 3v (Paris, Bibliothèque Nationale, MS lat. 1: Photo Bibl. Nat., Paris)

43. "Incipit epistola Sancti Hieronymi ad Paulinum" (Title page to St. Jerome's letter to Paulinus of Nola). First Bible of Charles the Bald, fol. 4r (Paris, Bibliothèque Nationale, MS lat. 1: Photo Bibl. Nat., Paris)

44. "Frater Ambrosius." First Bible of Charles the Bald, fol. 4v (Paris, Bibliothèque Nationale, MS lat. 1: Photo Bibl. Nat., Paris)

45. "Incipit praefatio Sancti Hieronymi presbyteri" (Title page to St. Jerome's preface). First Bible of Charles the Bald, fol. 8r (Paris, Bibliothèque Nationale, MS lat. 1: Photo Bibl. Nat., Paris)

INCEPLSCIHE
RONMADPAV
LINV PRBRM
EONINTEX
DIVINISHISTORIAELIBRIS

Pl. 43 / 99

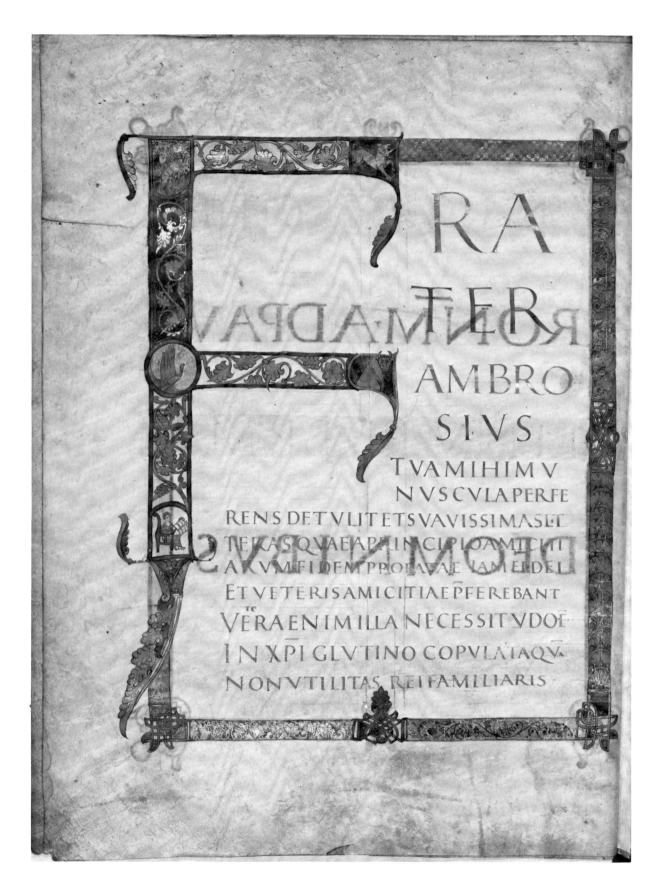

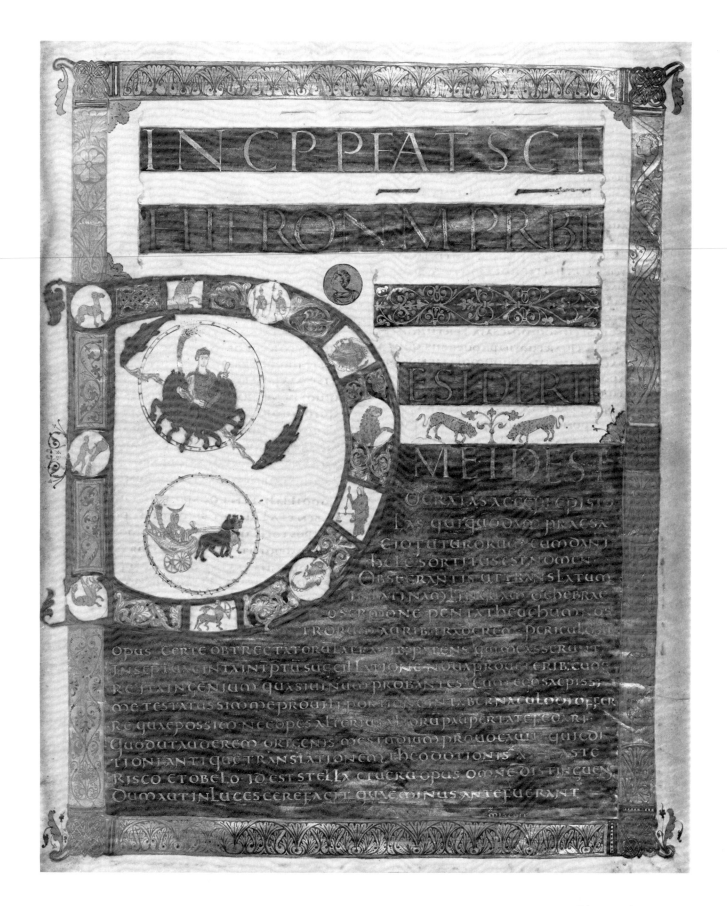

INCPPEATSCI

HIERONIMPRBI

DESIDERII

MELDESI

Pl. 45 / 101

with a crescent moon on her head, also drives a chariot. Derived from a revived interest in classical astronomical treatises, these representations were unparalleled in earlier Carolingian Bibles: the opening *D* of this preface in the Moutier-Grandval Bible in London merely contains cocks flanking foliage in a chalice and two animals leaping away from a plant, perhaps references to the Fountain and the Tree of Life, signifying the life-giving properties of the Scriptures, current from the late antique period onward. Similar animals, reminiscent of the stags in the fifth-century mosaics of the Mausoleum of Galla Placidia in Ravenna, appear on the Paris page between the bands with the inscription "[D] esiderii mei desi." A number of other initials in the Vivian Bible, as well as in the Moutier-Grandval Bible, contain similar small allegorical animals or figures relevant to the following book.

The lower half of the text area, dyed purple and written in gold, emulates the late antique and early Byzantine practice in such books as the Rossano Gospels. Possibly an indication of imperial patronage, this feature appears in a number of manuscripts written for members of the Carolingian imperial court. Although the ornamental trappings, the acanthus and leaf-scroll motifs in the frames and decorative bands, the palmettes projecting beyond the frame, and the coinlike medallions are classical in derivation, their use seems to be dictated by the Northern sensibility for lavishly decorated display pages.

A framed and arcaded tabulation for the capitula of the book of Genesis follows on folio 9 recto and verso. The architectural format of these tables is similar to that of the canon tables for the New Testament appearing later in the book. The same architectural device is also used for the tabulation of the concordance of St. Paul's Epistles, a repeated decorative accent that emphasizes the homogeneity of the manuscript.

Facing the incipit to the book of Genesis is a full-page miniature with three horizontal registers containing the story of the Creation and Fall of Man (Pl. 46). The narration begins with God giving life to Adam and continues with God taking the rib from Adam's side, God introducing Eve to Adam, the temptation of Adam and Eve, God's admonition, the expulsion from the Garden of Eden, and Eve with a child, Cain, while Adam tills the soil. All of these scenes depict events described in the book of Genesis: they depict man's fall from grace and the necessity for his salvation through the First and Second Comings of Christ. This theme is also implied in the frontispieces for the Gospels and the book of Revelation which follow later in the manuscript.

Similar Genesis frontispieces occur in all four of the ninth- cen-

tury Touronian Bibles, and appear to have their source in the same original model. Many of these individual scenes were probably derived from a fully illustrated copy of Genesis such as the Cotton Genesis of the fifth or sixth century. Although Wilhelm Koehler thought that they might have been copied from a similar frontispiece of a now lost Leonine Bible, Herbert Kessler has shown that this narrative sequence and full-page presentation of multiple scenes was a Carolingian invention.[6]

The incipit page for Genesis presents a restrained decorative format (Pl. 47). A delicate frame containing foliate motifs encloses the block of text and separates the two columns. Gold letters set against a purple panel state the heading, "Incipit liber genesis." Below, a monumental *I* forms most of the left side of the frame and introduces the first lines of the narrative, also written in gold against a purple field: "In principio creavit Deus caelum et terram." The *I* is framed and divided into sections in a manner reminiscent of the Insular initials, and although two panels contain interlace, the remainder of the letter contains acanthus foliage of classical derivation and is punctuated by a medallion with the bust of God. The rubric and opening verses set off against the purple field are written in increasingly smaller scale. The progression from epigraphic capitals in the title to uncial that comprises the body of the text is perhaps also a reflection of the persistent decorative devices of the Insular school from which Alcuin had come. Other major incipit pages follow this simple format, while the beginnings of books are not prefaced by a frontispiece merely contain versal initials decorated with foliage, interlace, and occasionally figures and animals. The clarity and precision of the script dominate these subdued, even austere, pages.

The book of Exodus is introduced by a frontispiece divided into two registers (Pl. 48). In the top scene Moses receives the Ten Commandments from the hand of God on Mount Sinai. He stands upon the burning mountain while Joshua keeps watch. Below, in a templelike building Moses addresses the Israelites. This miniature depicts the receiving of the Law, an appropriate representation before the book of Exodus, for this event occurred as the Israelites wandered in the wilderness after their exodus from Egypt and signifies the Covenant of the Old Testament.

Because of similarities between this miniature and an Exodus frontispiece in the Moutier-Grandval Bible in London, as well as a miniature containing the same scenes which introduces the book of Leviticus in the S. Paolo Bible, Kessler has determined that this particular representation may have been derived from an illustrated Pentateuch of the sixth century. This manuscript, together with the illustrated Genesis that provided scenes for the

46. Genesis frontispiece. First Bible of Charles the Bald, fol. 10v (Paris, Bibliothèque Nationale, MS lat. 1: Photo Bibl. Nat., Paris)

47. "Incipit liber genesis. In principio creavit Deus." First Bible of Charles the Bald, fol. 11r (Paris, Bibliothèque Nationale, MS lat. 1: Photo Bibl. Nat., Paris)

48. Exodus frontispiece. First Bible of Charles the Bald, fol. 27v (Paris, Bibliothèque Nationale, MS lat. 1: Photo Bibl. Nat., Paris)

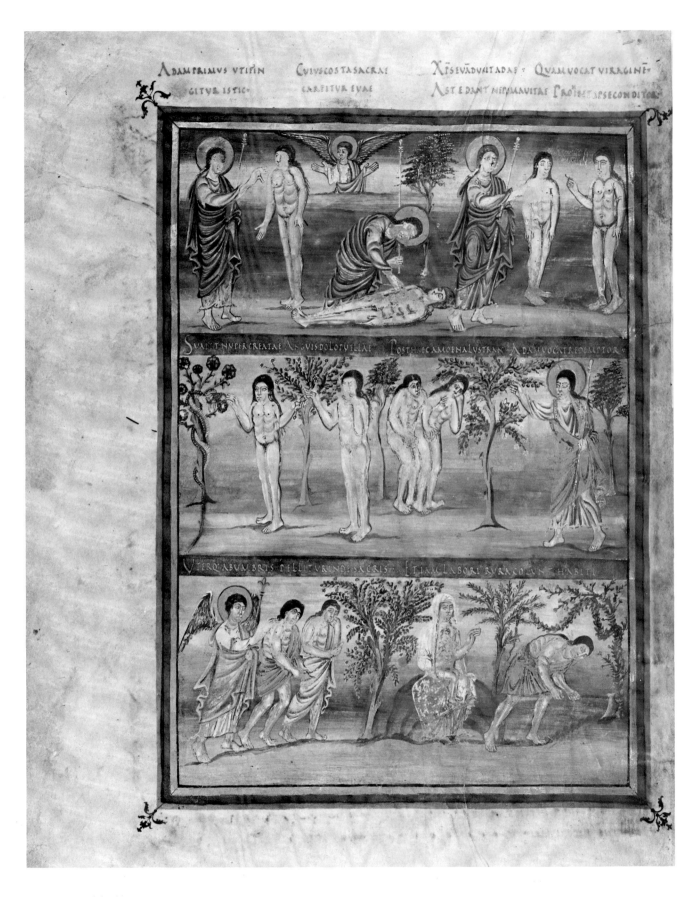

ADAMPRIMVS VTISIN CVIVSCOSTASACRAI XPSEVADVNTADAS ꞏ QVAMVOCAT VIRAGINEꞏ
GITVR ISTIC ꞏ CARPITVR EVAE AST EDANT NESMAVITAE CRÔISEE APSECONDITOR ꞏ

SVALE TNVPER CREATAE ANGVISDOLOPVELLAE POSTHEC AMOENA LVSTRANT ADAM VOCAT REDEMPTOR ꞏ

VTERO ABVMBRIS DELLI TVRINDE SACRIS ꞏ ETIAC LABORI RVRA COLVNT HABITA ꞏ

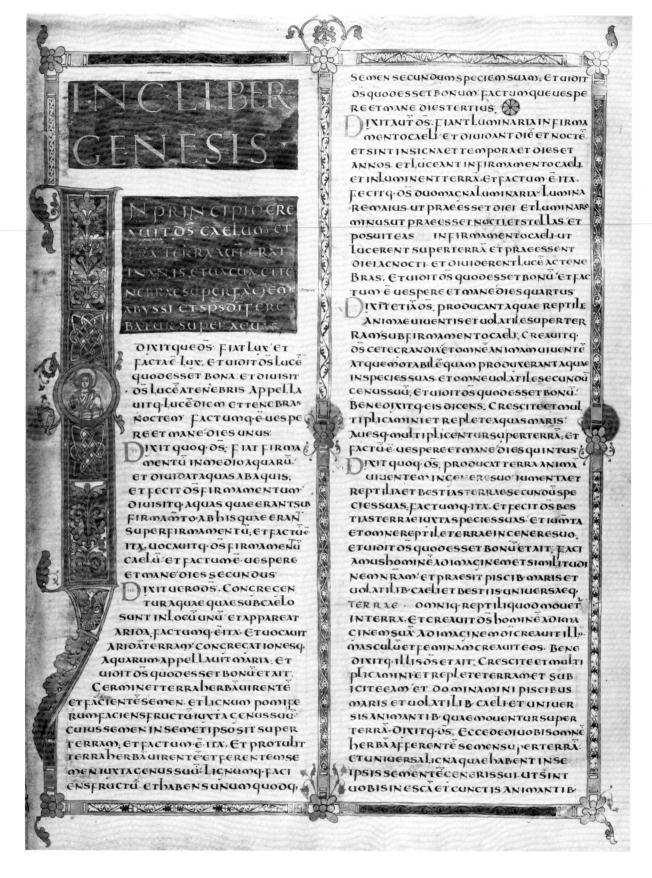

INC LIBER GENESIS

IN PRINCIPIO CRE
AVIT DS CAELUM ET
TERRA TERRA AUT ERAT
INANIS ET UACUA CT TE
NEBRAE SUPER FACIEM
ABYSSI ET SPS DI FERE
BATUR SUPER AQUAS.

DIXITQUE DS FIAT LUX ET
FACTA E LUX. ET UIDIT DS LUCE
QUOD ESSET BONA. ET DIUISIT
DS LUCE A TENEBRIS. APPELLA
UITQ LUCE DIEM ET TENEBRAS
NOCTEM FACTUMQ E UESPE
RE ET MANE DIES UNUS.

DIXIT QUOQ DS FIAT FIRMA
MENTU IN MEDIO AQUARU.
ET DIUIDAT AQUAS AB AQUIS,
ET FECIT DS FIRMAMENTUM.
DIUISITQ AQUAS QUAE ERANT SUB
FIRMAMTO AB HIS QUAE ERAN
SUPER FIRMAMENTU. ET FACTU
ITA. UOCAUITQ DS FIRMAMENTU
CAELU. ET FACTU E UESPERE
ET MANE DIES SECUNDUS.

DIXIT UERO DS CONGREGEN
TUR AQUAE QUAE SUB CAELO
SUNT IN LOCU UNU ET APPAREAT
ARIDA. FACTUMQ E ITA. ET UOCAUIT
ARIDA TERRA. CONGREGATIONESQ
AQUARUM APPELLAUIT MARIA. ET
UIDIT DS QUOD ESSET BONU ET AIT.
GERMINET TERRA HERBA UIRENTE
ET FACIENTE SEMEN. ET LIGNUM POMIFE
RUM FACIENS FRUCTU IUXTA GENUS SUU.
CUIUS SEMEN IN SEMETIPSO SIT SUPER
TERRAM, ET FACTU E ITA. ET PROTULIT
TERRA HERBA UIRENTE ET FERENTE SE
MEN IUXTA GENUS SUU. LIGNUMQ FACI
ENS FRUCTU ET HABENS UNUM QUODQ

SEMEN SECUNDUM SPECIEM SUAM, ET UIDIT
DS QUOD ESSET BONUM. FACTUMQUE UESPE
RE ET MANE DIES TERTIUS.

DIXIT AUT DS. FIANT LUMINARIA IN FIRMA
MENTO CAELI. ET DIUIDANT DIE ET NOCTE
ET SINT IN SIGNA ET TEMPORA ET DIES ET
ANNOS. ET LUCEANT IN FIRMAMENTO CAELI.
ET INLUMINENT TERRA. ET FACTUM E ITA.
FECITQ DS DUO MAGNA LUMINARIA. LUMINA
RE MAIUS UT PRAEESSET DIEI ET LUMINARE
MINUS UT PRAEESSET NOCTI ET STELLAS. ET
POSUIT EAS IN FIRMAMENTO CAELI. UT
LUCERENT SUPER TERRA ET PRAEESSENT
DIEI AC NOCTI. ET DIUIDERENT LUCE AC TENE
BRAS. ET UIDIT DS QUOD ESSET BONU. ET FAC
TUM E UESPERE ET MANE DIES QUARTUS.

DIXIT ETIA DS. PRODUCANT AQUAE REPTILE
ANIMAE UIUENTIS ET UOLATILE SUPER TER
RAM SUB FIRMAMENTO CAELI. CREAUITQ
DS CETE GRANDIA ET OMNE ANIMA UIUENTE
ATQUE MOTABILE QUAM PRODUXERANT AQUAE
IN SPECIES SUAS. ET OMNE UOLATILE SECUNDU
GENUS SUU. ET UIDIT DS QUOD ESSET BONU.
BENEDIXITQ EIS DICENS. CRESCITE ET MUL
TIPLICAMINI ET REPLETE AQUAS MARIS.
AUESQ MULTIPLICENTUR SUPER TERRA. ET
FACTU E UESPERE ET MANE DIES QUINTUS.

DIXIT QUOQ DS. PRODUCAT TERRA ANIMA
UIUENTEM IN GENERE SUO. IUMENTA ET
REPTILIA ET BESTIAS TERRAE SECUNDU SPE
CIES SUAS. FACTUMQ ITA. ET FECIT DS BES
TIAS TERRAE IUXTA SPECIES SUAS. ET IUXTA
ET OMNE REPTILE TERRAE IN GENERE SUO.
ET UIDIT DS QUOD ESSET BONU ET AIT. FACI
AMUS HOMINE AD IMAGINE ET SIMILITUDI
NEM NRAM. ET PRAESIT PISCIB MARIS ET
UOLATILIB CAELI ET BESTIIS UNIUERSAEQ
TERRAE. OMNIQ REPTILI QUOD MOUET
IN TERRA. ET CREAUIT DS HOMINE AD IMA
GINEM SUU AD IMAGINE DI CREAUIT ILLU
MASCULU ET FEMINAM CREAUIT EOS. BENE
DIXITQ ILLIS DS ET AIT. CRESCITE ET MULTI
PLICAMINI ET REPLETE TERRAM ET SUB
ICITE EAM. ET DOMINAMINI PISCIBUS
MARIS ET UOLATILIB CAELI ET UNIUER
SIS ANIMANTIB QUAE MOUENTUR SUPER
TERRA. DIXITQ DS. ECCE DEDI UOBIS OMNE
HERBA AFFERENTE SEMEN SUPER TERRA.
ET UNIUERSA LIGNA QUAE HABENT IN SE
IPSIS SEMENTE GENERIS SUI. UT SINT
UOBIS IN ESCA ET CUNCTIS ANIMANTIB

Pl. 47 / 105

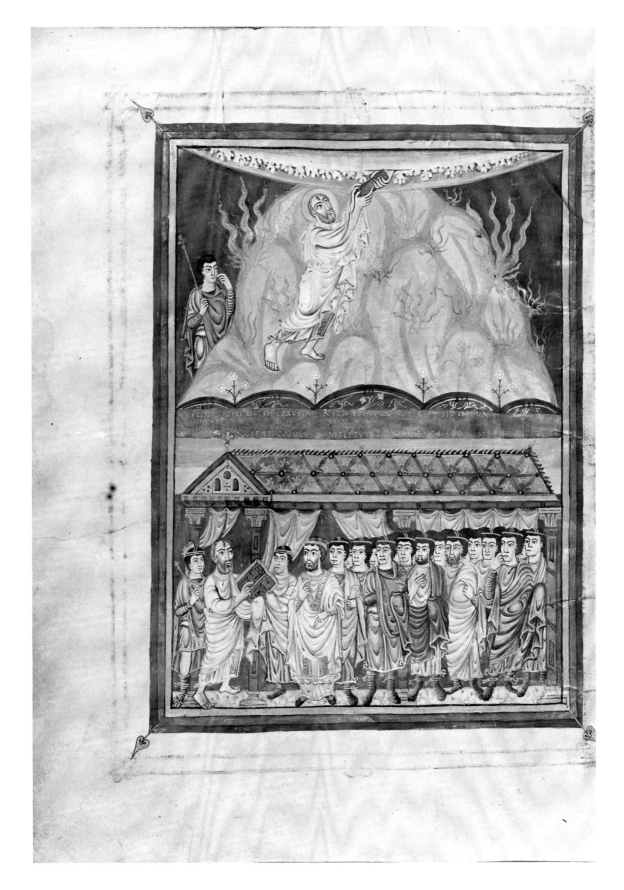

Genesis frontispiece, may have been at Tours in the ninth century.[7]

One of the most remarkable illustrations in the Vivian Bible is the frontispiece to the Psalms (Pl. 49). In the center of a blue ovoid mandorla, David as King and Prophet composes his songs of praise to the accompaniment of his psaltery. He is flanked by his two guards, Crethi and Plethi, clothed in Roman armor. Two kinds of images are combined, that of an author portrait and that of an imperial portrait in which it was customary for an enthroned emperor to be attended by two or four guards. The theme of authorship is expanded to one of inspiration by the Muses through the presence of David's four musicians, Asaph, Heman, Ethan, and Jeduthun. Ultimately the pictorial sources for this theme can be traced back to Byzantine representations of David dancing, or seated with scribes, but the Vivian frontispiece is closely derived from a Carolingian fusion and reworking of these traditions.[8] The theme of kingship is also amplified by the four half-figures in the corners, female personifications of the four cardinal virtues: Prudence, Justice, Fortitude, and Temperance. Moreover, as scholars have remarked, the facial features of David are actually those of Charles the Bald in the dedication miniature (see Pl. 54), and he wears the crown of the Carolingian kings. It had been traditional for Carolingian rulers to see themselves as continuing the rule of David. In the Bible of Charles the Bald the dedicatory verses and the royal portrait of Charles make this connection explicit.

David is therefore represented in several simultaneous guises: he is author and composer of the Psalms, the songs of praise brought from the Judaic tradition into the Christian liturgy; he is the just and able ruler of the Israelites; he is a prophet of the coming new order, and he is an ancestor of Christ who brings that new order. It is, therefore, not surprising that this Christ-like representation of David, complemented by four musicians and four Virtues, has compositional, thematic, and even symbolic similarity to the frontispiece of the Majestas Domini that precedes the four Gospels. It is a prefiguration of the next miniature in the manuscript.

The New Testament commences with a framed title page to the prefatory material for the Gospels. The Eusebian letter and four pages of canon tables follow. A single page of dedicatory verses to Charles the Bald on the theme of the Gospels occupies the recto of the folio that contains, on the verso, a full-page miniature of the Majestas Domini facing the beginning of Matthew (Pls. 50, 51).

This frontispiece for the four Gospels contains a representation of Christ enthroned on the globe of the cosmos within a double

49. David frontispiece. First Bible of Charles the Bald, fol. 215v (Paris, Bibliothèque Nationale, MS lat. 1: Photo Bibl. Nat., Paris)

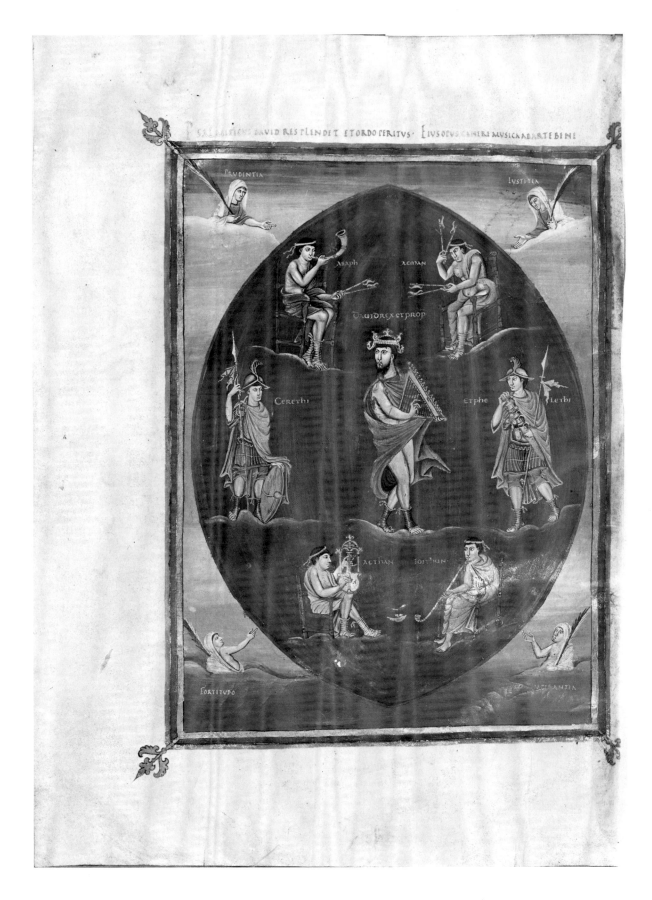

mandorla supported by the symbols of the four Evangelists. The celestial vision is placed within a lozenge punctuated at its points by circular medallions containing representations of four Old Testament prophets, Isaiah, Daniel, Jeremiah, and Ezekiel. In the corners of the miniature the four Evangelists are shown seated in various attitudes of contemplation, dipping a pen or writing. Close at hand are boxes filled with codices and cylinders containing scrolls. The fourfold juxtaposition of scribes, prophets, and symbols, as well as the diagrammatic arrangement of the groups of figures around Christ in Majesty, associate this page with the psalter page that depicted David, *Rex et Propheta*. In a larger context, this miniature embodies the symbolic structure of the Bible: the announcement of Christ's coming and sacrifice through the Old Testament prophecies, the recording of his miracles and teachings by the four Evangelists, the unity of these accounts and their harmony with the prophecies of the Old Testament, and the moment of his Second Coming (actually foretold by three of the prophets depicted) accompanied by the signs of the Four Beasts as recounted in the Apocalyptic vision of St. John in the book of Revelation.[9]

A number of details in this miniature are derived from Eastern and Western sources, but the Carolingian illuminators varied and recombined them, drawing inspiration from Jerome's prologue to the Gospels ("Plures fuisse"), which refers both to Ezekiel's vision of the signs of the Evangelists (Ezek. 1:1 ff). and to John's Apocalyptic vision (Rev. 4:1 ff) The rhomboid frame, at least in the Carolingian period, had cosmological significance: its four points referred to the four corners of the earth, the four winds, and the four cardinal points. It may also have embodied the theme of Paradise watered by the four streams of living water—a metaphor not only for the Gospels, but also for the Fountain of Life that was likened to the blood that flowed from Christ's side at his Crucifixion. The blue bands beneath each of the Evangelists may signify these living waters.[10]

Since the Epistles, containing the teachings of the apostles and the promulgation of the precepts of the early Christian faith, were a major division of the New Testament, they were given a decorative emphasis commensurate with the other sections of the Bible. They are introduced by a concordance (*Concordia epistolarum*), in canon table form, affirming the harmony of the teachings of the apostles. In addition, in two of the Carolingian Bibles a frontispiece was invented to face the incipit of the Epistles.

Arranged in three horizontal registers, the Vivian frontispiece (Pl. 52) narrates the story of the conversion of St. Paul: the blinding of Saul by the light from Heaven, Saul fallen to the ground, Saul led to Damascus, the dream of Ananias, the healing

50. Majestas Domini. First Bible of Charles the Bald, fol. 329v (Paris, Bibliothèque Nationale, MS lat. 1: Photo Bibl. Nat., Paris)

51. "Liber generationis." First Bible of Charles the Bald, fol. 330r (Paris, Bibliothèque Nationale, MS lat. 1: Photo Bibl. Nat., Paris)

52. Epistles frontispiece. First Bible of Charles the Bald, fol. 386v (Paris, Bibliothèque Nationale, MS lat. 1: Photo Bibl. Nat., Paris)

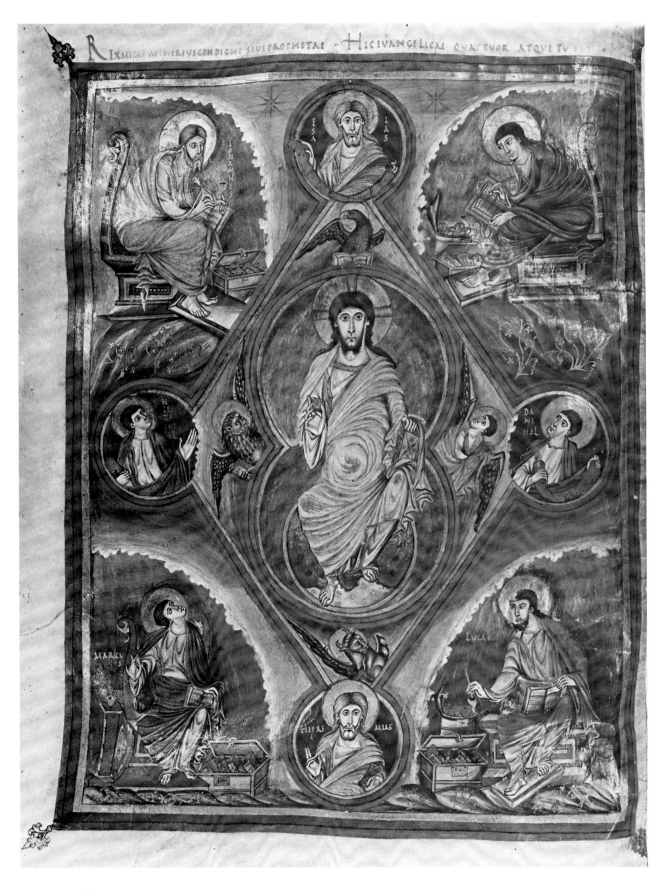

INCIPVG
MATHEI

LIBER
generationis
ihuxpi
filiidauid
filiiabra
ham

ABRAHAM genuit isaac isaac
autem genuit iacob. Iacob autem genuit iudam et fratres eius.
Iudas autem genuit phares et zaradethamar. phares aut gen
errem. Esrom aut genuit aram. Aram aut genuit aminadab.
Aminadab aut genuit naason. Naason aut genuit salmon.
Salmon aut genuit booz derachab. Booz aut genuit obed ex
ruth. Obed aut genuit iesse. Iesse aut genuit dauid regem.
Dauid aut rex genuit salomone ex eaquaefuit uriae.
Salomon aut genuit roboam. Roboam aut genuit abiā
Abia autem genuit asā. Asa aut genuit iosaphat. Iosaphat
autem genuit ioram. Ioram aut genuit oziam. Ozias aut
genuit ioatham. Ioatham aut genuit achaz. Achaz aut ge
nuit ezechiam. Ezechias aut genuit manassen. Manasses
autem genuit amon. Amon aut genuit iosiam. Iosias aut
genuit iechoniam et fratres eius intransmigratione babilonis.
Et post transmigrationem babilonis. Iechonias genuit sala
thiel. Salathiel aut genuit zorobabel. Zorobabel aut
genuit abiud. Abiud aut genuit eliachim. Eliachim aut
genuit azor. Azor aut genuit sadoc. Sadoc aut genuit
achim. Achim aut genuit eliud. Eliud autem genuit elea
zar. Eleazar aut genuit matthan. Matthan autem.
genuit iacob. Iacob aut genuit ioseph uirum mariae. de
quanatus est ihs quiuocatur xpt.

Omnes ergo generationes abraham usq; addauid generationes
quattuordecim. Et adauid usq; adtransmigratione babilo
nis. generationes quattuordecim. Et atransmigratione ba
bilonis usq; adxpm. generationes quattuordecim.

PIXPI AUTEM GENERATIO SIC ERAT
Cum esset desponsata mater eius maria ioseph. Antequam
conuenirent inuenta est inutero habens despusco.
Ioseph autem uir eius cum esset iustus et nollet eam traducere
uoluit occulte dimittere eam. Haec autem eo cogitante ecce
angelus dni insomnis apparuit ei dicens. Ioseph fili dauid noli
timere accipere mariam coniugem tuam. quod enim in ea
natum est despusco est. pariet aut filium et uocabis nomen
eius ihm. Ipse enim saluum faciet populum suum apeccatis eorum
Hoc autem totum factum est ut adimpleretur quod dictum est
adno per prophetam dicentem. Ecce uirgo inutero ha
bebit et pariet filium. et uocabunt nomen eius emmanu
hel quod est interpretatum nobiscum ds. Exsurgens aut io
seph asomno fecit sicut ei praecepit angelus dni. et accepit
coniugem suam. Et non cognoscebat eam donec pepit filium
suum primogenitum. et uocauit nomen eius ihm

CUM ERGO NATUS ESSET IHS IN BETH
leem iudaeae indieb; herodis regis. ecce magi aborien
te uenerunt hierosolymam dicentes. Ubi est quinatus est rex
iudaeorum. Uidimus enim stellam eius inoriente. et ueni
mus adorare eum. Audiens aut herodes rex turbatus est
et omnis hierosolyma cum illo. Et congregans omnes prin
cipes sacerdotum et scribas populi. sciscitabatur abeis
ubi xps nasceretur.

At illi dixerunt ei. Inbethleem iudae. sic enim scriptum est
per prophetam. Et tu bethleem terra iuda. nequaquam
minima es in principib; iuda. ex te enim exiet dux qui
regat populum meum isrl.

Tunc herodes clam uocatis magis. diligenter didicit abeis
tempus stellae quae apparuit eis. Et mittens illos inbeth
leem dixit. Ite interrogate diligenter depuero. et
cum inueneritis renuntiate mihi. ut et ego ueniens ad
orem eum. Qui cum audissent regem abierunt. Et ecce
stella quam uiderant inoriente antecedebat eos. usq; dum
ueniens staret supra ubi erat puer. Uidentes aut stellam
gauisi sunt gaudio magno ualde. Et intrantes domum
inuenerunt puerum cum maria matre eius. et procidentes
adorauerunt eum. Et apertis thesauris suis optulerunt ei
munera. Aurum tus et myrram. Et responso accepto
insomnis ne redirent adherodem. per aliam uiam reuersi sunt
inregionem suam. Qui cum recessissent. ecce angelus dni
apparuit insomnis ioseph dicens. Surge et accipe puerum
et matrem eius et fuge inaegyptum. et esto ibi usq; dum dicam tibi.
futurum est enim ut herodes quaerat puerum adperdendum eum.
Qui consurgens accepit puerum et matrem eius nocte. et se
cessit inaegyptum. Et erat ibi usq; ad obitum herodis. ut ad
impleretur quod dictum est adno per prophetam dicentem.
exaegypto uocaui filium meum. Tunc herodes uidens
qnm illusus esset amagis. Iratus est ualde. Et mittens
occidit omnes pueros qui erant inbethleem et inomnib;
finib; eius abimatu et infra secundum tempus quod

Pl. 51 / 111

of Saul, and St. Paul, after his conversion and his change of name, preaching in the synagogue—all events recorded in the Acts of the Apostles (9:3–7). The pictorial sources for some of these scenes may be traceable to an illustrated book of the Acts of the Apostles of Byzantine origin, which may also be reflected in the fifth-century frescoes in S. Paolo fuori le mura in Rome.[11]

The last major division of the Vivian Bible contains the book of the Revelation to St. John. The book records the Apocalyptic vision of St. John in which the prophecies of the Old and the New Testament are fulfilled at the moment that Christ himself foretold:

> The Son of Man shall come in his majesty, and all the holy angels with him, then shall he sit upon the throne of his majesty: and all nations shall be gathered together before him, and he shall separate them one from another as the shepherd separateth the sheep from the goats. [Matt. 25:31–32]

This is the moment of the Last Judgment, the time of salvation and damnation.

Three of the Carolingian Bibles contain frontispieces to this book. In the Vivian Bible, the miniature contains two scenes (Pl. 53). In the upper register a lamb with a halo breaks one of the seven seals of an enormous codex placed upon a covered throne or altar. Opposite, a lion looks on. The busts of the symbols of the four Evangelists appear in the corners, while a small figure on horseback gallops across the cloth behind the book. In the scene below, a bearded figure sits enthroned holding a billowing cloth above his head upon which is perched an eagle. A winged lion and ox flank this figure, while an angel blows a horn that partly obscures the seated figure's mouth.

The textual sources for the first representation are derived from passages in the Book of Revelation:

> . . . and round above the throne, were four living creatures, full of eyes before and behind.
> And the first living creature was like a lion: and the second living creature like a calf: and the third living creature, having the face, as it were, of a man: and the fourth living creature was like an eagle flying. [Rev. 4:6–9]

The second image is more problematical, although it seems to fit best the vision of the Elder of the Apocalypse:

> And in the midst of the seven golden candlesticks, one like to the Son of man, clothed with a garment down to the feet, and girt about the paps with a golden girdle.

53. Apocalypse frontispiece. First Bible of Charles the Bald, fol. 415v (Paris, Bibliothèque Nationale, MS lat. 1: Photo Bibl. Nat., Paris)

And his head and his hairs were white, as white wool, and as snow, and his eyes were as a flame of fire. [Rev. 1:13–14]

And he that sat, was to the sight like the jasper and the sardine stone [carnelian]; and there was a rainbow round about the throne, in sight like unto an emerald. [Rev. 4:3]

Although a similar billowing cloth was frequently used in classical art and derivations from it such as the image of Dawn in a Byzantine psalter now in Paris (B.N., MS gr. 139), Kessler has suggested that it may also be adapted here to reflect the passage from Isaiah 40:22: "He stretches out the skies like a curtain, he spreads them out like a tent to live in."[12] Perhaps most appropriate is the interpretation that the intense and visionary representation of the Elder is actually Moses, and that the cloth spread about the book, flanked by symbols of the Evangelists, reflects the theme of the revelation or unveiling of the Old Testament by the New. This view is confirmed by an exegetical commentary by Victorinus of Pettau, who interpreted the sealed codex as the Old Testament, the lion and the lamb as symbols of Christ's triumph over death, and the vision of the fifth chapter of the book of Revelation as the unveiling of Moses. Thus Christ reveals and fulfills the Old Testament above, and the four Gospels unveil Moses below.

Ancillary ingredients in the compositions may have been derived from a narrative Apocalypse cycle. In the upper register, a man carrying a bow and wearing a Phrygian cap rides a white horse across the drapery background: he is the First Horseman of the Apocalypse riding forth to conquer. In the bottom register a sorrowing St. John is being consoled by a crowned figure who points to the scene above: this is explained in the fifth chapter of Revelation:

And I saw in the right hand of him that sat on the throne, a book written within and without, sealed with seven seals.
And I saw a strong angel, proclaiming with a loud voice: Who is worthy to open the book, and to loose the seals thereof?
And no man was able, neither in heaven, nor on earth, nor under the earth, to open the book, nor to look on it.
And I wept much, because no man was found worthy to open the book, nor to see it.
And one of the ancients said to me: Weep not; behold the lion of the tribe of Juda, the root of David, hath prevailed to open the book, and to loose the seven seals thereof. [Rev. 5:1–5]

On the right John holds a rod and receives a book, which he raises to his mouth. This scene represents passages in Revelation

10:2–10 and 11:1, in which John is given the scroll to eat and the rod to measure the temple. He stands on two heads, the personifications of the Land and the Sea. The angel blowing the trumpet in front of Moses undoutedly refers to the recurrent trumpeting angels who announce the seven visitations of disaster in the Apocalypse.

Kessler has shown that the Apocalypse frontispiece constitutes a compositional parallel and symbolic complement to the Exodus miniature (Pl. 48). Both pages consist of only two horizontal scenes and together they affirm the unity of the Old and the New Testament: the etablishment of the Old Covenant through the Ten Commandments and the Hebraic laws, the revelation of their significance in paving the way for the New Order, and their substitution by the Christian Covenant.[13] The founding of a new order upon the old also parallels the David–*Carolus Rex* theme in the assertion of the continuity of the Christian Carolingian authority from the rule of David.

In the earlier Moutier-Grandval Bible in London, the Apocalypse miniature appeared at the end of the manuscript. In that position is provided a final statement of the revelation of the truths and of the unity of the Old and the New Testament. In the Vivian Bible, as well as in the later S. Paolo Bible, however, this miniature was positioned as a frontispiece to the Apocalypse and was replaced by the final dedication miniature.

Among the significant innovations in the decoration of the Carolingian Bibles was the introduction of a royal dedication or presentation miniature. In the Vivian Bible this scene is at the end of the volume (Pl. 54) and is prefaced by a two-page dedicatory poem to King Charles the Bald. Written in gold letters on purple dyed columns of text, the second half faces the full-page painting. This poem complements the dedicatory verses at the beginning of the volume.

The miniature depicts King Charles enthroned, flanked by attendants, and surrounded by clergy and lay persons. The figure in secular garments on the right is probably Count Vivian. He points to a group of three members of the clergy who offer with covered hands a sumptuously bound book—the Vivian Bible itself—to the king. This presentation scene takes place within a large arch hung with a curtain and containing at the top a representation of the hand of God bestowing Divine Grace upon the king. The scene is thus an elaboration of the traditional imperial portrait or Divine Investiture scene found in early Byzantine consular diptychs and in representations of Old Testament monarchs in early Christian and early Carolingian manuscripts.[14] The affinity with the representation of David flanked by similar bodyguards in the Vivian Bible not only reinforces the possibility of

54. Dedication-presentation miniature of Charles the Bald. First Bible of Charles the Bald, fol. 423r (Paris, Bibliothèque Nationale, MS lat. 1: Photo Bibl. Nat., Paris)

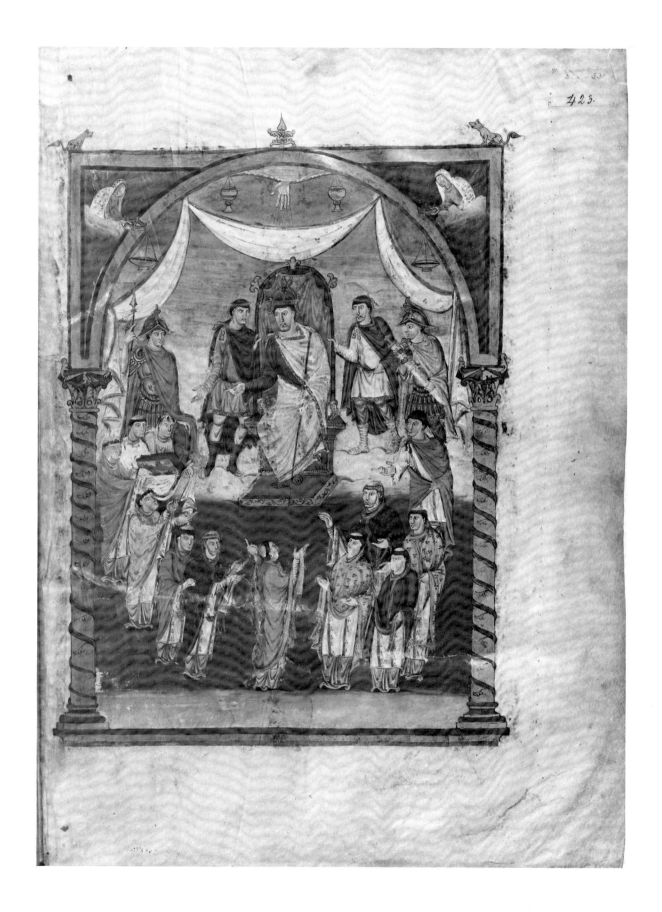

Pl. 54 / 117

these sources, but also emphasizes the theme of Charles as the new David stated in the dedicatory poem. The female figures offering crowns above the arch are thought to be personifications of Virtues, again a parallel iconography with the David frontispiece to the Psalms in which the four cardinal virtues of kingship were depicted.

Before the creation of the Vivian Bible the use of frontispieces had begun slowly: two prefatory miniatures, one before the Old and one before the New Testament, appears in the Bamberg Bible. In the Moutier-Grandval Bible in London this number had expanded to four, with the addition of an Exodus miniature and the final Apocalypse miniature. After the Vivian Bible, the S. Paolo Bible expanded the symbolic juxtaposition of scenes into twenty-four miniatures, many of which served a more narrative function. In the Vivian Bible, however, a balance was struck among pages that served as appropriate and meaningful author portraits (Jerome and St. Paul in narrative scenes, David in a schematic composition that evokes a Majestas Domini page), narrative pages prefacing Genesis and Exodus, and schematic pages introducing the Psalms, the Gospels, and the Apocalypse with the added innovation of the final presentation page. Although these miniatures, it has been determined, were derived from a variety of early Christian, early Byzantine, and early Carolingian sources and therefore do not always coalesce into a tight iconographical program, in general they work well together. They contribute additional meanings to each other and together they visually reaffirm the harmony of the Gospels, the unity of the New and the Old Testament, and the oneness of the Carolingian kingship with that of David.

A tradition of narrative illustration for the books of the Bible continued into the eleventh and twelfth centuries and developed into a separate genre. Many remarkable examples of these Bibles of the Romanesque period survive, containing full-page miniatures or magnificent historiated initials for each of the incipits of the books. These Bibles are so varied in format and iconographical content that they need to be discussed in a broader context than is possible here.[15] We shall therefore not attempt to discuss a representative example, but turn instead to a consideration of a developed program of illuminations for an imperial Gospel book and to the evolution of the decoration for liturgical manuscripts.

3 / The Imperial Gospel Book

In addition to the significant revival and elaboration of the large single-volume Bibles during the ninth century, sumptuous illuminated Gospel books continued to be made, usually for patrons at the court during the Carolingian and Ottonian empires. Most of these books adhered to the Continental tradition of prefacing each of the Gospels with author portraits of the Evangelists; the Insular tradition of carpet pages, with only a few notable exceptions in the Ottonian period, did not take hold. In early Carolingian Gospels, instead of elaborate full-page incipits, large decorative initials were used, frequently manifesting some of the decorative elements derived from Insular illumination, such as the paneled structure of the letter filled with plaitwork, and interlace terminals with zoomorphic heads. But many innovations were introduced which completely changed the character of the imperial Gospel books and resulted in the formulation of new decorative sequences.

The early Carolingian Evangelist portraits drew from two principal sources.[1] One group, related to miniatures in a manuscript produced for Ada, the half-sister of Charlemagne (Trier, Stadtbibliothek, MS 22), and therefore known as the Ada group, contained representations of the Evangelists enthroned beneath an arch. The effect of slight relief in the modeling of the figures, the tendency to schematize drapery folds into erratic patterns or concentric eddies reflects not only ivory plaques in the same style (hence also known as Ada ivories), but also late antique and early Byzantine ivories that might well have provided at least partial inspiration for the style. But the postures, activities, physical types, and settings of the Evangelist portraits were constantly varied and soon became the basis of their own generic development throughout the remainder of the Middle Ages.

The second major source of such representations, thought to

have originated with the presence of Mediterranean, perhaps even Greek or Byzantine, artists at the court of Charlemagne, was emphatically classical, not only in the pronounced volumetric treatment of the figures but also in the swirling, atmospheric handling of the landscape setting in which they were placed. This classical mode, which survives in only three manuscripts, in the so-called Coronation Gospels in Vienna and Aachen, and in the Xanten Gospels in Brussels,[2] was also transformed by later Carolingian miniaturists, particularly those associated with the scriptorium at Hautvillers near Reims and therefore known as the school of Reims. In the remarkable Gospel book made for Ebo, archbishop of Reims, at the monastery of Hautvillers, the hulking figures of the Evangelists have been charged with vibrant, sweeping strokes of pigment into frenetic, inspired beings receiving the Word of God.[3] This Reims style, which is related to the energetic drawing style of the contemporary Utrecht Psalter made in the same milieu, persisted in a somewhat subdued form until the end of the Carolingian Empire. These Evangelist portraits were usually placed as frontispieces to their Gospels.

The arcaded canon tables of the Ada manuscripts followed the same general configuration and architectural form as the sixth-century example now preserved in the Vatican Library (MS Vat. lat. 3806), with simulated fluted or spiraling porphyry columns, well-articulated bases and capitals, and decorative lunettes, usually adorned with signs of the Evangelists.[4] The earliest Carolingian examples were executed with flat, diagrammatic suggestions of the architectural elements and the columns were filled with geometric decoration similar to, but not dependent on, the interlace in the canon tables of the Lindisfarne Gospels and Book of Kells. Later, the architectural integrity of the framework was revived. In the Coronation Gospels group, however, the canon table architecture assumed the form and solidity of a classical temple front, with massive columns, entablature, and triangular or rounded pediments. Although the artist of the Ebo Gospels also used the temple front motif, he attenuated the form of the architecture and supported the triangular pediment on only two outside columns.

These Gospels reflect the deliberate reuse of classical elements of script, painting style, and architectural articulation. The revival of these forms in book illumination during Charlemagne's reign was part of the visual manifestation of the direct political and symbolic links that he wished to assert with the Christian Roman Empire.

The Codex Aureus of St. Emmeram

Among the many Gospel books produced for the members of the Carolingian court, the Codex Aureus of St. Emmeram, produced for the last major Carolingian emperor, Charles the Bald, is undoubtedly the most opulent.[5] It is justifiably called the Golden Gospels because of the lavish use of gold on the miniature, title, and incipit pages. An inscription on the folio with the imperial portrait of Charles the Bald states that he gave the gold for the manufacture of the book. It was written and signed by the scribes Beringar and Liuthard and completed in 870. After the death of Charles the Bald in 877 the manuscript came into the possession of King Arnulf of Bavaria who, shortly after 893, presented it to the Benedictine monastery of St. Emmeram in Regensburg. At the end of the tenth century Abbot Ramwold (975–1001) had the book refurbished by Aripo and Adalbertus and had a full-page portrait of himself, in a style approximating that of the decoration of the rest of the book, painted on the first folio of the manuscript.

Although scholars have not agreed where the Codex Aureus was written or decorated, either the imperial abbey of St. Denis or the palace school of Charles the Bald, the style of painting reflects the continuation of the vibrant and restless manner of the late school of Reims.[6] In fact, the elaborately bejeweled cover with low-relief figures in repoussé gold leaf (see Colorpl. 1) has close affinities with the metalwork influenced by the energetic drawings of the Utrecht Psalter a generation earlier. The activated figures resulting from this style of painting are combined with a lavish use of gold foliate and interlace designs, usually against purple-dyed vellum, to create incipits of astonishing complexity and splendor. The use of purple vellum as a special writing material in early Christian and early Byzantine manuscripts (for example, the Vienna Genesis and Rossano Gospels) is usually considered to indicate patronage by a member of the imperial court. Imperial Carolingian and Ottonian manuscripts continued this tradition.

The Codex Aureus of St. Emmeram opens with the added late tenth-century portrait of Ramwold, abbot of the monastery of St. Emmeram at Regensburg (Pl. 55). He is shown as a full-length standing figure within a geometric framework. Flanking him are the four symbols of the Evangelists and the personifications of four Virtues: Wisdom, Justice, Mercy, and Prudence. In its geometric composition, lavish gold foliate decoration, and variegated border, this miniature imitates the style of the other frontispieces in the manuscript. It was undoubtedly produced during the restoration of the book by the monks Aripo and Adal-

55. Abbot Ramwold frontispiece. Codex Aureus of St. Emmeram, fol. 1r (Munich, Bayerische Staatsbibliothek, Clm 14000)

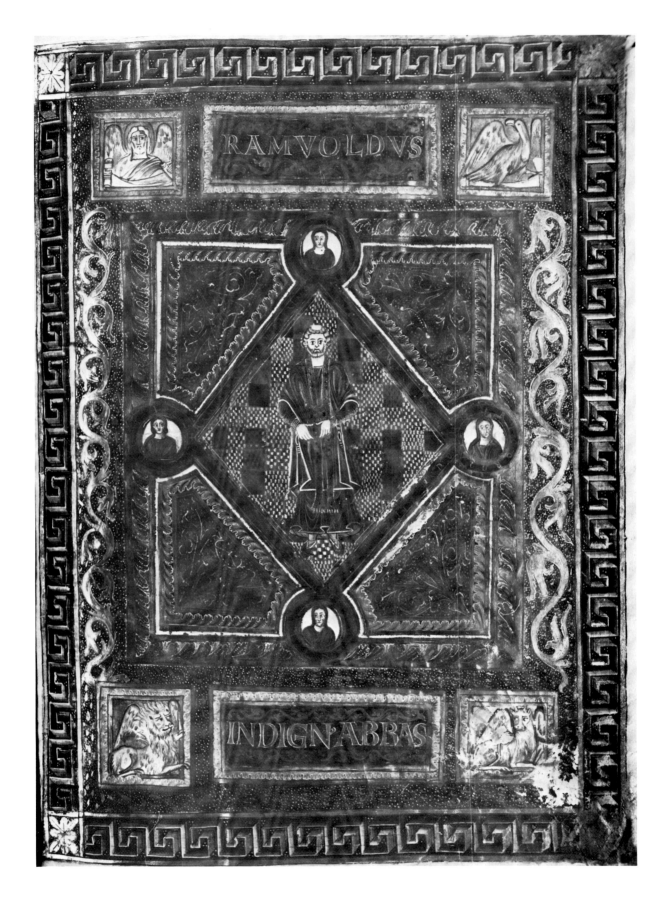

bertus under the order of Ramwold. This portrait was painted on a blank first page, the verso of which contains the title page of the preface of St. Jerome (Pl. 56) facing the letter of Jerome to Pope Damasus ("Novum opus," Pl. 57). Additional preliminary texts, the Jerome prologue beginning "Plures fuisse," without major accentuation, and the Eusebian preface follow (see Appendix 5).

A sequence of three major full-page miniatures interrupt the usual prefatory material. On opposite pages we find a monumental representation of Charles the Bald enthroned facing a heavenly vision of the Adoration of the Paschal Lamb (Pls. 58, 59). The imperial portrait is directly derived from a long tradition of imperial representations, showing the enthroned emperor beneath a golden canopy and flanked by military attendants and personifications of Francia and Gotica, two provinces of the Carolingian Empire, wearing castellated crowns and carrying cornucopias. In comparison with the casual, narrative effect of the presentation page in the Vivian Bible, this miniature manifests a static and solemn quality more closely related to late antique and early Byzantine imperial portraits. The inscriptions in gold letters against a purple ground identify the monarch as Charles the Bald and equate him to his Old Testament forerunners, David and Solomon—a reflection of the same theme recurring in the Vivian Bible. The hand of God within the canopy above and the two angels flanking the golden dome manifest the divine protection and investure of authority, while the soldiers below represent the terrestrial and military protection of the Church and Empire. The emperor turns toward the celestial vision of the Adoration of the Lamb of God on the opposite page.

On this facing frontispiece, a great celestial sphere hovers above representations of the sea on the left and earth on the right: their personifications as a male Mare and a female Tellus are borrowed from classical sources, such as the personification of the Tiber at the bottom of the Column of Trajan and of the Terra Mater on the Ara Pacis. The Four-and-Twenty Elders offer their golden crowns to the Lamb of God above. The Lamb stands on the open scroll of Divine Revelation within a clipeus, or roundel, his blood spurting into a golden chalice. That this sacrificial lamb is the symbol for Christ is emphasized not only by the crossed nimbus but also by the inscription surrounding the medallion which speaks of Christ's sacrifice on the cross and of the sacrificial rite of Holy Communion. The medallion with the Lamb appears in the variegated blue of the heavens, punctuated by the stars and crossed by a purple rainbow. This scene is an amalgamation of two visions in the book of Revelation, the first in chapter 4, in which the twenty-four elders wearing crowns of

56. "Incipit praefatio Sancti Hieronimi" (Title page to St. Jerome's preface). Codex Aureus of St. Emmeram, fol. 1v (Munich, Bayerische Staatsbibliothek, Clm 14000)

57. "Beatissimo papae Damaso Hieronimus. Novum opus" (Title page to St. Jerome's letter to Pope Damascus). Codex Aureus of St. Emmeram, fol. 2r (Munich, Bayerische Staatsbibliothek, Clm 14000)

58. Charles the Bald Enthroned. Codex Aureus of St. Emmeram, fol. 5v (Munich, Bayerische Staatsbibliothek, Clm 14000)

59. Adoration of the Paschal Lamb. Codex Aureus of St. Emmeram, fol. 6r (Munich, Bayerische Staatsbibliothek, Clm 14000)

60. Christ in Majesty with Evangelists and Prophets. Codex Aureus of St. Emmeram, fol. 6v (Munich, Bayerische Staatsbibliothek, Clm 14000)

61. Canon table. Codex Aureus of St. Emmeram, fol. 7r (Munich, Bayerische Staatsbibliothek, Clm 14000)

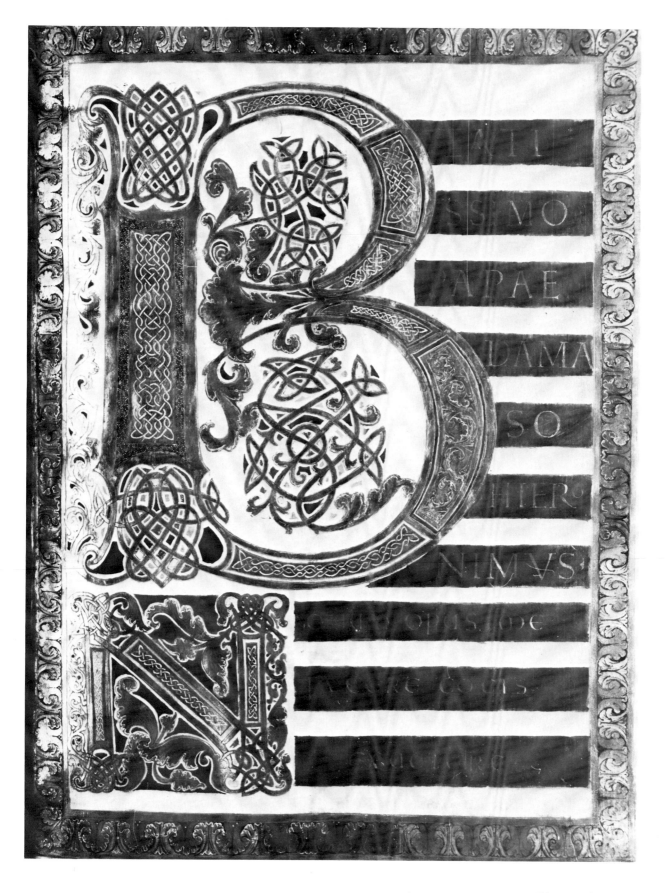

Pl. 57 / 125

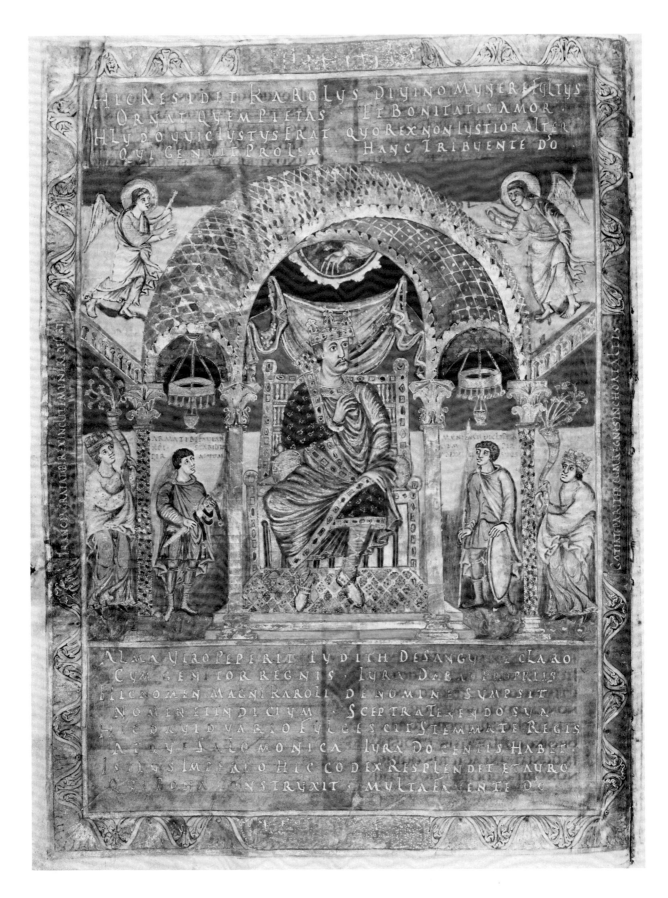

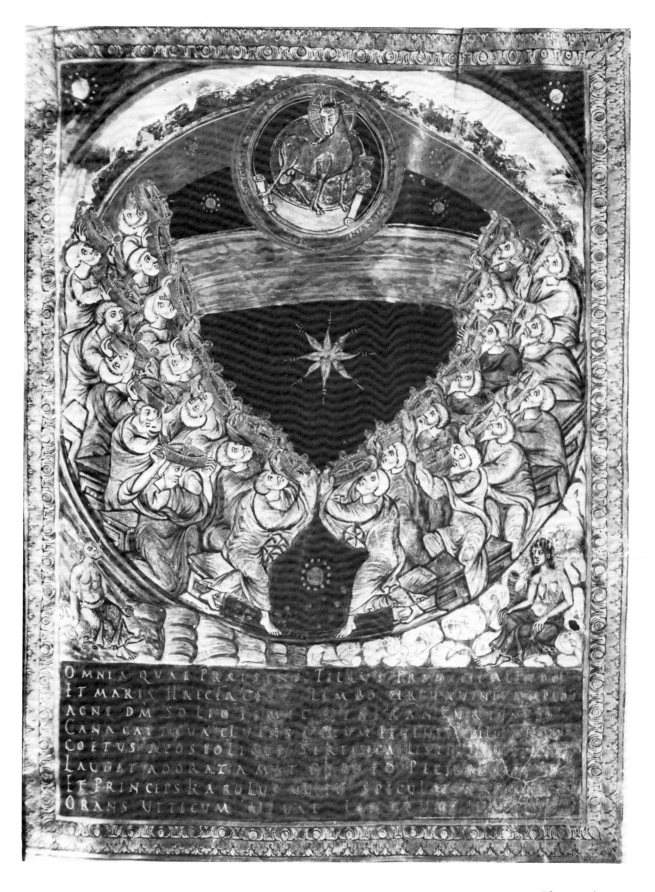

OMNIA QVAE PRAESENS TELLVS PRODVXIT ALVMNO
ET MARIS HAECIA TER LEMBO CIRCVMVENIT AMPLO
AGNE DM SOLIO TIMIDE VENIT TRANSIRE RVINA
CANA CATERVA CLVENS MAGNA ET VENERABILI OBORTV
COETVS APOSTOLICVS SERIA CAELESTRIOR ISTA
LAVDET ADORATA MET DEVOTO PECTORE LV
ET PRINCEPS KAROLVS VVLTV SPECVLATVR
ORANS VTILICVM ALLVAT IAN PRV

Pl. 59 / 127

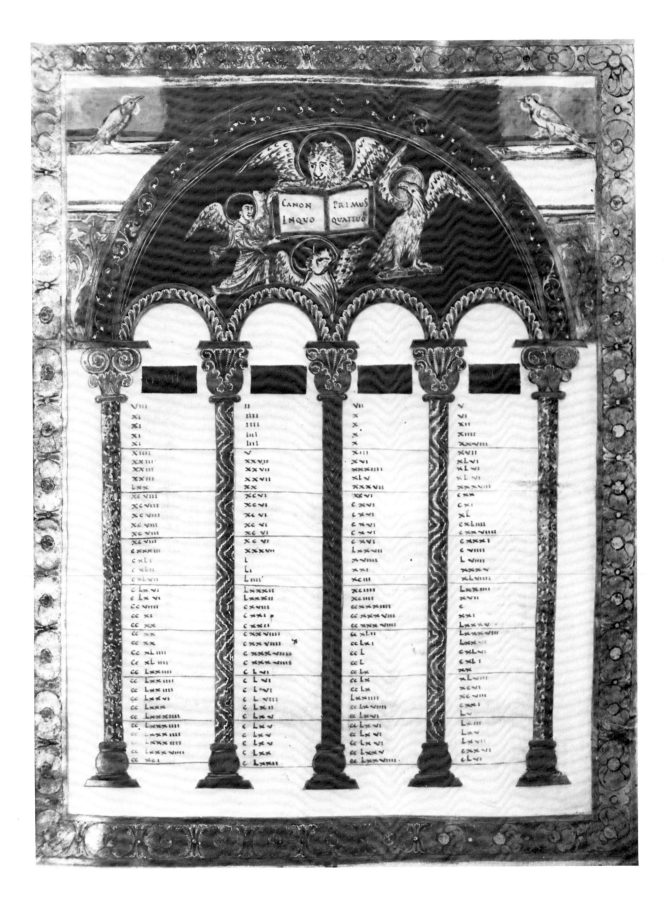

Pl. 61 / 129

gold are grouped around the throne of God appearing on a rainbow and then cast their crowns before the throne, and the second in chapter 5, in which the Lamb opens the book closed with seven seals and is adored by the elders.

It has been suggested that the Adoration of the Lamb may reflect the original mosaic decoration of the dome of the Palatine Chapel at Aachen and that the enthroned imperial effigy in the architectural framework may signify the emperor's place in the gallery of that building.[7] Thus the two-page spread emulated the emperor's actual place in the celebration of the Mass in his palace chapel, and he is also shown as a participant in the Adoration of the Sacrificial Lamb. This hypothesis seems likely, but in addition, the two-page representation is also a fitting prelude to this lavishly decorated Gospel, commissioned by the emperor and containing the revelation of God's Word within.

On the verso of the Adoration of the Lamb folio appears a third full-page miniature representing Christ in Majesty enthroned in an oval mandorla set within a lozenge (Pl. 60). In four circular medallions at the corners of the lozenge appear the four major Old Testament prophets, Jeremiah, Isaiah, Daniel and Ezekiel. In this case all four may be appropriate because they had theophanic visions, and the divine manifestation of Christ appears between them. In the four corners of the miniature are the Evangelists receiving inspiration from the beings that are their symbols. As in the case of the Majestas Domini frontispiece to the Gospels in the Vivian Bible, this miniature also asserts the unity of the Old Testament with the fulfillment of its prophecies in the New Testament. It also implies the harmony of the Gospels, an implication that is made explicit since this page is the frontispiece to the Eusebian canon tables, which begin on the facing page (Pl. 61).

The architectural format of the canon tables is closely derived from that of an earlier Carolingian manuscript of the Ada school, the Gospels of St.-Médard de Soissons (Paris, B.N., MS lat. 8850), with birds and peacocks perched on the curve of the arch and the signs of the Evangelists placed within the enclosed tympanum.[8] The debt of various motifs in the Codex Aureus, as well as in the Gospels of St. Médard de Soissons, to the Mediterranean tradition, not only in the greater accuracy of the architectural elements but also in the use of twisted columns and simulated antique cameos and coins, manifests a continuing interest in emulating the forms of classical antiquity.

The miniatures prefacing the incipits to the Gospels in the Codex Aureus form more complex relationships than those in most Carolingian Gospel books. Normally, full-page Evangelist portraits served as frontispieces for the incipits to the appropriate

62. St. Matthew with Angel. Codex Aureus of St. Emmeram, fol. 16r (Munich, Bayerische Staatsbibliothek, Clm 14000)

63. Lion of Christ. Codex Aureus of St. Emmeram, fol. 16v (Munich, Bayerische Staatsbibliothek, Clm 14000)

64. "Liber generationis." Codex Aureus of St. Emmeram, fol. 17r (Munich, Bayerische Staatsbibliothek, Clm 14000)

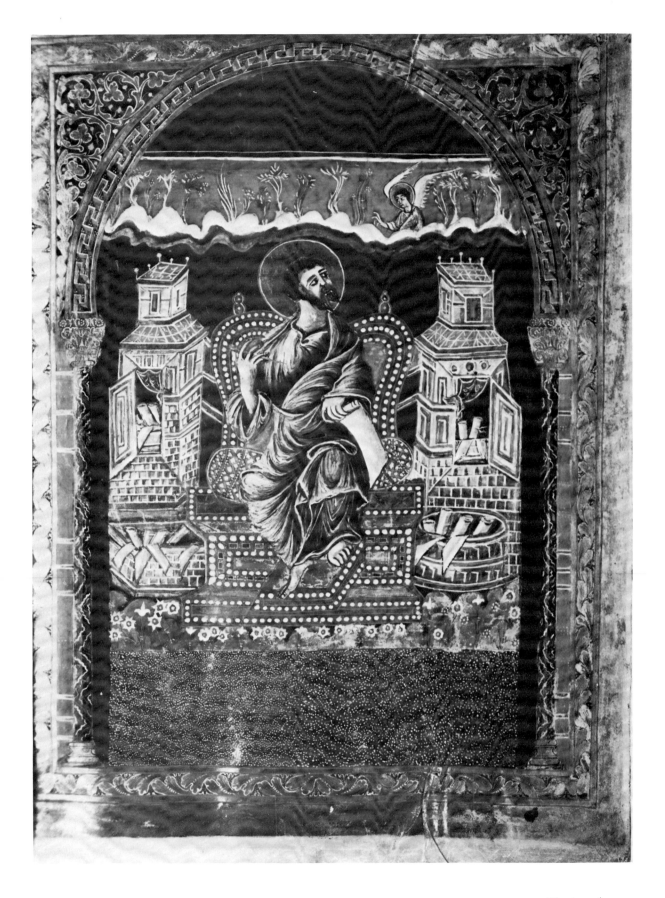

Pl. 62 / 131

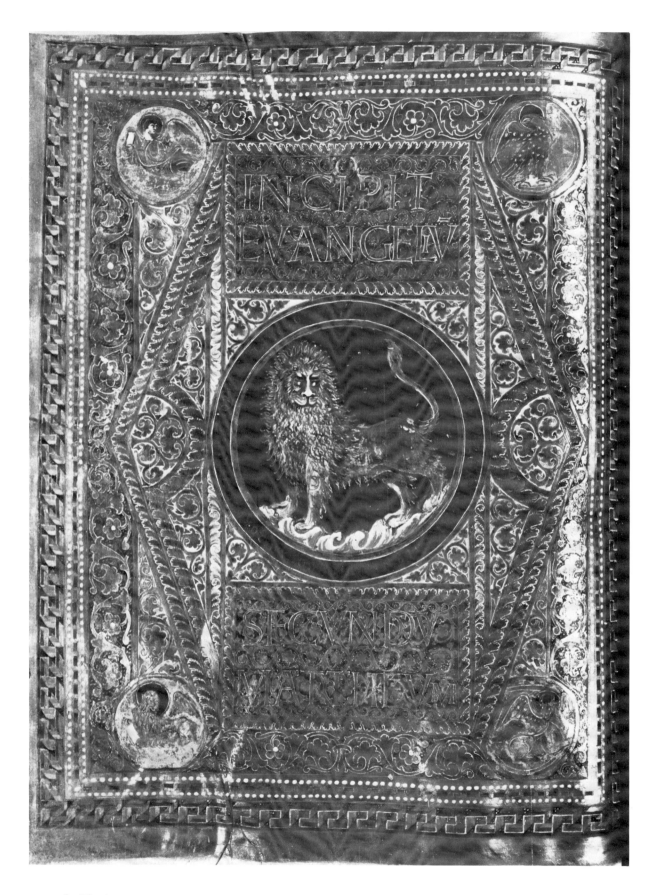

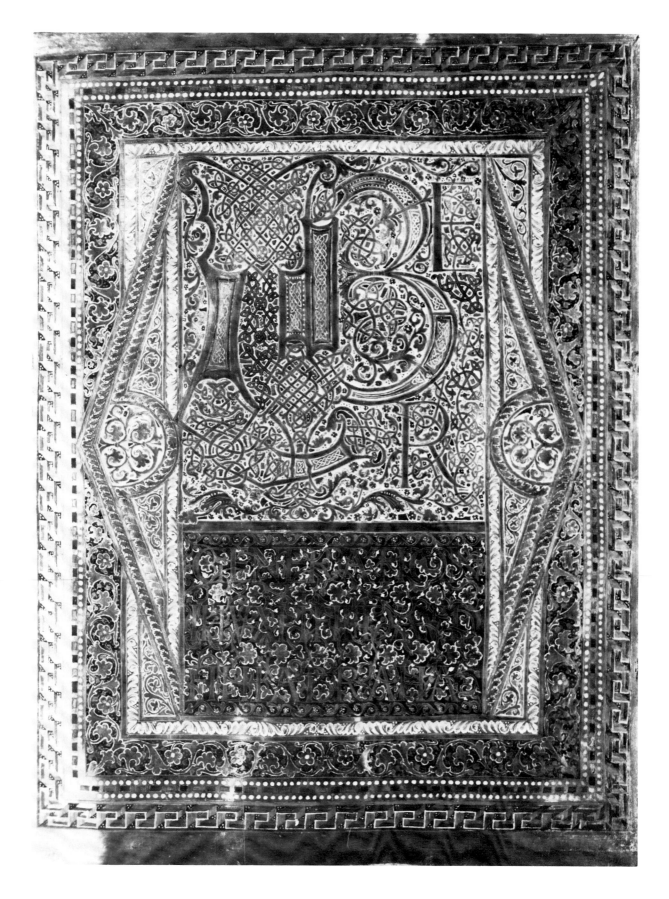

Pl. 64 / 133

Gospels, as in the Ebo Gospels, or to their prefatory material, such as the Argumentum in the Lorsch Gospels.[9] In the Codex Aureus, however, a frontispiece containing verses explaining the significance of the Gospel of St. Matthew faces the page containing the Evangelist portrait with his symbol. St. Matthew (Pl. 62) sits upon a bejeweled throne flanked by towerlike book depositories and looks over his shoulder at the angel who inspires him with the Divine Word. Reflecting a combination of the arcaded setting of the Evangelist portraits of the Ada school, and the landscape setting with billowing ground line of the Ebo Gospels, this miniature contains forms charged with the energetic brushwork found earlier in the school of Reims. The lavish use of gold throughout the miniature and its frame and the rich patterns and colors lend the page an opulence befitting its imperial destination.

On the verso of the Evangelist page a lion appears within a medallion placed within a rhomboid frame (Pl. 63). At the corners of the frame are the four signs of the Evangelists in smaller medallions. Almost lost in the network of gold foliate ornament against a purple ground is the inscription in quadrata capitals, "Incipit evangelium secundum Mattheum." This page serves as the title page to the Gospels, facing the incipit, "Liber generationis Jesu Christi" (Pl. 64), which is equally interwoven into the intricate golden design, set within a similar rhomboid frame on the opposite page. The lion serves as a symbol for Christ and the analogy is stated by the inscription around the clipeus which refers to Christ's victory over death and to his eternal wakefulness. The lion was often equated with Christ because the lion cub was believed to have been stillborn but come to life on the third day, in the same manner that Christ rose from the dead, and because the lion apparently slept with his eyes open, as he who watches over Israel is eternally wakeful. These observations appeared in the medieval bestiary based upon the antique account of natural history, the Physiologus, which was adapted to a series of Christian moralizations. The lion as a symbol of Christ, surrounded by the signs of the Evangelists, prefaces the Gospel of St. Matthew in the same way that the Majestas Domini serves as the frontispiece to the four Gospels in the earlier Vivian Bible.

This tripartite sequence of Evangelist portrait, Christological representation, and incipit is repeated for the remaining three Gospels. The portrait of St. Mark (Pl. 65), executed in the same manner as that of St. Matthew, appears after the preface to that Gospel. On the verso, a standing figure of Christ within a geometric framework and surrounded by the four Evangelist symbols (Pl. 66) serves as the frontispiece facing the "Initum evangelii" of Mark (Pl. 67). St. Luke and his symbol (Pl. 68) occupy

65. St. Mark with Lion. Codex Aureus of St. Emmeram, fol. 46r (Munich, Bayerische Staatsbibliothek, Clm 14000)

66. Christ with Symbols of the Four Evangelists. Codex Aureus of St. Emmeram, fol. 46v (Munich, Bayerische Staatsbibliothek, Clm 14000)

67. "Initium evangelii." Codex Aureus of St. Emmeram, fol. 47r (Munich, Bayerische Staatsbibliothek, Clm 14000)

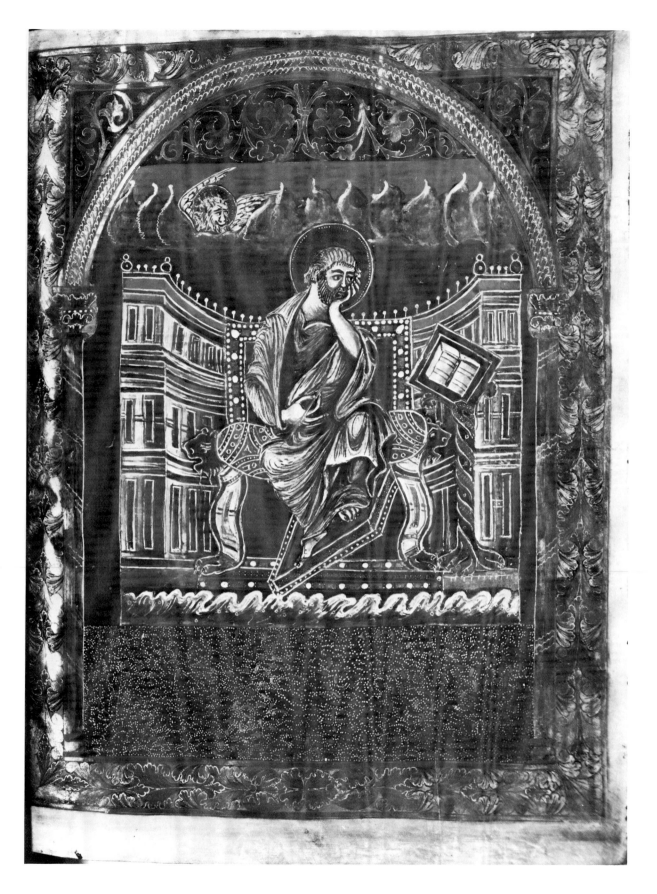

Pl. 65 / 135

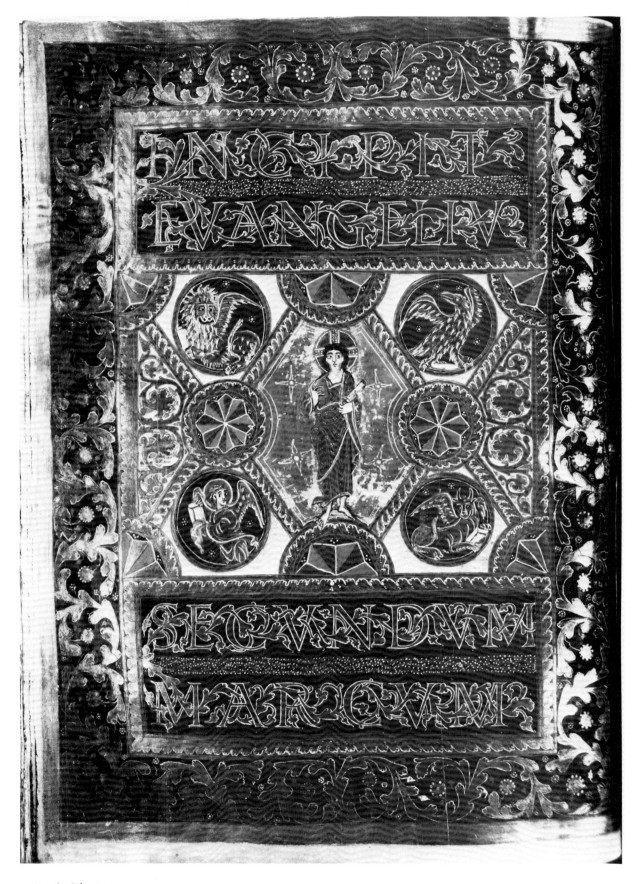

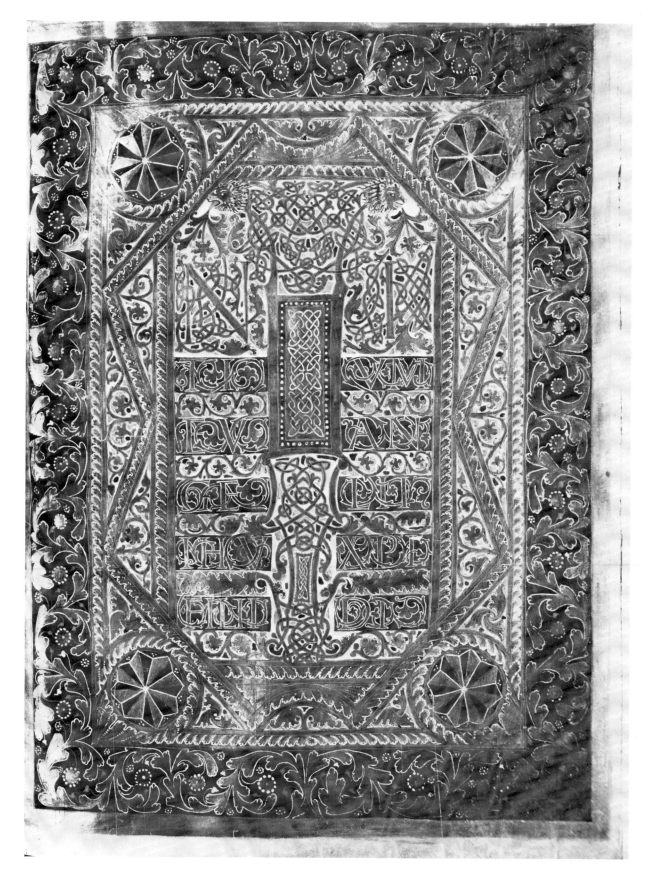

Pl. 67 / 137

a similar full-page miniature after the Prologue to Luke's Gospel, and the image of the Paschal Lamb (Pl. 69) another symbol for Christ, also surrounded by the symbols of the four Evangelists, faces the incipit, "Quoniam quidem multi" (Pl. 70). The portrait of John and his symbol, the eagle (Pl. 71), follows the prologue to John's Gospel, and a full-page miniature with the hand of God (Pl. 72) faces the incipit, "In principio erat verbum" (Pl. 73). Thus the theme of Christ in Majesty, stated as a frontispiece before the canon tables and signifying the unity of the Gospels, is continued by means of varied symbols before each of the individual books.

The incipit pages are barely legible because the profusion of gold ornamentation, the interweaving of the letters, and the complexity of integrated interlace and foliate motifs largely obscure the letters. The intricate and lavish effect, the illumination of the Word of God to the degree that it becomes a mystical experience of shimmering highlights, is the Carolingian equivalent of the decorative incipit pages in the Book of Kells.

In contrast to the decorative obscurity of the opening pages of the Gospels, the body of the text is written in clear letters of gold against the creamy vellum. Each page is laid out in two columns within a painted rectangular frame containing varied decorative motifs, similar to the format of the Vivian Bible (cf. Pl. 47). The result is a series of facing folios of text written with precision and decorated with a sense of restrained elegance.

The book is enclosed in one of the most sumptuous bindings produced during the Middle Ages (Colorpl. 1). Believed to have been made at Reims in about 870, the front cover consists of gold leaf executed in repoussé relief depicting, in the center, Christ in Majesty surrounded by the symbols of the four Evangelists.[10] In the corners are four narrative scenes: Christ and the Woman Taken in Adultery, the Cleansing of the Temple, the Healing of the Leper, and the Healing of the Blind. The tapering forms and lively gestures of the figures closely resemble the figural styles found in the Utrecht Psalter and Ebo Gospels, manuscripts produced at Hautvillers near Reims about 830. The illuminations of the Codex Aureus of St. Emmeram, in fact, are a later variation of this same vivacious, energetic style.

Christ is enthroned in imperial splendor holding a book upon which is written "Ego sum via veritas et vita" (I am the Way, the Truth, and the Life). The proof of this way through his divine powers is shown in the narrative scenes. Accompanying the Woman Taken in Adultery is the phrase "Si quis sine peccato" taken from John 8:7 (He who is without sin). Christ's compassion in this scene is contrasted with his wrath in the Cleansing of the Temple. In the two miracles the way of Truth is made manifest:

68. St. Luke with Ox. Codex Aureus of St. Emmeram, fol. 65r (Munich, Bayerische Staatsbibliothek, Clm 14000)

69. Paschal Lamb. Codex Aureus of St. Emmeram, fol. 65v (Munich, Bayerische Staatsbibliothek, Clm 14000)

70. "Quoniam quidem multi." Codex Aureus of St. Emmeram, fol. 66r (Munich, Bayerische Staatsbibliothek, Clm 14000)

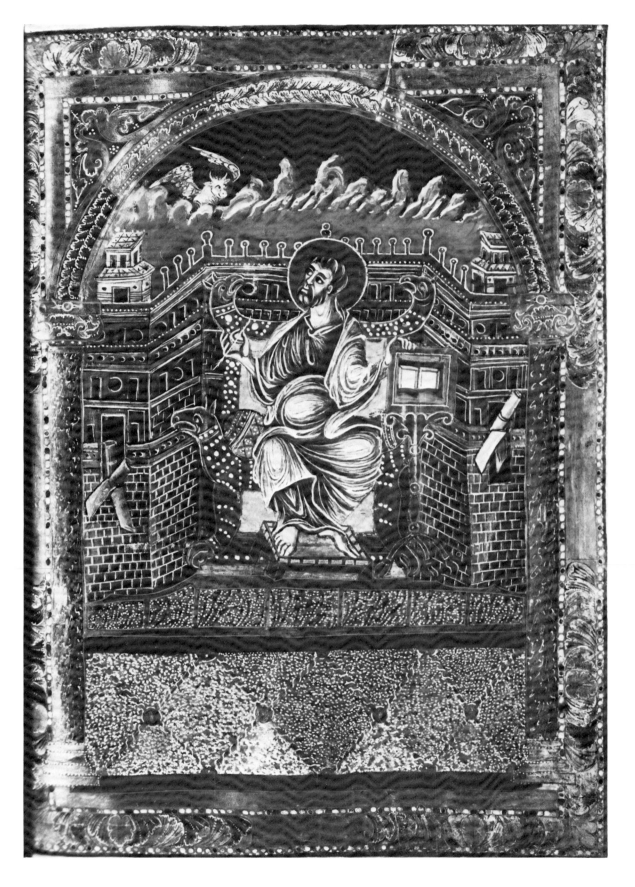

Pl. 68 / 139

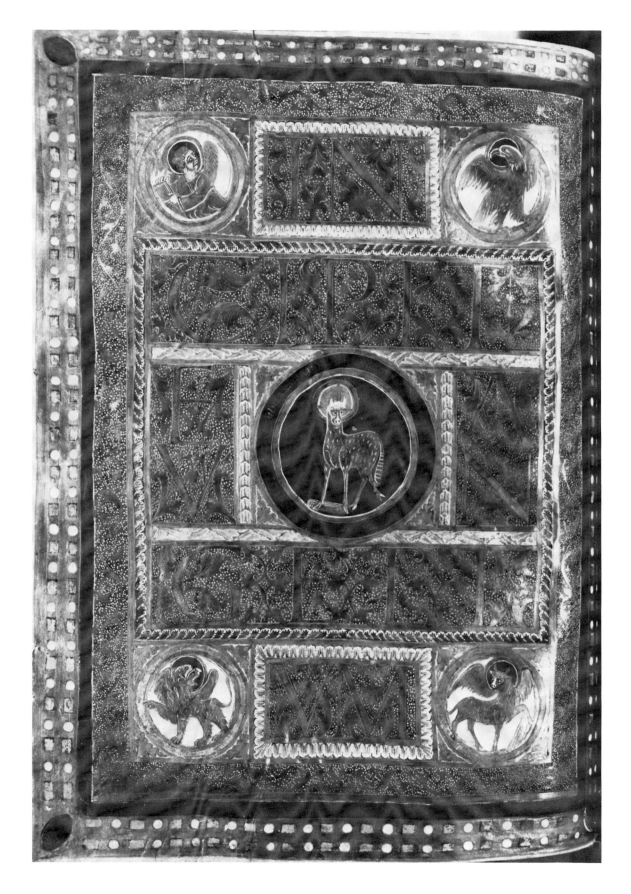

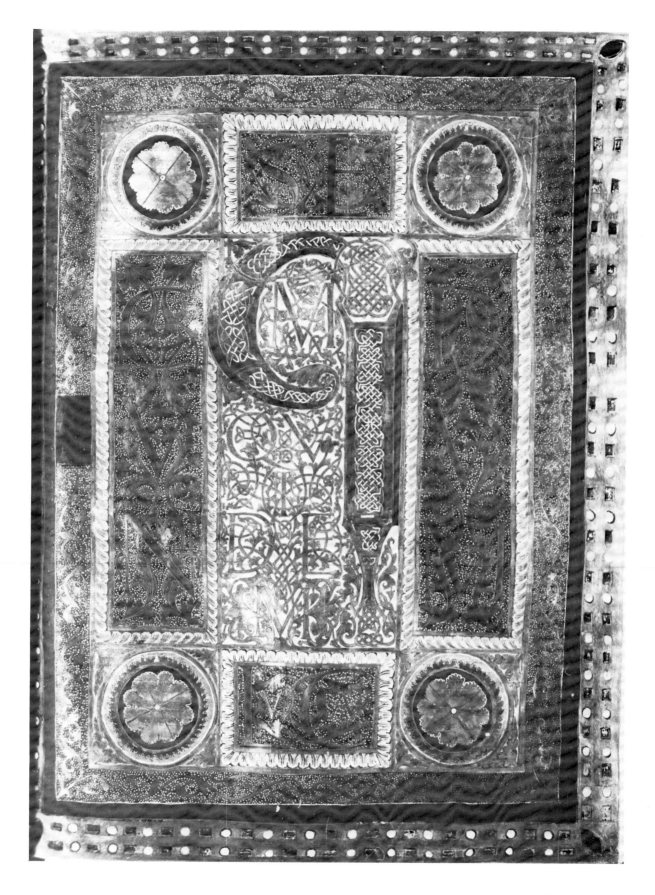

Pl. 70 / 141

health and sight are restored, metaphors for the way of life. The role of these scenes as manifestations of the forgiveness and redemption of sins is particularly appropriate, for three of them are the subjects of lessons that were read during Lent, the period of atonement. Christ's sacrifice for mankind is implied by the cruciform composition of the cover, formed by the bejeweled rectangle surrounding Christ and the vertical and horizontal arms set with precious stones that divide the scenes.

This elaborate cover, of a type called a "treasure binding," had its origins in the period of late antiquity. By Carolingian times it had become an essential element, along with the interior decoration, of sumptuously clothing the Word of God in the most worthy of substances. The development of this custom can be seen in the fine tooled leather bindings of Coptic Egypt, Cassiodorus's description of a pattern book for cover designs in the sixth century, and the use of carpet pages and elaborate book shrines for Insular manuscripts of the seventh and eighth centuries. In the eastern Mediterranean, a similar attitude prevailed. The central role played by the lectionary in the Byzantine liturgy, in which the Word of Christ, in the form of the Gospel lessons, was elevated before the congregation, led to its being bound in elaborate covers. The Gospels enclosed in such bindings, like reliquary shrines, were regarded as one of the essential liturgical furnishings: the Codex Aureus of St. Emmeram, a chalice, a paten, and a ciborium or metalwork tabernacle for housing the consecrated bread and the wine of Communion are depicted upon the high altar of St. Emmeram in Regensburg in a didactic Ottonian miniature of the eleventh century.[11] As reliquaries frequently took the form of a church, so the Codex Aureus cover also contains architectural motifs. Many of the precious stones are set on mounts of gold fashioned like arcades and chalices. The precious substances had symbolic connotations, pearls of purity, rubies of the blood of the martyrs, and the gold itself of the light of God. The chalice mounts thus refer to Christ's sacrifice and to the sacrament of Communion through which this sacrifice is reenacted. The architectural setting may therefore symbolize the Heavenly City of Jerusalem in which Christ, in the center, is so majestically enthroned.

71. St. John with Eagle. Codex Aureus of St. Emmeram, fol. 97r (Munich, Bayerische Staatsbibliothek, Clm 14000)

72. Hand of God. Codex Aureus of St. Emmeram, fol. 97v (Munich, Bayerische Staatsbibliothek, Clm 14000)

73. "In principio erat verbum." Codex Aureus of St. Emmeram, fol. 98r (Munich, Bayerische Staatsbibliothek, Clm 14000)

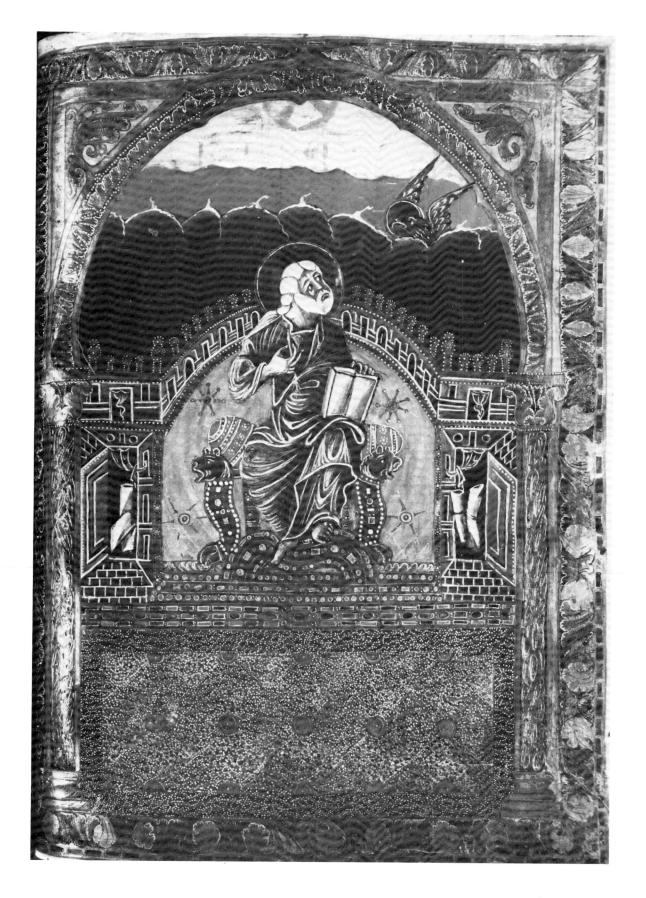

Pl. 71 / 143

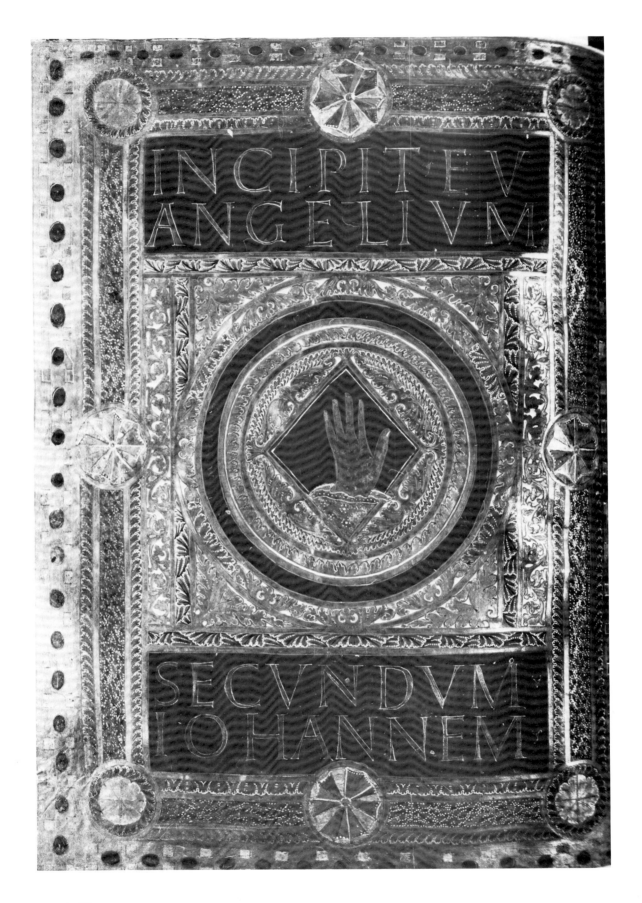

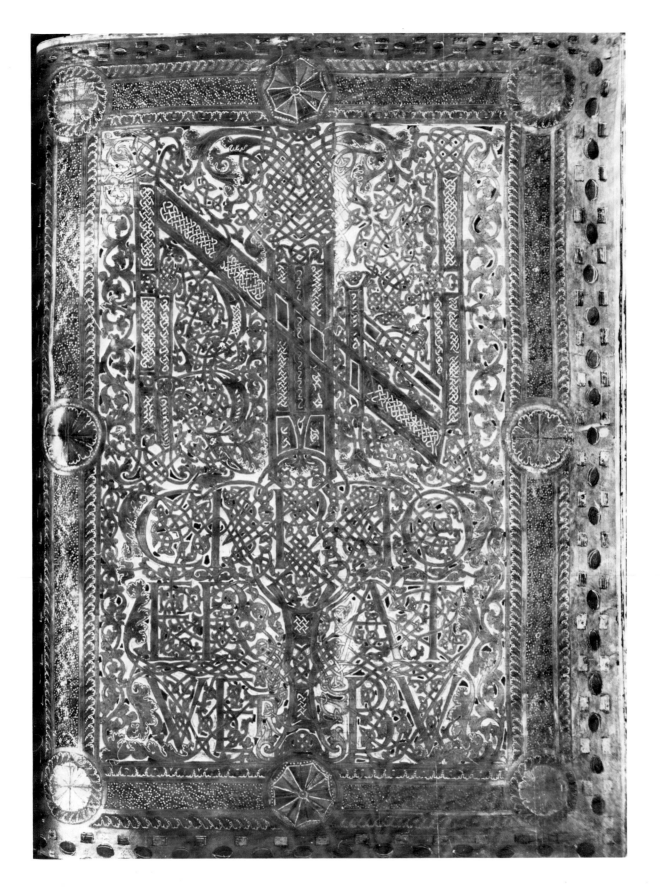

Pl. 73 / 145

4 / The Ottonian Evangelistary

hiatus in political continuity and artistic production for courtly patronage followed the disintegration of the Carolingian Empire toward the end of the ninth century. During the first half of the tenth century, however, a reconsolidation of the German lands was accomplished under a dynasty of German kings of the House of Saxony. Under Otto I, crowned king of the Germans in 936 and Roman emperor in 962, and particularly under his successors, Otto II (973–983) and Otto III (983–1002), a brilliant imperial court was formed which sought to rival the splendor of Byzantium at Constantinople and to continue the traditions of the Carolingian Empire. This resurgence of political and military power under the three Ottos is now known as the Ottonian Empire.

As a result of the renewed need for visual manifestations of imperial power and splendor, many of the superb examples of Carolingian manuscript illumination, as well as other forms of the arts, served as models to be emulated and further developed by Ottonian artisans. Thus the Lorsch Gospels, now divided between Alba Julia in Romania and the Vatican Library, served as a direct model for some of the miniatures in a Gospel book known as the Gero Codex, now in Darmstadt, produced at the end of the tenth century.[1]

The illustrations of imperial Gospel books for the Ottonian court were soon expanded beyond the comparatively restrictive Carolingian format. A lavishly decorated Gospel book made for Otto III, (Munich, Bayerische Staatsbibliothek, Clm 4453) contains not only a double-page imperial portrait, extraordinary portraits of the Evangelists inspired by the books of the Old Testament, and elaborate incipit initials, but also a lengthy cycle of twenty-nine full-page narrative miniatures of the Life of Christ.[2] Seven spaces for these miniatures were left in the text of each of

the Gospels (eight for Luke) so that the narrative scenes—from one to four incidents—would appear in proximity with the written account. Considered as a total group, the miniatures generally follow a chronological order: the Nativity cycle, commencing with the Annunciation, to the Baptism and four scenes of Christ's ministry, finishing with the Giving of the Keys of Heaven to Peter, appear in Matthew; scenes of Christ's miracles and ministry appear in Mark and Luke; and the Raising of Lazarus and the Passion of Christ, finishing with the post-Resurrection scenes of the Noli Me Tangere, Christ before the Apostles, and the Doubting Thomas illustrate the Gospel of St. John. This innovative cycle of narrative scenes, a major accomplishment of a school of illuminators thought to have been active at Reichenau, was adapted to a different format in a later Ottonian Gospel book.

The Codex Aureus of Echternach (Nuremberg, Germanisches Nationalmuseum), thought to have been illuminated for Emperor Henry III between 1053 and 1056, fused the format of miniatures and narrative traditions of Carolingian Bibles such as the Vivian Bible with the expanded narrative of the Gospels of Otto III.[3] This book begins with a Majestas Domini page with Old Testament prophets and writing Evangelists patterned after the similar composition in the Vivian Bible. It faces an elaborate title page with an inscription held by two angels and flanked by medallions with personifications of the four cardinal virtues. After the normal prefatory material, the letter of Jerome, prologue, Eusebian canon tables, and Argumenta to the Gospels, we encounter a double-page decoration painted to simulate precious Byzantine or Sassanian silk textiles (Pl. 74). These remarkable textile or "curtain" pages serve as introductory shrouds or "covers" to each of the Gospels and therefore represent an Ottonian equivalent of the role and effect of the carpet pages of the Insular Gospel Books. They also recall the pair of curtains pulled aside to reveal the seated Evangelists within their architectural settings in each of their portraits. When these pages are turned, the Word of God is similarly unveiled. They are followed by four pages of full-page miniatures, organized in three horizontal bands similar to the format of some of the Vivian Bible frontispieces, depicting narrative scenes of the Life of Christ (Pl. 75). These scenes follow the general arrangement found in the Gospels of Otto III: they begin with incidents of the Nativity prefacing Matthew; cures, miracles, and parables prefacing Mark and Luke; and the Passion and Ascension before John. Immediately after these miniature pages the Evangelist portraits face title pages executed in a format similar to that which faces the Majestas Domini. Full-page framed incipit pages follow, facing the actual opening words

74. Imitation Byzantine textile pages introducing Gospel of St. Luke. Codex Aureus of Echternach, fols. 75v–76r (Nuremberg, Germanisches Nationalmuseum, MS 156142)

of the Gospels within a similar frame. The strict sequence of prefatory material is maintained throughout, expanding the number of decorative and narrative pages to ten before each Gospel. The debt to the Carolingian Bibles is manifested not only in the Majestas Domini page and the triple bands of the narrative pages, but also in the placement of opening titles and rubrics within horizontal bands of color and in the use of tituli between the horizontal scenes.

In contrast to this presentation of the four Gospels as four separate texts unified by the narration of miniatures and repetitive sequence of the decorative pages, another arrangement of the Gospels was formulated for greater ease in reading the lessons during the Mass. This version, called an evangelistary, arranged the lessons, or pericopes, from the Gospels according to the order in which they were read during the celebration of the Mass

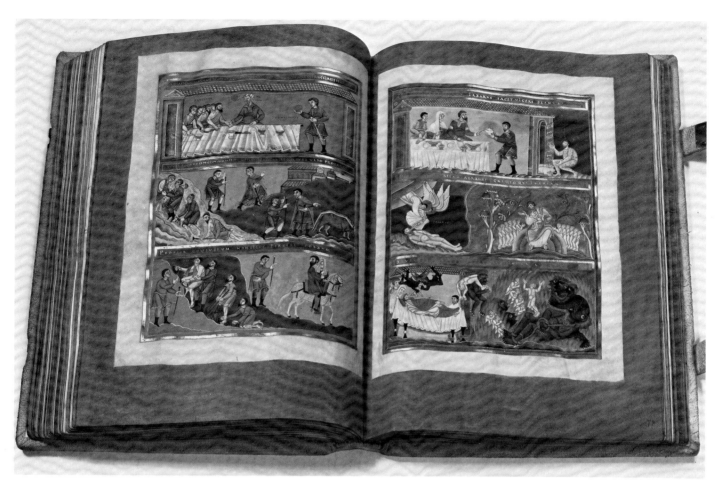

75. Narrative scenes: Parables of the Banquet and of Lazarus and Dives introducing Gospel of St. Luke. Codex Aureus of Echternach, fols. 77v–78r (Nuremberg, Germanisches Nationalmuseum, MS 156142)

during the liturgical year. Thus relevant passages from the four accounts followed each other in an order according to the sequence of various kinds of feast days, which were grouped in three sections. The first part contained the movable feasts (the Proper of Time, *Proprium de Tempore*, or *Temporale*) commencing with Advent, the Christmas season, proceeding through Lent to Easter, the Easter season to Pentecost, and then from Pentecost to Advent. Lessons from the Gospels to be read during the masses said on the fixed feast days of major saints (the Proper of the Saints, *Proprium Sanctorum*, or *Sanctorale*) might constitute a second annual cycle in the evangelistary, or they might be interspersed with the Temporale. Lessons to be read on feast days of lesser or unspecified saints were included in the Common of the Saints (*Commune Sanctorum* or *Communale*). With this arrangement, the canon tables and the lists of capitula of normal Gospel

books were inapplicable and were omitted. Properly speaking, evangelistaries are Mass books and should therefore be considered with missals and graduals. Nevertheless, because of their transitional nature between the Gospel book and the service book, considering them as a separate entity will clarify their particular order and structure, and provide the basis for understanding the arrangement of other liturgical books. With the increasing prevalence of the evangelistary or Gospel lectionary as the principle source for reading the lessons during the Mass, the production of the Gospels as a separate entity began to decline after the twelfth century.

The Pericopes of Henry II

A remarkable illuminated evangelistary, known as the Pericopes of Henry II, was commissioned by the Ottonian emperor for presentation to Bamberg Cathedral either in 1007 in commemoration of the founding of the bishopric, or in 1012 upon the consecration of the cathedral.[4] It contains twenty-eight full-page miniatures and ten full-page incipit initials. Stylistically, it is closely related to the Gospels of Otto III mentioned above, and it probably comes from the same center of manuscript illumination, perhaps at Reichenau.[5]

The manuscript commences with a dedicatory inscription facing a full-page representation of the Christ Enthroned crowning Henry II and his empress, Kunigunde (Pl. 76). The imperial figures are flanked by Peter and Paul, patron saints of Bamberg Cathedral. Below stand three female figures: one bearing a wreath and another a nimbed orb flank a woman wearing a castellated crown. This figure is thought to be a personification of the Burg Babenburg, the site of Henry II's castle and of the newly built cathedral, and by extension, a personification of the house of Henry II's lineage. This view is strengthened by the busts of six crowned female figures in the background, perhaps personifications of the provinces of the empire, who bear cornucopias or vessels and pay homage. This miniature is a condensed and hieratic version of the two-page imperial miniature in the Gospels of Otto III and of the earlier Carolingian page in the Codex Aureus of St. Emmeram. The juxtaposition of dedicatory poem and imperial image recalls the arrangement in the First Bible of Charles the Bald, and repeats, now in an Ottonian idiom, the motif of an introductory imperial diptych.

Four Evangelist portraits with the appropriate symbols follow. They are grouped in pairs, Matthew facing Mark (Pls. 77, 78)

76. Christ Enthroned Crowning Emperor Henry II and Kunigunde. Pericopes of Henry II, fol. 2r (Munich, Bayerische Staatsbibliothek, Clm 4452)

77. St. Matthew portrait. Pericopes of Henry II, fol. 3v (Munich, Bayerische Staatsbibliothek, Clm 4452)

78. St. Mark portrait. Pericopes of Henry II, fol. 4r (Munich, Bayerische Staatsbibliothek, Clm 4452)

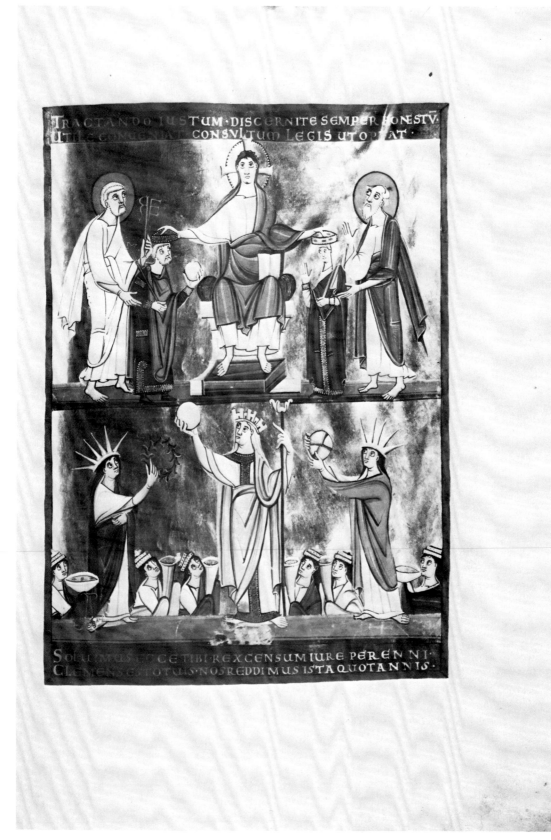

Pl. 76 / 151

Pl. 78 / 153

and Luke facing John, with blank folios in between. These "Evangelist diptychs" follow a format used frequently throughout the manuscript, in which double folios containing facing miniatures, devoid of text on the other side, have been inserted before many of the lessons for major feast days.[6] Because the following text of the Gospels is mixed and integrated acccording to the readings during the liturgical year (see Appendix 6), this group of double frontispieces serves as author portraits and reminders to the beholder of the harmony of the lessons that follow.

Ten of the major feast days are introduced by monumental foliate initials for the incipit of the pericope, and the rubric, initial, and first words of the text are set off against a colored ground surrounded by a full-page decorative frame. Some of these title-page incipits, such as the one for the first pericope for the vigil of Christmas (Christmas Eve, Pl. 79), appear without any prefatory miniatures. Here the rubric, heavily abbreviated—"Seq sci ev sec Matheu in il temp" for "Sequentia sancti evangelii secundum Matheum, in illo tempore" (Continuation of the Holy Gospel according to Matthew. At that time)—indicates that the reading is from the Gospel of St. Matthew. The text begins, "Cum esset desponsata mater eius Maria Ioseph" (When his mother Mary was espoused to Joseph; Matt. 1:18–21).

Nine of the pericopes for principal masses are prefaced by two facing miniatures depicting an incident related in the appropriate pericope: Christmas, Epiphany, Palm Sunday, Good Friday, Easter, Pentecost (Whitsunday), the Birth of St. John the Baptist, the Assumption of the Virgin, and the Mass of the Dead. In these cases a large initial and a framed incipit appear on the following recto. In some of these sequences the two miniatures represent different episodes within the lesson, as in the miniatures before the Christmas pericope where the Annunciation to the Shepherds faces a scene of the Nativity (Pls. 80, 81). The lesson for the Christmas Mass taken from the opening of the Gospel of St. John begins "In principio erat verbum" on the following recto.

In a few cases a single incident occupies both facing scenes, as in the Three Marys at the Tomb, where the three women are grouped together beneath an architectural frame on the left page facing a monumental angel seated on the open sarcophagus within a similar frame opposite (Colorpls. 8, 9). The beginning of the pericope for the Easter Mass, "Maria Magdalena et Maria Jacobi" (Mark 16:1), appears on the recto of the following folio.

For six of the other feast days, such as Pentecost or that of St. Peter, a single miniature faces the incipit page (Colorpls. 10, 11). For the latter, St. Peter is shown receiving the keys of the Kingdom of Heaven from Christ, an incident described in the peric-

79. "Cum esset desponsata" (Lesson for Christmas Eve). Pericopes of Henry II, fol. 7r (Munich, Bayerische Staatsbibliothek, Clm 4452)

80. Annunciation to the Shepherds. Pericopes of Henry II, fol. 8v (Munich, Bayerische Staatsbibliothek, Clm 4452)

81. Nativity. Pericopes of Henry II, fol. 9r (Munich, Bayerische Staatsbibliothek, Clm 4452)

82. Raising of the Dead. Pericopes of Henry II, fol. 201v (Munich, Bayerische Staatsbibliothek, Clm 4452)

83. Last Judgment. Pericopes of Henry II, fol. 202r (Munich, Bayerische Staatsbibliothek, Clm 4452)

Pl. 79 / 155

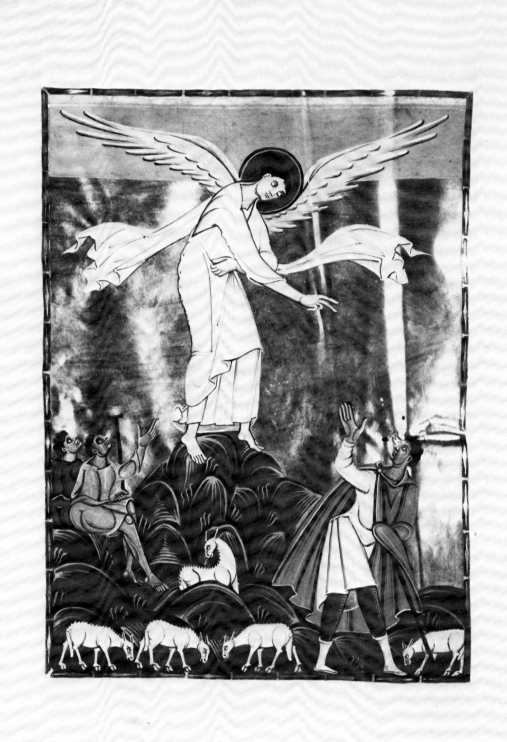

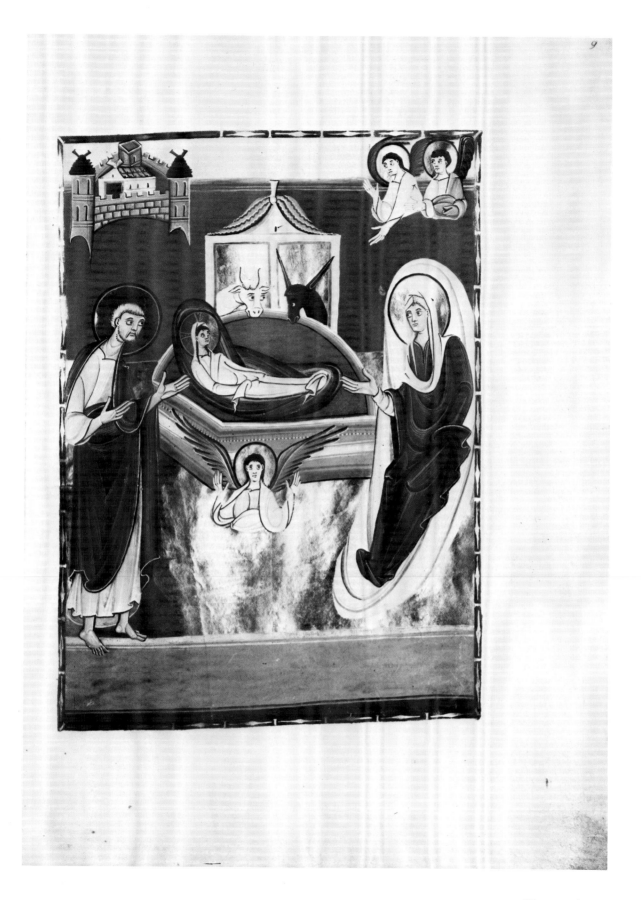

Pl. 81 / 157

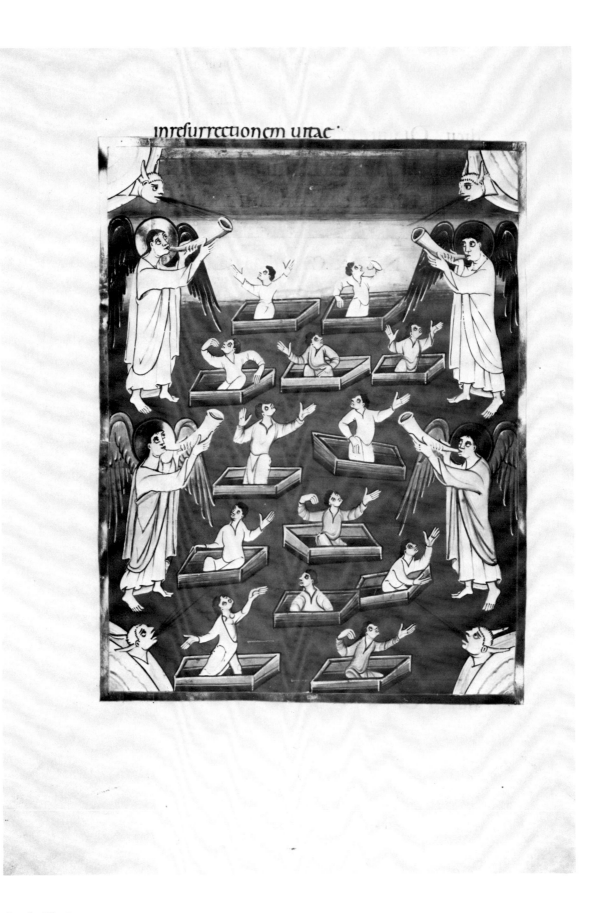

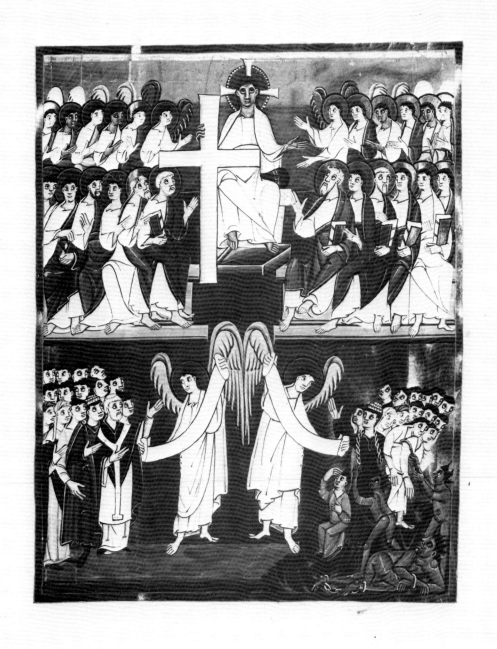

Pl. 83 / 159

ope beginning "Venit Jesus in partes" (And Jesus came into the district; Matt. 16:13–19) on the facing folio.

These lessons for the feast days terminate with the pericope for the first Sunday in Advent. The readings for the liturgical year in this first section of the manuscript thus comprise a combination of lessons for the Temporale or movable feasts with some of the Sanctorale or fixed feasts such as those of S. Vitale, John the Baptist, and St. Peter. Readings appropriate for the masses in celebration of saints' days for which no specific readings were designated (the Common of the Saints) follow in a section beginning on folio 188r with the vigil of *Omnium Apostolorum* (All Apostles). In the Pericopes of Henry II, none of these lessons is articulated with major decorative accents, although small initials introduce the subdivisions. Other pericopes for specialized masses follow, such as for the Dedication of a Church and for the Mass of the Dead. Prefacing the pericopes for the Mass of the Dead is a double-page representation of the Last Judgment with the Raising of the Dead on the left and the Separation of the Good and the Evil among the Resurrected on the right (Pls. 82, 83). As a final major decorative accent, the theme of the Last Judgment is a fitting conclusion to readings that begin with the heavenly announcement of Christ's Incarnation and Nativity and end with the Mass of the Dead by which Christians attain the salvation made possible by Christ's sacrifice.

The style of these miniatures reflects a simplification and hardening of form when compared with the Carolingian miniatures. Landscape, horizon line, and sky have congealed into horizontal colored bands. The small, lively figures in Carolingian painting have become more monumental in scale, and now gesture with strong, slow movements. The volumes of figures and the space of settings have been reduced to luminously colored patterns. Narration has given way to a distillation of the essence of the meaning of the scenes: they possess the gravity and impact of Byzantine icons.

5 / The Mass Book

In addition to the production of Bibles for use in the celebration of the Mass, whether as large pandects, or divided into constituent parts, or arranged according to the order of lessons, numerous other manuscripts were developed during the Middle Ages to contain the various Christian rituals. The most important of these were books consisting of prayers, invocations, readings, and instructions for the ritual of the Mass in which the sacrament of Communion was celebrated.

The basic service of the Mass is contained in the *Ordo Missae* or Ordinary of the Mass. It consists of the Mass of the Catechumens, the Offertory, Prefaces for common masses and for special high feast days, the Canon of the Mass, in which the bread and wine of the Eucharist are consecrated, and the order of Holy Communion itself in which the bread and wine are offered to the celebrants. To this were then added groups of devotions for the feasts of the liturgical year. In the Proper of Time are feasts that occur on Sundays and are based upon the events of the Life of Christ and therefore correspond to the major feasts we have already considered with reference to the evangelistary. The lessons to be read with these masses are the same as those listed for the Pericopes of Henry II. In modern usage, the temporal cycle begins with the first Sunday in Advent (the Sunday closest to November 30), and after such fixed feast days as Christmas and Epiphany, the dates depend on the fixing of the movable date for Easter, which falls on the Sunday after the first full moon after the vernal equinox. A second section contains the prayers, lessons, and recitations for the Proper of the Saints, the feasts of special saints which are fixed on predetermined dates. A third section, the Common of the Saints, consists of prayers, lessons, and recitations for saints for whom there are no special commemorative rites. In addition, special votive masses, the Mass of

the Dead, and a variety of blessings, hymns, and special prayers might be included.

The earliest form of this liturgical book was the Sacramentary. It contained the prayers, Collect (a short introductory prayer), Secret (a prayer said in a low voice), Postcommunion, and Canon recited by the officiating celebrant (pope, bishop, or priest) in the performance of Mass. With the growing complexity of the liturgy and the increasing preponderance of low or private masses, the missal developed. Some of the early liturgical books for the Mass also contained the chants; later the chants were placed in a separate volume, usually of large format in order to be visible to the entire choir, known as a gradual. As the chief readings for masses during the liturgical year were drawn from the Gospels, they might be placed in a separate volume (evangelistary), similar to the Pericopes of Henry II, which were read by the deacon. Other readings from the Epistles, read by the sub-deacon, were also excerpted in their liturgical order, into a book called an epistolary.

The Drogo and Metz Sacramentaries

A Sacramentary now in Paris (B.N., MS lat. 9428) made for Archbishop Drogo of Metz (844–855), the illegitimate son of Charlemagne, exemplifies an early form of the Mass book, although the format and the contents were not yet standardized.[1] Richly decorated with foliate versal letters, initials made of gold bars entwined with gold acanthus leaves like a trellis, the Drogo Sacramentary is a lavish example of an unusual school of illumination which flourished in Metz in the middle of the ninth century. Many of the initials contain figures or scenes. Although such "historiated" initials had been used in earlier Carolingian manuscripts, such as the Gospels of St. Médard de Soissons, in the Drogo Sacramentary they became the principal vehicle for accentuating the major divisions of the text and the most important feast days of the liturgical year within these divisions.

The Drogo Sacramentary consists of four sections of text, the Canon of the Mass, the principal feasts of the Temporale and Sanctorale combined, the Common of the Saints, and miscellaneous masses, benedictions, and texts (see Appendix 7). It begins unobtrusively with a series of benedictions and episcopal prayers for specific occasions. Although introduced by rubrics written in gold rustic capitals, only small-scale foliate initials precede the text written in black ink in Carolingian minuscule.

The first major accent is an architectural frame enclosing the

84. Front cover. Drogo Sacramentary (Paris, Bibliothèque Nationale, MS lat. 9428: Photo Bibl. Nat., Paris)

Pl. 84 / 163

85. "Per omnia saecula
saeculorum." Drogo Sacramentary,
fol. 14r (Paris, Bibliothèque
Nationale, MS lat. 9428: Photo Bibl.
Nat., Paris)
86. "Vere dignum." Drogo Sacra-
mentary, fol. 14v (Paris,
Bibliothèque Nationale, MS lat.
9428: Photo Bibl. Nat., Paris)
87. "Sanctus." Drogo Sacramen-
tary, fol. 15r (Paris, Bibliothèque
Nationale, MS lat. 9428: Photo Bibl.
Nat., Paris)
88. "Te igitur." Drogo Sacramen-
tary, fol. 15v (Paris, Bibliothèque
Nationale, MS lat. 9428: Photo Bibl.
Nat., Paris)
89. "Clementissime." Drogo Sacra-
mentary, fol. 16r (Paris,
Bibliothèque Nationale, MS lat.
9428: Photo Bibl. Nat., Paris)
90. "Pater per Iehsum." Drogo Sac-
ramentary, fol. 16v (Paris,
Bibliothèque Nationale, MS lat.
9428: Photo Bibl. Nat., Paris)

rubric and subsequent preface for the episcopal benediction writ-
ten in gold: "Consecratio: Per omnia saecula saeculorum"
(Throughout all ages, world without end"). As though building
toward a crescendo, the remainder of the preface, "Vere dignum
et justum est aequum et salutare" (It is very meet, just, right, and
availing unto salvation), is introduced by a large foliate *V* with
the heads of the four Evangelist symbols. The Common Preface
is repeated in larger scale four folios later, immediately before the
Canon of the Mass, in which the consecration of the bread and
wine take place. A monumental full-page architectural frame in
the form of a pedimented classical temple front encloses the "Per
omni saecula saeculorum," and a full-page *V* announces the "Vere
dignum" (Pls. 85, 86). Small medallions enclosed in the gold fo-
liage contain the half-figure of a high priest making an offering
and the Paschal Lamb. Both are references to Old Testament sac-
rifices prefiguring the sacrifice of Christ, and they embody the
essence of the Mass as a sacrificial rite. On the facing page
(Pl. 87), within a full-page gold frame, a six-winged seraph is
surrounded by the text of the Sanctus, "Sanctus, sanctus, sanc-
tus, Dominus Deus Sabbaoth" (Holy, Holy, Holy, Lord God of
Hosts). The Canon of the Mass proper begins on the verso of
this folio (Pl. 88) with a monumental foliate *T*, "Te igitur" (You,
therefore [addressing God]). Within the crosslike *T* are represen-
tations of the Old Testament prefigurations of Christ's sacrifice
on the cross: Abel with a lamb, Melchizidek at the high altar
with Eucharistic vessels, and Abraham holding a ram and point-
ing to two oxen at the foot of the *T*. All three figures look at the
hand of God appearing above the initial.

The opening words of the Canon continue on the following
pages. Facing the "Te igitur," "clementissime" is written in elab-
orate foliate letters, but on a smaller scale (Pl. 89). On the verso,
the text continues, "pater per Iehsum Christum filium tuum domi-
num nostrum" (Pl. 90), but the decorative emphasis diminishes
as this phrase is written in gold quadrata capitals and subsequent
phrases on the next folio are written in smaller gold uncials. The
opening words of the Canon thus read: "Therefore, most mer-
ciful Father, through Jesus Christ thy Son our Lord. . . ." The
remainder of Canon is written in gold rusic capitals with a large
decorative initial introducing the Lord's Prayer, "Pater noster."
Decoration and script therefore work together in building to-
ward an elaborate crescendo at the beginning of the Canon, and
the diminishing hierarchy of scale after the "Te igitur" symmetri-
cally balances the ornamental weight of the text as it continues
through the consecration, the most sacred part of the Mass.

The cycle of masses for the principal feasts of the liturgical
year, interspersed with some of the feasts of the major saints,

PER OMNIA SCLA SCLORU
R AMEN ·
DNS UOBIS CUM ·
R ET CUM SPU TUO ·
SURSUM COR DA ·
RHABEMUS AD DNM
GRATIAS AGAMUS DNO DO NRO
R DIGNU ET IUSTUM EST ·

Pl. 85 / 165

ERE DIGNUM ET
IUSTUM ESTAE
QUUM ET SALU
TARE NOS TIBI
SEMPER ET UBIQ:
GRATIAS AGERE·
ONE SCE PATER
OM NIPOTENS AE TER
NE DS PER XPM DNM
NRM PERQUEM MAIES
TATE TUAM LAU DANT
ANGELI A DO RANT DO
MINATI ONES TREMUNT
POTESTA TES CAELICAE
LORUM q: UR TUTES AC
BEATASERA phim SOCIA
EXULTATIONE CONCELEBRAN
CUMQUIBUS ET NOSTRAS
UOCES UT AD MITTI IUBEAS
DE PRECAMUR SUPPLICI
CONFESSIONE DICENTES·

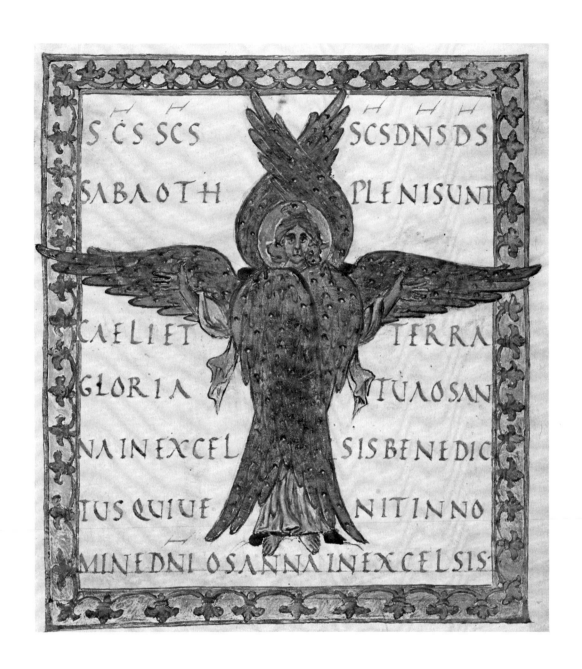

SCS SCS SCS SCS DNS DS
SABAOTH PLENI SUNT
CAELI ET TERRA
GLORIA TUA O SAN
NA IN EXCEL SIS BENEDIC
TUS QUI UE NIT IN NO
MINE DNI OSANNA IN EXCELSIS

Pl. 87 / 167

Pl. 89 / 169

PATER

PERIHM

XPMELM

TVMDMN

begins after the Canon of the Mass. This section of the text is therefore a combined Temporale and Sanctorale. The rubrics for some of the feasts occasionally contain additional notations: "In nativitate ad s. Petrum," "Yppopanti . . . ad s. Mariam," "In Quadragesima ad s. Johannem in Lateranis."[2] These are "stational" notations indicating the feasts on which the pope said Mass in special churches in Rome.

The Temporale begins with the vigil of Christmas. It is introduced by a small historiated initial showing the Virgin lying in a bed. The major decorative emphasis, however, is reserved for Christmas Mass (Pl. 91), beginning with a large C) "Concede quaesumus omnipotens Deus" [Grant we beseech thee, almighty God]). The letter contains representations of the Christ Child in the manger with the ox and the ass, Mary reclining on a bed with a midwife and Joseph nearby, the bathing of the Child, and three shepherds. Subsequent feast days are introduced by smaller historiated initials of varying sizes, such as the D containing the Journey of the Magi, the Magi before Herod, and the Adoration of the Magi for the Mass of Epiphany (Pl. 92). In this case, but not always elsewhere, the illustrated scenes depict incidents recounted in the pericope for that mass (Matt. 2:1–12)

The masses for the last weekend in Lent are introduced by a small initial containing the Entry into Jerusalem for the prayer, "Omnipotens genitor qui unigenitum" (Almighty father, who [your] only begotten), said on the Saturday before Palm Sunday. Prayers for the blessing of holy water on Holy Saturday require a repeat of the Preface, "Vere dignum," and precede the mass for Easter Sunday which is introduced by a major initial appropriately containing representations of the Three Marys at the Tomb and two subsequent appearances of Christ to the Holy Women (Pl. 93). These are incidents related in the pericope (Matt. 16:1–7). Another Preface and a large V with a triumphant Paschal Lamb as a symbol of the resurrected Christ introduce the masses during the Octave of Easter, or the week following Easter Sunday. Major initials containing representations of the Ascension and the Penetcost introduce these appropriate feast-day masses. A series of masses of various saints begins the liturgical cycle with the Annunication to Zaccharias in a large initial for the birth of St. John the Baptist and terminates with the feast of St. Andrew at the beginning of Advent. This section, although not specifically articulated, marks a resumption of the most important feasts of the Sanctorale. The remainder of the manuscript contains extraneous matter, the Mass for the Dedication of the Church, the Common of Saints, and additional formulas for masses that were inserted later. A list of the early bishops of Metz concludes with "Drogo archiepiscopus, VI id. decembris."

91. "Concede quasumus" with Nativity. Drogo Sacramentary, fol. 24v (Paris, Bibliothèque Nationale, MS lat. 9428: Photo Bibl. Nat., Paris)
92. "Deus qui hodierna" with Adoration of the Magi. Drogo Sacramentary, fol. 34v (Paris, Bibliothèque Nationale, MS lat. 9428: Photo Bibl. Nat., Paris)
93. "Deus qui hodierna" with Three Marys at the Tomb. Drogo Sacramentary, fol. 58r (Paris, Bibliothèque Nationale, MS lat. 9428: Photo Bibl. Nat., Paris)

IN NATONIADSCOMPETRUM

CONCEDECS OMNIPOTENS DS UT
NOS UNIGENITI
TUINOUA CARNEM
PER TIUITAS
NA BERET QUOS
LI SUBPEC
 CATIIUGO
 UETUSTA
 SERUITUS TENET
 PEREUN DEM
 DNM NOS TRUM
 IHM XPM FILIU
 TUUM QUI
 TECUM
 ETREG
UIUIT
NATDS
INUNITATE
SPSSCI PEROMNIASCLA SCLORUM·

D S E

QUI HODIERNA DIE
unigenitum tuum gen
tibus stella duce reue
lasti · concede propi
tius · ut qui iam te ex
fide cognouimus · usq:
ad contemplandam
speciem tuae celsitudinis
perducamur · per eunde
dnm nostrum ihm xpm filium tuum · qui tecum ui
uit et regnat in unitate sps sci · per omnia scla
seculorum · SUPER OBLATA
ecclesiae tuae qs dne dona propitius intuere ·
quibus non iam aurum · thus et myrra pro
fertur · sed quod eisdem muneribus declara
tur · Immolatur · et sumitur · p dnm nrm ·
et iustum est aequum et salutare ·
nos tibi semper et ubiq: gratias agere

Pl. 92 / 173

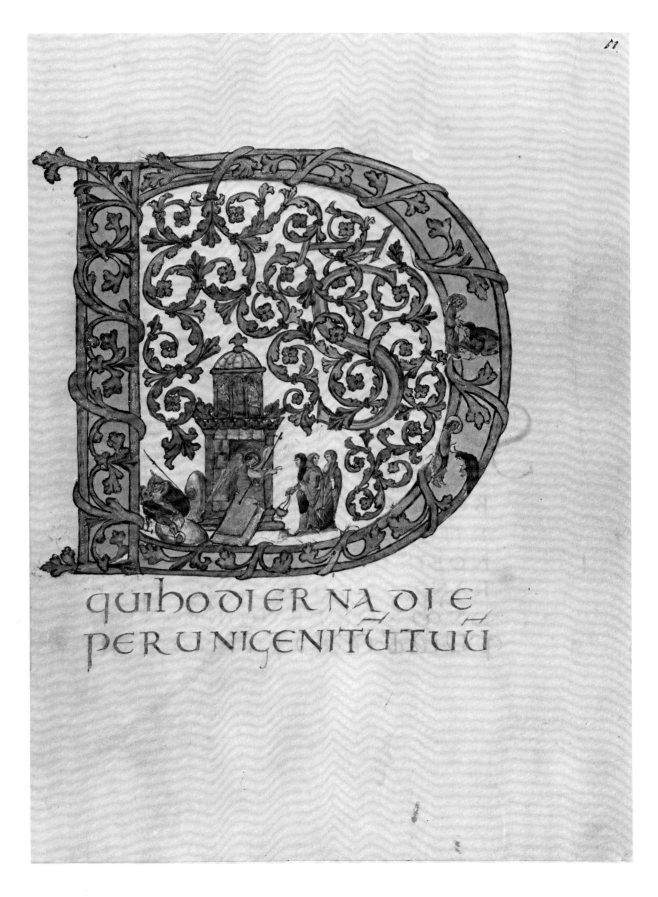

quihodiernadie
perunigenitutuū

The text of the Drogo Sacramentary is a composite from two principal sources. The main body was derived from a Gregorian Sacramentary of the eighth century, a copy of which Charlemagne had obtained from Pope Hadrian I as an authoritative version of the Mass according to the Roman rite. Since this copy, frequently called the *Gregorianum* or the *Hadrianum*, contained only the stational masses, Alcuin created a supplement that added other Gregorian formulas, as well as some drawn from the indigenous Gallican rite. A selection of the texts from the *Hadrianum* and Alcuin's Supplement appears in the last section of the manuscript beginning with the Mass for the Dedication of a Church. Although this Sacramentary was therefore composed of a composite of texts embodying the Carolingian borrowings from Rome, Alcuin's additions and revisions, and even special formulas for the diocese of Metz, it nevertheless reflects the developing structure of the Mass book which will be discernible in most later examples.[3]

Ivory plaques adorning the front and back covers of the Drogo Sacramentary reflect many of the themes of offering and consecration embodied in the text and in the historiated initials.[4] Although these reliefs are now set in incorrect order, and the original framework and either gold or silver backing that would have showed through the cut-out backgrounds are now missing, the ivories constitute the oldest surviving representations of the practice of the liturgy. On the front cover (Pl. 84) principal incidents of Christ's ministry, his Baptism, his appearance before the apostles at the Last Supper, and his Ascension (or blessing the apostles at Bethany [Luke 24:50]), are juxtaposed with a series of pontifical blessings: the blessing of the Oil on Maunday Thursday, the ordination of a deacon, the dedication of a church, confirmation, consecration of the Baptismal water, and Baptism by emersion. The reliefs constitute, therefore, a pictorialization of some of the benedictions before the Prefaces and the Canon of the Mass in the text.

The reliefs on the back cover (Pl. 94) depict significant moments in the performance of the Mass: the clergy during the reading of the Epistle, the veneration of the Almighty at the beginning of the Mass, the Kiss of Peace, the bishop kissing the Gospels, the beginning of the *Kyrie eleison*, the entrance of the bishop from the sacristy, the collection of the offerings, the blessing of the offerings, and Communion being given to the clerics. These ivories are also out of order, but they are important as representations of the Carolingian ritual of the Mass, particularly as it was practiced in Metz under Archbishop Drogo. As in the case of a number of lavish service books produced for erudite and demanding patrons throughout the Middle Ages, these

94. Back cover. Drogo Sacramentary (Paris, Bibliothèque Nationale, MS lat. 9428: Photo Bibl. Nat., Paris)

ivory covers complement the decorative program of the text and add to the book an external pictorial statement of its meaning and purpose.

In a fragment of what must have been an extraordinarily lavish Sacramentary made for the coronation of Charles the Bald as King of Lorraine in 869 (Paris, B.N., MS lat. 1141), only the introductory miniatures survive.[5] These make up an elaborate pictorial accentuation of the Preface and opening of the Canon of the Mass (see Appendix 8). After a title page written in gold capital letters is a full-page miniature of the king, Charles the Bald, being crowned by the hand of God between two bishops (Pl. 95). This faces a representation of Pope Gregory (Pl. 96), who wrote the formulas used in the Mass which were reintroduced during Carolingian times, receiving divine inspiration from the dove of the Holy Ghost. Divine investitures with temporal and ecclesiastical authority are thus juxtaposed. The elaborately executed text of the "Per omnia," written in gold against bands of purple, faces the "Vere dignum," entwined in gold interlace and surrounded by gold foliage (Colorpls. 12, 13). The end of this text, written in gold and enframed, faces a full-page miniature of Christ in Majesty with the four symbols of the Evangelists, and the angels and seraphim of the Kingdom of Heaven (Pl. 97). This celestial vision is repeated on the following sequence of facing pages, where angels, apostles, and saints arranged in five rows pay homage to Christ enthroned between seraphim opposite (Pls. 98, 99). Beneath him are personifications of the Sea and the Earth. These facing pages therefore illustrate the phrase written below Christ, which translates "Holy, Holy, Holy, Lord God of Hosts, Heaven and Earth are full of thy glory." This magnificent sequence of miniatures terminates with a representation of the crucified but triumphant Christ, treading on the serpent of evil, placed upon the *T* of the "Te igitur" that begins the Canon of the Mass (Pl. 100). This painting therefore clearly states the theme of Christ's sacrifice implied by the Old Testament representations that adorn the *T* of the Drogo Sacramentary. The remainder of the text in this fragment is written in gold and enclosed in richly painted foliate frames (Pl. 101).

The Metz Coronation Sacramentary, with its lavish use of gold, rich acanthus borders and backgrounds, and frames with simulated inset jewels, was one of the most lavish productions by the illuminators of Metz. Destined for the imperial court, it was a fitting and perhaps immediate predecessor of the most elaborate of all manuscripts made for Charles the Bald, the Codex Aureus of St. Emmeram.

95. Charles the Bald between Two Bishops. Metz Coronation Sacramentary, fol. 2v (Paris, Bibliothèque Nationale, MS lat. 1141: Photo Bibl. Nat., Paris)

96. Pope Gregory Receiving Divine Inspiration. Metz Coronation Sacramentary, fol. 3r (Paris, Bibliothèque Nationale, MS lat. 1141: Photo Bibl. Nat., Paris)

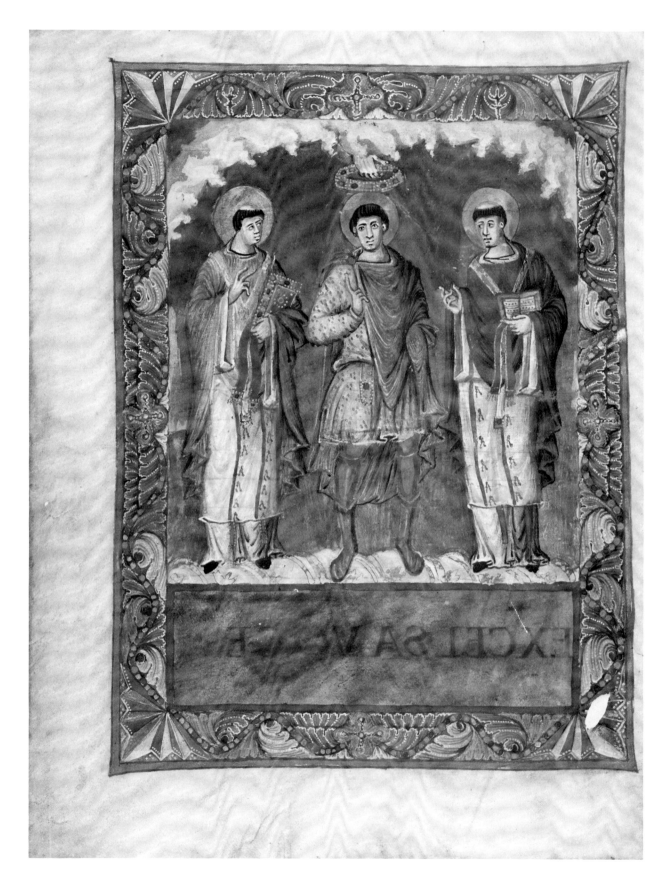

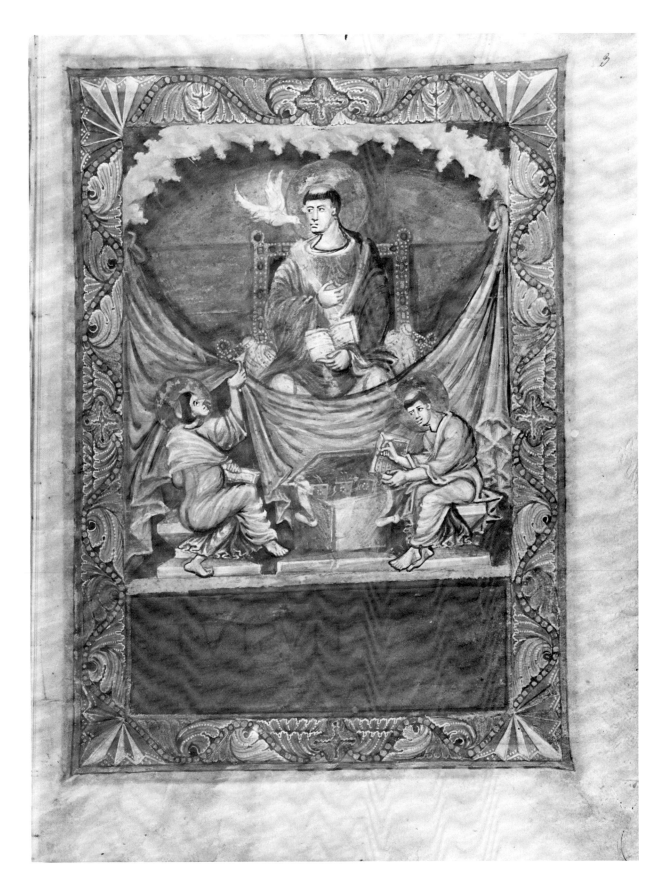

Pl. 96 / 179

The Berthold Missal

The contents of a missal follow closely those of the Sacramentary but with the addition of elements recited by the celebrant in the performance of low or private Mass. The Sacramentary had only those elements for High or Solemn Mass. Since all the elements of the Low Mass were said by a single celebrant, the lessons and chanted portions of the service were added to and combined with the prayers and benedictions of the Sacramentary. In this expanded form, the missal became increasingly prevalent in the twelfth century, and by the thirteenth it had almost completely supplanted the Sacramentary.

A lavish missal commissioned by Berthold (1200–1235), abbot of Weingarten Monastery at the beginning of the thirteenth century, marks a high point of German Romanesque illumination just before the transition to a Gothic style. Written and decorated at the abbey, the manuscript contains sumptuous miniatures and initials influenced by Flemish and Anglo-Saxon manuscripts in the Weingarten Library which were given by the early benefactors, Henry IV, duke of Guelph (Welf IV) and his wife, Countess Judith of Flanders, in the late eleventh century. Hanns Swarzenski has pointed out that evidence in the manuscript, in the iconography of its miniatures, and in the elaborate gold and bejeweled cover indicates that the Berthold Missal was written between 1215 when the abbey church was destroyed by fire and 1217 when it was rebuilt and rededicated.[6]

Many of the miniatures are painted in brilliant reds, blues, and greens, shot with white highlights, and set off against a shimmering polished gold ground. Concentric drapery patterns, in chevrons, circles, or ovoid ripples, eddy across the limbs and torsos, imparting to the figures a controlled energy typical of much twelfth-century Romanesque painting and sculpture. At the same time, many of the figures are in large scale in relation to the size of the miniatures and this, together with the frequent approximation of Byzantine physiognomic types and the Byzantine formula for the articulation of Christ's body in the Crucifixion miniature, combine to give the figures a calm monumentality.

In spite of the inclusion of additional material, the structure and sequence of the missal remained similar to that of the Sacramentary (see Appendix 9). The Berthold Missal begins with seven folios of a Calendar with the feast days of the saints, now necessary because of the expanded Proprium Sanctorum. The text commences with the Prefaces and the Canon of the Mass, then follow the Temporale and Sanctorale, now separated into two sections, a series of votive masses for the days of the week, some general votive masses beginning with one for the patron

97. Christ in Majesty. Metz Coronation Sacramentary, fol. 5r (Paris, Bibliothèque Nationale, MS lat. 1141: Photo Bibl. Nat., Paris)
98. Hierarchy of Heaven Paying Homage. Metz Coronation Sacramentary, fol. 5v (Paris, Bibliothèque Nationale, MS lat. 1141: Photo Bibl. Nat., Paris)
99. Christ Enthroned between Seraphim above "Sanctus." Metz Coronation Sacramentary, fol. 6r (Paris, Bibliothèque Nationale, MS lat. 1141: Photo Bibl. Nat., Paris)
100. "Te igitur." Metz Coronation Sacramentary, fol. 6v (Paris, Bibliothèque Nationale, MS lat. 1141: Photo Bibl. Nat., Paris)
101. "Clementissime." Metz Coronation Sacramentary, fol. 7r (Paris, Bibliothèque Nationale, MS lat. 1141: Photo Bibl. Nat., Paris)

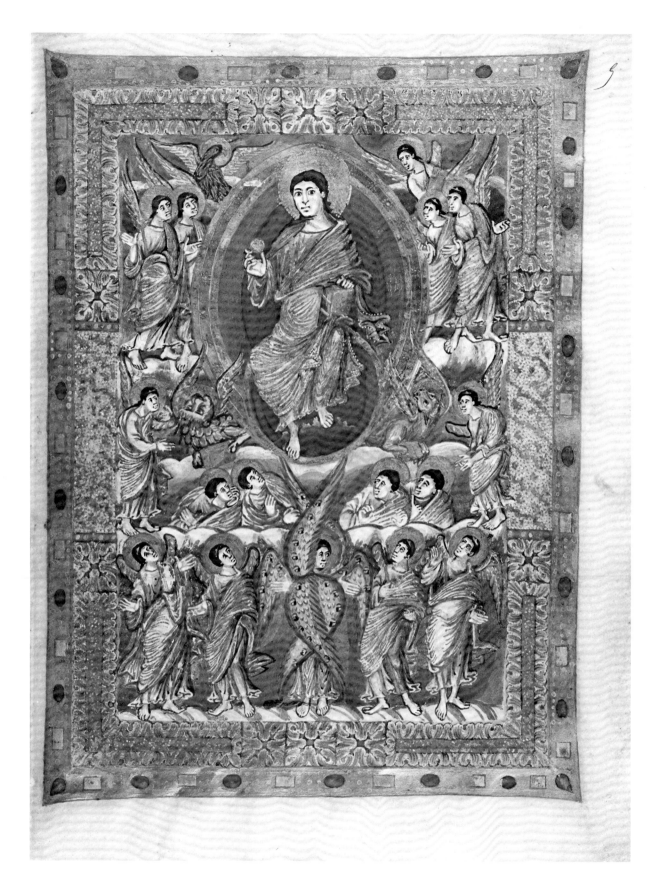

Pl. 97 / 181

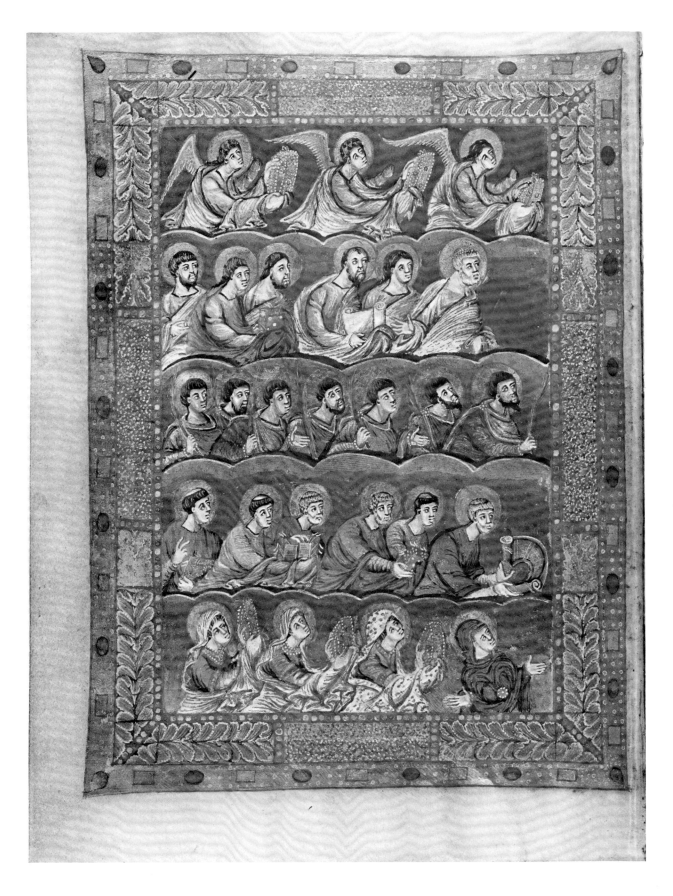

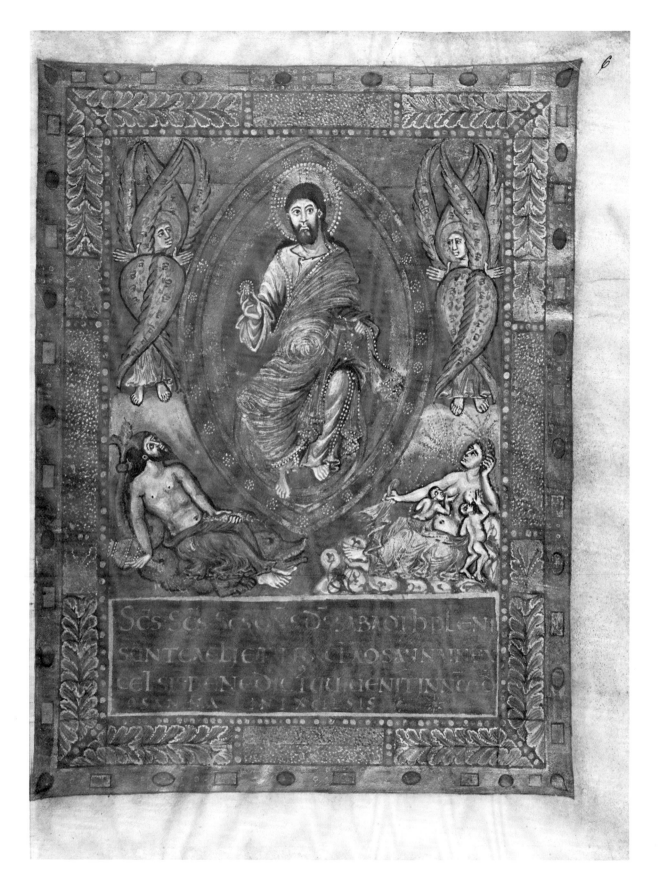

Pl. 99 / 183

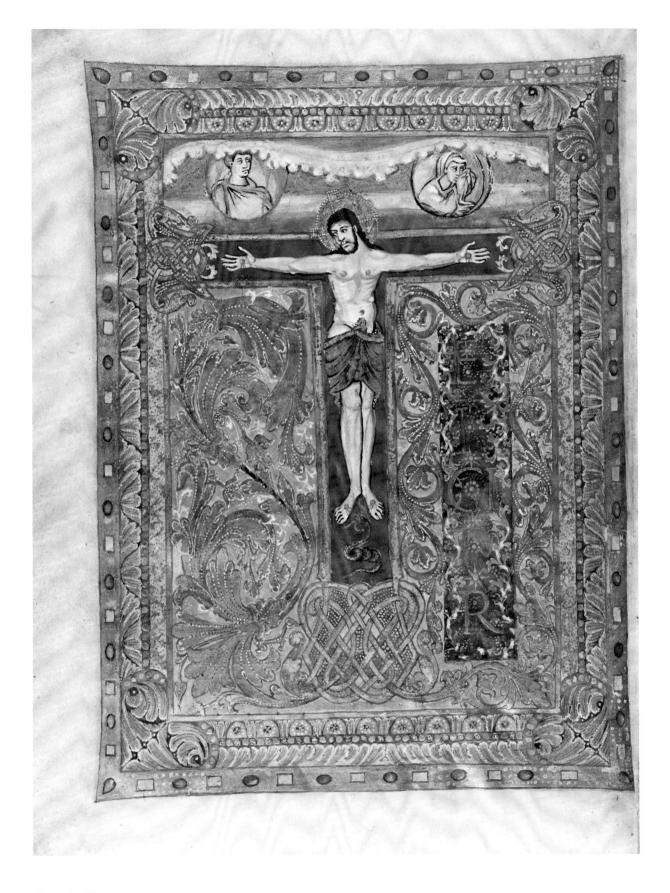

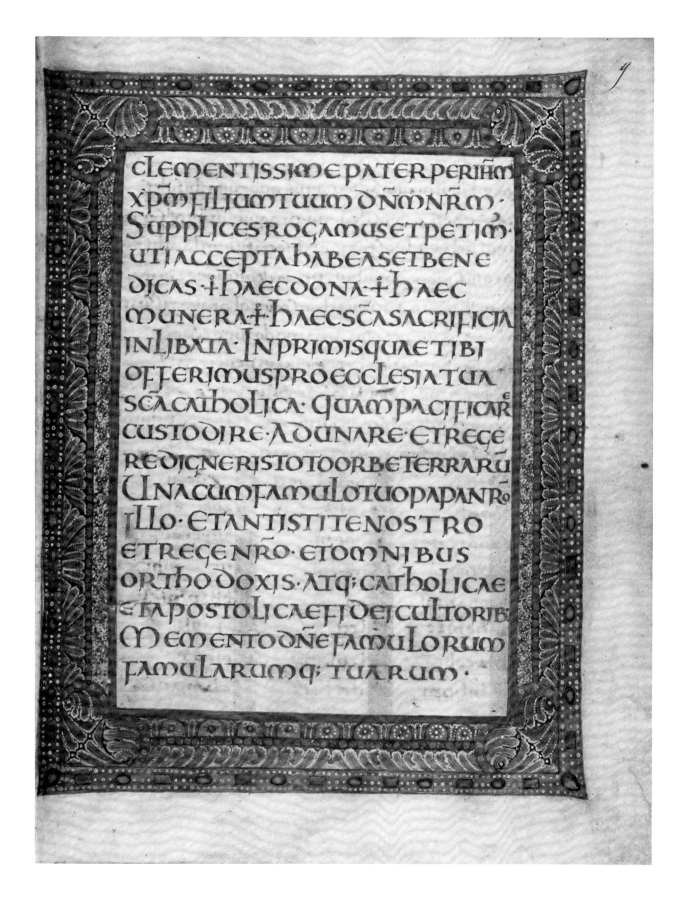

Pl. 101 / 185

saints of Weingarten Abbey, Martin and Oswald, and finally a selection of Collects added by another hand, benedictions, and notes by Abbot Berthold. The decoration is lavish, with twenty-one full-page miniatures introducing major feasts and numerous smaller miniatures, historiated initials, and decorative initials opening less important divisions.

As in the case of the Drogo Sacramentary, the Canon of the Mass is prefaced by the decorated "Per omnia" articulated by a large foliate *P*, with the remainder of the passage written in horizontal bands (Pl. 103) reminiscent of the incipits found in Carolingian manuscripts. This page faces another foliate initial, the *V* to the "Vere dignum," which in this case by mistake omits "dignum" and reads "Vere et iustum est" (Pl. 104). These two decorative pages form a harmonious double-page ensemble introducing the Canon. A verso full-page miniature of the crucified Christ flanked by the Virgin and St. John and with the signs of the Four Evangelists in corner medallions follows (Pl. 105), but faces a blank page. On the subsequent verso an almost full-page foliate initial *T* for the "Te igitur clementissime pater" opens the Canon of the Mass (Pl. 106). Thus the image of the crucified Christ, which was often placed upon the *T* of the "Te igitur," as on a cross, here serves as an appropriate frontispiece for the opening of the sacrificial rite.

The openings of the following major divisions of the text, the Temporale and the Sanctorale, do not receive elaborate decorative emphasis. The Temporale, beginning with the vigil of Christmas, simply commences with an initial containing the standing figure of the crowned Virgin. The major decorative impact was reserved for the opening of the Christmas Mass, where a full-page miniature of the Nativity and Annunciation to the Shepherds faces an elaborate foliate *C* and banded opening phrase, "Concede quaesumus omnipotens deus" (Grant we beseech thee, almighty God). An even more elaborate two-page spread opens the feast of Pentecost, with a full-page miniature of the Descent of the Holy Spirit facing a foliate initial *D* with seven birds signifying the Seven Gifts of the Holy Ghost (Colorpls. 14, 15). But double-page spreads occurred only when convenient. Frequently a full-page miniature would be painted on a recto of a folio with the subsequent elaborate initial and opening phrase on the verso: the Resurrection, Three Marys at the Tomb, and Noli Me Tangere appear together on folio 56r, but the incipit, "Deus qui hodierna die per unigenitum tuum" (O God on this day through your only begotten) follows on folio 56v.[7] Some of the lesser feasts in the Temporale are introduced by small miniatures within the text, such as the Stoning of St. Stephen (Pl. 107), or by historiated initials, as for the feast commemorating the Baptism of Christ.

102. Front cover. Berthold Missal (New York, The Pierpont Morgan Library, MS M. 710)

103. "Per omnia." Berthold Missal, fol. 8v (New York, The Pierpont Morgan Library, MS M. 710)

104. "Vere et iustum est." Berthold Missal, fol. 9r (New York, The Pierpont Morgan Library, MS M. 710)

105. Crucifixion and Symbols of the Four Evangelists. Berthold Missal, fol. 10v (New York, The Pierpont Morgan Library, MS M. 710)

106. "Te igitur clementissime poiter." Berthold Missal, fol. 11v (New York, The Pierpont Morgan Library, MS M. 710)

107. Stoning of St. Stephen. Berthold Missal, fol. 17v (New York, The Pierpont Morgan Library, MS M. 710)

Pl. 102 / 187

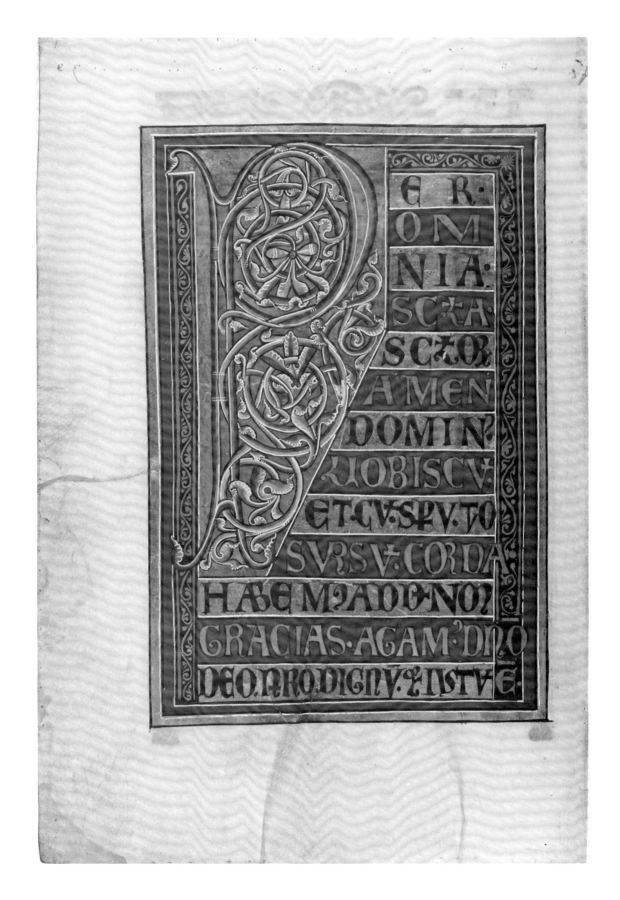

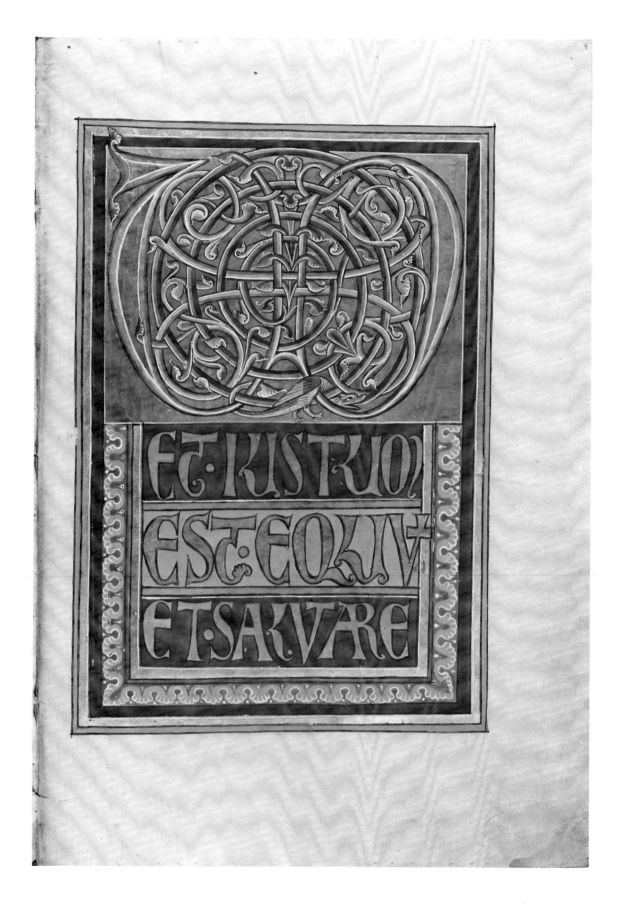

Pl. 104 / 189

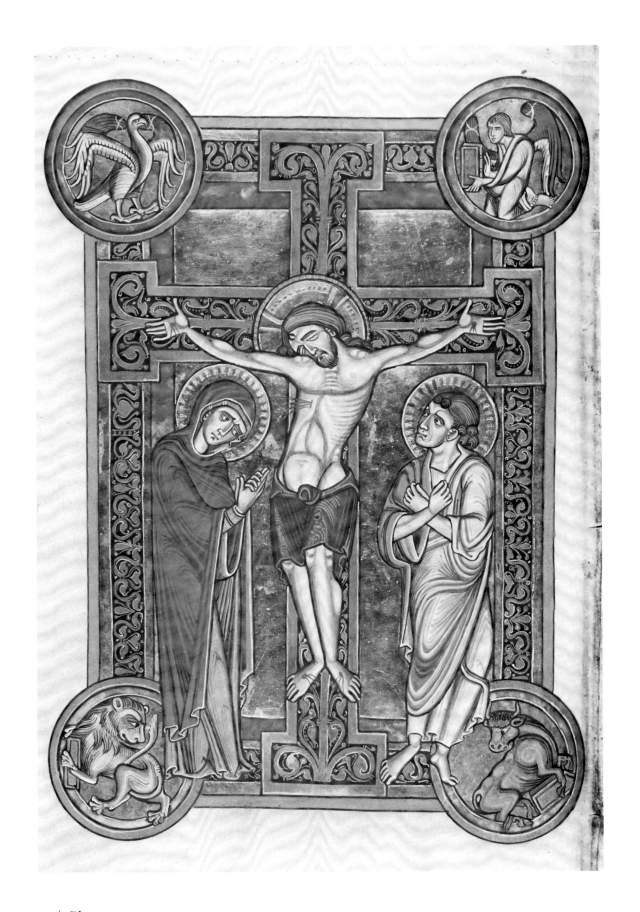

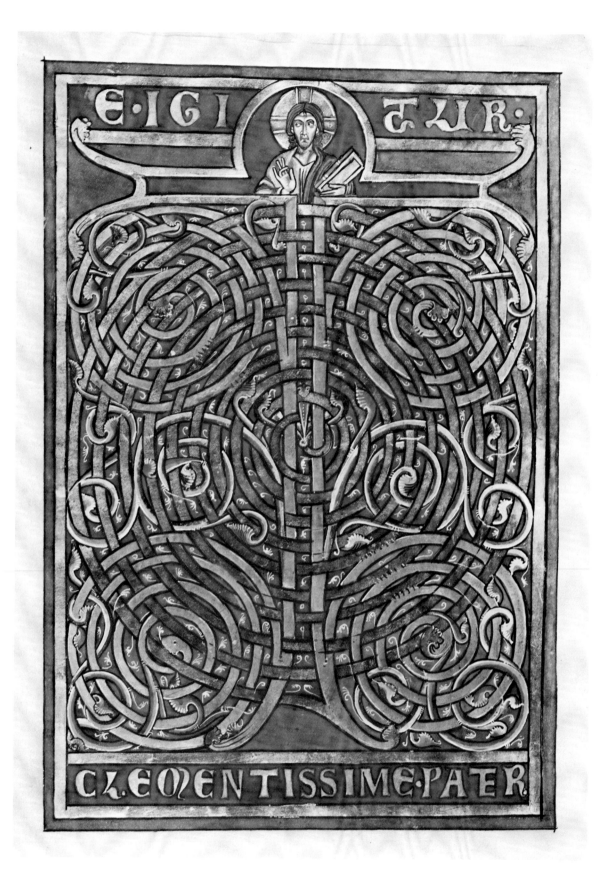

Pl. 106 / 191

ē auctor. ſta & immortaliſ ſit ipſe largitor. Q.
uccū.

N HOBIS QS DNE Stephani oj.
imitari quod colimuſ. ut diſca
muſ & inimicoſ diligere. quia
eiuſ natalicia celebramuſ. qui no
uit etiam pro pſecutoribuſ exorare. Dnm.
Suſcipe dne munera piiorum SECR.
commemoratione ſcōҙ. ut quod illoſ paſſio
gloſoſ. noſ deuotio reddat innocuoſ. P Cōj.
Auxilient̄ nobiſ dne ſumpta myſteria. & in
tercedente beato ſtephano martyre tuo. ſen
piterna pretione cōfirment̄ P nobiſ eﬅ.
CCLESIAM TUA DNE
benignuſ illuﬅra. ut beati IOHANNIS

The Sanctorale begins unobtrusively with an initial containing the standing figure of St. Silvester (December 31). Among the major feast days singled out for full-page miniatures are those of St. Oswald (August 5; Pl. 108), facing the opening prayer for his feast, "Deus qui nos beati Oswaldi" (O God who us of the blessed Oswald; Pl. 109) and of St. Martin (November 11), both patron saints of Weingarten Abbey.[8] Appropriately, immediately after the latter and interrupting the normal liturgical sequence of feast days appears the service for the Dedication of a Church with a full-page miniature of a kneeling crowned person, thought to be the benefactor of the abbey, Duke Welf IV,[9] followed by the incipit, "Deus qui nobis per singulor annos" (O God who year by year for us) on the verso (Pls. 110, 111). In this manuscript, the Sanctorale ends with the feast of St. Thomas (December 21), immediately before Christmas.

In later missals, other adjustments were made to the order and sequence of the texts and further elements were added. It became customary to begin the Temporale with the First Sunday in Advent rather than to end with it; thus the feast of St. Andrew often appears at the beginning. It also became the custom to insert the Canon and the Ordinary of the Mass with the Preface after Holy Saturday and before Easter. This was an appropriately symbolic placement, for the sacrificial rite of the Mass was placed in proximity to the feast days that commemorate Christ's sacrifice and his triumph over death, and it is this order that still persists in modern missals.

The magnificent gilt silver and jeweled cover of the Berthold Missal (Pl. 102) contains a relief of the Virgin and Child enthroned in the center surrounded by the four Evangelists and their symbols. Like the cover of the Codex Aureus of St. Emmeram, these surrounding scenes in the corners are separated by the cruciform layout of the cover. In a descending order of hierarchy, Sts. Michael and Gabriel are represented in the top row with John and Matthew, below are personifications of Virginity and Humility (attributes of the Virgin), Sts. Oswald and Martin (patrons of Weingarten Abbey), and on the bottom Abbot Berthold himself with St. Mark, and Martin with Luke. On the rim of the cover are inscribed the names of saints whose relics are actually contained within compartments in the cover. This was an unusual practice, but one in keeping with the veneration of such treasure bindings as relics.[10]

A Lombard Gradual

As the Sacramentary contained only the prayers to be said by the principal celebrant in the offering of the Mass, other elements

108. Sts. Oswald and Aidan. Berthold Missal, fol. 101v (New York, The Pierpont Morgan Library, MS M. 710)

109. "Deus qui nos beati Oswaldi." Berthold Missal, fol. 102r (New York, The Pierpont Morgan Library, MS M. 710)

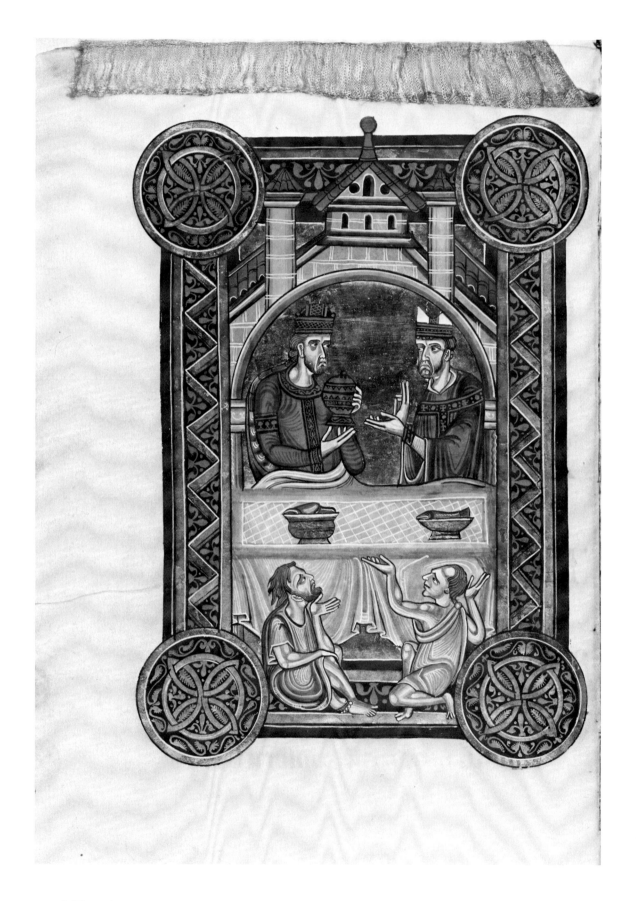

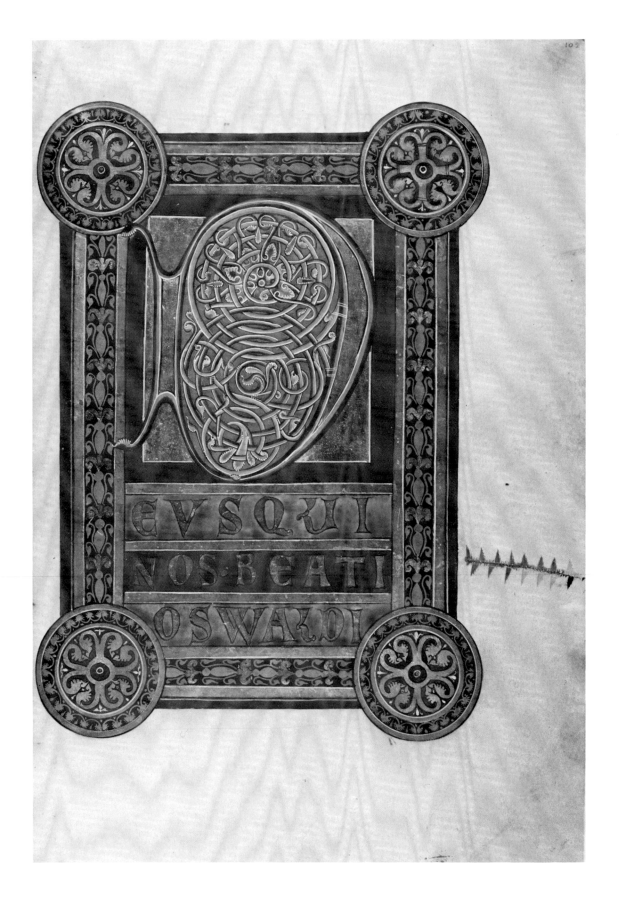

Pl. 109 / 195

of the service, such as the lessons from the Gospels and Epistles, were excerpted and compiled in separate volumes for use by the other participants. The sung portions of the Mass were frequently grouped in a large choir book called a gradual. These manuscripts contained the antiphons for the Introit (opening phrase), Offertory, and Communion chants and the gradual (an antiphon or response sung between the reading of the Epistle and the Gospel) after which the book was named. It also contained tracts (verses of the Scriptures sung after the gradual instead of the usual Alleluia on penitential days, and for vigils and requiems), the Alleluia, and versicles (short sung verses). The gradual was usually written in a large format so that it could be read by all of the members of the choir. Lines of musical notation alternated with those of the text and dense passages of instructions, written in a smaller scale, provided references to other portions of the Mass which were to be sung on specific occasions.

These choir books were organized in a manner similar to the Sacramentary or missal, with the chants arranged according to the liturgical year in the Temporale, Sanctorale, and Common of Saints. A complete gradual would also contain the fixed chants for the Ordinary of the Mass: the Kyrie, Gloria, Credo, Sanctus, and Agnus Dei. Because of their size such manuscripts might be divided into two or three parts, such as the kyrial, which contained only the fixed chants, and a responsorial, which contained the variable chants.

A volume of a gradual, or more properly a responsorial containing chants for the Sanctorale and Common of Saints, now in the Cornell University Libraries (Ithaca, N.Y., MS B 50++), exemplifies the nature of the decoration found in such choir books in the later Middle Ages (see Appendix 10). This particular manuscript, probably produced in Lombardy, in the area around Milan, in the 1440s, contains twelve large historiated initials introducing major feast days, fifteen smaller initials containing portrayals of saints, and twenty-seven decorative initials. The major illuminations are by an anonymous artisan known as the Master of the Franciscan Breviary, named after a manuscript in Bologna (Biblioteca Universitaria, MS 337). They contain fanciful architectural forms that comprise the initials (Colorpl. 24b) and startling passages of monochromatic groups of figures in blue or green juxtaposed with a brilliant palette and polished gold typical of the late—so-called International Gothic—style just before the advent of the Renaissance in northern Italy. These initials have close affinities in style and inspiration with the principal Lombard illuminators of the first half of the fifteenth century, Giovannino de' Grassi, Michelino da Besozzo, the Master of the *Vitae Imperatorum*, and particularly Belbello da Pavia.[11] In

110. Dedication of a Church with Kneeling Benefactor. Berthold Missal, fol. 127r (New York, The Pierpont Morgan Library, MS M. 710)
111. "Deus qui nobis per singulos annos." Berthold Missal, fol. 127v (New York, The Pierpont Morgan Library, MS M. 710)

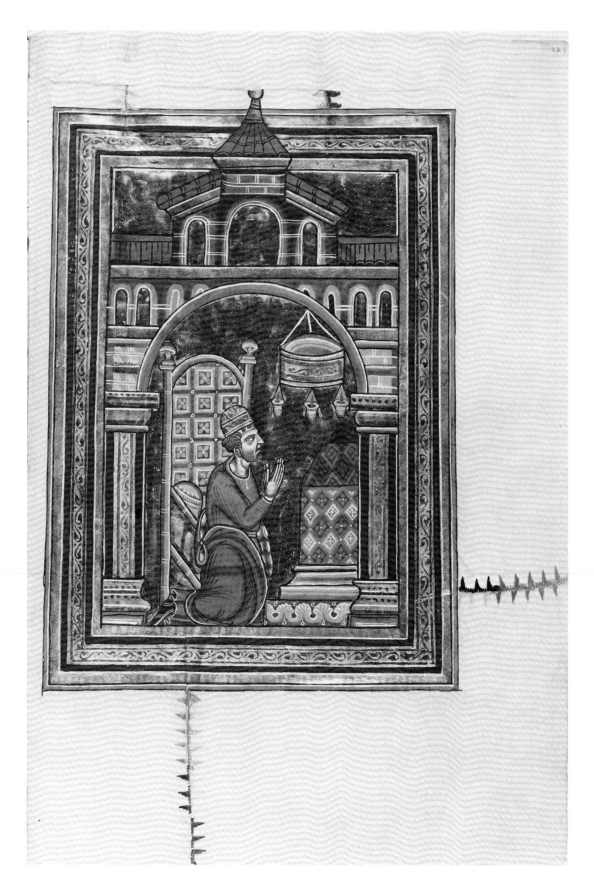

Pl. 110 / 197

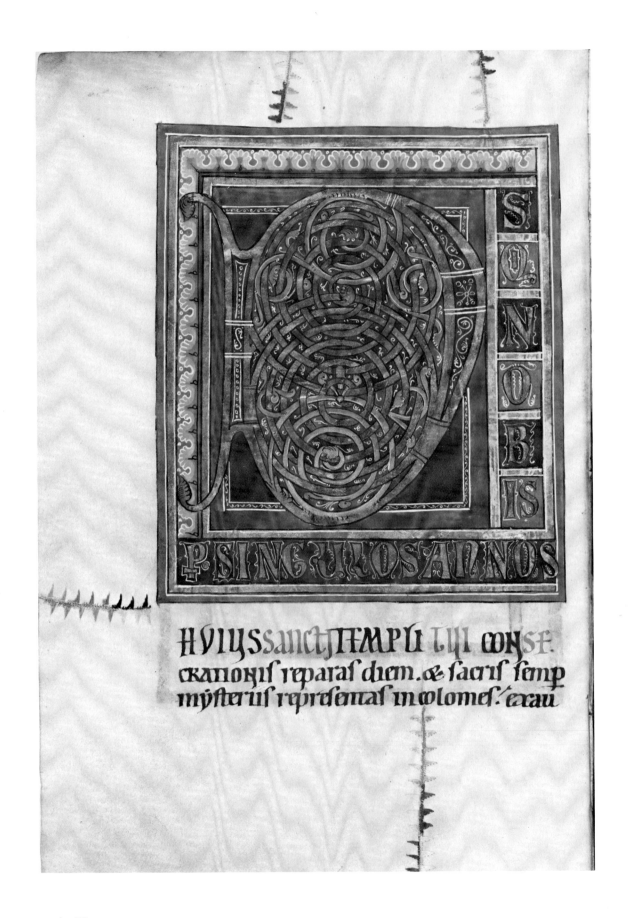

fact, some of the designs for initials used by the Franciscan Master demonstrates that he was clearly aware of similar designs employed by Belbello in the Visconti Hours, finished for Filippo Maria Visconti between 1430 and 1440.[12]

The Lombard Gradual, as were most choir books that had to be legible to all choristers, is large in size (21 ¼ × 15 ⅝": 540 × 370 mm.), with a correspondingly large text area, and is written on heavy vellum. Five lines of text alternate with five lines of musical notation per page. Rubrics and instructions are written in smaller scale, six lines of text in the space usually devoted to one line of music and its accompanying text. Red and blue Roman numerals indicate the foliation on the verso of each leaf to facilitate locating chants referred to in other sections of the manuscript.

Lombard gradual.

By the time the Lombard Gradual was compiled it had become the custom to begin the Sanctorale with the vigil or Eve of St. Andrew (see Appendix 10). St. Andrew's day, celebrated on November 30, also begins Advent in the Temporale. Often, as in the case of the Cornell manuscript, this incipit is heralded by a historiated initial *D* representing the Calling of Peter and Andrew ("Dominus secus mare Galilaeae") referred to in the Introit that follows (Pl. 112). Thus Christ is shown standing on the shore of the Sea of Galilee summoning the fishermen Peter and Andrew to follow him, as recounted in the Gospel of St. Matthew (4:18–20):

> And Jesus walking by the Sea of Galilee saw two brethren, Simon, who is called Peter, and Andrew, his brother, casting a net into the sea (for they were fishers). And he saith to them: Come ye after me, and I will make you to be fishers of men. And they immediately leaving their nets, followed him.

A remarkable initial depicting St. Helen kneeling before a gold cross in an elaborate letter *N* ("Nos autem gloriari" [But it behoves us to glory]; Colorpl. 24a) introduces the Introit for the mass celebrating the Invention (or Discovery) of the Holy Cross (May 3). This refers to the legendary discovery of the True Cross, upon which Christ was crucified, by St. Helen, the mother of the emperor Constantine the Great, in the first third of the fourth century. The crowned empress is shown clothed in a delicately embroidered red robe, her hands upraised as though to embrace the cross in front of her. A bearded figure within the foliage of the initial, painted in finely drawn gold lines against a monochromatic green, clasps his hands in prayer and returns the ardent gaze of the kneeling saint. This figure is a variation of a design in the Visconti Hours, and here may represent God the Father, for there is evidence of a faintly rendered halo in rose

112. Initial *D* with Calling of Peter and Andrew. Lombard Gradual, fol. 1r (Ithaca, N.Y., Cornell University Libraries, MS. B 50++)

ens m.

hilee ni dit du o

above his head.[13] The landscape and distant city of Jerusalem are set off against a nocturnal sky studded with stars. The contrast of brilliant greens, reds, and blues with the shimmering polished gold of the cross and background against which the initial is placed enhance the stunning decorative quality of the painting.

The initial *C* ("Confessio") containing the Martyrdom of St. Lawrence (Colorpl. 24c), which opens the Introit to his feast (August 10), in contrast, presents an extensive landscape with variegated blue sky and distant mountains seen through an arcade at the far end of an ample courtyard. In the foreground St. Lawrence, who was martyred by being roasted, is being turned over by two attendants while the Emperor Decius, painted in green monochrome shot with yellow, looks on from a canopied balcony in the fanciful architectural initial. Remarkable for its glowing colors, startling juxtapositions, and whimsical details, such as the pendent balcony at the lower end of the *C*, the scene is nevertheless eclectic, borrowing the composition of the martyrdom from a design by the Boucicaut Master and closely paralleled by a predella relief by Jacobo della Quercia at S. Frediano at Lucca.[14]

Equally splendid is the celestial vision of the Virgin ascending into Heaven (Colorpl. 24d) in a historiated *G* ("Gaudeamus" [Let us praise]) introducing the Introit for the feast of the Assumption of the Virgin (August 15). The letter is composed entirely of undulating pink and blue clouds, a device also used in the Visconti Hours, and the Virgin is borne heavenward by a group of golden cherubim to the accompaniment of brilliantly colored music-making angels. Around the initial swarm throngs of angels in green monochrome highlighted with yellow and set off against the burnished gold field.

Most of the major initials in the Lombard Gradual are not associated with any other decoration on the page. They appear as colorful accents, sometimes in the upper left corner of the text, as in the case of the Calling of Peter and Andrew, but more often in the middle or even at the bottom of the page—wherever the demands of the text dictated. Around the initial introducing the Introit for the feast of the Dedication of St. Michael Archangel (September 29), however, the decoration erupts into the top and inner magins (Pl. 113). Luxurious multicolored acanthus leaves emanate from the tower comprising the upright of the letter *B* ("Benedicite Dominum omnes angeli eius"). These heavy, convoluted leaves are a particularly Lombard variant of decoration prevalent in Italian manuscripts of the fifteenth century, and their rich coloring and use of motifs such as the cog-wheel outlined gold roundels again relate closely to the circle around Belbello da Pavia. The historiated initial shows God in Majesty blessing a

113. Initial *B* with God Blessing the Angels. Lombard Gradual, fol. 65r (Ithaca, N.Y., Cornell University Libraries, MS. B 50++)

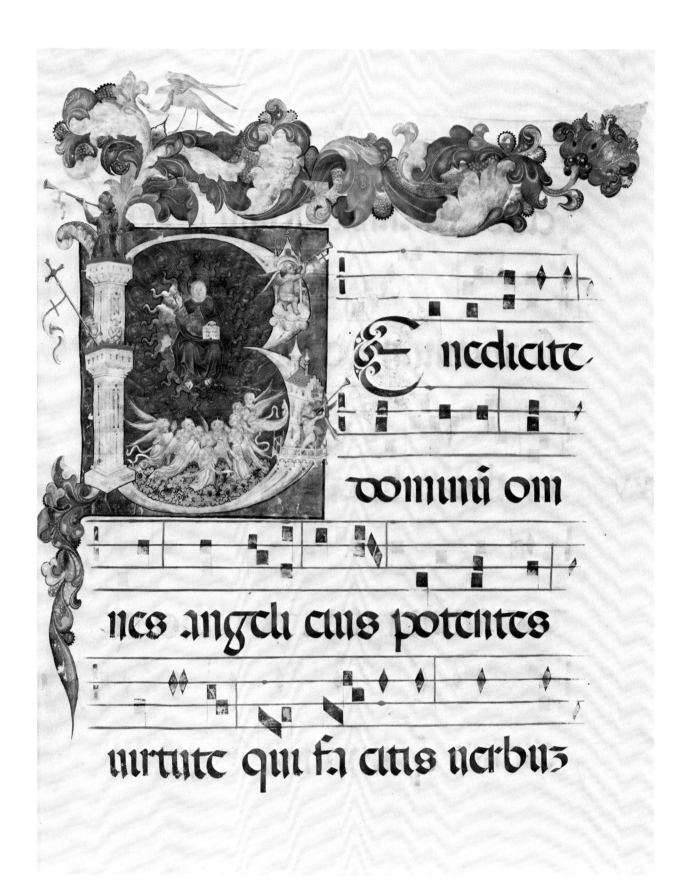

nedicite

domini om

nes angeli eius potentes

uirtute qui facitis uerbuz

throng of adoring angels, a theme directly derived from the Introit that it introduces: "O Praise the Lord ye angels of his." Again, the initial is made of architectural elements, buildings perched precariously upon curving traceried arms. This splendid celestial vision is unusual, for ordinarily one would expect to find in this position a representation of St. Michael killing the dragon.

In the Common of the Saints are the chants that accompany the feasts of various categories of saints who have no special mass designated for them. Thus we have vigils of apostles in general, of one martyr in Eastertide and of many martyrs out of Eastertide, of confessors, of virgins and martyrs, and so forth. Each of these categories is introduced by an initial representing one of these types of saints. The most resplendent of these is the initial *I* ("Intret in conspectu tuo Domine" [Let him enter into thy sight O Lord]) for the Common of Many Martyrs out of Eastertide (Pl. 114). Painted in blue and shaped like a canopied turret, blue monochromatic armored saints stand in the two lower tiers while a winged angel with spear and shield appears beneath the pinnacle. This composition recalls similar canopies and standing figures in the capitals of the columns in Milan Cathedral, designed by Nicolas da Bonaventure and supervised by Giovannino de' Grassi, to whom the Franciscan Master and other Lombard illuminators were indebted for many of their architectural motifs.[15]

Many Italian choir books of the late Middle Ages have survived, although countless more have been cut up and sold by the page or have had their sumptuous initials excised. Fortunately only one letter is missing from the Cornell Gradual, a letter *G* for the Feast of All Saints. It may well have been the most lavish initial of the manuscript, for it undoubtedly depicted an assemblage of All Saints in Heaven which would have rivaled the Assumption of the Virgin and the Angels Adoring God the Father. Cuttings now in the Cini Collection in Venice and elsewhere, many with scenes appropriate for the movable feasts, could have been taken from a companion volume containing the chants for the Temporale by the Franciscan Master.[16]

Such a volume containing the Temporale would begin with the Introit for the First Sunday in Advent, "Ad te levavi animam meam" (Unto thee have I lifted up my soul, from Psalm 25). In another Lombard Gradual in the Cornell University Libraries (Ithaca, N.Y., MS B. 45++), which contains the chants for the Temporale, the opening initial *A* occupies almost the entire page and is filled with intricate pen flourishes (Pl. 115). Other large decorative initials, although not as elaborate, introduce the Introit for the Fourth Sunday of the Advent, "Rorate caeli desuper" (Drop down dew, ye heavens, from Isa. 45) and the In-

114. Initial *I* with Martyr Saints. Lombard Gradual, fol. 105v (Ithaca, N.Y., Cornell University Libraries, MS. B 50++)

115. "Ad te levavi."North Italian Gradual, fol. 3r (Ithaca, N.Y., Cornell University Libraries, MS. B. 45++)

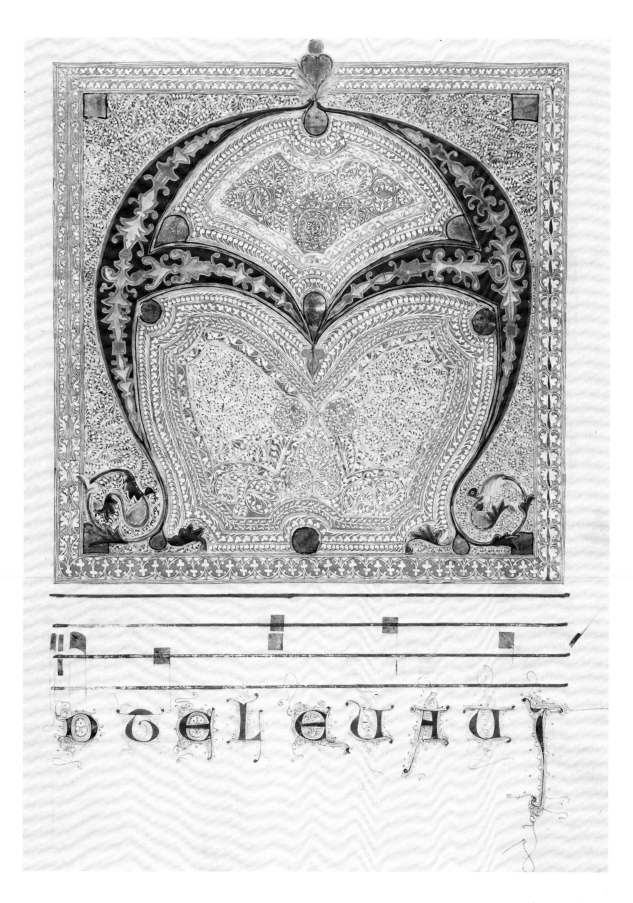

Pl. 115 / 205

troit for the Third Mass of Christmas, "Puer natus est nobis" (Unto us a child is born, from Isa. 9). The opening of Easter Mass, "Resurrexi," frequently received major accentuation and was usually accompanied by a representation of the Resurrection.

6 / The Psalter

In addition to attending the sacrificial rite of the Mass, the devout Christian was also expected to engage in a series of daily devotions. Originally these were structured around the reading of the Psalms, the songs of praise of David. In the early Middle Ages all 150 psalms were to be recited during a single day, but as this proved to be impractical, the sequence of their reading was restructured to encompass a full week. Eight specific times during the day, the canonical hours, were set aside for these recitations. Gradually additional material was included, at first antiphons before and after the Psalms, then Collects, Lessons, Litany of the Saints, a Calendar, hymns, and a variety of other responses to make up eight individual services of public prayer (the Divine Office) in addition to the daily mass. These services were to take place at the following approximate times of day:

Matins (Matutinum)	Midnight or 2:30 A.M.
Lauds (Laudes)	3:00 or 5:00 A.M.
Prime (Prima)	6:00 A.M.
Tierce (Terce or Tertia)	9:00 A.M.
Mass	11:00 A.M.
Sext (Sexta)	12:00 NOON
None (Nones or Nona)	3:00 P.M.
Vespers (Vesperae)	4:30, 6:00 P.M. or sunset
Compline (Completorium)	6:00 or 9:00 P.M.

In the early Middle Ages the psalter was the most commonly used book for private devotions, and it remained so until the fourteenth century, when it was supplanted by the Book of Hours. Used in Judaic rites, it was adapted to Christian usage and served as the basis for the developing Christian liturgy, particularly, as noted above, in the evolution of books for the Divine Office.

The Psalms were divided and ordered in a number of ways, some merely oganizational, others reflecting their particular usage. The simplest of these was purely formal, a three-part division of groups of fifty psalms, which was prevalent in early psalters of Ireland and Germany. These sections were usually articulated by large initials at the beginning of Psalm 1 ("Beatus vir"), Psalm 51 ("Quid gloriaris"), and Psalm 101 ("Domine exaudi"). The text of the Psalms derived from the Vulgate translation by St. Jerome and used throughout much of Europe was known as the Gallican version. In this sequence Psalm 9 also included Psalm 10 of the Hebraic version, so that the numbering of the Hebrew Psalms from this point on to Psalm 147 (which the Gallican version divides into two) is one more, hence indicated Psalm 10 (11).

In the Roman usage, the Psalms were divided into eight "liturgical" sections, corresponding to the readings for each day of the week at matins and the last section comprising all of the weekly readings at vespers. The eight-part division, usually accentuated with large decorative or historiated initials is as follows:

1	"Beatus vir" (Happy is the man)
26	"Dominus illuminatio mea" (The Lord is my light)
38	"Dixi custodiam vias" (I said, I will watch my ways)
52	"Dixit insipiens in corde" (The fool said in his heart, "There is no God")
68	"Salvum me" (Save me, Oh God, for the waters threaten my life)
80	"Exultate Deo adiutori nostro" (Rejoice to God our helper)
97	"Cantate Domino" (Sing to the Lord a new song)
109	"Dixit Dominus" (The Lord said to my Lord, "Sit at my right hand")

The English psalter usually combined the three-part Irish form with the Roman usage, which had been imported into England by St. Augustine, resulting in a ten-part division (the decoration of Psalm 1 is common to both). In the area around Milan, the Ambrosian psalter also used a ten-part division. A five-part division (1, 41, 72, 89, 106) was rarely used.

The eight-part division of the psalter, usually with major decorative initials introducing each part, marked the readings for each day of the week at matins and the beginning of the vespers section. The weekly readings of the Psalms were normally organized as follows:

Sunday	Matins	1–20		
	Prime	21–25	Vespers	109–113
Monday	Matins	26–37	Vespers	114–120

Tuesday	Matins	38–51	Vespers	121–125
Wednesday	Matins	52–67	Vespers	126–130
Thursday	Matins	68–79	Vespers	131–136
Friday	Matins	80–96	Vespers	137–142
Saturday	Matins	97–108	Vespers	143–147
			Compline	148–150

The psalter usually contained a series of canticles or additional poetic passages drawn from the Old and the New Testament. Seven of the canticles were to be sung at lauds on specific days of the week, and an additional five were to be sung daily at matins, lauds, prime, vespers, and compline:

"Confitebor tibi Domine" (Isa. 12:1–6)	Lauds, Monday
"Ego dixi in dimidio" (Song of Hezekiah, Isa. 38:10–20) Tuesday	Lauds, Tuesday
"Exultavit cor meum" (1 Kings 2:1–10)	Lauds, Wednesday
"Cantemus Domino gloriose" (Exod. 15: 1–19)	Lauds, Thursday
"Domine audivi auditionem" (Hab. 3:2–19)	Lauds, Friday
"Audite celi" (Deut. 32:1–43)	Lauds, Saturday
"Benedicite omnia opera" (Dan. 3:57–88, and 56)	Lauds, Sunday
"Te Deum" (actually a hymn)	Matins, Daily
"Benedictus Dominus Deus israel" (Luke 1:68–79)	Lauds, Daily
"Quicumque vult" (actually the Athanasian Creed)	Prime, Daily
"Magnificat anima mea Dominum" (Luke 1:46–55)	Vespers, Daily
"Nunc dimittis" (Luke 2:29–32)	Compline, Daily

As the order, divisions of the text, and actual contents of the psalter varied considerably, there were variant modes of decorating the book. An early and rare example of full narrative illustration of the individual psalms occurred in a Carolingian psalter now in Utrecht (Universiteitsbibliotheek, MS 32/484).[1] In this remarkable book 166 vibrant pen drawings illustrate the psalms. Each composition contains episodic groups of figures which provide literal depictions of passages in the text. Thus in the illustration for Psalm 43 (44), the verse "Arise, why sleepest thou O Lord? Arise and cast us not off in the end" is depicted at the top of the miniature by God reclining in a bed and angels bending over him to awaken him (Pl. 116). In the lower left corner of the drawing a figure lies face down before a temple, an illustration of the verse "For our soul is humbled down to the dust: our belly cleaveth to the earth." The battle scene along the bottom of the

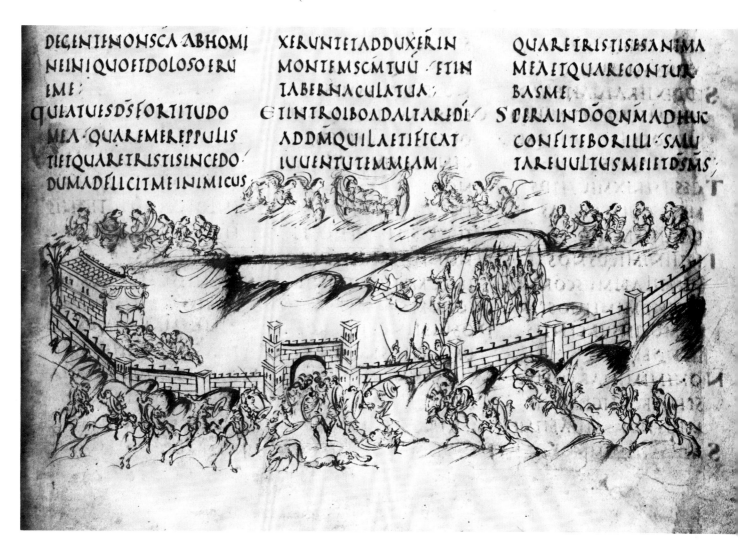

DEGENTEMONSCAABHOMI
NEINIQUOETDOLOSOERU
EME:
QUIATUESDSFORTITUDO
MEA·QUAREMEREPPULIS
TIETQUARETRISTISINCEDO·
DUMADFLICITMEINIMICUS

XERUNTETADDUXERIN
MONTEMSCMTUU·ETIN
TABERNACULATUA:
ETINTROIBOADALTAREDI
ADDMQUILAETIFICAT
IUUENTUTEMMEAM·

QUARETRISTISESANIMA
MEAETQUARECONTUR
BASME
SPERAINDOQNMADHUC
CONFITEBORILLI·SALU
TAREUULTUSMEIETDSMS

116. Psalm 43 (44). Utrecht Psalter, fol. 25 (Utrecht, Universiteitsbibliotheek, MS 32/484)

miniature and the flock of sheep reflect the phrase "Because for thy sake we are killed all the day long: we are counted as sheep for the slaughter." Since not all of the pictorial images relate directly to the text of the Psalms in the Gallican version of St. Jerome, these seem to be best explained by the text of another version, the Hebraicum. It is therefore thought that the Utrecht Psalter may have been copied from an early Christian psalter that was a two- or three-column compendium with the several variants side by side.

Although some scholars believe that the Utrecht Psalter was copied after a late antique prototype, no previous examples of this kind of illustration have survived, and the interpretation of the imagery in the Psalms is so original that it appears to tran-

scend any earlier model that might have been used. Much of the
originality of the Utrecht Psalter may derive from the precocious
environment of the monastery at Hautvillers near Reims, where
it is believed to have been made. It may, as in the case of the Ebo
Gospels, be a product of the patronage of Archbishop Ebo. Al-
though executed in different media, the illustrations of both
manuscripts manifest a similar energtic vibrancy and affinity to
the illusionistic depiction of landscape found in late antique paint-
ing. As in the case of the Ebo Gospels, where the streaky, acti-
vated style of painting permeated other schools of illumination
and survived for decades—as exemplified by the Codex Aureus
of St. Emmeram—so the Utrecht Psalter had a lasting influence.
Similar episodic groups of figures appear in metalwork, crystal
engraving, and ivory carving of the late Carolingian period.
Some ivories, in fact, contain direct repetitions of compositions
found in the Utrecht Psalter.

A few later reflections of the literal illustration of the Psalms in
this same format have survived, but these are eleventh- and
twelfth-century manuscripts that were directly copied from the
Utrecht Psalter at Christ Church, Canterbury, after it was
brought there in about A.D. 1000. Variations of this form of illus-
tration also survive in a few Anglo-Saxon copies where marginal
drawings depict occasional verses of the Psalms. But in these
psalters the program of illustration is considerably reduced.

Two major families of psalter illustration prevailed in the Byz-
antine realm. One of these, perhaps too narrowly called the "mo-
nastic" or "theological" type by J. J. Tikkanen, contains marginal
illustrations adapting either phrases from the Psalms, as in the
case of the Utrecht Psalter mentioned above, or appropriate inci-
dents derived from the Septuagint or the Gospels.[2] These ver-
sions or recensions are varied in iconography, borrowing from a
wide range of sources and often employing unique representa-
tions. This type of psalter is thought to have evolved after the
iconoclastic movement and to have flourished in the eleventh
century.

A second form of the Byzantine psalter employed a variety of
frontispieces before Psalms 1, 50, and 75, and before the Canti-
cles or Odes. Although these can usually be construed as author
portraits of David and the canticlers, they normally were de-
picted as narrative scenes showing incidents from the lives of the
authors. Frequent variations within these categories of psalters
and changes in artistic and liturgical concerns led to transforma-
tions of subject matter and style of these images; nevertheless,
two important examples will illustrate this tradition. In the tenth-
century Paris Psalter (Paris, B.N., MS gr. 139), fourteen full-
page narrative miniatures serve as author-portrait/frontispieces to

the Psalms and Canticles: eight depict incidents from the life of David, two of Moses, and one for each of the Old Testament canticlers Hannah, Jonah, Isaiah, and Hezekiah before their appropriate canticles.[3] These miniatures manifest an extraordinary revival of classical forms and may be a reflection of the epitome of the classicizing style of the so-called Macedonian renaissance. Since this book may have been produced at the Byzantine court, Tikkanen labeled such frontispiece psalters the "aristocratic" type.

A second less spectacular example may have been produced elsewhere. A page now in Baltimore (The Walters Art Gallery, MS W.530B), detached from the Vatopedi Psalter at Mount Athos (Vatopedi MS 761), has been shown by Kurt Weitzmann to be a close provincial reflection and combination of scenes from a Constantinopolitan prototype for such narrative-author frontispieces.[4] This page (Pl. 117) shows three incidents from the life of Moses within one miniature: Moses removing his sandals in the upper left corner, Moses receiving the Ten Commandments from the hand of God in the upper right corner, and Moses teaching the Law to the Israelites at the bottom. The three incidents are thus represented simultaneously, perhaps reflecting three separate miniatures in the now lost archetype, but here each is contained in a separate pocket of space and unified by the continuity of landscape and the repetitive color patterns of Moses' robe. In this case the incidents are a combination of those described in Exodus, when, for instance, Moses was commanded to remove his sandals (3:2): "Do not come near; put off your shoes from your feet, for the place on which you are standing is holy ground," and the opening line of Psalm 77 (78) before which this miniature may have been placed: "Give ear, O my people, to my law." The Vatopedi manuscript can be dated to 1088, for the book contains computational tables to determine the date of Easter which commence with that year.

In western Europe a tradition of placing a group of full-page frontispieces or cycles of miniatures before the Psalms may have begun in England circa 1050, the earliest surviving example of which is the Cotton Psalter (The British Library, MS Cotton Tiberias C. VI) with a series of full-page scenes of the life of David and the Life of Christ. This juxtaposition implied the connection of lineage, since Christ was a descendant of the house of David, as well as an equation of the Old Testament kingship with the New Testament theme of Christ the King. This comparison was particularly appropriate for psalters destined for royal patrons. The choice and mixture of Old and New Testament scenes varied considerably according to the intention of the compiler and the destination of the book. In the St. Albans Psalter now in

117. Moses frontispiece. Folio from Vatopedi Psalter (Baltimore, The Walters Art Gallery, MS W.530B)

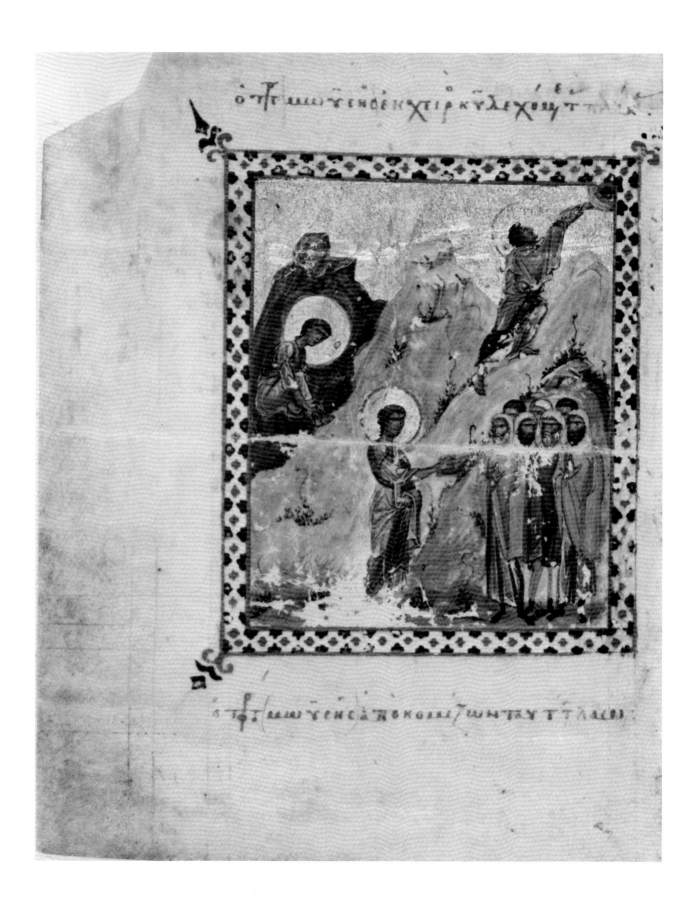

Pl. 117 / 213

Hildesheim, produced in England between 1119 and 1123, forty full-page miniatures illustrate the book.[5] Thirty-nine of these precede the Psalms, of which only two, the Fall of Man and the Expulsion are Old Testament scenes; a portrait of David and New Testament scenes make up the rest. A second portrait of David with his musicians prefaces the Canticles.

Perhaps one of the most elaborate programs of prefatory miniatures is that executed for the Psalter of St. Louis (Paris, B.N., MS lat. 10525) about 1260.[6] It contains seventy-eight full-page miniatures illustrating scenes from the Old Testament, beginning with Cain and Abel making their sacrifices and finishing with the coronation of Saul as the first king of the Israelites. It is probable that some gatherings containing miniatures are missing, particularly scenes of the Creation at the beginning and of the life of David at the end of the sequence. Nevertheless, the surviving miniatures indicate that this program of illustrations was intended as a history of the Israelites, at least up to the time of David as manifested by his Psalms that follow, signifying a parallel with the kingship of St. Louis. The completeness of this narrative cycle is commensurate with a vastly increased number of scenes conceived for the many stained-glass windows of St. Louis's Ste. Chapelle. The text of the Psalms which follows is divided into the eight liturgical parts, each one introduced by a large, ornate foliate initial.

In addition to the prefatory miniatures, which varied considerably in subject matter and number of representations, there evolved in twelfth- and thirteenth-century psalters a series of historiated initials for each of the liturgical divisions. Although these frequently represented David in a number of appropriate activities, many elaborately decorated psalters juxtaposed these scenes in two-part or four-part initials with New Testament scenes that fulfilled the prophecies of the Old Testament. Since many of these thirteenth-century psalters were made for wealthy members of the nobility, additional decoration was placed in the margins. Hybrids, grotesques, satirical scenes such as a hare chasing a hound, or incidents drawn from the Old or New Testament abounded in some of these books. One of the most elaborate psalters of this kind, the Tickhill Psalter in the New York Public Library (Spencer Coll. MS 26), contains scenes of the lives of David and Solomon not only in the initials but also in the open space beneath the text (the bas-de-page).[7]

The Windmill Psalter

Although not one of the most profusely illustrated examples, the so-called Windmill Psalter in the Morgan Library (MS M.

102) is nevertheless one of the most refined and elegant surviving English psalters of the late thirteenth century. Believed to have been made in either Canterbury or East Anglia, it contains on one of its decorated pages a representation of a windmill which some scholars believe might be a clue—as yet unresolved—to its original patron. The book unfortunately is incomplete, missing its Calendar, a folio containing the initial to Psalm 68, and most of the Litany (see Appendix 11).[8] Leaves reunited with the manuscript while it was in the possession of William Morris indicates that it also originally contained the Office of the Dead.

Following the traditional English practice, the Psalms are divided into ten parts, and in this case, a historiated initial also introduced the First Canticle. Heavy, painted branches spring from the initials and extend along the sides of the text into two or three margins, a nascent form of the foliate decoration that continued to grow throughout the margins of the fourteenth-century manuscripts. Line endings, filling out the line of script within the block of the text, contain drawings of animals and grotesques, also a beginning of the growing marginal fantasy that proliferated in the manuscripts of the following century.

The Psalms open with an unusual double-page ensemble of facing initials. A monumental painted B of the "Beatus vir" faces an elaborate pen-flourish E on the opposite page (Colorpls. 16, 17). The remainder of the opening phrase, "—atus vir qui non abiit," is painted on the scroll held by the diving angel below the crossbar of the E. The B is an intricate maze of intertwined foliage and figures. Within the letter is a depiction of the Tree of Jesse showing Jesse reclining in the lower loop, David crowned in the middle, and the Virgin and Child in the upper loop. This image serves as a reduced genealogical tree fulfilling the prophecy of Isaiah (11:1): "There shall come forth a rod out of the stem of Jesse, and a branch shall grow out of his roots," and affirms that Christ is a direct descendant of the house of David, the author of the Psalms. The figure of God at the top of the letter actually represents the Day of Rest after the Creation, for interwoven in the foliage are the creation of the universe, earth and water, the trees, the sun, birds and fishes, and of Adam and Eve. The four major and twelve minor prophets converse and gesticulate in the surrounding foliage, as though commenting on the fulfillment of their prophecies in the coming of the Messiah. The symbols of the four Evangelists in the corner medallions of the surrounding frame confirm the establishment of the New Covenant that replaces the Old Dispensation signified by the representations within the initial.

David's son, Solomon, presides over the red and blue divided initial E surrounded by a deliate filigree of pen flourishes on the opposite page. Enthoned and holding a sword, he points to a

soldier who is about to cut a baby in half, while the woman above appears to consent and the one below, the baby's real mother, protests and begs that the child be given to the false mother in order to spare its life. A naturalistically rendered pheasant occupies the bottom margin and an accurately depicted post windmill appears at the top of the letter. These elements, together with the hybrid human-headed dragon in the line ending, reveal a mixture of realism and fantasy which is beginning to manifest itself in such manuscripts at the end of the thirteenth century.

The decoration of the other initials for the liturgical divisions of the Psalms is less intricate, but is nevertheless equally striking. Many of these initials contain representations that were becoming more or less standardized in the thirteenth century. The initial for the incipit of Psalm 26, "Dominus illuminatio mea," contains a representation of the anointing of David (Pl. 118). This is a reflection of the phrase "The Lord is my light and my salvation," for it signifies that David is purified and filled with the Holy Spirit. This scene is frequently paired with the New Testament equivalent, the Baptism of Christ, in which Christ is purified and filled with the spirit of the Holy Ghost, or even the Presentation in the Temple, where Christ is purified according to the Judaic rite.[9]

In the initial that introduces Psalm 38, "Dixi custodiam vias" (I said, I will take heed to my ways: that I sin not with my tongue), David is shown pointing to his mouth (Pl. 119), as though to reinforce the assertion made in the opening verse, which continues: "I have set a guard to my mouth, when the sinner stood against me. I was dumb." Christ holding a book, the True Word, appears above.

A historiated initial also decorates the beginning of Psalm 51, a remnant of the three-part division of the Psalms which is here incorporated with the usual eight-part division. Withn the Q for "Quid gloriaris in malitia" (Why dost thou glory in malice?) is an unusual representation of the Betrayal of Christ (Pl. 120). This New Testament scene exemplifies the malice, injustice, and deceit that is the subject of the psalm, directed at the wickedness of Doeg. In other psalters this psalm is often prefaced with David killing Goliath, signifying his victory over tyranny and unrighteousness.[10]

The fourth liturgical division of the Psalms commences at Psalm 52. The large D of "Dixit insipiens in corde" (The fool said in his heart, "There is no God") shows a fool standing holding a club and eating a round bread (Colorpl. 18). The club refers to the inequities of mankind, "there is none that doth good," and the bread to verse 5, "Shall not all the workers of inequity know, who eat up my people as they eat bread?"

118. Initial *D* with David Anointed. Windmill Psalter, fol. 24v (New York, The Pierpont Morgan Library, MS M. 102)

119. Initial *D* with David Pointing to His Mouth before Christ. Windmill Psalter, fol. 39v (New York, The Pierpont Morgan Library, MS M. 102)

120. Initial *Q* with Betrayal of Christ. Windmill Psalter, fol. 52v (New York, The Pierpont Morgan Library, MS M. 102)

locum habitationis glorie tue.

Ne perdas cum impiis animam meam: & cum uiris sanguinum uitam meam.

In quorum manibus iniquitates sunt: dextra eorum repleta est muneribus.

Ego autem in innocentia mea ingressus sum: redime me & miserere mei.

Pes meus stetit in directo: in ecclesiis benedicam te domine.

psal. XXVII.

Dominus illuminatio mea: & salus mea: quem timebo? Dominus protector uite mee: a quo trepidabo.

Cum appropiant super me nocentes: ut edant carnes meas.

Pl. 118 / 217

mati sunt sup me: & multiplicati st
qui oderunt me inique.

ui tribuunt mala p bonis detrahe
bant m: qm sequebar bonitatem.

Ne derelinquas me domine deus'
meus: ne discesseris a me.

Intende in adiutorium meum: do
mine deus salutis mee.

psal. XXXIX.

ixi custodiam ui
as meas: ut non
delinquam in
lingua mea.

Posui ori meo
custodiam: cum
consisteret pecca

tor aduersum me.

Mmutui & humiliatus sum & si
lui a bonis: & dolor ms renouat' est.

Concaluit cor meu intra me: & ī me

Psalm 51

Q ñ si uoluisses sachtaum dediss̄: uti
cp holocaustis ñ delectaberis.

S acrificiū dõ sps contbulat: cor cont
tum & humiliatū ōs non despicies.

B enigne fac in bona uoluntate tua sy
on: & edificentur muri ierl̄m.

T unc acceptabis sacrificiū iusticie ob
lationes & holocausta: tunc imponēt
sup altare tuum uitulos.

psal. LII

ᵁO.GᴸᴿIARIS
in malicia: qui
potens es in ini
quitate?
T ota die in
iusticiam cogi
tauit lingua
tua: sicut no

uacula acuta fecisti dolum.

Dilexisti maliciam sup benignitatem:

Pl. 120 / 219

Unfortunately, the beginning of the fifth division, Psalm 68, is missing. Commencing "Salvum me fac, Deus" (Save me, O God: for the waters are come even unto my soul), this psalm usually contains a representation of David immersed in water looking upward in supplication for salvation. But any number of other scenes might be used, such as the Resurrection, or the whale disgoring Jonah, all themes of salvation:[11] in the Psalter of the Breviary of Charles V discussed below, Christ calms the waters that imperil St. Peter.

The joyous opening verse of Psalm 80, "Exultate Deo adiutori nostro jubilate Deo Jacob" (Rejoice to God our helper, Sing aloud to the God of Jacob), usually requires a scene of David as a musician. In the Windmill Psalter he is shown playing a carillon (Pl. 121), but in other psalters he is often shown playing his harp and occasionally being accompanied by other musicians. A similar musical theme dominates Psalm 97, "Cantate Domino canticum novum" (Sing to the Lord a new song). Appropriately in the Windmill Psalter a group of monks sings from an open choir book (Colorpl. 19). But here too, David playing a musical instrument or the New Testament subject of the Annunciation to the Shepherds might be used.

Another vestige of the three-part division, the decorated initial for Psalm 101, "Domine exaudi orationem meam" (Here, O Lord, my prayer), shows King David kneeling and praying before an altar with a cross (Pl. 122). Christ appears in a cloud above. This is the fifth of the Penitential Psalms and serves as a prayer for a person in affliction.

The traditional representation for the initial introducing the vesper cycle beginning with Psalm 109 is the Trinity. Usually God the Father and God the Son are shown seated side by side with the dove of the Holy Spirit hovering overhead. This image reflects the opening verse "Dixit Dominus Domino meo; Sede a dextris meis" (The Lord said to my Lord, "Sit thou at my right hand"). Other appropriate variations for this imagery are representations of the Last Judgment, in which the blessed sit on the right hand of God, or the Coronation of the Virgin, where the Mother of God is shown enthroned to the right of Christ.[12] In the Windmill Psalter (Pl. 123), God the Son is enthroned on the left side of the miniature (the right-hand side of God) holding a book inscribed "Ego sum pastor bonus novi" (I am the new Good Shepherd).

The first of the Canticles, "Confitebor tibi domine" (I will give thanks to thee, O Lord) is accentuated with a historiated initial showing Isaiah being sawed in two (Pl. 124). The traditional belief was that Isaiah was thus martyred in the reign of Manasseh, based upon the oblique reference by St. Paul in his Epistle to

121. Initial *E* with David Ringing a Carillon. Windmill Psalter, fol. 84r (New York, The Pierpont Morgan Library, MS M. 102)

122. Initial *D* with David Kneeling. Windmill Psalter, fol. 102v (New York, The Pierpont Morgan Library, MS M. 102)

123. Initial *D* with the Trinity. Windmill Psalter, fol. 117v (New York, The Pierpont Morgan Library, MS M. 102)

124. Initial *C* with Isaiah Being Sawed Asunder. Windmill Psalter, fol. 152v (New York, The Pierpont Morgan Library, MS M. 102)

nos: & nom̄ tuū inuocabimus.
Domine ds uirtutum conūte nos: &
ostende faciem tuam & salui erim̄.

XVITIE
deo adiutori no
stro iubilate do
iacob.
umite psal
mum & date ty
panum: psalte
rium iocundum cum cythara.
Bucinate in neomenia tuba: in insig
ni die solennitatis nr̄e.
Quia preceptum in israel est: & iudi
cium deo iacob.
Testimonium in ioseph posuit illud
cum exiret de terra egypti: linguam
quam non nouerat audiuit.

Pl. 121 / 221

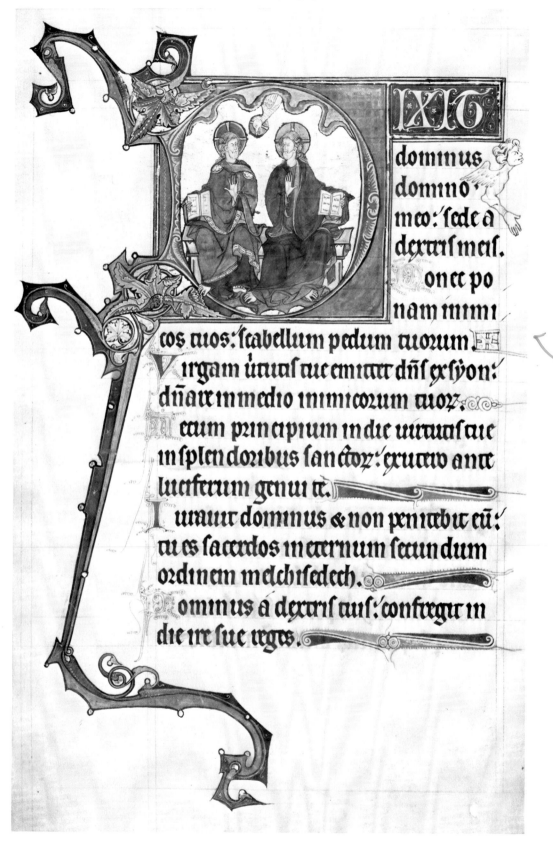

dominus
domino
meo: sede a
dextris meis.
onec po
nam inimi
cos tuos: scabellum pedum tuorum
Virgam virtutis tue emittet dñs ex syon:
dñare in medio inimicorum tuor.
ecum principium in die virtutis tue
in splendoribus sanctor: ex utero ante
luciferum genui te.
Iurauit dominus & non penitebit eū:
tu es sacerdos in eternum secundum
ordinem melchisedech.
Dominus a dextris tuis: confregit in
die ire sue reges.

Pl. 123 / 223

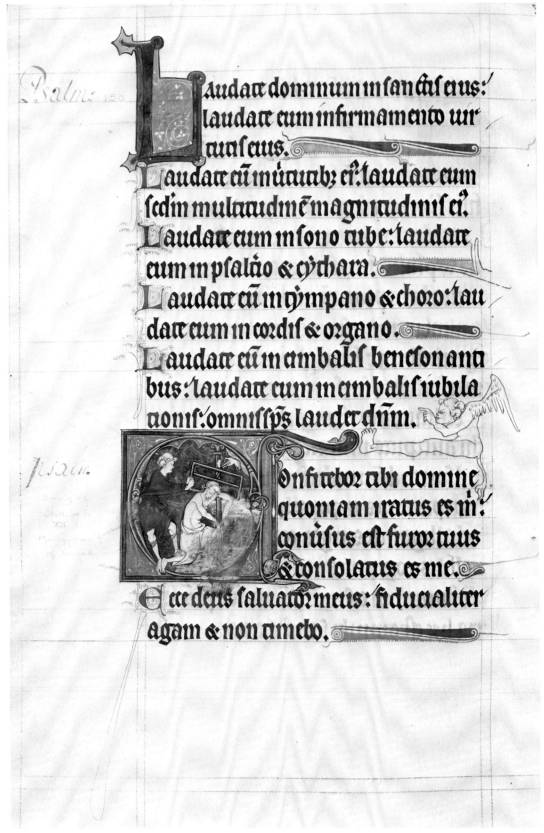

Psalmus

audate dominum in sanctis eius:
laudate eum in firmamento vir-
tutis eius.
Laudate eum in virtutibz eius: laudate eum
secundum multitudinem magnitudinis eius.
Laudate eum in sono tube: laudate
eum in psalterio & cythara.
Laudate eum in tympano & choro: lau-
date eum in cordis & organo.
Laudate eum in cimbalis benesonanti-
bus: laudate eum in cimbalis iubila-
tionis: omnis spiritus laudet dominum.

Psalm

Onfitebor tibi domine
quoniam iratus es m:
conversus est furor tuus
& consolatus es me.
Ecce deus saluator meus: fiducialiter
agam & non timebo.

the Hebrews (11:32–37): ". . . and the prophets who by faith conquered kingdoms, . . . but others were racked, not accepting deliverance, that they might find a better resurrection . . . they were stoned, they were cut asunder. . . ." Although apocryphal, the scene of Isaiah's martyrdom prefigures that of Christ in the New Testament and of the Christian saints.

The bold, vigorous style of painting in these initials and the strong, angled branches or rinceaux are representative of manuscript illumination in England in the second half of the thirteenth century. Both Continental influences in the style of the figures and an East Anglian predilection for naturalistic marginalia and elaborate decoration are evident and have led to the suggestion that the Windmill Psalter is a transitional work between the court style of the illuminators of Henry III at Westminster and the East Anglian style.[13]

7 / Books for the Divine Office

t he development of the various services of public worship
paralleled the use of the eight canonical hours of daily de-
votions for the recitation of the Psalms. To the Psalms
were added responses, chants, and prayers resulting in the for-
mulation of the Divine Office. At first a variety of books, the
psalter, the office lectionary with the lessons, an antiphonal with
the chants, and a martyrology with the suffrages or commemo-
rative prayers to the saints were created as separate books for use
in the Divine Office. By the thirteenth century much of this ma-
terial was put together into a single volume, the breviary. The
breviary, which was used primarily by the clergy, thus became
the principal service book for the Divine Office, the equivalent of
the missal for the Mass, and was arranged according to a similar
structure following the liturgical year. The eight-part division of
the psalter and its subsequent adaptation for purposes of private
devotion resulted, by the end of the thirteenth century, in the
formulation of the Book of Hours.

As the gradual is the choir book that is used with the missal in
the celebration of Mass, so the antiphonary is the choir book
used with the breviary in the performance of the Divine Office.
Like the gradual, antiphonaries are usually large manuscripts for
easy visibility by the members of the choir, and are often in two
to six volumes. The major divisions of the text are the same as
for the missal and breviary, thus these choir books contain the
chants for the offices of the Temporale, Sanctorale, and Com-
mon of the Saints.

Breviaries and antiphonals exist in large numbers and many of
them are exceedingly complex and varied in contents and decora-
tion. The following examples were chosen not only for their ar-
tistic quality and importance, but also because of the fairly
straightforward relationships between their texts and decoration.

226

The Breviary of Charles V

Like the missal, the breviary usually contained a Calendar and a series of devotions for every Sunday and weekday throughout the ecclesiastical year, arranged according to the Temporale, the Sanctorale, and the Common of the Saints. Originally based upon and developed from the psalter, breviaries usually contained the Psalms, arranged in their biblical order but divided into eight sections corresponding to their daily readings. The psalter in the office book was accompanied by antiphons and followed by a list of venerated saints or Litany. The breviary also might contain special offices dedicated to the Virgin, or for the dead, as well as for the dedication of a church. The contents of the devotions differ, however, from those of the missal: none of the sacramental rites is included. The devotions begin at matins with an invitatory and hymn and continue with three nocturns consisting of antiphons, psalms, lessons and responses, and the hymn "Te Deum." They continue at lauds with an antiphon, seven psalms, a capitulum and response, the Benedictus with response and a prayer, and then repeat similar elements throughout the rest of the offices during the day.

Elements of the Divine Office were formulated in the earliest period of Christianity, but the oldest surviving complete breviaries date from the eleventh and twelfth centuries. Originally they were destined for the clergy and were largely used in monastic communities, but in the thirteenth and later centuries their use expanded to the nobility. It is in these books destined for the laity that we find some of the most elaborate programs of illumination, decorative borders around incipit pages, miniatures illustrating the main divisions of the Psalter, the Calendar, liturgical feasts and saints' days, and even marginal ornament, some pertaining to the particular office, and some with fanciful grotesques and secular content.

No two breviaries are exactly alike, as the list of saints in the Litany and Calendar vary with different dioceses and even according to personal preferences. Many of the monastic breviaries are virtually unadorned, while some destined for the laity are exceedingly complicated and richly illuminated. Nevertheless, the examination of several pages from one manuscript can demonstrate the representative structure and types of illumination in such office books.

Because breviaries frequently contained long and elaborate texts for each of the offices for all of the feast days of the year, they were often bound in several volumes. The usual division was in two parts, the Calendar, Temporale, Psalter, Sanctorale, and Common of the Saints for the period from Advent to Easter,

227

or Winter portion, and the same sections for the feasts between Easter and Advent, or the Summer part. The Belleville Breviary, illuminated by Jean Pucelle before 1343 (Paris, B.N., MS lat. 10483–84) is such a two-volume breviary.[1]

For convenience, however, we shall examine a one-volume breviary, recorded in the 1380 inventory of Charles V of France, in the Bibliothèque Nationale in Paris (MS lat. 1052), as a representative fourteenth-century breviary.[2] Although there is no absolute proof that the book was made for Charles V, the style of the painting and the apparent portrait of the king kneeling before God in the miniature for Psalm 109 strongly suggest that it was illuminated for him by the court painter Jean Le Noir.[3] This artist was not only trained in the tradition of Jean Pucelle, the illuminator of the Hours of Jeanne d'Evreux and the Belleville Breviary, he actually copied the bas-de-page illustrations of the psalter in the latter manuscript, which was also in the collection of Charles V, in the Breviary of Charles V.

The Calendar of the Breviary of Charles V occupies the first six leaves of the text and contains references to saints particularly venerated in Paris (see Appendix 12). It is decorated with depictions of the Signs of the Zodiac and the Labors of the Months. Thus for the month of May a falconer, representative of hunting with birds of prey, and the sign of the Gemini are shown. These figures signify the passage of the liturgical year on earth in terms of man's activities and in the heavens by the motions of the stars and the cycle of the dominant constellations. Such representations had been common throughout medieval art and were especially prevalent in the Calendars of books of private devotion in the later Middle Ages.

The devotions for the Temporale follow. The rubrics are in French; thus at the beginning of the Temporale we find "Ci commence le bréviaire selonc l'usage de Paris. Premierement en l'Avent de Nostre Seigneur" (Here begins the breviary according to the use of Paris. First in the Advent of our Lord). Beginning at the antiphon for the psalm for the Eve of the First Sunday in Advent is an appropriate miniature of Isaiah prophesying the coming of the Messiah to a group of sleeping persons, one of whom awakens to hear the prophet (Pl. 125). In the corner of the miniature stands the Virgin crowned, the fulfillment of his prophecy "Behold a Virgin shall conceive. . . ." Marginal figures play musical instruments as if in celebration of the announcement. One figure, however, holds a flask, perhaps a urinal as an irreverent juxtaposition of those who ignore the prophecy with those who heed it, or perhaps a vessel connoting the Virgin's purity. Delicately drawn butterflies and birds flit about in the marginal foliage.

A series of miniatures illustrating Old Testament scenes intro-

125. Isaiah Announcing the Coming of the Messiah. Breviary of Charles V, fol. 7r (Paris, Bibliothèque Nationale, MS lat. 1052: Photo Bibl. Nat., Paris)

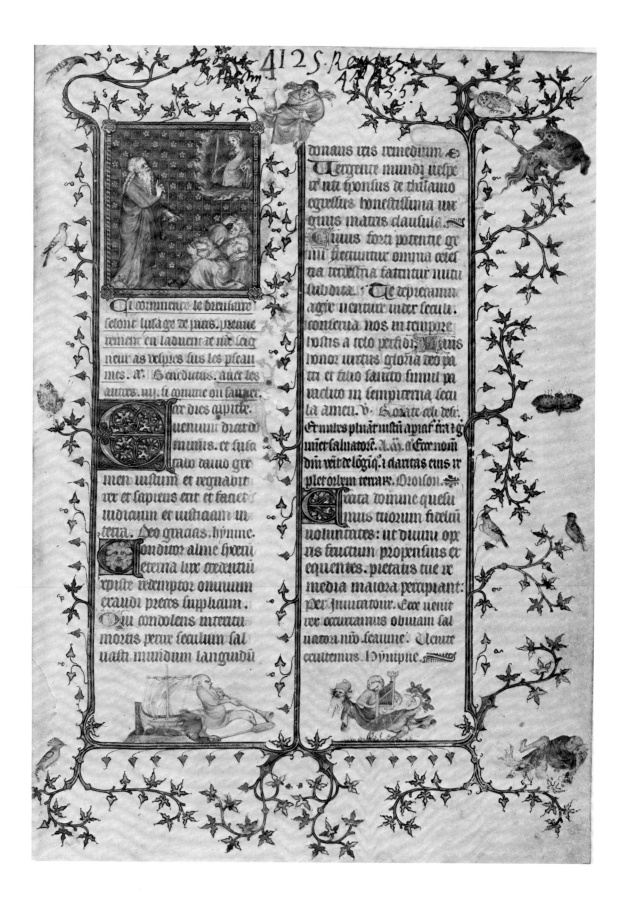

Pl. 125 / 229

duces the offices of various days in Septuagesima, a period of approximately seventy days before Easter. These miniatures, such as that of Moses and the Burning Bush for the Fourth Sunday in Lent, refer to the subject matter of the lesson read for that day at matins.

The feast of Corpus Christi or Corpus Domini occurs in the Temporale on the Thursday after Trinity Sunday in June. In the Breviary of Charles V it is illustrated with a miniature showing a priest elevating the Host and assisted by a kneeling angel (Pl. 126). This observance was proclaimed by Pope Urban IV in 1264.

Normally the Psalter of the breviary preceded the Temporale and Sanctorale, but in the Breviary of Charles V, it occurs between these two sections. Here, the Psalms are arranged according to their biblical or numerical order, but are divided into eight parts according to their ferial or weekday usage and are interspersed with appropriate antiphons. As in the case of the psalter, the initials introducing these sections were normally illustrated with scenes of the life of David applicable to the psalm decorated, but in this case an unusual decorative program intrudes. The illuminator, Jean Le Noir, copied the iconography of the scenes in the bas-de-pages from the Belleville Breviary. As in the case of the earlier manuscript, Psalm 68, which begins "Salvum me fac Deus, quoniam intraverunt aquae usque ad animanm meam" (Save me, O God, for the waters threaten my soul), is prefaced not by the usual image of David up to his neck in water, but the equally appropriate image of Christ appearing to St. Peter adrift in his storm-tossed boat on the Sea of Galilee (Pl. 127). Jean Le Noir also copied the equally innovative bas-de-page scenes with repesentations of the Seven Virtues and their opposing Vices, and the Seven Sacraments. Thus below the beginning of Psalm 68 are Samson and Delilah, signifying Weakness, on the left, opposed to the female personification of the virtue of Strength on the right. The middle scene represents the Sacrament of Confirmation, with a young boy standing in the portal of church receiving the Holy Spirit through the blessing of a bishop.

Undoubtedly, the bas-de-page of the Last Judgment below the beginning of Psalm 109 was also copied by Jean Le Noir from a now lost page in the Belleville Breviary, but the miniature prefacing the psalm was given a contemporary context. The Trinity normally would have been represented in this space, but here a king, a close likeness of known portraits of Charles V, kneels before Christ (Pl. 128). Since the psalm begins "Dixit Dominus Domino meo: sede a dextris meis" (The Lord said to my Lord, "Sit at my right hand"), this miniature has rightly been construed

126. Elevation of the Host. Breviary of Charles V, fol. 157r (Paris, Bibliothèque Nationale, MS lat. 1052: Photo Bibl. Nat., Paris)

127. St. Peter in a Boat (Ps. 68: "Salvum me fac"). In bas-de-page, Samson and Delilah, Confirmation, Fortitude. Breviary of Charles V, fol. 238r (Paris, Bibliothèque Nationale, MS lat. 1052: Photo Bibl. Nat., Paris)

128. Kneeling King (Charles V?) before Christ Enthroned (Ps. 109: "Dixit dominus domino meo, sede a dextris meis"). In bas-de-page, Last Judgment, Heaven and Hell. Breviary of Charles V, fol. 261r (Paris, Bibliothèque Nationale, MS lat. 1052: Photo Bibl. Nat., Paris)

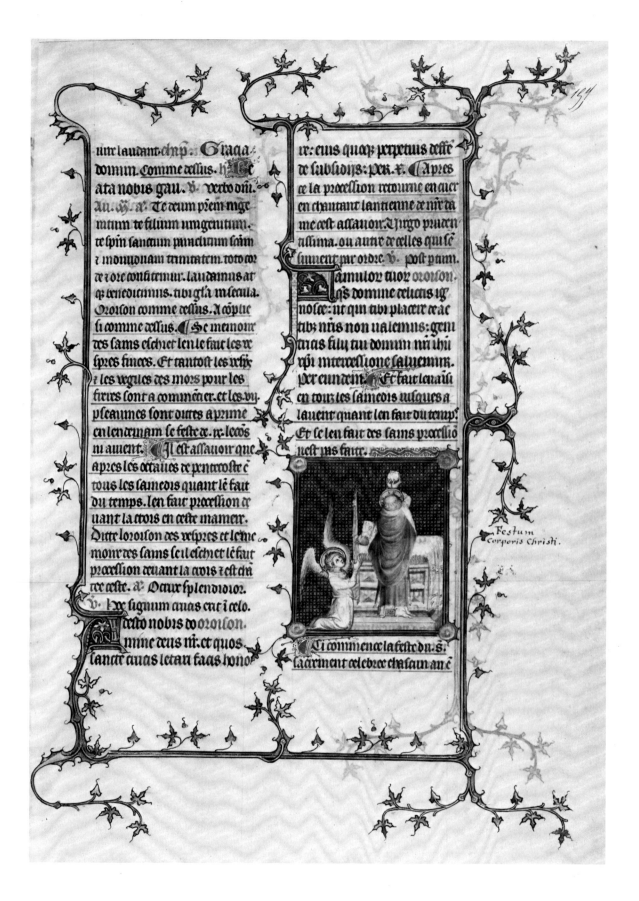

Festum
Corporis Christi.

Pl. 126 / 231

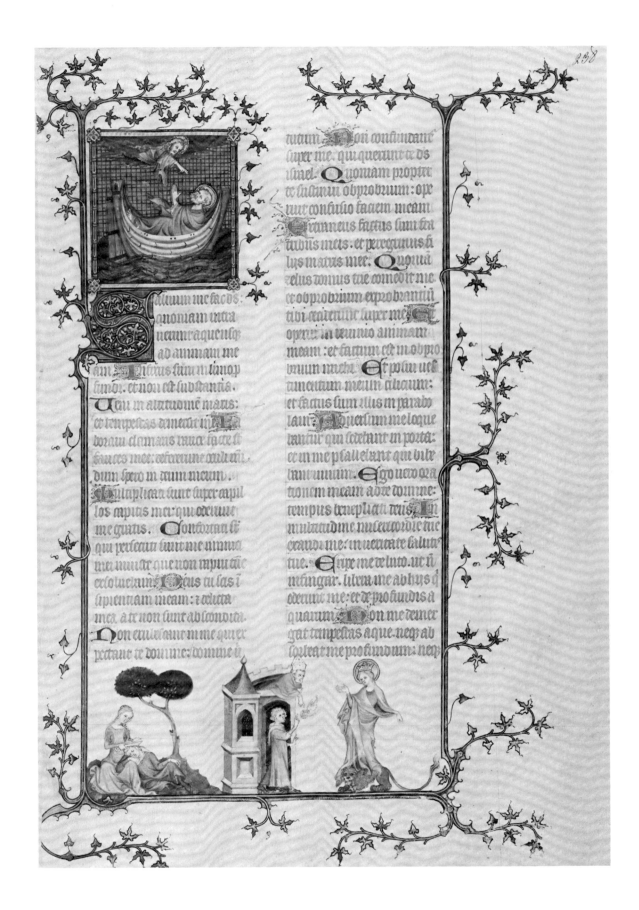

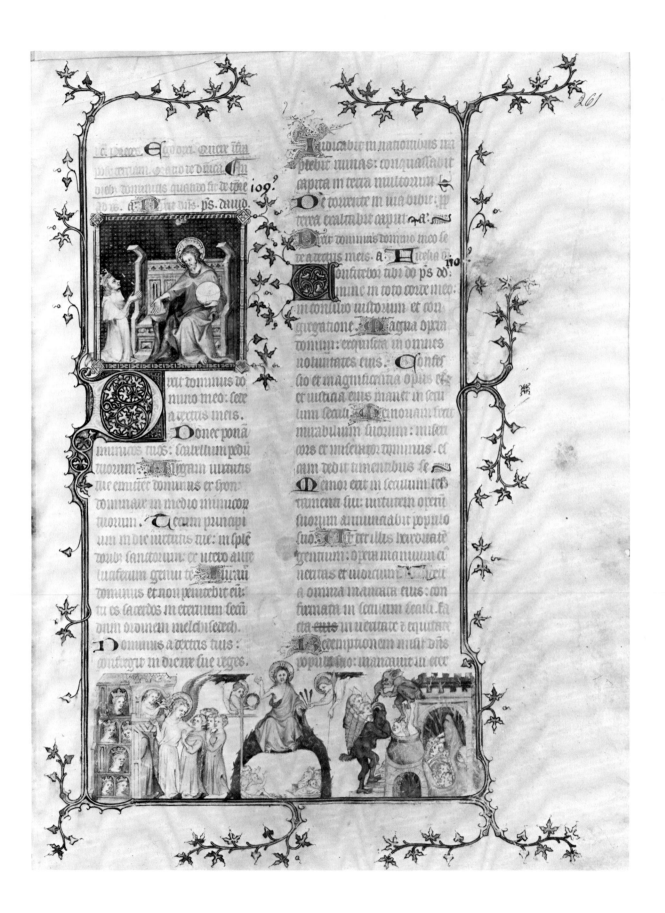

Pl. 128 / 233

as a reflection of the exalted view Charles V held of his position as king of France.[4]

Two other pages will exemplify the copious illustration of the Sanctorale of the Breviary of Charles V. Both of these are feast days that are particularly revered in France: for St. Louis (August 25), and for SS. Denis, Rusticus, and Eleutherius (October 9). The miniature prefacing the feast of St. Louis shows Louis IX, who died in 1270 and was canonized in 1297 because of his saintly life as king of France, enthroned holding a monstrance with a thorn from the Crown of Thorns. This was one of the major Christian relics that St. Louis obtained in Constantinople in 1240 and brought back to France to be housed in the elaborate architectural reliquary chapel, the Ste. Chapelle. The Feast of St. Denis, the patron saint of France, who was martyred in 258, is introduced by the miraculous Last Communion administered by Christ to the saint in prison before his execution by beheading. In all, the breviary contains 243 miniatures, of which there are 186 scenes for the saints' days of the Sanctorale. Only two illustrations, representations of an apostle and of a martyrdom, adorn the Common of the Saints. Such copious illustration is representative of the elaborate program of miniatures that adorned breviaries made for the nobility in the fourteenth and fifteenth centuries.

The Beaupré Antiphonary

The large choir books or antiphonaries made to contain the chants for the Divine Office usually consisted of several volumes. In the multivolume set considered here, the Beaupré Antiphonary (Baltimore, The Walters Art Gallery, MSS W.759–762), volume 1 contains the chants for the office according to the three divisions, the Temporale, Sanctorale, and Common of the Saints, from Easter to the Assumption of the Virgin; volume 2 from the Asssumption to Christmas; and volume 3 from Christmas to Easter. A fourth volume now contains additions made to these three volumes in the fifteenth through seventeenth centuries (see Appendix 13).[5]

The internal elements of text consist primarily of antiphons or anthems from which this choir book gets its name, invitatories, versicles, and responses as well as indications of the opening words of the hymns for the canonical hours throughout the liturgical year. Most of the elaborate historiated initials introduce the first response at matins of principal feast days, but some important vigils are also articulated with historiated initials for the

opening anthem to the Psalms at vespers. Exceptions to this careful hierarchy of ornament, but entirely appropriate, are the historiated initials for the anthem to the Magnificat at Epiphany, for the anthem to lauds at Easter, for the anthem to the Benedictus on Easter Monday, for the Te Deum in volume 3, and for the hymn for Christmas Day in volume 3.

The Beaupré Antiphonal, believed to have been produced at Cambron in western Flanders, is remarkable not only for its large-scale illuminations but also for the completeness of information we have concerning it. Consisting of three volumes containing the office chants according to Cistercian usage for the entire liturgical year, the antiphonal contains in its first volume the following inscription:

> The book of the Church of St. Mary of Beaupré. Which was written in the year of the incarnation of the Lord, one thousand two hundred and ninety. If anyone steals it, let him be anathema. If anyone devoutly and honorably handles and uses it, let him be blessed. Amen.

In addition, two kneeling figures in the outer margin of the page containing the response for matins of Easter (Colorpl. 20) provide clues to the identity of the Cistercian nunnery for which the volumes were made. Next to the initial a kneeling lady, "Domicella de Viana," appears within a small Gothic chapel, and below her "Domicella Clementia" kneels on the foliate joint of the frame. These ladies are members of the Viane family, which is documented as benefactors of a Cistercian nunnery of St. Mary of Beaupré near Grammont in Flanders. At the beginning of the third volume a monk, shown in a little Gothic cell in the bottom margin, holds a scroll containing the inscription "Ego Johannes scripsi hunc librum" (I, John, have written this book) indicating that he was the scribe of the third volume. Since no scriptorium is documented at Beaupré, Dorothy Miner has suggested that Brother John may have been active at the mother house at Cambron, only fifteen miles away.

The elegant page with the Beaupré inscription also contains the rubric "In sanctissima vigilia pasche ad vesperas super psalmos antiphona" (On the most holy vigil of Easter for vespers, the antiphon before the psalms), all of which faces the incipit of the antiphon for the solemn Paschal vigil office: "Alleluya, alleluya" (Pl. 129). A monumental initial *A*, eight lines high, contains the scene of Christ in Limbo pulling Adam and Eve from the jaws of Hell, while above, three angels play musical instruments. Painted bars emanate from the letter in the top and inner margins, bend at the corners of the page in broad cusped joints filled with deco-

129. Opening inscription and initial *A* with Harrowing of Hell. Beaupré Antiphonary, Vol. 1, fols. 1v–2r (Baltimore, The Walters Art Gallery, MS W.759)

rative leaves, and sprout into rudimentary branches in the outer margin. This form of decoration is representative of a continuing development of such ornament seen in an earlier English form in the Windmill Psalter. The three-margin frames with an increased number of sprouting rinceaux in the Breviary of Charles V manifest a later fourteenth-century evolution of this decoration.

The decorated antiphon for the vigil of Easter begins the Temporale in this first volume of the Beaupré Antiphonal. A larger and even more splendid initial, however, opens the first response for matins on Easter Day (Colorpl. 20): "Angelus Domini descendit de caelo" (The Angel of the Lord descended from heaven).

The historiated *A*, ten lines high, contains the Three Marys at the Tomb being informed that Christ had risen, and above, the Resurrection of Christ is flanked by two angels while three Roman soldiers sleep. It is here that we find the portraits of the two ladies of the Viane family in the outer margin.

The Temporale proceeds through the feast of the Trinity to just before the feast of the Assumption of the Virgin, which opens the second volume. At the end of the Temporale are the chants for the Office of the Dedication of a Church (Pl. 130). The placement of this office here is appropriate, for it precedes the feast of the Assumption of the Virgin, and the inscription states that the volumes were made for a church dedicated to the Virgin Mary. We have seen a similar placement of the Mass for the Dedication of a Church in the proximity of the feast of St. Martin, one of the patron saints of Weingarten Abbey, in the Berthold Missal. The initial shows a bishop, in alb, dalmatic, chasuble, and mitre, holding a crozier and followed by four clerics, one holding a book, another an aspergillum for sprinkling holy water, approaching from the left while four nuns are shown kneeling through the half-open door of the porch of their church. Undoubtedly this scene depicts the dedication of the Church of St. Mary of Beaupré.

A lively marginal scene occupies the bas-de-page. Showing the death of Dives, it is a continuation of the narrative of the parable begun in a similar marginal illustration on folio 60 beneath an initial of the Crucifixion introducing the responsorium for Trinity Sunday. Dives lies on a bed, a devil wresting his soul from his mouth, while his widow stands at the foot of his bed in an attitude of despair. At the right, a youth steals moneybags from a chest. A parable of avarice and charity, in the context of the Dedication initial, this marginal scene may be a moralization on a *vanitas* theme: one cannot take one's riches with one after life. Perhaps it is also a reference to the charitable patronage of the Viane family on behalf of the church shown above. Throughout many other pages in the book similar marginal scenes once abounded, but many of them were erased, perhaps because of their frivolous, distracting, or even risqué content.

The Sanctorale begins with no major rubrics or decoration, although the first feast of this section, that of the vespers to St. Benedict (March 21) is prefaced by a small initial showing the saint with his nurse. The feast of the Annunciation (March 25) however, contains a larger initial commencing the responsorium "Missus est gabriel" (Gabriel was sent), within which is an elegant representation of the Annunciation. In the lower margin is a vignette of late thirteenth-century life: a fishmonger selling his wares to two women and a boy.

130. Initial *O* with Dedication of Abbey of Beaupré. Beaupré Antiphonary, Vol. 1, fol. 90r (Baltimore, The Walters Art Gallery, MS W.759)

per verticem montium Responsorium

..naue runt faciem tuam

pli coronis au re is.

et dedicaue runt alta re dom

no. Et facta est leticia magna

in popu lo In ynmis et cō

fessionibz benedice bant do mi num.

Et facta R In ynmis et cōfessio nibz

After the feast of St. Lawrence (August 10) no further initials appear. The remaining fifty folios or so contain the offices for the Common of the Saints and a portion of the Te Deum. Subdivisions of these texts are indicated by elaborate pen-flourish initials.

The second volume contains the office chants for feasts from before the Assumption of the Virgin to Christmas. The first ninety-six folios contain the antiphons, versicles, responds, and invitatories in the Temporale for Saturdays in this period. Since no major feast days are indicated here, the decoration continues as in the Common of the Saints of the previous volume, with large, elaborately worked pen-flourish initials. Thus the first decoration (Pl. 131), a large red and blue initial S ("Sapientia edificavit sibi domum" [Wisdom builds her house]), commences the Magnificat antiphon for the vespers on the Saturday before the first Sunday in August. Painted historiated initials resume in the Sanctorale beginning with vespers for the vigil of the Assumption of the Virgin on folio 97. The response, "Vidi speciosam" (I saw her fair as a dove), begins the feast of the Assumption, and contains in the large initial U (V) the Entombment of the Virgin in the lower register and the Coronation of the Virgin above (Pl. 132). In the bas-de-page below the text two fighting hybrids have been erased. The Common of the Saints begins after the feast of St. Andrew (November 30), although it seems likely that leaves with the feast of St. Nicholas (December 6) and the first leaf of the Communale are missing. The Communale and part of the Te Deum occupy the remainder of the volume.

The third volume contains the office chants for the feasts from Christmas to Easter, and thus rounds out the cycle of the liturgical year. Commencing with the vigil of the Nativity, an initial A begins the antiphon "Antequam convenirent" (Before they came together) with a representation of the Visitation, a traditional image for this position. In the bas-de-page is the portrait of Brother Johannes, the scribe who wrote at least this volume. A large initial H begins the response "Hodie nobis celorum rex" (This day unto us the King of Heaven), for matins of Christmas Day. Within the letter is the Nativity, while above the crossbar is the Annunciation to the Shepherds.

The Temporale would have ended with the chants for the offices of Good Friday, but ten leaves are missing and only one damaged folio with the response for Good Friday has survived in the collection of the Victoria and Albert Museum.

The Sanctorale commences with the feast of St. Stephen (December 26) and ends with a repeat of the feasts of St. Benedict and of the Annunciation, which also appear in volume 1. Because of the variable dates for Easter, they conveniently reappear here

131. Initial S. Beaupré Antiphonary, Vol. 2 (MS W. 760), fol. 1r (Baltimore, The Walters Art Gallery, MS W.759)
132. Initial U (V) with Entombment and Coronation of the Virgin. Beaupré Antiphonary, Vol. 2, fol. 100r (Baltimore, The Walters Art Gallery, MS W.760)

ria gra plena Dns tecum. R.

pdi

specio

sam sic

colum

bam

ascendentem desup ruios aqua ru

cuius inestimabilis odor e

Pl. 132 / 241

for the times that they fall before Easter. Then follows the Common of the Saints, the Te Deum, and a variety of other hymns, some of which are now partially missing.

Inscriptions added to these books, perhaps in the seventeenth century, suggest that the Beaupré Antiphonal originally consisted of six volumes, three for the side of the choir on which the abbess sat, and three for the side of the prioress. The first and the third volumes of the Baltimore set were for the side of the abbess, the second for that of the prioress. Three other volumes, dated 1289, would have neatly complemented the surviving group of volumes but were destroyed in a fire at Sotheby's in 1863.[6]

Some of the surviving initials and pages in scattered European collections appear to have been cut from either the Walters volumes or the destroyed ones. One of the most elaborate of these, a page with antiphons for the vespers of the feast of St. Catherine, is now in the Ashmolean Museum in Oxford (Colorpl. 21). Its extended rubric is written in multicolored letters, in vermillion, blue, dark pink, gold, and green, and the opening initial contains the standing figure of St. Catherine. This page appears to have been excised from the Sanctorale of the second volume in the Walters Art Gallery. Since these choir books were used over an extended period of time, some pages were removed and many substitutions as well as alterations and additions were made over the centuries. A fourth volume in the possession of the Walters Art Gallery now contains many of the emendations of the fifteenth to the seventeenth century. In all, fifty historiated initials have survived.

8 / The Book of Hours

uring the period from the tenth to the thirteenth century a calendar indicating the feast days of the saints, various antiphons, prayers, and finally lessons were added to the Psalms to create the offices or services of worship which were to be read during the canonical hours of each day. The principal devotional sequence was centered around the veneration of the Virgin Mary and became known as the Little Office or Hours of the Virgin. The evolution of this text through the twelfth and thirteenth centuries as an appendage to both the psalter and the breviary was no doubt encouraged by the pervasive cult of the Virgin. By the end of the thirteenth century, however, this office and other associated elements had become sufficiently long and complex to be produced and used as a separate entity, the Book of Hours. In the fouteenth century it supplanted the psalter as the principal text for private devotion, primarily because it was destined, not for the clergy as was the breviary, but for the laity.

The various offices in the Book of Hours were divided into the same eight canonical hours as the breviary; its contents, however, were not organized according to the Temporale, Sanctorale, and Communale, but according to special daily devotions on specific themes. Thus in addition to the Office of the Virgin, the essential text of the Book of Hours, there also evolved the Hours of the Cross, the Hours of the Holy Spirit, the Office of the Passion, and the Office of the Trinity. Since these books were often destined for members of the nobility or of the wealthy merchant class in a variety of different dioceses, the individual predilections of patrons and the requirements of local usage often determined which texts would be included. Thus considerable variety occurs in the contents and in their order in Books of Hours, and it is extremely difficult to select a typical

example. Nevertheless, certain basic contents make up most normal Books of Hours, and the degree of variation or elaboration of these contents reveals the complexity and peculiarities of usage of many of the most lavish examples.[1]

The principal text of the Book of Hours was the Little Office of the Virgin. Divided into eight canonical hours similar to those of the Divine Office in the breviary, it nevertheless contained fewer elements. As can be seen in the table of contents for a normal Hours of the Virgin (Appendix 14), matins begins with the versicle "Domine labia mea aperies"; the offices of lauds through vespers commence with "Deus in adiutorium meum" and compline begins with "Converte nos deus salutaris noster." These eight devotions then continue with a variety of responses, hymns, psalms with antiphons and capitula, and in matins with at least three lessons as well as canticles and prayers. Variations in the text, particularly in the antiphons and capitula for matins, lauds, and vespers can often help to identify the diocese in which the book was intended to be used, but further research has indicated that many more of the variables need to be recorded and compared before these indications can be considered conclusive.[2]

In the early Books of Hours other texts were used in conjunction with the Office of the Virgin (see Appendix 15). A Calendar was necessary to indicate the feast days of the saints. The Seven Penitential Psalms were included, followed by a Litany of saints invoked to grant mercy to the supplicant. A Vigil or Office of the Dead was often included. This was not only said around the bier of a deceased person the eve before the morning of burial, but also was read daily as a reminder of the necessity of repentance in preparation for the Last Judgment. Frequently a long series of prayers or commemorations—the Suffrages of the Saints—were added, to be read on their feast days. These texts formed the basic core to which were later attached a series of other elements such as excerpts from the four Gospels, the narrative of the Passion of Christ derived from the Gospel of St. John, votive prayers to the Virgin, occasionally offices for the weekdays in addition to those already noted above, and a recitation of the Fifteen Joys of the Virgin and the Seven Requests to the Savior. Occasional masses might also be added.

In very elaborate Books of Hours the number and complexity of the texts were considerably expanded. Thus in the *Petites Heures* (Paris, B.N. MS lat. 18014) and *Très Riches Heures* (Chantilly, Musée Condé), both made for the duke of Berry, and in the Hours of Catherine of Cleves (Pierpont Morgan Library, MSS M. 917 and 945), a Dutch manuscript of about 1445, the seven additional weekday offices and their masses were included: The Sunday Hours of the Trinity, the Monday Hours of the

Dead, the Tuesday Hours of the Holy Ghost, the Wednesday Hours of All Saints, the Thursday Hours of the Blessed Sacrament, the Friday Hours of the Compassion of God, and the more common Saturday Hours of the Virgin.

As L. M. J. Delaissé has suggested, regional variations in the contents can be significant for localizing problematic manuscripts.[3] Generally, French Books of Hours include the *Sequentiae* of the Gospels, the Fifteen Joys of the Virgin, and the Seven Petitions to the Lord, while Dutch Books of Hours omit them. Sometimes a special office of regional significance was created, as in the Office of St. Louis, denoting special usage in Paris, which appears in the Hours of Jeanne d'Evreux, queen of France.[4] Even the order of the texts in the manuscript might be useful in shedding light on the origins of a Book of Hours, but as we shall see, two books apparently produced in the same milieu and decorated in part by the same artist might have different contents and sequence of texts.

In the late fifteenth century in France "mixed" Books of Hours became prevalent. In these manuscripts the texts for several of the offices, for instance, for the Hours of the Virgin, Hours of the Cross, and Hours of the Holy Ghost, might be grouped together for prime, tierce, sext, none, vespers, and compline. As a result, if these texts were illustrated, the narrative sequence of miniatures for the Hours of the Virgin might be interspersed by scenes of the Passion and illustrations appropriate for the Hours of the Holy Ghost. These mixed hours need to be studied more thoroughly in order to determine if there were any significant regional variations in their evolution.

As in the case of the missal, breviary, and Psalter, Books of Hours, in order to be used properly, were prefaced by a Calendar. It listed the major ecclesiastical feasts not only of the temporal cycle but also of the saints, and in particular those of saints revered in specific dioceses. When one compares the saints listed in the Calendar with those in the Litany, which follows the Penitential Psalms, and with the prayers to the saints included in the Suffrages, usually at the end of the manuscript, one can sometimes determine whether the destination of the book was changed before the Calendar was inserted.[5] Sometimes the lines of the Calendar are written in alternating red and blue ink with gold reserved for major feasts, but most often, these saints' names are accentuated in red, in contrast to the black ink used for the remainder of the listings.

From an early moment in the Middle Ages it became the custom to decorate calendars with the Signs of the Zodiac and the Labors of the Months.[6] These miniatures indicated the cosmic passage of time and the annual cycle of terrestrial activities com-

mensurate with the cycle of the liturgical year. This tradition reached its fullest expression in the Calendars of Books of Hours, and in particular in the full-page illustrations to the *Très Riches Heures* painted by the Limbourg brothers just before their deaths in 1416. They placed the astrological signs in a lunette at the top of the page and painted astonishing landscapes as the settings for the Labors of the Months (Pl. 133). These secular scenes might vary from manuscript to manuscript, but normally they were equated with the months and signs as follows:

January	Aquarius	Feasting
February	Pisces	Sitting by the fire
March	Aries	Pruning trees
April	Taurus	Planting a garden or picking flowers
May	Cancer	Hawking
June	Gemini	Harvesting hay
July	Leo	Reaping corn
August	Virgo	Threshing wheat
September	Libra	Harvesting or treading grapes
October	Scorpio	Ploughing and sowing
November	Sagittarius	Gathering acorns for pigs
December	Capricorn	Killing the pig or baking bread

Here again, variations in the labors depicted might be symptomatic either of regions with different climatic conditions or of the innovations of a particular miniaturist.

The decoration of normal Books of Hours, particularly the cycles of narrative miniatures for the various offices and canonical hours, soon became generally standardized. Although there might be some regional variations, the traditional sequence of miniatures for the Hours of the Virgin was usually as follows:[7]

Matins	Annunciation
Lauds	Visitation
Prime	Nativity
Tierce	Annunciation to the Shepherds
Sext	Epiphany
None	Presentation at the Temple
Vespers	Massacre of the Innocents or Flight into Egypt
Compline	Coronation of the Virgin

Since this office was devoted to the glorification of the Virgin, these scenes illustrating the infancy of Christ therefore emphasized the Virgin's role as the Mother of Christ.

But occasionally the Hours of the Virgin were illustrated with the scenes of the Passion of Christ, particularly if no opportunity

133. February scene. *Très Riches Heures* of the Duke of Berry, fol. 2v (Chantilly, Musée Condé: Photo Giraudon)

Pl. 133 / 247

was provided for such a cycle in the Hours of the Passion or Hours of the Cross. These scenes might be as follows:[8]

Matins	The Betrayal of Judas
Lauds	Christ before Pilate
Prime	The Flagellation
Tierce	Christ Carrying the Cross
Sext (The Hour of Christ's Crucifixion)	The Crucifixion
None (The Hour of Christ's Death)	The Deposition
Vespers	The Entombment
Compline	The Resurrection of Christ or Christ in Majesty

Sometimes both cycles might be combined, as in the Hours of Jeanne d'Evreux in which full-page scenes of the Passion cycle face smaller miniatures depicting the Infancy cycle above two lines of text (Pl. 134). Similar juxtapositions of scenes, contrasting the joy of the Infancy scenes with the sorrow of Christ's sacrifice, frequently appeared on small ivory diptychs—also intended for private devotion.

More often, however, where it was customary to provide a full cycle of miniatures, the Passion scenes were used for the long Hours of the Cross or Hours of the Passion. Although these cycles of miniatures became traditional throughout much of Europe, Delaissé has pointed out that variations such as the substitution of the Massacre of the Innocents for the Coronation of the Virgin for compline in the Hours of the Virgin may have been due to specific regional traditions. The possibility of such regional preferences needs to be further investigated, but it is fraught with qualifications. As we shall see below, the same artist sometimes used different scenes to introduce the same texts in two different Books of Hours made in the same milieu, apparently drawing upon several current regional traditions.

The marginal decoration of these devotional books destined for the laity in the Gothic period, particularly the psalters and the Books of Hours but also such books as the Breviary of Charles V and the Beaupré Antiphonary, became profuse and increasingly secular. Major incipit pages were lavishly decorated, and, in addition, all of the ordinary text pages throughout the book increasingly received marginal ornament. In the Windmill Psalter and the Beaupré Antiphonary, extensions of large decorative or historiated initials projected down the adjacent margin and frequently turned and spread through the top and bottom margins. Budding leaves and acorns sprouted from these branches, and the foliage became more dense as the branch grew into the fourth border. Birds, butterflies, and a variety of marginal figures began to proliferate in the ornament. Often the marginal animals were

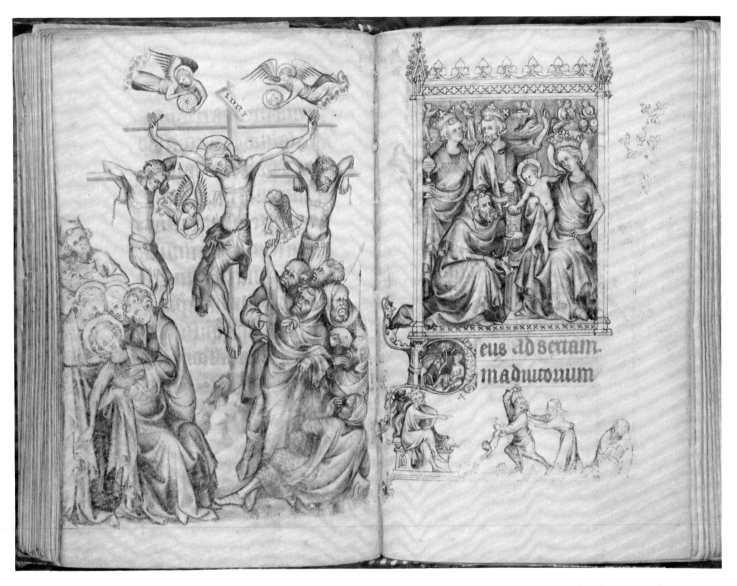

134. Crucifixion and Adoration of the Magi. The Hours of Jeanne d'Evreux, fols. 68v–69r (New York, The Metropolitan Museum of Art: The Cloisters Collection Purchase, 1954, 54.1.2:)

exquisitely and naturalistically drawn, frequently they were fanciful, sometimes the figures were engaged in satirical activities, occasionally they were merely crude.[9] Such charming and irreverent scenes undoubtedly enlivened the routine cycle of daily devotions.

In the fourteenth century the text was frequently framed on all four sides, either by bars and foliate branches or rinceaux similar to the decoration of the Breviary of Charles V, and by the early fifteenth century the heavy painted branches gave way to a pro-

liferation of penned sprays with a dense frieze of polished gold leaves.[10] As the century progressed, however, additional elements were added, first curling acanthus leaves at the corners, then flowers, pods, and fruits. Shortly after 1450 the delicate ivy-leaf borders were supplanted by series of naturalistically rendered plants or objects, usually placed against a solid colored or gold ground and casting a shadow upon it. The remarkable illusionistic borders of the Hours of Engelbert of Nassau (Pl. 135), now preserved in Oxford (Bodleian Library, MS Douce 219), exemplify this outbreak of realism, which was in turn supplanted by the device of surrounding the miniature or text with an actual scene, as in the Hennessy Hours in Brussels (Bibliothèque Royale, MS II.158; Pl. 136).[11]

The decoration and resulting effect of devotional books had become secularized. No longer were these books primarily the vehicle of the Word, embellished and mystically cloaked in ornament. Instead they became precious objects to be treasured in their own right, as exemplified by the inventories of the collection of the duke of Berry at the beginning of the fifteenth century, which listed his "very beautiful" and "very rich" Books of Hours among his *joyaux* (jewels) and other priceless objects. By the end of the fifteenth century such books had become the vehicles for exercises of bravura painting and illusionistic realism intended to delight and amaze the eye. Usually small in format, fine in quality, lavish in decoration, and splendid in color, they were to be held and marveled at as exquisite objets d'art.

An Italo-French Book of Hours

The most widely published and therefore most accessible Books of Hours have been those with lavish decorations and extraordinarily expanded cycles of miniatures. The *Très Riches Heures* decorated first by the Limbourg brothers and later by Jean Colombe, the Hours of Catherine of Cleves painted by an anonymous but innovative Dutch illuminator about 1445, and the Rohan Hours with an expanded set of miniatures further amplified by scenes from the *Bible moralisée* by an illuminator of extraordinary intensity have all been published in moderately priced facsimiles.[12] The texts of such Books of Hours are usually full and complex, therefore requiring an inordinate number of miniatures. While such books are justifiably noteworthy and informative, the purpose here is to present a visually attractive but more normal example. Among the wealth of possible choices, any single selection will seem arbitrary. Nevertheless, a Book of

135. Joseph and the Angel. The Hours of Engelbert of Nassau, fol. 153r (Oxford, Bodleian Library, MS Douce 219)

136. Border with Hunting scene. Hennessy Hours, fol. 8or (Brussels, Bibliothèque Royale, MS II. 158)

Pl. 135 / 251

Ad tertiam :/: Aue maria ħ

DEVS i adiu
torium me
um inten
de:
Domi

ne ad adiuuandum me

festina :/

loria patri ꝛ filio ꝛ
spiritui sancto:

icut erat in principi
o ꝛ nunc ꝛ semper ꝛ ĩ sɔla
seculorum amen: Allta uꝛ

Hours in London (The British Library, MS Add. 29433) made for the use of Paris, average in its contents but particularly sumptuous in its decoration, is rich in its associations with related manuscripts and provocative in its revelations about the nature of the illuminator's role in the production of the book.

The principal illuminator of this manuscript is an anonymous Italian who was active in the Parisian milieu in the first decade of the fifteenth century. Picturesquely but perhaps erroneously called at first Zebo or Zanobi da Firenze after an inscription in his most lavish production, the Hours of Charles the Noble in Cleveland (Museum of Art, 64.40) he is now known by the more mundane but safer name of the Master of the Brussels Initials, after a series of historiated initials he executed in the *Très Belles Heures* of the duke of Berry in Brussels.[13] Although his work in these and related manuscripts has been discussed by Millard Meiss, his role in the Parisian book industry and his associations with French miniaturists and decorators are still being investigated.[14] He brought with him to France a repertoire of iconographical themes current in Italy but new in France, and a penchant for colorful and sumptuous decoration by which he completely transformed some of his miniature pages in otherwise French manuscripts. His role in the production of manuscripts in France seems to have varied: in what may be one of his earliest works in France, a Book of Hours now in Parma (Biblioteca Palatina, MS lat. 159) he merely painted a group of five miniatures while French miniaturists provided the rest as well as the marginal decoration. But in the Hours of Charles the Noble, the Italian Master appears to have exercised more control: he not only transformed all pages with miniatures and historiated initials with his Italian ornament, he, or his helpers, also provided many of the decorative initials. Thus, although this book is a French Book of Hours, all of the major pages have been thoroughly transformed by the style of the Italian Master. Many of the text pages with French decoration have also received additional Italianate motifs, small green foliate tendrils, flowers, birds, and butterflies, which provide an accent of decorative consistency, since these same motifs also appear in conjunction with the Italian acanthus borders.[15]

In the Book of Hours in London, the Master of the Brussels Initials worked in conjunction with French miniaturists and decorators, although perhaps a different group from those with whom he worked in his other collaborative efforts. He provided colorful acanthus borders, sometimes set against shimmering polished gold grounds, around the entire page and he also seems to have provided the major three-line initials opening the text below most of the miniatures. The sumptuousness of these pages,

transformed by the Italian decoration, is matched by the prevailing fully developed French rinceaux or ivy-branch borders that surround all of the text pages in the manuscript.

The decoration of the text pages of the "London Hours" follows two formats. That of the Calendar (Pl. 137) and two bifolios in the Hours of the Virgin consists of two vertical bars framing the text from which spring densely foliated curling painted rinceaux. The remainder of the text pages (Pl. 151) are framed with heavy painted foliate bars from which less dense leafy rinceaux emanate. The designs of the foliate bars framing the text varies from page to page. Both systems, however, contain a multitude of polished gold leaves providing sparkling accents, which are further enlivened by the insertion of small red and blue flowers, light green tendrils, butterflies, birds, and a variety of hybrid creatures. These decorations are consistent with motifs current in France in the first decade of the fifteenth century and they also exemplify the continuing tradition of elaborate ornament in books for private devotion.

The contents of the London Hours are normal for an early fifteenth-century French Book of Hours. In addition to the Calendar, Sequentiae, and Hours of the Virgin, the Cross, and the Holy Spirit in Latin, two devotional sections in French have been added: the Fifteen Joys of the Virgin and the Seven Petitions to the Lord (Appendix 16). The Prayers to the Virgin appear after the normal contents and just before these vernacular devotions. As one finds in many Books of Hours, devotional masses are also included; in this book five masses precede the Suffrages.

The miniatures that illustrate the major divisions of this manuscript reflect, with only a few exceptions, the traditional cycle of miniatures found in French Books of Hours of the beginning of the fifteenth century. The Master of the Brussels Initials imparts to them, however, a brilliance of color and liveliness of presentation in both the scenes and their accompanying borders which make them particularly remarkable in contrast to other contemporary French illuminations.

The Calendar of the London Hours (Pl. 137), surrounded by the ivy rinceaux border referred to above, is further accentuated by red and blue tri-lobed medallions in the inner corners of the frame and red suns emitting golden rays at the outer corners. These added accents of color and gold make this calendar one of the most elaborate from the circle of the Brussels Initials Master. The Signs of the Zodiac appear in the outer margin among the foliage while the Labors of the Months appear in horizontal miniatures beneath the text. Several variations in the cycle of the Labors are evident in this book in contrast with the "normal" list given above. Instead of a banquet scene for January, we have a

137. Calendar for April–May. "London Hours," fols. 4r–5r (London, The British Library, Add. MS 29433)

figure warming himself by a fire, the scene normally reserved for February. February is illustrated with a figure fishing—an appropriate play on the sign of the month, Pisces (the fish), although, as Meiss has pointed out, inappropriate for either a northern European or Italian climate in February.[16] A man blowing on two horns for March, which Meiss considers a characteristically Italian motif, may also be derived from the sign of the Ram, or Aries, perhaps combined with a traditional motif for the winds, as March is usually a windy month. For August, the traditional Labor of harvesting or threshing wheat is supplanted by the innovative Labor of making a barrel, a necessary preparation for the Labor of September, the picking of grapes in order to make

wine. These charming scenes, some of which are apparently un-finished as they have no background, are very similar to the style of the Master of the Brussels Initials but may be by a close fol-lower, as they lack his intense characterizations and swarthy modeling.

Each of the four excerpts from the Gospels is provided with an author portrait of the Evangelist and his symbol. Thus preceding his account of the birth of Christ, St. Matthew (Pl. 138) is shown seated reading from a book held by a winged man, his symbol. An elaborate two-storied lectern behind his bench holds two books. Richly colored clumps of acanthus in the margins contain areas of polished gold against which nude putti and a clothed giant cavort. A delicate array of green tendrils, flowers, snowflake designs, birds, and butterflies transform what would have been a heavy Italian acanthus border into a lighter, more scintillating design commensurate with the effect of the French ivy borders. As we have noted above, these same addenda occur on the text pages with French decoration and give the manuscript an effect of homogeneity. The four-line initial *I* ("In illo tempore" [At that time], a frequently used opening phrase to the lessons) is composed of a nude torso with arms and legs hidden by curling acanthus leaves. It was apparently painted by the same Italian artist. Similar portraits and rich Italianate borders intro-duce the other three excerpts from the Gospels.

The miniatures that illustrate the Hours of the Virgin follow the normal sequence of Nativity scenes found in many French Books of Hours. Yet in their execution, iconography, and elabo-ration of detail they surpass miniatures found in many more well-known productions. Justifiably, the Annunciation (Pl. 139; Colorpl. 22), the miniature introducing matins in the Hours of the Virgin, is one of the most elaborate pages of the manuscript. This reflects a practice found frequently in other French Books of Hours in which this opening page was made the most lavish.[17] The miniature, unframed, exceeds its implied boundaries, which usually conform to the ruled area of the text. The architecture spills into the top and side margins and is balanced in the lower third of the page by the acanthus whorls set against a burnished gold ground and peopled by nude putti, one playing a drum, an-other using a pair of bellows, and a third flagellating himself. The borders and miniature create a major decorative display commensurate with the opening of the Hours of the Virgin.

The Italian artist has placed the Annunciation in a many-tur-reted architectural ensemble, a pile of Italian Gothic forms painted in the manner of the spindly columned structures in the frescoes of Altichiero and the Paduan school of the end of the fourteenth century.[18] Three Old Testament prophets lean from

138. St. Matthew. "London Hours," fol. 18r (London, The Brit-ish Library, Add. MS 29433: By permission of The British Library) 139. Annunciation. "London Hours," fol. 20r (London, The Brit-ish Library, Add. MS 29433: By permission of The British Library)

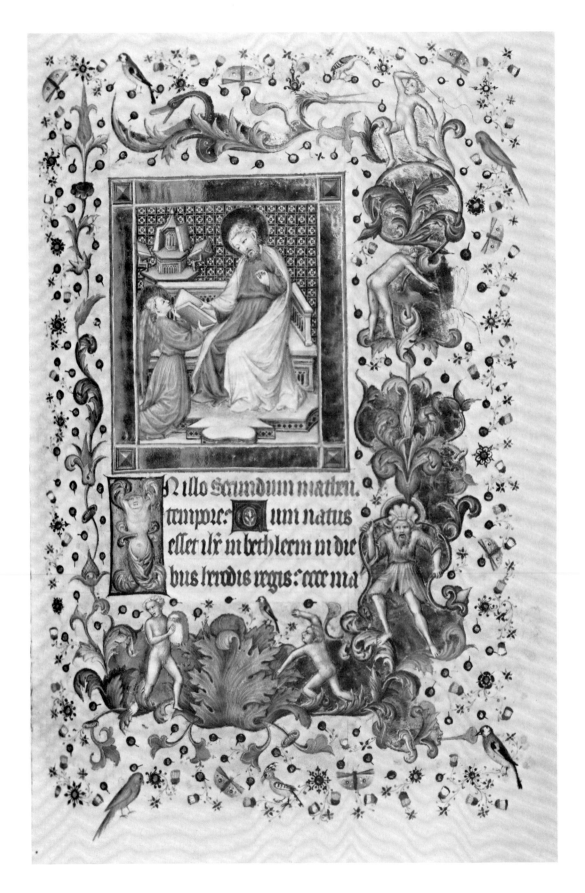

Pl. 138 / 257

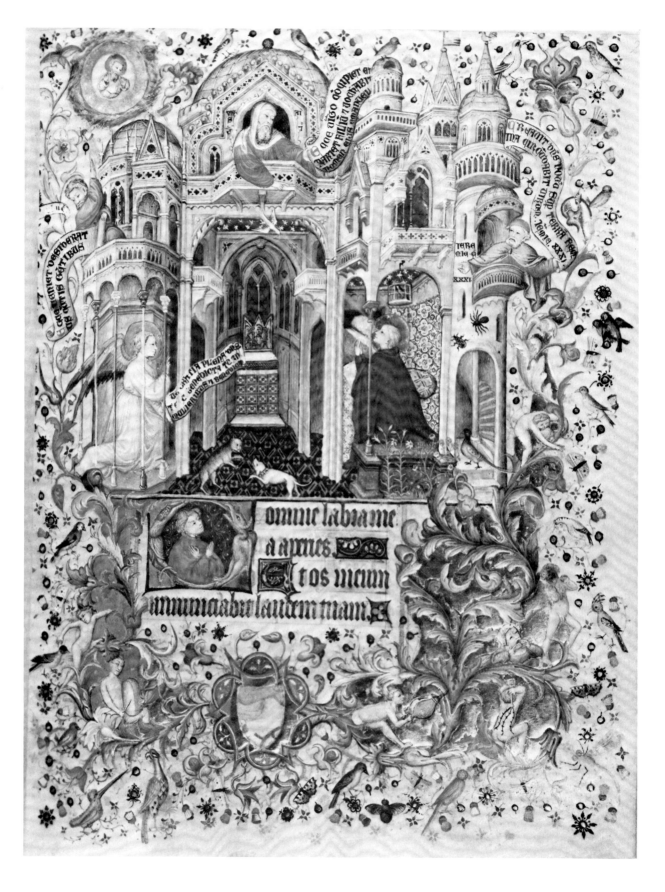

balconies holding scrolls containing their prophecies of the coming of the Messiah and of the virgin birth. The scene abounds with lively details, some of them symbolic. A dog and a cat cavort in the nave of the churchlike building, a caged bird behind the Virgin symbolizes the Incarnation in that the soul of Christ will be imprisoned in his body, the spider and the ladybug may signify peril of the devil for the unwary, and the mating birds in the outer margin are a deliberate contrast with the virgin birth of Christ, asserted by the lilies growing in front of the Virgin, symbols of her purity.

In the bottom margin an escutcheon-shaped space in a medallion was left blank to receive the arms of an owner. Because of their use for private devotion, psalters and Books of Hours lent themselves to a higher degree of personalization. Not only might saints who were particularly venerated by the person for whom the book was made be included in the Calendar, Litany, and Suffrages, but the patron might have his or her portrait included in the miniatures, either adoring the Virgin at the incipit to one of her prayers, kneeling in supplication at the beginning of the Penitential Psalms, praying before a patron saint in the Suffrages, or praying in an initial below the Annunciation, as in the London Hours. In addition, the arms of the donor might be included in the miniatures or borders, as they appear beneath each miniature and even on a separate page in the most sumptuous book painted by the Master of the Brussels Initials, the Hours of Charles the Noble. In the London Hours, however, the arms were never filled in—an indication that the manuscript was prepared for the book trade as a ready-made devotional book to be personalized when a customer agreed to buy it.

The beginning of lauds, often read together with matins, also received major decorative emphasis with the use of a solid gold border in the bottom and outside margins, although the miniature of the Visitation (Pl. 140) is constrained within the decorative panels framing the text. Normally set within a landscape, this scene of the moment when Elizabeth, the expectant mother of John the Baptist, is visited by the Virgin, a prefiguration of the meeting of John and Christ at the Baptism, is placed within a barrel-vaulted room. Three courtly damsels look on as Joseph enters the house on the right. A complicated cityscape looms above the chamber and occupies the top margin. Another strong decorative accent is provided for the beginning of prime, with the acanthus border set against a gold panel in two margins, and the Nativity scene, set in an atmospheric landscape, is now entirely contained within the encompassing frame (Pl. 141). Thus, by a progressive diminuendo, the scale and impact of the decoration for the first three hours of the Office of the Virgin are reduced.

140. Visitation. "London Hours," fol. 43v (London, The British Library, Add. MS 29433: By permission of The British Library)

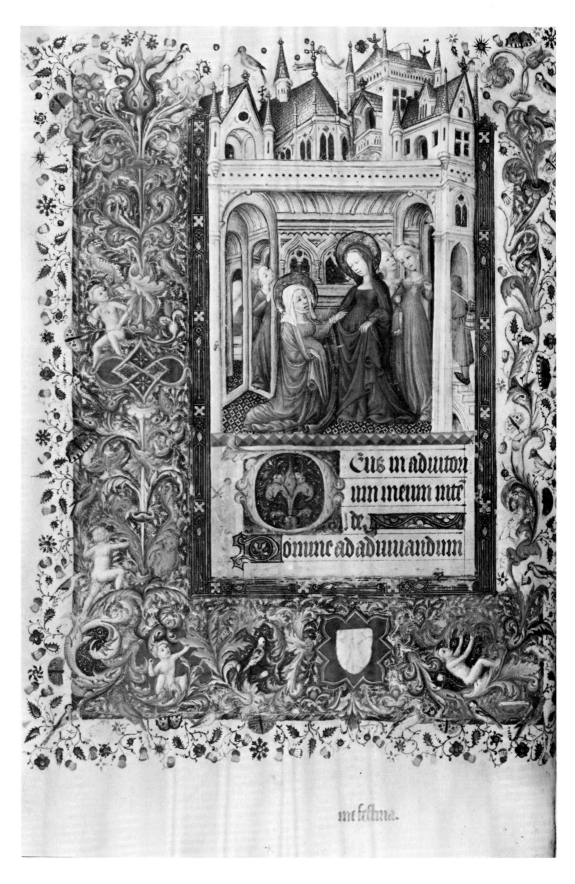

The remainder of the miniatures, the Annunciation to the Shepherds, Adoration of the Magi, Presentation at the Temple, Flight into Egypt, and Coronation of the Virgin (Pls. 142–146; Colorpl. 23), all occupy the framed space above the opening lines of the text, and the borders are lighter, consisting of curling acanthus sprays enclosing gold areas, but without the heavy gold panel. This form of decoration is consistent with the borders used by the Master of the Brussels Initials in Books of Hours in Oxford (Bodleian Library, MS Douce 62) and Cleveland.

The Penitential Psalms of the London Hours are introduced by a Hell scene (Pl. 147) that is very similar in its composition and internal vignettes to the miniatures for the same text in the Cleveland and Oxford books (Pl. 158). It reflects an Italian tradition, particularly the Hell scene in the fresco of the Last Judgment in the Arena Chapel painted by Giotto between 1304 and 1306. Within the miniature the damned are speared, led by ropes, and brought by cart, wheelbarrow, and backpack to the boiling cauldron of Hell at the bottom of the scene. Kings, nobels, cardinals, and monks are all dispatched without mercy, a fitting reminder to the beholder to repent—the theme of penance being the subject of the following psalms. This miniature supplants the usual representation of David praying or composing his psalms or Christ in Majesty which often prefaced these psalms. But variations in illustrating this text were frequent, as Leroquais and Delaissé have pointed out, for in the second half of the fifteenth century the image of a transgression of David, his spying on Bathsheba in her bath, was also used.

In contrast with his other representations of the Hell scene, the Master of the Brussels Initials has here allowed the miniature to spill over into the border area and has again placed the border acanthus against a gold ground. Even the foliate frame, which previously had delineated the space of the miniature and text, here is made to bend outward to receive the inordinately large miniature.

In the London Hours only one miniature introduces the short Hours of the Cross. It represents the dead body of Christ held up by an angel before the mourning figures of the Virgin and St. John (Pl. 148). This *Imago Pietatis* or Man of Sorrows is surrounded by the instruments of the Passion—the three crosses, the column against which Christ was tied when beaten, the lance, crown of thorns, scourge, and so forth. This image was intended to invoke the full impact of the suffering and sacrifice of Christ, the subject of the following devotions. As in the case of the Annunciation for the Hours of the Virgin and the Hell scene for the Penitential Psalms, this incipit has been given a major decorative emphasis: a gold field has again been provided for the

141. Nativity. "London Hours," fol. 56r (London, The British Library, Add. MS 29433: By permission of The British Library)

142. Annunciation to the Shepherds. "London Hours," fol. 62r (London, The British Library, Add. MS 29433: By permission of The British Library)

143. Adoration of the Magi. "London Hours," fol. 67r (London, The British Library, Add. MS 29433: By permission of The British Library)

144. Presentation to the Temple. "London Hours," fol. 71v (London, The British Library, Add. MS 29433: By permission of The British Library)

145. Flight into Egypt. "London Hours," fol. 76r (London, The British Library, Add. MS 29433: By permission of The British Library)

146. Coronation of the Virgin. "London Hours," fol. 83r (London, The British Library, Add. MS 29433: By permission of The British Library)

147. Hell scene. "London Hours," fol. 89r (London, The British Library, Add. MS 29433: By permission of The British Library)

148. Man of Sorrows. "London Hours," fol. 107v (London, The British Library, Add. MS 29433: By permission of The British Library)

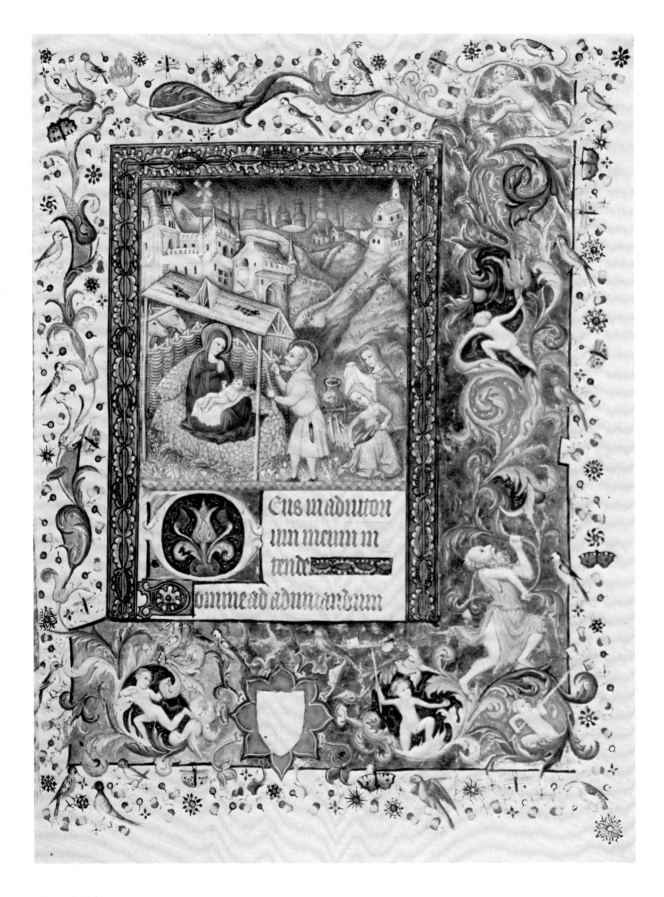

Pl. 142 / 263

Pl. 144 / 265

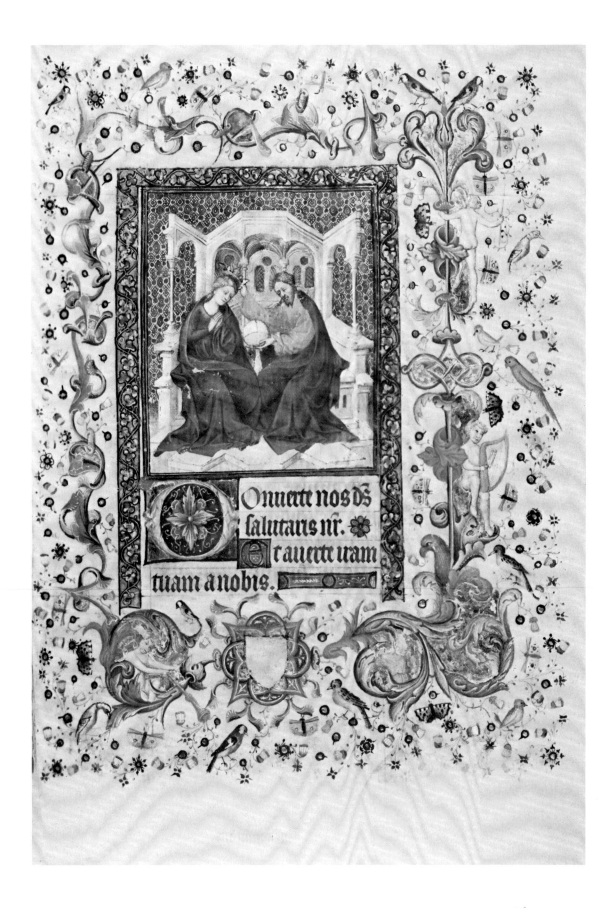

Pl. 146 / 267

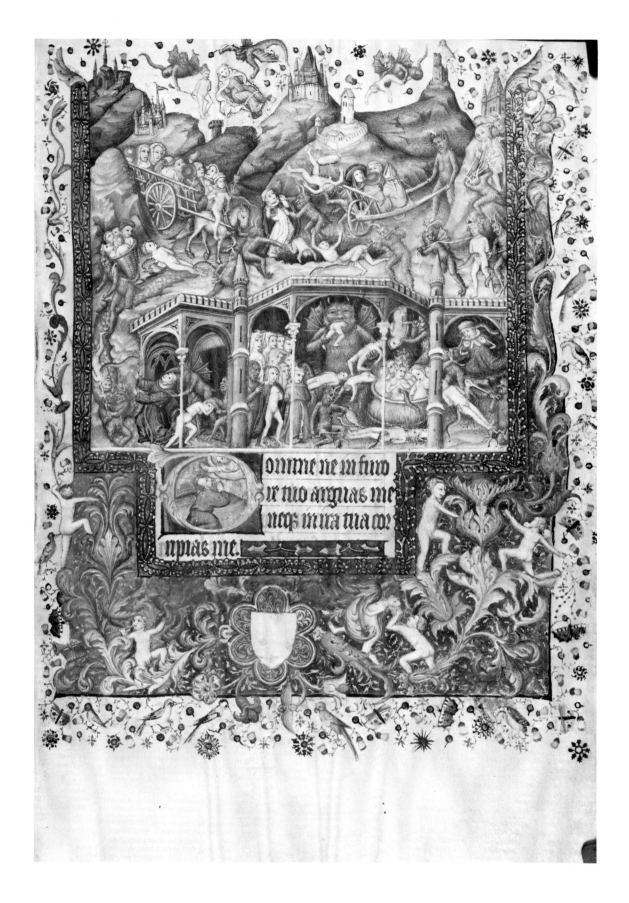

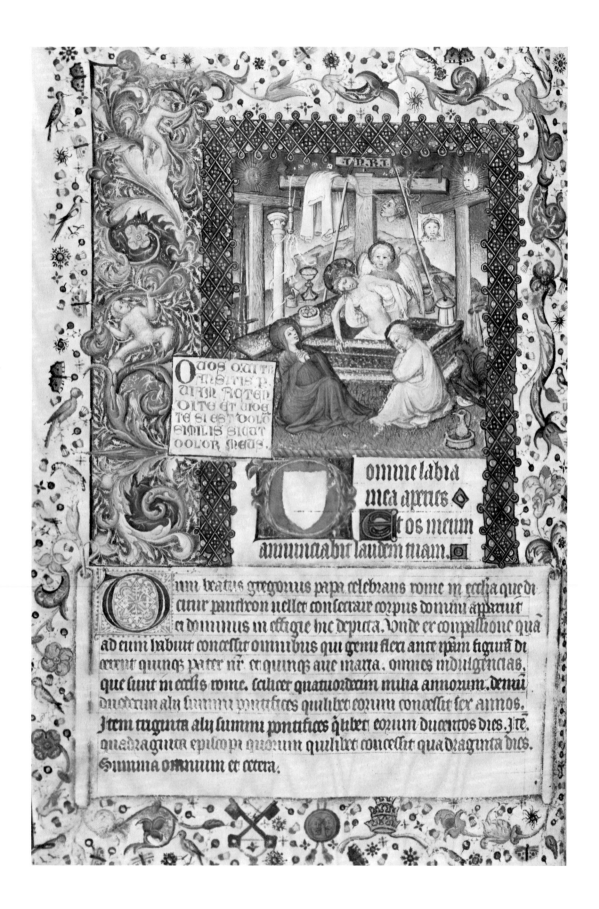

Pl. 148 / 269

acanthus decoration in the outside margin. Immediately below the opening lines of the text, however, has been written, in a different script, a prayer to St. Gregory. It occupies a space equal to the width of the solid border decoration and is placed on a simulated scroll that appears to be lying on top of the page, casting a shadow on the parchment beneath it. A stem of a flower emerges from the curled scroll on the left, reinforcing the illusion. This precocious device anticipates by five or six decades the widespread use of illusionistically depicted objects on the page and the *trompe l'oeil* reversals in which text was placed upon a likeness of a parchment stretched before a scene occupying the space of the border decoration. A smaller text, placed within a square, overlaps the miniature and border. This inscription is written in Italian *gotica rotunda*, probably by the hand of the artist, as similar lettering occurs in the Annunciation and on scrolls in other miniatures by the Master of Brussels Initials. The prayer below is introduced by an initial with typically Italian penwork. The script, although more square and regular than the text above, appears, however, to contain many of the conventions of a French hand.

The prayer to St. Gregory serves as a further elaboration of the theme of the Man of Sorrows, for Pope Gregory had had a vision of the Imago Pietatis while celebrating Mass. Representations of St. Gregory praying before the Man of Sorrows above an altar were frequently used in fifteenth-century Books of Hours to introduce either the Hours of the Cross or the penitential psalms. The Imago Pietatis and the Mass of St. Gregory were both increasingly portrayed in the art of the late fourteenth and early fifteenth century, but the Italian Master created out of them not only an innovative composition but also a unique combination of image and text.[19] The presence of the prayer and the special nature of the page may also reflect the personal preference of the unknown prospective owner, for the empty escutcheon intended for his coat of arms, usually appearing in the bottom margin, here was placed in a position of prominence in the initial opening the text.

A lavish page, with large miniature of Pentecost and a border set against a gold ground, also opens the Hours of the Holy Ghost (Pl. 149). The elaborate architectural setting, perhaps evocative of the domed Church of S. Antonio in Padua, is again a close reflection of an architectural scene painted by Altichiero in S. Giorgio in Padua.[20] In keeping with the accentuation of major incipits, this page also has a miniature larger than the text area surrounded by a solid border.

In contrast, the decoration for the other texts in the London Hours remains more restrained. The Last Judgment introduces the Vigil of the Dead (Pl. 150). This is a variant theme for this

149. Pentecost. "London Hours," fol. 111v (London, The British Library, Add. MS 29433: By permission of The British Library)

150. Last Judgment. "London Hours," fol. 115v (London, The British Library, Add. MS 29433: By permission of The British Library)

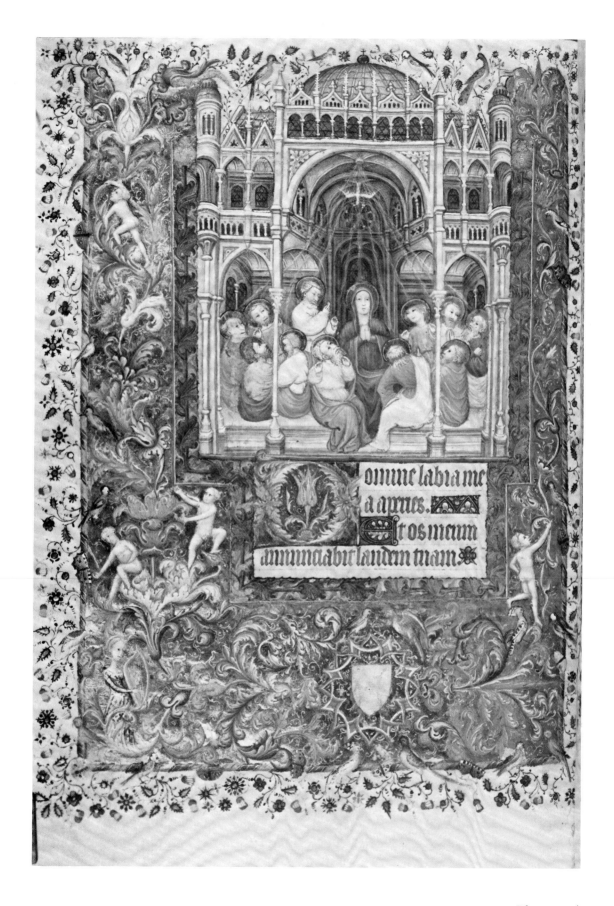

Pl. 149 / 271

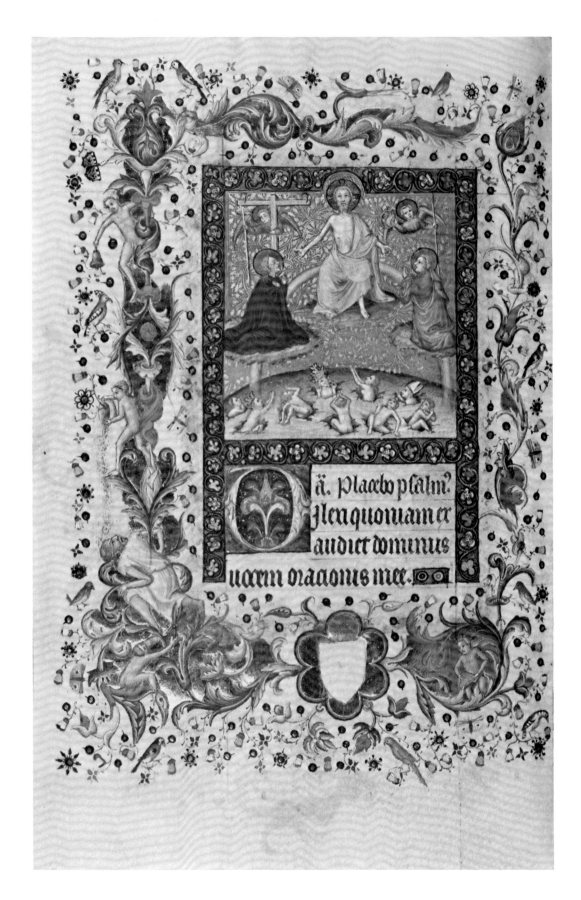

text, for in other manuscripts by the Master of the Brussels Initials, such as the Book of Hours in Cleveland, he used a scene of the monks chanting around a bier (Pl. 155).[21] Although this latter scene appears to have been used most frequently, numerous other subjects were also used, such as the story of Dives and Lazarus, the resurrection of Lazarus, and, at the end of the fifteenth century, Job on a dung heap confronting his wife and friends—all themes of the ultimate salvation of the faithful.

After the Mass of the Dead follow two special prayers to the Virgin, the "Obsecro te" (I implore thee) and the "O Intemerata" (O Matchless One). These frequently appear in French Books of Hours and are usually introduced by representations of the Virgin alone and the Virgin and Child, here, in historiated initials (Pl. 151). These prayers are then followed by two devotions in the vernacular French, the Fifteen Joys of the Virgin and the Seven Petitions to Our Lord. The first, commencing "Doulce dame de misericorde, mère de pitié, fontaine de tous biens" (Sweet lady of mercy, mother of pity, fountain of all goodness), is prefaced by a miniature showing a nude Christ Child wading in a pool while the Virgin prays and Joseph looks on (Pl. 152). Meiss has pointed out that this may be a unique and innovative representation of the *fons vitae* suggested by the opening phrases of the text.[22] As this scene captures an intimate, happy moment of the divine family, it serves as a strong contrast to the pietà that introduces the Seven Petitions to the Lord (Pl. 153), a scene in which the dead body of Christ is laid out across the lap of the Virgin, recalling the more joyful image of the Virgin and Child, but now invoking the pathos of Christ's sacrifice.

The Suffrages of the London Hours, commencing, as was frequently the case, with a prayer to the Trinity (Pl. 154), open with a miniature of God holding Christ on the cross, the dove of the Holy Ghost in between, and blue music-making angels surrounding them. This "Throne of Mercy Trinity" again emphasizes the sacrifice of the Son and reminds the beholder of the grace attainable through that sacrifice. Thirty other miniatures of various saints to whom there are special prayers appear in the suffrages. Four of these were not painted by the Master of the Brussels Initials but by an indigenous French artisan, the Luçon Master, who may also have completed the miniature of the Coronation of the Virgin (Pl. 146).[23]

In many French Books of Hours, including the London Hours, only one miniature prefaced the Hours of the Cross or Hours of the Passion. But in at least two other manuscripts in which the Master of the Brussels Initials participated, a full cycle of Passion scenes was provided. In the Hours of Charles the Noble in Cleveland he and a northern artist known as the Egerton Master

151. Text page and "Obsecro te" with Virgin and Child. "London Hours," fols. 160v–161 (London, The British Library, Add. MS 29433: By permission of The British Library)

152. Christ Wading in a Pool. "London Hours," fol. 168r (London, The British Library, Add. MS 29433: By permission of The British Library)

153. Pietà. "London Hours," fol. 174r (London, The British Library, Add. MS 29433: By permission of The British Library)

contributed these miniatures.[24] In the second Book of Hours, now in Oxford, where his illuminations also appear alongside work by French artisans, he painted all of the Passion miniatures. Comparison of the Oxford and London books reveals similarities and differences between these manuscripts, produced at almost the same time and probably in the same locale.

The contents are similar (see Appendixes 16 and 17), but the Prayers to the Virgin follow the Sequentiae and precede the

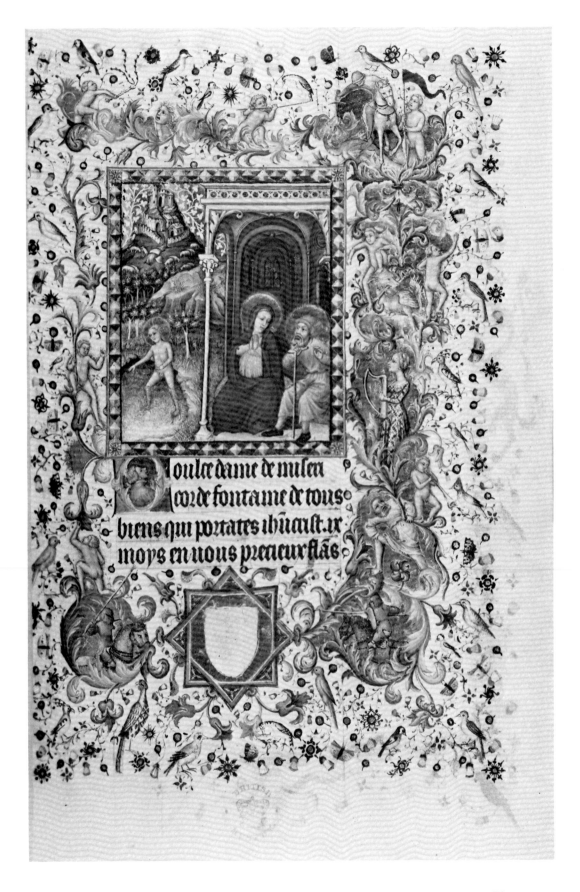

Pl. 152 / 275

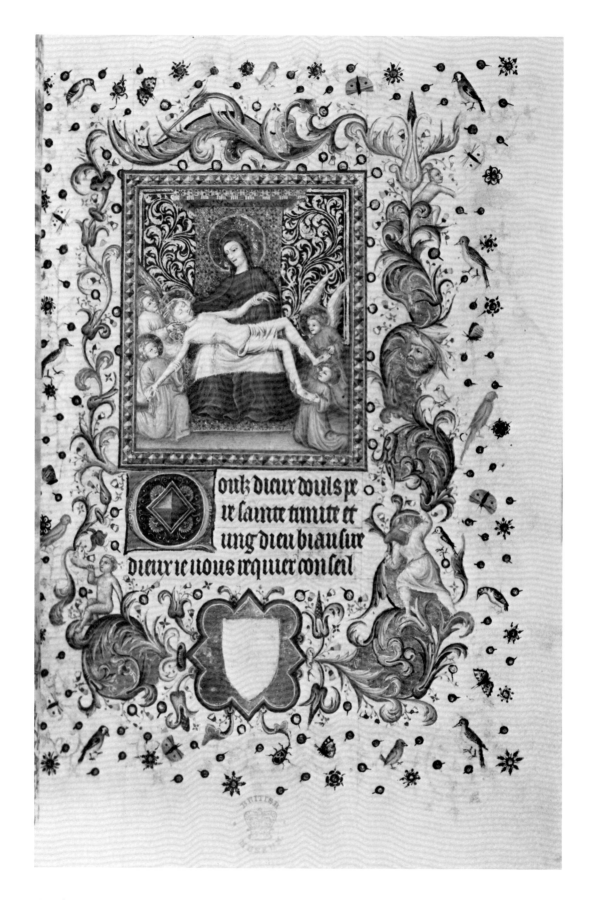

Hours of the Virgin as in most French Books of Hours. The illustrations of the Calendar, Sequentiae, Hours of the Virgin, and Penitential Psalms not only depict the same incidents, but are very close in composition (cf. the Adoration of the Magi, Pls. 143, 156). The Short Hours of the Cross in the Oxford book are missing their first folio, but we may surmise that they were also introduced by a miniature of the Man of Sorrows, since this theme was used in the London manuscript and appears as the single introductory miniature in the Hours of Charles the Noble. Other differences occur in that the Vigil of the Dead is introduced by monks singing around a bier, and the Fifteen Joys of the Virgin simply contain a representation of the Virgin and Child without the innovative pictorial interpretation of the prayer found in the London Hours. The Hours of the Passion, however, appear in a long form permitting a full cycle of Passion miniatures. Beginning at matins with the Betrayal of Christ by Judas, we find among the eight narrative scenes Christ before Pilate at prime (Pl. 157), Christ being nailed to the cross at sext, the hour of the Crucifixion, and Christ dead upon the cross at none, the hour of his death. The narration ends at compline with the entombment. In spite of the completeness of the Hours of the Passion, the Suffrages of the Oxford book have no miniatures at all.

The decoration of the text pages of the Oxford Hours, executed by a French hand, is less elaborate than that of the London manuscript, and the Italian artist does not intrude upon them. In fact, careful examination of the miniature pages painted by him reveals that he actually erased some of the French foliate frames around the miniatures and text to accommodate his own Italian decoration. Without the Italian Master's alterations and miniatures, the Oxford Hours would have been merely an average French workshop production.

The proliferation of such Books of Hours as these during the fifteenth century reflected profound changes in the role of books in society and in the nature of religious worship. Increased production of these books was occasioned by an increased demand, not only among the clergy and the nobility, but also now among an expanding proportion of the mercantile class, and by a widening literacy in all of these classes. The pervasive need for more immediate, personal, and meaningful religious experience through private devotions was not only making Europe ripe for the changes brought about by the Reformation in the sixteenth century, it was also providing further stimulus for the book industry. But with greater literacy, and increased demand for books, the stage was set for the successful introduction of the

154. Trinity. "London Hours," fol. 192r (London, The British Library, Add. MS 29433: By permission of The British Library)

155. Mass of the Dead. Hours of Charles the Noble, p. 415 (Cleveland, Museum of Art, Purchase, Mr. And Mrs. William H. Marlett Fund, 64–40)

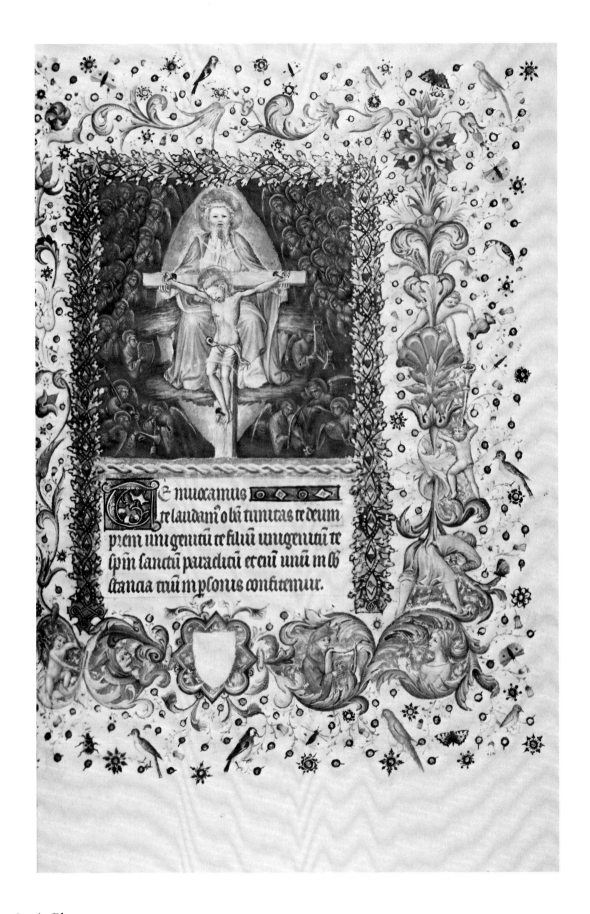

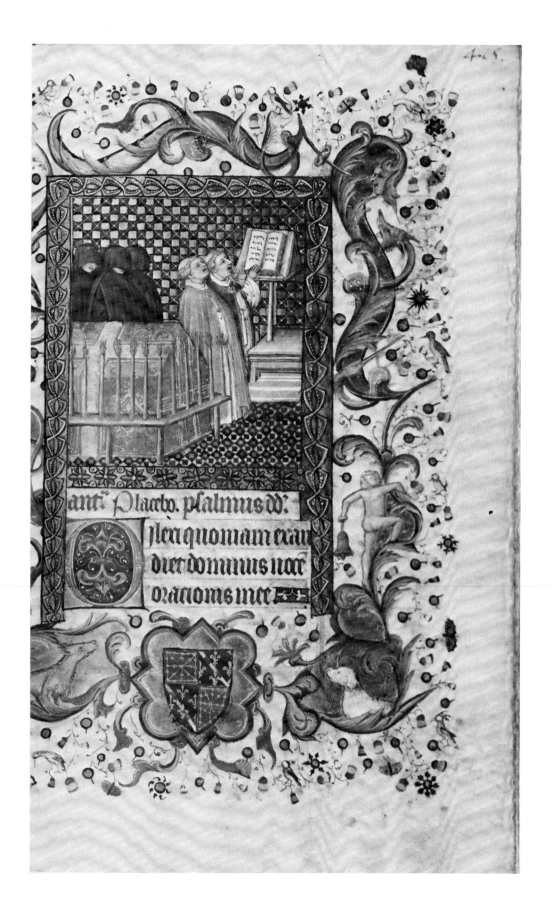

Pl. 155 / 279

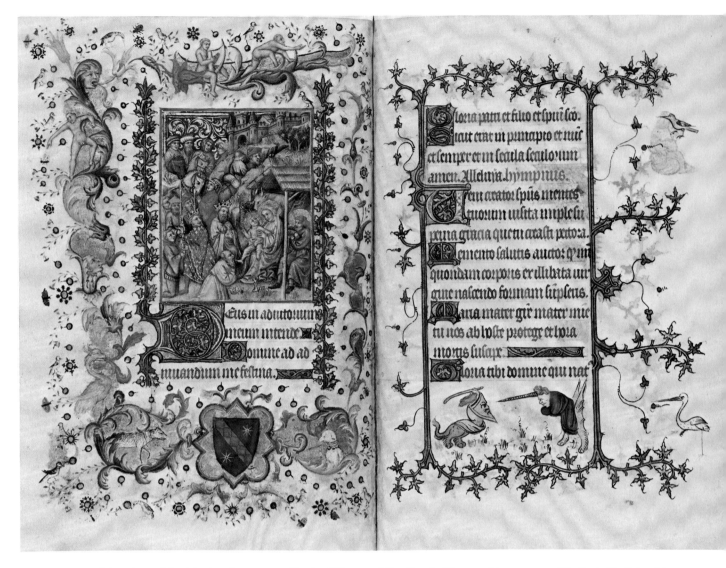

156. Adoration of the Magi and text page. Book of Hours of Cordier de Bignan, fols. 73v–74r (Oxford, Bodleian Library, MS Douce 62)

book reproduced through mechanical means rather than laboriously copied by hand. Although Gutenberg's perfection of the printing press with movable type was not an immediate commercial success in 1452, his followers were able to match the greater availability of their mass-produced books to the increasing demands of the literate populace. Many of these early printed books, such as some copies of Gutenberg's forty-two-line Bible, were hand illuminated and thereby retained the decorative splendor of earlier manuscripts. But it was not long before the illustrations, decorative initials, and even ornamental borders were also

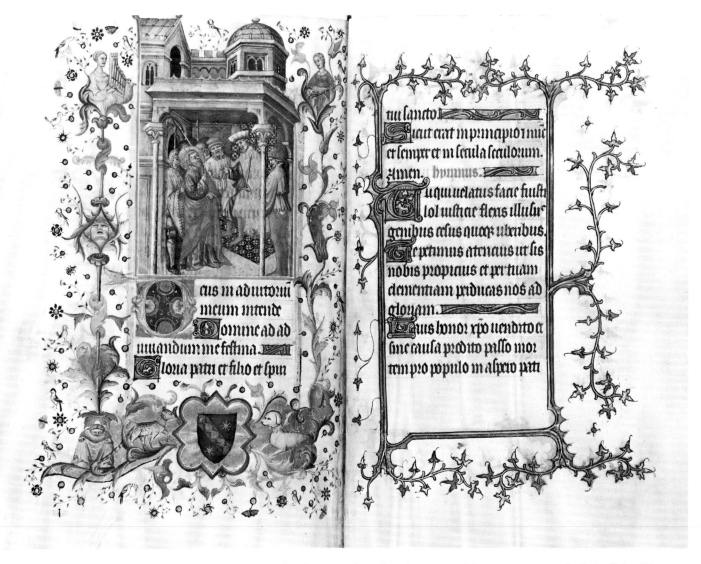

157. Christ before Pilate and text page. Book of Hours of Cordier de Bignan, fols. 194v–195r (Oxford, Bodleian Library, MS Douce 62)

printed, by means of the wood cut, the metal cut, and the engraving. By the end of the fifteenth century the primacy of the hand written and decorated manuscript had given way before the more efficient production of the printed book.

158. Hell scene. Book of Hours of Cordier de Bignan. fol. 95r (Oxford, Bodleian Library, MS Douce 62)

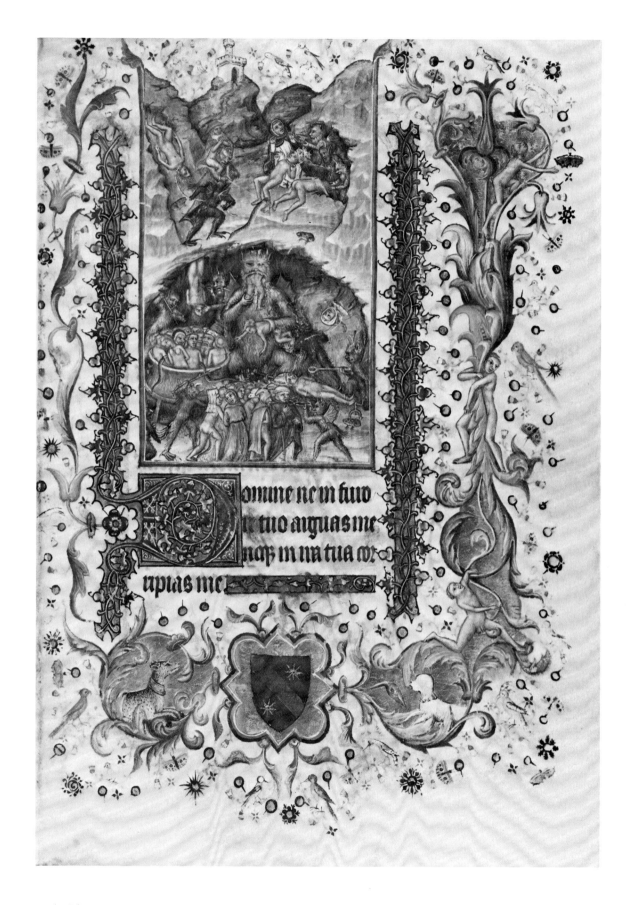

9 / Other Types of Manuscripts

*V*arious other kinds of manuscripts were compiled for diverse liturgical and devotional purposes throughout the Middle Ages which have not been discussed in the foregoing chapters. Although some of them have survived in plentiful numbers, such as pontificals and benedictionals, their contents and decorations are often highly variable and therefore difficult to summarize by picking a single example for detailed discussion. Some of these additional types of manuscripts and their decorations will be discussed here, without, however, an attempt being made to give a complete tabulation of their contents and illuminations.

Bibles in the Romanesque period were, for the most part, decorated according to the programs established in Carolingian and Eastern manuscripts.[1] Full-page frontispieces might preface sections of books, as in the Bible of Charles the Bald, or each book might be introduced by a miniature or a historiated initial, first exemplified by the Syriac Bible in Paris.[2] In Italy from the mid-eleventh through the twelfth century massively large Bibles, "giant Bibles" or "atlantes Bibles," with introductory full-page miniatures became customary. The multivolume, large-scale Winchester Bible, illuminated in the mid-twelfth century at Winchester, used historiated initials to open each book.[3] In the Romanesque and Gothic periods the Prologues of St. Jerome usually prefaced each of the books of the Bible, and these were introduced by decorative initials smaller in scale than the historiated initials for the incipit of the text proper. In the book of Psalms the eight-part division, usually with the same representations in the initials or miniatures as in the psalter, was retained. The martyrdom of Isaiah by being sawed asunder, which opened the Canticles in the Windmill Psalter, frequently opened the book of Isaiah. During the Romanesque period canon tables were used

less and less frequently, and by the thirteenth century they were abandoned completely.

During the Gothic period a multitude of small, closely written Bibles were mass-produced in Paris for study at the University. These "University Bibles" were rarely decorated, but their more lavish, illuminated counterparts usually continued the tradition of the introductory historiated initial.[4] By the late fourteenth and particularly in the fifteenth century, greater emphasis was placed upon pictorial narration of biblical incidents, and numerous framed miniatures not only introduced the opening of each book but also were inserted in the columns of text next to the relevant passages. Some of these copiously illustrated Bibles also contained parallel passages taken from Petrus Comestor's *Historia scholastica*, and these supplemented versions are often referred to as "history Bibles" or *Bibles historiales*. Numerous examples of these Bibles, containing as a rule just the Old Testament, were produced in the northern Netherlands in the fifteenth century.[5]

The *Bible moralisée*, another variant of the illustrated biblical manuscript, became prevalent in the thirteenth century. It did not contain the text of the Bible, but rather a commentary upon it in which excerpted passages were equated with moralized or allegorical interpretations. Primarily a picture Bible, the text was placed in two cramped columns flanked by two miniatures in medallions showing the incident and its moralization. With eight medallions to a page in two vertical rows, the compositional layout and effect, and even the predominately red and blue coloring, resembled stained-glass windows after which they were undoubtedly patterned. A moralized Bible in Vienna (Österreichische Nationalbibliothek, MS 2554) contains 1,950 such medallions.[6]

The *Biblia pauperum*, or so-called Bible of the Poor, was a biblical commentary that became popular in manuscript form in the fourteenth century.[7] It consisted of typological juxtapositions of two Old Testament incidents with one from the New Testament. Busts of prophets frequently accompanied these representations with pertinent quotations from their prophecies, showing the relevance of the Old Testament as a prefiguration of the New. These didactic pictorial arrangements were not intended for poor people, but rather for the lesser clergy who could use them as a basis for preaching the unity of the Bible to their congregations. In the fifteenth century it was printed as a block book with woodcut illustrations.

We have seen how the Gospels were divided up and arranged according to the sequence of lessons to be read on feast days during the liturgical year in the Gospel lectionary or evangelistary (see the Pericopes of Henry II). The epistolary or Epistle lection-

ary provides the same function for the lessons read from the Epistles, although sometimes it contains other lessons as well. Normally, it is arranged according to the same tripartite grouping as in the evangelistary, the Temporale, Sanctorale, and Common of the Saints.

A special type of liturgical roll, the exultet roll, was a distinctive invention of southern Italian scriptoria in an area where the church services were still heavily influenced by Monte Cassino.[8] It contained texts for the celebration of Easter: the blessing of the baptismal font (*benedictio fontis*) and a hymn of rejoicing sung on Easter Eve (for the blessing and lighting of the Paschal candle) and after which the roll is named ("Exultet iam angelica urba caelorum" [Let now the heavenly hosts of angels rejoice]). Normally these rolls were draped over the lectern, and as they were unrolled, appropriate illustrations, placed upside down in relation to the text but appearing right side up to the congregation, would become visible.

The Apocalypse, the book of Revelation of St. John which normally concludes the New Testament, was frequently produced as a separate book. An Asturian monk known as Beatus of Liébana compiled a collection of exegetical writings or commentaries on the Apocalypse and the book of Daniel in 776. These texts were combined with the actual text of the book of Revelation and together they are known, therefore, as the "Beatus Apocalypse." It became one of the principal liturgical manuscripts in Spain from the tenth through the twelfth century, where it was customary to read it in church during the period from Easter to Pentecost. Richly illuminated copies were produced, often containing more than sixty illustrations.[9] In addition to such representations as the Paschal Lamb in a medallion surrounded by the symbols of the four Evangelists and the Four-and-Twenty Elders of the Old Testament playing musical instruments (Rev. 5:6–8), or the Four Horsemen, that is, War, Famine, Pestilence, and Death (Rev. 6:1–8), the Beatus Apocalypses had a fully developed series of prefatory miniatures. In the Gerona Apocalypse of 975, illuminated by Emetrius and Ende of Tavara, this sequence opens with a depiction of the Cross of Oviedo, a talismanic symbol of the protection of the Christian enclave in northern Spain from the incursions of the Muslims, and continues with a two-page miniature of the circles of Heaven, representations of the four Evangelists, and a series of Old and New Testament scenes from Adam and Eve to the Rejoicing of the Righteous at the moment of Resurrection.[10]

Northern European examples of the Apocalypse did not incorporate the Beatus commentaries, and their miniatures lacked the brilliant color and frequent two-page format of their Spanish

counterparts. Richly illustrated Apocalypses were popular again in the middle of the thirteenth century in France and England[11] and again in the fifteenth century as an early printed book, first as a block book, and then, just before 1500, in an edition printed with movable type containing woodcuts by Albrecht Dürer.

An extended series of liturgical books gradually evolved, in addition to the sacramentary and then the missal and gradual, to assist in the performance of the Mass. Among the more important of these were directories or ordinals, books that contained the directions and prayers for the preparation of the Mass and canon, instructions that one might find rubricated in some complete missals. Sometimes combined with the ordinal, but also frequently appearing as a separate volume, a benedictional was the compilation of blessings said by the bishop after the Lord's Prayer in the celebration of the Mass. These were ordered according to the sequence of feasts during the liturgical year. If illuminated, the miniatures in such a manuscript might depict, as in the Benedictional of St. Aethelwold in London (British Library, MS. Add. 49598), representations appropriate to the various feasts and saints' days upon which the blessings were said.[12] In this manuscript a series of prefatory miniatures depicts heavenly choirs of various categories of saints, apostles, and angels.

A pontifical contains the texts for those services performed by a bishop or pope for such occasions as the consecration of a church and its liturgical furnishings, the ordination of clergy, the blessing of a graveyard, confirmation, and so forth. Decorations of these texts usually show a pope or bishop performing these functions. Beyond these basic services the contents of the pontifical were highly variable, often containing elements of principal masses and various episcopal prayers.[13]

Since the celebration of the feast days of the saints, in addition to the major feasts of the Church, was an important element of the liturgical year, manuscripts were compiled containing just this appropriate material. A martyrology or passional, based upon the feasts of the Sanctorale, contained lessons concerning the martyrdoms of the saints to be read at the office of prime in the Divine Office. It therefore served as a brief compendium of the saints' lives arranged according to the sequence of the liturgical year. The most spectacular example of such a book is the *Mēnologion* used by the Byzantine Church from the end of the tenth century.[14] Divided into twelve or twenty-four volumes, one for each month or half-month, it might contain a miniature at the beginning and end of each short biography, usually portraits or scenes of martyrdom.

Many other kinds of manuscripts were of course produced during the Middle Ages: commentaries on books of the Bible,

theological treatises, books on canon law, as well as astro-
nomical, medical, and other scientific texts. During the Gothic
period in particular, historical and literary texts were written in
increasing numbers, and more and more of them were either
translated or written in the vernacular. The exegetical and scien-
tific texts did not lend themselves to narrative miniatures, and
because many of them were intended only for study, they were
not usually elaborately decorated. But chronicles, histories, and
literary works, many of which were inspired by classical texts,
such as the History of Livy and the *Aeneid* of Vergil, as well as
new works by Dante, Boccaccio, and Petrarch, gave rise to a
profusion of new secular illustrations. As varied and magnificent
as these manifestations of the new directions in narrative pro-
grams of miniatures are, they must, unfortunately, remain out-
side the focus of this book.

Appendixes: Contents of Manuscripts

In the following Appendixes, the contents of the manuscripts show the major divisions of the text and their accompanying illuminations. Single-spaced entries indicate facing folios:

85v	Carpet page
86r	"Initium evangelii Jesu Christi" (Incipit of St. Mark)

Appendix 1. The Book of Durrow

Dublin, Trinity College Library, MS 57
248 vellum folios, 247–228 mm. × 160 mm.
Text area 220–205 mm. × 120 mm.; 32–22 lines of text, but usually 25
Irish majuscule script

1v	Carpet page
2r	Symbols of the Four Evangelists
3v	Carpet page
4r	"Novum opus" (Letter of St. Jerome to Pope Damasus)
6v–7 v	Glossary of Hebrew names
8r–10 r	Canon tables
11r–14 r	*Breves causae* (Summaries)
14r–20 v	*Argumenta* (Prefaces or prologues)
21v	Man (Symbol of St. Matthew)
22r	(Carpet page? now missing) "Liber generationis" (Incipit of St. Matthew)
23r	"Christi autem generatio sic erat" (Matt. 1:18: Chi Rho monogram)
84v	Eagle (Symbol of St. Mark, pre-Jerome tradition)
85v	Carpet page
86r	"Initium evangelii Jesu Christi" (Incipit of St. Mark)
124r	Glossary

124v	Ox (Symbol of St. Luke)
125v	Carpet page
126r	"Quoniam quidem multi" (Incipit of St. Luke)
191v	Lion (Symbol of St. John, pre-Jerome tradition)
192v	Carpet page
193r	"In principio erat verbum" (Incipit of St. John)
247v	Colophon: "Ora pro me frater mi dñs tecum sit"
248r	Carpet page

Appendix 2. The Lindisfarne Gospels

London, The British Library, MS Cotton Nero D. IV
259 vellum folios, 340 × 240 mm.
Text area 240 × 190 mm.; 25 lines of text in two columns
Insular half-uncial or majuscule script

1r	Later inscription
2v	Carpet page
3r	"Novum opus" (Jerome's letter)
5v	"Plures fuisse" (Jerome's preface)
8r	"Eusebius Carpiano" (Eusebius's letter)
10r–17v	Canon tables
18v	"Incipit argumentum Matthei"
19r	"Incipiunt capitula lectionum sec. Mattheum"
24r	List of festivals for reading in Matthew
25v	St. Matthew and Winged Man
26v	Carpet page
27r	"Liber generationis"
29r	"Christi autem generatio sic erat" (Chi Rho monogram)
90r	"Incipit argumentum [Marci]"
91r	"Incipiunt capitula lectionum: Esaiae testimonium Johannis"
93r	Festivals for reading in Mark
93v	St. Mark and Lion
94v	Carpet page
95r	"Initium evangelii"
130r	"Explicit liber Marci [*sic*]." Festivals for reading in Luke
131r	"Incipit praefatio Lucae"
131v	"Incipiunt capitula"
137v	St. Luke and Ox
138v	Carpet page
139r	"Quoniam quidem multi"
139v	"Fuit in diebus Herodis" (Luke 1:5)

203v "Incipit argumentum secundum Johannem"

204r "Incipiunt capitula secundum Johannem"

208r "Quae lectio cum in natale sancti petri"

209v St. John and Eagle

210v Carpet page
211r "In principio erat verbum"

259r "Explicit liber secundum Iohanen [*sic*]. Eadfrith biscop" (Colophon)

Appendix 3. The Book of Kells

Dublin, Trinity College Library, MS 58
339 vellum folios, 330 × 250 mm.
Text area c. 250 × 170 mm.; 16–18 lines
Insular half uncial or majuscule script

1r Glossary and Symbols of the Four Evangelists

1v–6r Eusebian canon tables

6v–7r Later Irish charters (on unexecuted canon table pages)

7v Miniature of Virgin and Child
8r *Breves causae* of Matthew: "Nativitas Christi in Bethlem"

12r Argumentum of Matthew: "Matheus"

13r *Breves causae* of Mark: "Et erat Johannis baptizans"

15v Argumentum of Mark: "Marcus evangelista"

16v Argumentum of Luke: "Lucas syrus natione"

18r Argumentum of John: "Hic est Johannis Evangelista"

19v *Breves causae* of Luke: "Zachariae sacerdotii"

24r *Breves causae* of John: fragments

26r Glossary

27r Later Irish charters

27v Symbols of the Four Evangelists

28v St. Matthew
29r "Liber generationis"

32v Miniature of Christ Enthroned
33r Carpet page

34r "Christi autem" (Chi Rho monogram)

114r Arrest of Christ: "Et hymno dicto" (Matt. 26:30)

114v "Tunc dicit illis" (Matt. 26:31)

124r "Tunc crucifixerant Xpi cum eo duos latrones" (Matt. 27:38)

129v Symbols of the Four Evangelists

 (St. Mark, portrait missing)
130r "Initium evangelii"

183r "Erat autem hora tercia" (Mark 15:25)

187v	"[Et Dominus] quidem [Iesus] postquam" (Mark 16:19)
	(Symbols of the Four Evangelists, missing)
	(St. Luke, missing)
188r	"Quoniam quidem multi"
188v	"Fuit in diebus Herodis" (Luke 1:5)
200r	Genealogy of Christ (Luke 3:23–38)
202v	Temptation of Christ
203r	"Iesus autem plenus" (Luke 4:1)
285r	"Una autem sabbati valde": Four Angels (Luke 24:1)
290v	Symbols of the Four Evangelists
291v	St. John
292r	"In principio erat verbum"

Appendix 4. The First Bible of Charles the Bald

Paris, Bibliothèque Nationale, MS lat. 1
423 vellum folios, 495 × 345 mm.
Text area 362/365 × 272/280 mm.; 51 lines of text in two columns
Quadrata, capitalis rustica, uncial, and Carolingian minuscule scripts

1–2v	Introductory dedicatory verses
3v	St. Jerome frontispiece
4r	"Incipit epistola Sancti Hieronymi ad Paulinum presbyterum de omnibus divinis historiae libris" (Title page to Jerome's letter to Paulinus of Nola)
4v	"Frater Ambrosius"
8r	"Incipit praefatio Sancti Hieronymi presbyteri" (Title page to Jerome's preface)
9r	"Capitula Liber Genesis" (Table)
10v	Genesis frontispiece to Old Testament
11r	"In principio creavit Deus caelum et terram" (Gen.)
27v	Exodus frontispiece
28r	"Haec sunt nomina filiorum Israel" (Exod.)
215v	David frontispiece
216r	"Beatus vir" (Ps.)
324r	Title page
325v	Eusebian letter
326r–327v	Canon tables
329v	Majestas Domini frontispiece to New Testament
330r	"Liber generationis"
340r	"Initium evangelii"
347r	"Quoniam quidem multi"
358v	"In principio erat verbum"
383r	"Concordia Epistolarum"

386v	Epistles frontispiece
387r	"Paulus servus Iesu Christi" (Epistles of St. Paul)
415v	Apocalypse frontispiece
416r	"Apocalypsis Iesu Christi" (Apocalypse of St. John)
422r–v	Dedicatory verses
423r	Dedication-presentation miniature of Charles the Bald

Appendix 5. The Codex Aureus of St. Emmeram

Munich, Bayerische Staatsbibliothek, Clm 14000
126 vellum folios, 420 × 330 mm.
Text area 345 × 245 (interior of painted frame); usually 40 lines in two
 columns (345 × 102 mm. each)
Quadrata, capitalis rustica, and uncial scripts

1r	Abbot Ramwold with Four Virtues and Symbols of the Four Evangelists (late tenth-century addition)
1v	"Incipit praefatio Sancti Hieronimi"
2r	"Beatissimo papae Damaso Hieronimus, novum opus" (Jerome's letter)
3v	"Plures fuisse" (Jerome's preface)
4v	"Eusebius Carpiano" (Eusebius's letter)
5v	Charles the Bald Enthroned
6r	Adoration of the Paschal Lamb
6v	Christ in Majesty with Evangelists and Prophets
7r	Canon table
13r	"Incipit argumentum . . . Mattheum" (Title page)
15v	Tituli on meaning of Gospels of St. Matthew
16r	St. Matthew with Angel
16v	Lion of Christ
17r	"Liber generationis"
44v	"Incipit praefatio . . . Marcum"
46r	St. Mark with Lion
46v	Christ with Symbols of the Four Evangelists
47r	"Initium evangelii"
63r	"Incipit prologus . . . Lucam"
65r	St. Luke with Ox
65v	Lamb of Christ with Symbols of the Four Evangelists
66r	"Quoniam quidem multi"
94r	"Incipit prologus . . . Johannem"
96v	Tituli on meaning of Gospels of St. John
97r	St. John with Eagle
97v	Hand of God
98r	"In principio erat verbum"

Appendix 6. Pericopes of Henry II

Munich, Bayerische Staatsbibliothek, Clm 4452
206 vellum folios, 425 × 320 mm.
Text area 270 × 160 mm.; 19 lines
Quadrata, capitalis rustica, uncial, and minuscule scripts

1v	Dedicatory inscription
2r	Christ Enthroned Crowning Henry II and Kunigunde
3v	St. Matthew portrait
4r	St. Mark portrait
5v	St. Luke portrait
6r	St. John portrait

Lessons for the Temporale and Sanctorale

Christmas Eve (Dec. 24)
7r	Pericope 1 for Vigil of Christmas: "Cum esset desponsata" (Matt. 1: 18–21)

Christmas (Dec. 25)
8v	Annunciation to the Shepherds
9r	Nativity
10r	Pericope 2 for Christmas: "Exiit edictum" (Luke 2:1–14)
11v	Title page: "In die natalis Domini"
12r	Pericope 4 for Christmas: "In principio erat verbum" (John 1:1–14)

Epiphany (Jan. 6)
17v–18r	Adoration of the Magi
19r	Pericope 12: "Cum natus esset Jesus" (Matt. 2:1–12)

Purification of the Virgin
35v	Presentation at the Temple
36r	Pericope 35: "Postquam impleti sunt" (Luke 2:22–32)

Palm Sunday
76v	Pericope 78: "Cum appropinquassent Jerosolymis" (Matt. 21:1–9)
77v	Apostles find Ass with Foal
78r	Entry into Jerusalem
79r	Pericope 79: "Scitis, quia post biduum pascha fiet" (Matt. 26:2–27, 66)

In Caena Domini
105v	Last Supper
106r	Pericope 83: "Sciens Jesus, quia venit eius hora" (John 13:1–15)

Good Friday
107v	Christ on the Cross; Christ before High Priest
108r	Descent from the Cross; Entombment
109r	Pericope 84: "Egressus est Jesus" (John 18:1–19, 42)

Easter
116v	Three Marys at the Tomb
117r	Angel on the Open Tomb
118r	Pericope 86: "Maria Magdalene et Maria Jacobi" (Mark 16:1–7)

Ascension
131v	Ascension
132r	Pericope 103: "Recumbentibus" (Mark 16:14–20)

	Pentecost
135v	Pentecost
136r	Christ Takes Leave of the Apostles
137r	Pericope 109: "Si quis diligit me" (John 14:23–31)
	Birth of St. John the Baptist (June 24)
149v	Angel before Zacharias at the Temple; Zacharias before the People
150r	Birth of St. John; the Naming of John
151r	Pericope 126: "Elizabeth autem impletum est tempus pariendi" (Luke 1:57–68)
	Feast of St. Peter Apostle (June 29)
152v	Christ Gives Peter the Keys of Heaven
153r	Pericope 128: "Venit Jesus in partes" (Matt. 16:13–19)
	Assumption of the Virgin (Aug. 15)
161v	Death of the Virgin and Assumption of the Virgin
162r	Christ at the House of Mary and Martha
163r	Pericope 142: "Intravit Jesus in quoddam castellum" (Luke 10:38–42)

Lessons for the Common of the Saints
188r	"In vigilia omnium apostolorum"
188v	"In natali apostolorum"

Lessons for Other Masses
198r	"In Dedicatione Aecclesiae"
199r	Pericope 190: "Ingressus Jesus perambulabat Jericho" (Luke 19:1–10)
200r	Christ Calls Zacchaeus from the Tree; Christ in the House of Zacchaeus
200v	"Contra Judices inique agentes" Pericope 191: "Dicebat Jesus parabolam" (Luke 18:1–8)
201r	"In agenda mortuorum" Pericope 192: "Amen, Amen, dico vobis" (John 5:25–29)
201v	Raising of the Dead
202r	Last Judgment

NOTE: Only those feasts accentuated with miniatures and major initials are listed here; for a complete list of the pericopes, see Leidinger, *Das Perikopenbuch,* pp. 6–11.

Appendix 7. The Drogo Sacramentary

Paris, Bibliothèque Nationale, MS lat. 9428
130 vellum folios, 264 × 214 mm.
Text area 168 × 130 mm.; usually 20 lines
Quadrata, capitalis rustica, uncial, and Carolingian minuscule scripts

3r	"Incipit ordo de sacris ordinibus benedicendis"
9v	"Oratio ad ordinandos episcopos"
10r	"Consecratio: Per omnia saecula" (in architectural frame)
10v	"Praefatio: Vere dignum"

The Common Preface

14r "Consecratio: Per omnia saecula saeculorum" (in architectural frame)

14v "Praefatio: Vere dignum"
15r "Sanctus" (in framed area)

Canon of the Mass

15v "Te igitur"
16r "Clementissime" (in frame)

16v "Pater per Iehsum Christum filium tuum dominum nostrum" (in gold capitals)

20v Lord's Prayer: "Pater noster"

Temporale and Sanctorale

21v Beginning of yearly cycle of feasts: Vigil of Christmas

22v "Natale domini. Missa de nocte [Dec. 25]:
Deus qui hanc sacratissimam" with Mary Lying on Bed

23v "Missa primo mane statio ad s. Anastasiam:
Da quaesumus omnipotens deus" with Annunciation to the Shepherds

24v "In nativitate domini ad s. Petrum:
Concede quaesumus omnipotens deus" with Nativity

27r "Natale s. Stephani [Dec. 26]. Inde ad missam:
Da nobis quaesumus domine" with Stoning of St. Stephen

29r "Natale s. Johannis Evangelistae [Dec. 27]:
Ecclesiam tuam domine benignus inlustra" with Writing Evangelist

31r "Natale Innocentum [Dec. 28]:
Deus cuius hodierna die preconium innocentes" with Massacre of the Innocents

32v "In octavas domini:
Deus qui salutis aeternae" with Holy Family

34v "Ephyphania statio ad s. Petrum [Jan. 6]:
Deus qui hodierna die unigenitum tuum gentibus" with Adoration of the Magi

38r "Yppopanti [sic] Ad missam ad s. Mariam:
Omnipotens sempiterne deus maiestatem tuam" with Presentation of Christ at the Temple

41r "In Quadragesima ad s. Johannem in Lateranis:
Deus qui ecclesiam tuam annua quadragesimali" with Temptations of Christ

43r "Oratio in acceptione palmarum ante processionem dicenda:
Omnipotens genitor qui unigenitum" with Entry into Jerusalem

43v "Die in dominica in ramis palmarum:
Omnipotens sempiterne Deus qui humano generi ad imitandum" with Crucifixion

44v "In caena domini:
Deus a quo et Iudas reatus" with Last Supper and Arrest of Christ

46v "Benedictio chrismatis:
Vere dignum et iustum et aequum" with Benediction of Oil

48v "Oratio ad catecuminum faciendum:
Omnipotens sempiterne deus" with Praying Cleric

51r "Dominus vobiscum" in architectural frame

51v Preface of Part II; Easter season:
 "Vere dignum" with Blessing of Baptismal Water

54r "Oratio ad infantes consignandos:
 Omnipotens sempiterne deus qui regenerare dignatus es" with Bestowing of Confirmation

56r "In Sabbato Sancto. Ad primam missam:
 Deus qui sollemnitate" with two Apostles at the Grave

57r "Ad secundam missam:
 Perfice domine benignus" with Three Marys at the Tomb

57v "In die pasche domini ad missam statio ad s. Petrum:
58r Deus qui hodierna die per unigenitum" with Three Marys at the
 Tomb and Christ Appearing to the Women

59r "Praefatio" in architectural frame

59v "Vere dignum" with Paschal Lamb

61v Weekdays in Easter Week. "Feria II in albis:
 Deus qui sollempnitate paschali" with Way to Emmaus

62r "Feria III ad s. Paulum:
 Deus qui ecclesiam tuam novo semper foetu" with Christ Showing
 His Wounds

63r "Feria IIII ad s. Laurentium:
 Deus qui nos resurrectionis" with Mary Magdalene Speaking with
 Christ

63v "Feria V ad Apostolos:
 Deus qui diversitatem gentium" with Magdalene and Christ

64v "Feria VI ad s. Mariam:
 Omnipotens sempiterne deus qui paschale sacramentum" with
 Christ Sending the Apostles out into the World

65r "Sabbato ad s. Johannem:
 Concede quaesumus omnipotens deus" with Resurrected Christ
 among the Apostles

66r "Die dominica post albas:
 Praesta quaesumus omnipotens deus" with Doubting of Thomas

71r "In die ascensa [sic] domini ad missam"

71v "Concede quaesumus omnipotens deus" with Ascension

77v "In die [Pentecostes] statio ad s. Petrum:
78r Deus qui hodierna die corda fidelium" with Pentecost

83r "Vigilia s. Johannis Baptistae [June 23]:
 Praesta quaesumus omnipotens deus" with Angel announcing the
 Birth to Zacharias

84r "In die [natalis s. Johannis Bapt.] ad missam [June 24]:
 Deus qui praesentem diem honorabilem" with Birth of John the
 Baptist

86r "Natale sanctorum Petri et Pauli [June 29]:
 Deus qui hodiernam diem apostolorum tuorum" with Martyrdoms
 of Peter and Paul

87v "Natale s. Pauli [June 30]:
 Deus qui multitudinem gentium" with Bishop Celebrating Mass

89r	"Natale s. Laurentii. In die ad missam [Aug. 10]: Da nobis quaesumus omnipotens deus" with Martyrdom of St. Lawrence
90r	"Adsumptio s. Marie [Aug. 15]: Veneranda nobis domine huius est diei festivitas"
91r	"Natale s. Arnulfi: Deus qui beatum Arnulfum" with miracles of Arnulf
92v	"Nativitas s. Mariae [Sept. 8]: Supplicationem servorum tuorum" with ornamental initial
98v	"Natale s. Andreae [Nov. 30]: Majestatem tuam domine suppliciter exoramus" with Martyrdom of St. Andrew

Various Benedictions and Miscellaneous Material

100–105v	"Ordo dedicationis ecclesiae"
106–112r	Common of the Saints
112v–128	Miscellaneous texts and List of Bishops of Metz (126–128) 128r: "Drogo archiepiscopus, VI id. decembris" [Dec. 8] in gold
128v–130	Various tenth-century prayers

Appendix 8. The Metz Coronation Sacramentary (Fragment)

Paris, Bibliothèque Nationale, MS lat. 1141
10 vellum folios, 267 × 205 mm.
Text area 186 × 135 mm. (inside frame); 18–19 lines
Quadrata, capitalis rustica, uncial, and Carolingian minuscule scripts

1r	"Incipit liber sacramentorum"
2v	King Charles the Bald between Two Bishops
3r	Pope Gregory Receiving Divine Inspiration
3v	Preface: "Per omnia saecula saeculorum"
4r	"Vere dignum"
5r	Christ in Majesty
5v	Hierarchy of Heaven Paying Homage
6r	Christ Enthroned between Seraphim above "Sanctus"
6v	"Te igitur"
7r	"Clementissime"
9v	"Pater Noster"
10r	"Libera nos"

Appendix 9. The Berthold Missal

New York, The Pierpont Morgan Library, MS M. 710
165 vellum leaves, 293 × 203 mm.
Text area 198 × 140 mm.; 22 lines
Rounded majuscule and minuscule scripts

2v–8r	Calendar

★Full-page miniatures are indicated by an asterisk.

89v	"Deus qui"
94r	Annunciation to Zacharias★ (June 24)
94v	"Deus qui presentem"
96r	Crucifixion of St. Peter: Execution of St. Paul★ (June 29)
96v	"Deus qui" with Christ
99r	Martyrdom of St. James Major (July 25) "Esto Domine"
101v	SS. Oswald and Aidan at dinner, offering ciborium to beggars★ (Aug. 9)
102r	"Deus qui nos beati Oswaldi"
104v	Martyrdom of St. Lawrence★ (Aug. 10)
105r	"Da nobis"
107r	Death of the Virgin★ (Assumption of the Virgin: Aug. 15)
107v	"Famulorum tuorum"
108v	Martyrdom of St. Bartholomew (Aug. 24)
109r	"Omnipotens"
110r	Salome Offering Head of St. John the Baptist to Herod (Aug. 29)
110v	"Sancti Johannis"
112r	Tree of Jesse★ (Birth of the Virgin: Sept. 8)
112v	"Famulis tuis Domine"
114r	Heraclius Beheading Chosroes II★ (Feast of the Exaltation of the Cross: Sept. 14)
114v	"Deus qui nos" with Jerusalem Cross
116r	"Beati" with St. Matthew (Sept. 21)
119r	"Deus qui"; St. Michael Slaying the Dragon (Sept. 29)
120v	"Deus qui"; St. Gall (Oct. 16)
122r	"Deus qui"; St. Simon and St. Jude (Oct. 28)
122v	Vigil of All Saints (Oct. 31): "Domine Deus noster"
123r	Abraham representing Paradise★ (All Saints: Nov. 1)
123v	"Omnipotens sempiterne Deus"
125v	St. Martin Dividing Cloak and Raising Three Dead Persons★ (Nov. 11)
126r	"Deus qui"★
127r	Dedication of a Church with Kneeling Benefactor★
127v	"Deus qui nobis per singulos annos"
131r	"Majestatem Tuam" with Crucifixion of St. Andrew (Nov. 30)
132r	"Da nobis Domine" with St. Thomas Apostle (Dec. 21)

Votive Masses for Days of the Week

132v	Trinity★ (Sunday Mass of the Trinity)
133r	"Omnipotens sempiterne Deus"
136–158r	General votive masses (begins: "Missa de patrono. Martini et Oswaldi")
159–159v	Collects added in another hand

160–161r Benedictions

161v–164 Notes by Abbot Berthold

Appendix 10. A Lombard Gradual

Ithaca, N.Y., Cornell University Libraries, MS B 50++
193 vellum leaves, 540 × 370 mm.
Text area 365 × 280 mm.; 5 lines of text and 5 of musical notation
Gotica rotunda script

Introits of major feasts decorated with historiated initials:
Sanctorale

1r	Vigil of St. Andrew Apostle: "Dominus secus mare galilaeae" with Calling of Peter and Andrew (Nov. 29)
10v	Purification of the Virgin: "Suscepimus deus misericordiam tuam" with Presentation of Christ at the Temple (Feb. 2)
15r	"Gaudeamus" with St. Agatha (Feb. 5)
26v	"Exclamaverunt ad te Domine" with SS. Philip and James (May 1)
28v	The Invention of the Cross: "Nos autem" with St. Helen Kneeling before the Cross (May 3)
32r	"In medio Ecclesiae" with St. Anthony of Padua (June 13)
34r	Vigil of St. John the Baptist: "Ne timeas Zacharia" with St. John the Baptist (June 23)
36r	Birth of John the Baptist: "De ventre matris meae" with Birth of John the Baptist (June 24)
39v	Vigil of SS. Peter and Paul: "Dicit dominus" with St. Peter in a Boat (June 29)
41r	Feast of Apostles Peter and Paul: "Nunc Scio vere" with St. Peter in Prison (June 29)
42v	"Scio cui credidi" with St. Paul (June 30)
45r	"Gaudeamus" with Visitation (July 2)
49r	Vigil of St. Lawrence: "Dispersit, dedit pauperibus" with St. Lawrence (Aug. 9)
51r	"Confessio et pulchritudo" with Martyrdom of St. Lawrence (Aug. 10)
54r	Assumption of the Virgin: "Gaudeamus" with Ascension of the Virgin (Aug. 15)
56v	Octave of St. Lawrence; "Probasti domine" with Monogram *IHS* (Aug. 17)
58r	Nativity of the Virgin: "Salve sancta parens" with Birth of the Virgin (Sept. 8)
65r	Dedication of St. Michael Archangel; "Benedicite dominum omnes angeli" with God Blessing the Angels (Sept. 29)
72v	Feast of All Saints: "Gaudeamus" (Initial missing)
75r	"Dicit dominus" with St. Clement (Nov. 23)

Commune Sanctorum

77r	Vigil of an Apostle: "Ego autem sicut" with an Apostle

87r	Feast of a Martyr not a Pope: "In virtute tua domine" with Stigmatization of St. Francis
101r	Feast of a Martyr from Easter to Pentecost: "Protexisti me deus" with Martyr Saint with a Palm Branch
105v	Feasts of Many Martyrs: "Intret in conspectu tuo" with Group of Martyr Saints
141r	Feast of Bishop Confessors: "Sacerdotes tui domine" with St. Louis of Toulouse (?) Holding Crozier
158v	Feasts of Confessors not Bishops: "Os iusti meditabitur" with St. Bernardino of Siena (?) Holding *IHS* Monogram
162r	Feasts of Virgins: "Dilexisti iustitiam" with St. Catherine
182r	Dedication of a Church: "Terribilis est locus iste" with Angel Protecting a Church

Appendix 11. The Windmill Psalter

New York, The Pierpont Morgan Library, MS M. 102
167 + 1 vellum folios, 324 × 222 mm.
Text area 219/220 × 139/140 mm.; 19 lines
Gotica textualis formata script

1v	Initial *B*: Virgin and Child, David, Tree of Jesse, Creation scenes, Signs of Four Evangelists, 12 minor and 4 major Prophets
2r	Initial *E*: "—atus vir qui non abit" in scroll held by angel: Judgment of Solomon
24v	Psalm 26: "Dominus illuminatio." Initial: David Anointed
39v	Psalm 38: "Dixi custodiam." Initial: David pointing to his mouth before Christ
52v	Psalm 51: "Quid gloriaris." Initial: Betrayal of Christ
53v	Psalm 52: "Dixit insipiens." Initial: Fool Brandishing Club and Eating Round Bread
	Psalm 68: "Salvum me fac." (Missing)
84r	Psalm 80: "Exultate Deo." Initial: David Ringing a Carillon
100r	Psalm 97: "Cantate Domino." Initial: Singing Monks before Choir Book
102v	Psalm 101: "Domine exaudi." Initial: Crowned David Kneeling before Altar with Cross, Christ in Cloud Above
117v	Psalm 109: "Dixit Dominus." Initial: The Trinity
152v	First Canticle: "Confitebor tibi." Initial: Isaiah Being Sawed Asunder (Isa. 12:1)

Appendix 12. Breviary of Charles V

Paris, Bibliothèque Nationale, MS lat. 1052
617 vellum leaves, 230 × 178 mm.
Text area 148 × 103 mm.; 30 lines in 2 columns
Gotica textualis formata script

226r Ps. 38: "Dixi custodiam vias"
 Saul Attempting to Spear David
 Cain and Abel; Eucharist; Charity

232r Ps. 52: "Dixit insipiens in corde"
 Absalom Hung by His Hair
 Dethroned King; Sacrament of Ordination; Prudence

238r Ps. 68: "Salvum me fac, Deus"
 Peter in Boat
 Samson and Delilah; Confirmation; Fortitude

245v Ps. 80: "Exultate Deo adiutori nostro"
 David Dancing before Ark
 Death of Holophernes; Marriage; Temperance

252v Ps. 97: "Cantate Domino"
 Monks Carrying Coffin
 Condemned Person Led to Gallows; Penitence; Justice

261r Ps. 109: "Dixit Dominus Domino meo, sede a dextris meis"
 Christ Enthroned with Kneeling King
 Last Judgment; Heaven and Hell

279r Litany

Sanctorale
285–584 Beginning with Vigil of St. Andrew, 186 miniatures of saints★

Common of the Saints
585r An Apostle

588r A Martyrdom

606–617r *Ordo officii* for Advent

Appendix 13. The Beaupré Antiphonary

Baltimore, The Walters Art Gallery MSS W.759–762
Vol. 1 (W.759) 223 vellum leaves, 490 × 345 mm.
Vol. 2 (W.760) 258 vellum leaves, 490 × 325 mm.
Vol. 3 (W.761) 270 vellum leaves, 425 × 313 mm.
Vol. 4 (W.762) 62 vellum leaves, 490 × 345 mm.
Text area 343/355 × 223/230 mm. (Vol. 3: c. 310 × 212 mm.); 8 lines of
 text interspersed with lines of musical notation
Gotica textualis formata script

VOL. 1 (W.759): EASTER TO THE ASSUMPTION OF THE VIRGIN

Temporale
1v Vigil for Easter: "In sanctissima vigilia pasche ad vesperas super
 psalms antiphona"

2r Ant: "Alleluja" with Angels and Harrowing of Hell

★For a complete list of the saints in the Sanctorale, see Leroquais, *Les bréviares,*
2:54–56.

8r	Same to middle of Sept.
15v	Same from middle of Sept.
22r	Same from Oct. 1
29r	Same from Nov. 1
36r	Anthems to Benedictus and Magnificat from Ninth to Twenty-fifth Sunday after Pentecost
45r	Anthems, versicles, etc. during Advent
91v	Anthems to Magnificat on the seven days preceding the Vigil of Christmas
93v	Vigil of Christmas

Sanctorale

97	Vespers of the Assumption of the Virgin Ant: "Quae est ista quae ascendit" with Death of the Virgin
100r	Feast of the Assumption (Aug. 15) Resp: "Vidi speciosam" with Entombment and Coronation of the Virgin
113r	Feast of St. Bernard (Aug. 20) Resp: "Prima virtus viri sancti" with St. Bernard
122v	Vespers of Feast of Martyrdom of St. John the Baptist Ant: "Baptisma Cristi et praecursor" with St. John
(Initial in Brussels, Bibliothèque Royale, MS 3634²) 	Feast of Martyrdom of St. John the Baptist (Aug. 29) Initial *M* with Martyrdom of St. John the Baptist
123v	Nativity of the Virgin (Sept. 8) Resp: "Nativitas tua" with Birth of the Virgin
137v	Feast of St. Michael (Sept. 29) Resp: "Factum est silentium in caelo" with St. Michael and Two Other Angels
152r	All Saints (Nov. 1) Resp: "In principio erat verbum" with Christ and Saints and Prophets
163r	St. Martin (Nov. 11) Resp: "Hic est Martinus" with St. Martin Dividing Cloak with Beggar
172r	Vespers of St. Cecilia (Nov. 21) Ant: "Virgo gloriosa semper" with Martyrdom of St. Cecilia
173r	Feast of St. Cecilia (Nov. 22) Resp: "Cantantibus organis" with Marriage Feast of St. Cecilia
(Leaf in Oxford, Ashmolean Museum) [182r]	St. Catherine: "In sollempnitate sponse Cristi eximiae gloriosissime Virginis Katherine Ad vesperas Super ps.a" in vermillion, blue, dark pink, gold, and green with illuminated letters Ant: "Virginis eximie Katherine" with St. Catherine
185r	St. Andrew Resp: "Dum perambularet" with Martyrdom of St. Andrew

Communale Sanctorum

195r	Proprium sanctorum

220r	In natali plurimorum martyrum Resp: "Absterget deus omnem lacrimam" with Pope, Bishop, and Cistercian Monk
230v	In natali unius confessoris pontificis Resp: "Euge serve bone" with Bishop and Two Cistercian Monks
245v	Office of the Virgin
256r	Te Deum
258v	"In adventu domini ad completorium"

VOL. 3 (W.761): CHRISTMAS TO EASTER

Temporale

1r	Vigil of the Nativity Ant: "Antequam convenirent" with Visitation
4r	Christmas Day (Dec. 25) Resp: "Hodie nobis caelorum rex" with Annunciation to the Shepherds and Nativity
11v	Lauds of Christmas Day Ant: "Genuit puerpera regem" with Virgin and Child
28r	Vigil of Epiphany Ant: "Magi viderunt stellam" with Adoration of the Magi
29v	Epiphany (Jan. 6) Resp: "Hodie in Jordane baptizato" with Baptism of Christ
112r	Palm Sunday Resp: "In die qua invocavi" with Entry into Jerusalem
(Leaf in London, Victoria and Albert Museum)	Good Friday Resp: "Omnes amici mei dereliquerunt" with Arrest of Christ

Sanctorale

125r	Vespers of St. Stephen Ant: "Stephanus autem plenus gratia" with St. Stephen
125v	St. Stephen (Dec. 26) Resp: "Hesterna die dominus natus est" with Martyrdom of St. Stephen
133v	St. John the Baptist (Dec. 27) Resp: "Qui vicerit faciam illum columpnam in templo dicit dominus" with Death of St. John
142r	Innocents' Day (Dec. 28) Resp: "Sub altare dei audivi vocem occisorum" with Massacre of the Innocents
151r	St. Agnes (Jan. 21) Resp: "Diem festum sacratissime virginis celebremus" with St. Agnes
162v	Conversion of St. Paul (Jan. 25) Resp: "Qui operatus est petro" with Conversion of St. Paul
175v	Purification of the Virgin (Feb. 2) Resp: "Adorna thalamum tuum" with Presentation of Christ at the Temple
186r	St. Agatha (Feb. 5) Resp: "Agatha laetissime" with St. Agatha

196v	St. Peter's Chair (Feb. 22) Resp: "Quem dicunt homines" with St. Peter as Pope
207v	St. Benedict (Mar. 21) Resp: "Fuit vir vitae venerabilis" with St. Benedict
218v	The Annunciation (Mar. 25) Resp: "Missus est Gabriel" with Annunciation

Communale Sanctorum
| 26r | Common of the Saints |

(Leaf now in London, Victoria and Albert Museum)
In natali plurimorum martyrum
Resp: "Absterget" with Pope, Bishop, and Cistercian Monk

253v	In natali unius confessoris pontificis Resp: "Euge serve bone" with Baptism of a Saint
268r	Te deum with Christ Blessing
270v	Hymn for Vespers of Christmas Day "Intende qui regis" with Monk Playing Organ

Vol. 4 (W.762): Fifteenth- to Seventeenth-Century Additions

Appendix 14. The Normal Contents of the Hours of the Virgin

Matins
Versicle: "Domine labia mea aperies" (O Lord, open thou my lips)
Response: Et os meum annunciabit laudem tuam" (And my mouth shall proclaim your praise)
Versicle: "Deus in adiutorium meum intende" (Haste thee, O God, to deliver me)
Invitatory: "Ave Maria" (Hail Mary)
Ps. 94: "Venite exultemus" (Come let us praise the Lord with Joy)
Hymn: "Quem terra pontus aethera"
Three psalms with antiphons, last two with versicles and responses for Sundays, Mondays, and Thursdays:
 Ps. 8: "Domine dominus noster" (O Lord our Lord)
 Ps. 18: "Caeli enarrant" (The heavens show forth)
 Ps. 23: "Domini est terra" (The earth is the Lord's)
Usually three lessons with versicles and responses, but sometimes as many as nine
Additional psalms, three for Tuesdays and Fridays; another three for Wednesdays and Saturdays
"Te Deum" (We praise thee, O Lord) with versicle and response
Collect or prayer

Lauds
"Deus in adiutorium meum intende" (Haste thee, O God to deliver me)
"Gloria"
Four psalms with antiphons:
 Ps. 92: "Dominus regnavit" (The Lord hath reigned)
 Ps. 99: "Jubilate Deo" (Sing joyfully to God)
 Ps. 62: "Deus Deus meus" (O God my God)
 Ps. 66: "Deus misereatur" (May God have mercy on us)
Canticle: "Benedicite omnia opera" (All ye works of the Lord, bless the Lord: Dan. 3:57) with antiphon
Three psalms with antiphons and capitula:
 Ps. 148: "Laudate Dominum de caelis" (Praise ye the Lord from the heavens)
 Ps. 149: "Cantate Domino" (Sing ye to the Lord)

Ps. 150: "Laudate Dominum in sanctis" (Praise ye the Lord in his holy
 places)
Hymn with antiphon or versicle and respond
Canticle: "Benedictus dominus deus" (Blessed be the Lord God: Luke 1:68–79)
 with antiphon, versicle, and respond
Prayer or collects

Prime, Tierce, Sexte, None, Vespers
"Deus in Adiutorium meum intende"
"Gloria"
Hymn (Vespers, with versicle and respond)
3–4 psalms with antiphons and capitula (Vespers: 5 psalms)
Additional hymn in Vespers: "Ave Maris stella" (Hail, Star of the Sea) with
 versicle and respond
Additional canticle in Vespers: "Magnificat anima" (My soul doth magnify the
 Lord: Luke 1:46–55) with antiphon and versicle
Collects or prayers

Compline
"Converte nos deus salutaris noster" (Convert us, O God our savior": Ps. 84:5)
"Deus in adiutorium"
"Gloria"
3–4 psalms with antiphon and capitulum
Hymn: "Fit porta Christi" with versicle and respond
Canticle: "Nunc dimittis" (Now thous dost dismiss thy servant: Luke 2:29 ff)
 with antiphon
Collects or prayers

Appendix 15. Contents of an Average Book of Hours

The average Book of Hours might contain the following elements, but not all
 of them possess all this material, and not necessarily in this order:

Calendar
Special feast days sometimes in red, blue, and/or gold

Four Gospel Lessons (Cursus evangelii; Sequentiae)
Usually pertaining to 4 major Church feasts:
 Christmas (John 1:1–14): "In principio . . . gratiae et veritatis"
 Annunciation (Luke 1:26–38): "Missus est angelus . . . secundum verbum
 tuum"
 Epiphany (Matt. 2:1–12): "Cum ergo natus . . . in regioneum suam"
 Ascension (Mark 16:14–20): "Recumbentibus . . . sequentibus signis"

Fragments of Passion according to St. John (18:1–19:42)

Intercessory Prayers to the Virgin
"Obsecro te" (I implore thee)
"O intemerata" (O matchless one)

Hours or Office of the Virgin (see detailed contents, Appendix 14)
Matins: "Domine labia mea aperies"
Lauds–Vespers: "Deus in adiutorium meum intende"
Compline: "Converte nos deus salutaris noster"

Hours of the Cross
Same invocations, but different internal elements

Hours of the Holy Ghost
Same as above

Hours of the Trinity
Same as above

Office of the Passion
Same as above

Five Sorrows of the Virgin

Fifteen Joys of the Virgin
"Doulce dame de misericorde, mère de pitié, fontaine de tous biens"

Seven Petitions to Our Lord
"Doulx Dieu, doulx père, sainte Trinité"

Prayer to the Cross
"Sainte Vraye Croix"

Seven Penitential Psalms
Ps. 6: "Domine ne in furore" (O Lord, rebuke me not)
Ps. 31: "Beati quorum" (Blessed are they)
Ps. 37: "Domine ne in furore" (Rebuke me not, O Lord)
Ps. 50: "Miserere me" (Have mercy on me)
Ps. 101: "Domine exaudi" (Hear, O Lord, my prayer)
Ps. 129: "De profundis" (Out of the depths)
Ps. 142: "Domine exaudi" (Hear, O Lord, my prayer)

Litany of the Saints
"Kyrie eleison, Christe eleison, Kyrie eleison" (Lord have mercy on me, Christ have mercy on me, Lord have mercy on me) followed by list or major saints including those particularly revered in the diocese or by the patron

Mass of the Dead
"Requiem aeternam" (Rest eternal)

Vigil or Office of the Dead
Vespers: "Placebo domino" (I will please the Lord)
 Ps. 114: "Dilexi quoniam exaudiet Dominus" (I love the Lord because he has heard)
Matin: "Dirigi Domine Deus meus" (Direct, O Lord my God)
 3 nocturnes with psalms, antiphons, and lessons
Lauds: "Exultabunt domino ossa humiliata" (The bones you have crushed shall rejoice in the Lord)

Prayers of Intercession or Memorials or Suffrages of the Saints

Appendix 16. Contents of an Italo-French Book of Hours ("London Hours")

London, British Library, MS Add. 29433
219 vellum folios, 155 × 221 mm.
Text area 101 × 60 mm., 14 lines of text
Gotica textualis formata script

1–12	Calendar		
1r	January	Aquarius	Warming by the fire

2r	February	Pisces	Fishing
3r	March	Aries	Figure blowing two horns; lamb in margin
4r	April	Taurus	Picking flowers
5r	May	Gemini	Hawking
6r	June	Cancer	Cutting hay
7r	July	Leo	Cutting wheat
8r	August	Virgo	Making a barrel
9r	September	Libra	Picking grapes
10r	October	Scorpio	Sowing
11r	November	Sagittarius	Feeding a pig acorns
12r	December	Capricorn	Killing a fatted pig

13–19	Four Gospel Lessons	
13r	St. John	
14v	St. Luke	
16v	St. Mark	
18r	St. Matthew	

20–87	Hours of the Virgin	
20r	Matins	Annunciation
43v	Lauds	Visitation
56r	Prime	Nativity
62r	Tierce	Annunciation to the Shepherds
67r	Sext	Adoration of the Magi
71v	None	Presentation to the Temple
76r	Vespers	Flight into Egypt
83r	Compline	Coronation of the Virgin
88	blank	

89r	Penitential Psalms: Hell scene
102–107r	Litany

107v	Hours of the Cross
107v	Matins: Man of Sorrows (and special prayer to St. Gregory)

111v	Hours of the Holy Spirit
111v	Matins: Pentecost

115v	Vigil of the Dead
115v	Vespers: Last Judgment

161	Prayers to the Virgin
161r	"Obsecro te": Initial with Virgin and Child
164r	"O Intemerata": Initial with Praying Virgin

168	Fifteen Joys of the Virgin
168r	"Doulce dame de misericorde, mère de pitié, fontaine des tous biens": Christ Wading in a Pool

174	Seven Petitions to Our Lord
174r	"Doulz dieu douls père, sainte trinité": Pietà

178	Mass of the Trinity
178r	Six-line initial with three-face Trinity

184	Mass of the Virgin
184r	Five-line initial with Virgin and Child

186	Mass of the Cross
186r	Five-line initial with Bishop worshiping the Cross

Appendix 17. Contents of the Hours of François de Cordier de Bigan

Oxford, Bodleian Library, MS Douce 62
241 vellum folios, 193 × 141 mm.
Text area 97 × 58 mm., 14 lines
Gotica textualis formata script

15–19 Four Gospel Lessons
 15r St. John and Eagle (erased) in margin
 16r St. Luke and Ox in margin
 17v St. Matthew and Winged Man in margin
 18r St. Mark and Lion in margin

20–27 Prayers to the Virgin
 20r "Obsecro te" with initial: Bust of Virgin and Child
 23r "O Intemerata": Decorative initial

28 Hours of the Virgin
 28r Matins Annunciation
 51v Lauds Visitation
 63r Prime Nativity
 69v Tierce Annunciation to the Shepherds
 73v Sext Adoration of the Magi
 78r None Presentation to the Temple
 82v Vespers Flight into Egypt
 89v Compline Coronation of the Virgin

95 Penitential Psalms
 95r Hell scene
 107r Litany

110 Short Hours of the Cross (missing first page)

119 Hours of the Holy Ghost
 119r Pentecost

125 Vigil of the Dead
 125r Vespers: Monks singing around a bier

171v Fifteen Joys of the Virgin
 171v "Doulce dame de misericorde, mère de pitié, fontaine des tous
 biens": Virgin and Child

182 Hours of the Passion
 182r Matins Betrayal
 188v Lauds Mocking of Christ
 194v Prime Christ before Pilate
 198r Tierce Christ Carrying the Cross
 203v Sext Nailing to the Cross
 209r None Crucifixion
 215r Vespers Lamentation
 218v Compline Entombment
224 Suffrages
 (No illustrations)

Notes

Introduction: *From the Earliest Bibles to Byzantine Manuscripts*

1. For an introductory survey, see John, "Latin Paleography," and Lowe, *Handwriting*. For general surveys of manuscript illumination, see Herbert, *Illuminated Manuscripts* and Robb, *Art of the Illuminated Manuscript*. For a history of facsimile production and a useful handlist, see Nordenfalk, *Color of the Middle Ages*.

2. Weitzmann, *Illustrations in Roll and Codex*. See also Turner, *Typology of the Early Codex*.

3. See Farquhar, "The Manuscript as a Book," for a detailed discussion of the structure of manuscripts.

4. Kenyon, *Story of the Bible*, and Pattie, *Manuscripts of the Bible* present general surveys of the history of early biblical texts. For detailed discussions of particular issues, see Ackroyd and Evans, eds., *Cambridge History of the Bible*, Vol. 1, and Lampe, ed., *Cambridge History*, Vol. 2.

5. The story of this discovery is told in Allegro *Dead Sea Scrolls*.

6. Kenyon, *Chester Beatty Biblical Papyri*.

7. The English translation of the Vulgate text in the Douai-Reims version, first published in 1582 and 1609, most closely follows St. Jerome's translation, and is the text cited throughout this book.

8. For a facsimile edition, see Kenyon, *Codex Alexandrinus*.

9. In addition to Weitzmann, *Illustrations in Roll and Codex*, see *idem*, "Book Illustration of the Fourth Century"; *idem*, "Narration in Early Christendom"; and *idem*, *Ancient Book Illumination*.

10. See Wit, *Die Miniaturen*. For the facsimile edition, see *Fragmenta et picturae Vergiliana*. Selected color illustrations may be found in Weitzmann, *Late Antique and Early Christian Book Illumination*, pp. 32–39 (hereafter cited as *Late Antique*).

11. The facsimile edition is *Picturae ornamenta*. See also Weitzmann, *Late Antique*, pp. 11, 52–59.

12. For the Physiologus, see von Steiger and Homburger, *Physiologus Bernensis*; for the Pierpont Morgan Dioscurides, see Metropolitan Museum of Art, *Age of Spirituality*, pp. 207–208. The facsimile of the Vienna Dioscurides is Gerstinger, *Dioscurides*.

13. Degering and Boeckler, *Die Quedlinburger Italafragmente* Weitzmann, *Late Antique*, pp. 40–41.

14. Gerstinger, *Die Wiener Genesis*, Weitzmann, *Late Antique*, pp. 16, 76–87.

15. Weitzmann, "Observations on the Cotton Genesis Fragments," pp. 112–131; *idem, Late Antique*, pp. 72–75.

16. Von Gebhardy, *Miniatures of the Ashburnham Pentateuch*. See also Gutmann, "Jewish Origin of the Ashburnham Pentateuch Miniatures"; Weitzmann, *Late Antique*, pp. 118–125; and Lowe, *Codices Latini Antiquores*, 5 (hereafter cited as *C.L.A.*).

17. Leroy, *Les manuscrits syriaques*, pp. 208–219 and pls. 43–48; Weitzmann, *Late Antique*, pp. 107–111.

18. McGurk, *Latin Gospel Books*.

19. Muñoz, *Il codice purpureo Rossano*; Weitzmann, *Late Antique*, pp. 88–96.

20. For the Sinope Fragment, see Grabar, *Les peintures de l'Evangeliaire de Sinope*.

21. For an excellent survey of the development of Byzantine manuscript illumination, see the exhibition catalogue and introductory essays in Vikan, ed., *Illuminated Greek Manuscripts*.

22. For the Paris Psalter, see H. Buchthal, *Miniatures of the Paris Psalter*. For the Homilies, see Bibliothèque Nationale, *Byzance et la France médiévale*, No. 9, pp. 5–7.

23. Weitzmann, *Late Antique*, pp. 11–12, 60–61.

24. *Byzance et la France médiévale*, No. 29, pl. 14.

25. See the essay by Weitzmann, "The Study of Byzantine Book Illumination, Past, Present, and Future" with further bibliography in *idem, Place of Book Illumination in Byzantine Art*, pp. 1–60.

Chapter 1. *The Insular Gospel Book*

1. For an overview of Insular Gospel books, see McGurk, *Latin Gospel Books*, esp. p. 11. For the "pocket gospels," see *idem*, "Irish Pocket Gospels."

2. Brief descriptions, illustrations, and further bibliography concerning these and other Insular manuscripts are provided by Alexander, *Insular Manuscripts*.

3. See Alexander, *Decorated Letter*, fig. 5. This book gives an excellent introduction in English to the development of the illuminated initial. For a more thorough discussion, see Nordenfalk, *Die Spätantiken Zierbuchstaben*.

4. This manuscript is now in the Royal Academy in Dublin (MS 5 n). See Alexander, *Insular Manuscripts*, p. 28; *C.L.A.*, 2².

5. These illuminations now appear in Durham MS A.II.10: The *INI* monogram for the beginning of St. Mark appears on folio 2r, the decoration with the explicit of St. Matthew and incipit of St. Mark appears on folio 3v. See Alexander, *Insular Manuscripts*, pp. 29–30. For an analysis of this gathering, see Mynors, *Durham Cathedral Manuscripts*, pp. 17–18.

6. Nordenfalk, "Before the Book of Durrow." For the Glazier Codex, see Bober, "Glazier Codex."

7. Nordenfalk, "Before the Book of Durrow."

8. For a brief summary of the various positions, see Alexander, *Insular Manuscripts,* pp. 30–32. The full facsimile is Luce et al., *Evangeliorum quattuor Codex Durmachensis* (hereafter cited as *Durmachensis*). See also Masai, *Essai sur les origines de la miniature dite Irlandaise,* and the review thereof by Schapiro, "Place of Ireland in Hiberno-Saxon Art."

9. For a discussion of the order of folios and structure of the manuscript as it was being rebound, see Powell, "Book of Kells," with diagrams of the reconstructed gatherings. The entire book was cut into single folios during a previous rebinding.

10. See Bieler in *Durmachensis,* esp. pp. 94–95.

11. See Luce in *Durmachensis,* pp. 5–9.

12. Powell in "Book of Kells," 15, suggested that folio 1 with the carpet page belongs before the beginning of the Gospel of St. Matthew, and stated that he moved the carpet page that was previously before Matthew to the end of the book, where the evidence suggests it belongs. At present, no carpet page appears before Matthew.

13. Alexander, *Insular Manuscripts,* p. 30.

14. For the Echternach Gospels, see *ibid.,* pp. 42–43; for Durrow, see *Durmachensis,* p. 10; and for Kells, Henry, *Book of Kells,* pp. 167–171.

15. Powell, "Book of Kells," 17.

16. See *Durmachensis,* pp. 7–9, as well as Nordenfalk, "Illustrated Diatessaron," Schapiro and seminar, "Miniatures of the Florence Diatessaron," and Nordenfalk, "Diatessaron Miniatures Once More."

17. Werner, "Four Evangelist Symbols Page"; Nordenfalk, "Illustrated Diatessaron," 133–134.

18. Alexander, *Illuminated Manuscripts,* p. 31.

19. *Ibid.*

20. Nordenfalk, "Miniatures of the Florence Diatessaron," 536. The usual arrangement occurs in the Chad Gospels, the Book of Kells, and Gospel Books in Trier (Domschatz, Codex 61), Cambridge (Trinity College Library, MS 52), and London (Lambeth Palace, MS 1370).

21. Werner, "Four Evangelist Symbols Page."

22. Nees, "Fifth-Century Book Cover," pp. 4–5. In addition to book covers, Evangelist symbols also decorate Irish book shrines such as the eighth-century Soiscel Molaise in Dublin: see Werner, "Four Evangelist Symbols Page," fig. 10. For Werner's response to Nees, see his "Durrow Four Evangelist Symbols Page Once Again."

23. Nees, "Fifth-Century Book Cover," 6, and *Durmachensis,* pp. 66–67.

24. See n. 16 above.

25. Kendrick, *Anglo-Saxon Art,* pp. 94 ff.

26. See the discussion by Grohmann of early Islamic bindings in Arnold, *Islamic Book,* pp. 30–58 and pls. 16–22; and that of the Coptic bindings in the Pierpont Morgan Library by Needham, *Twelve Centuries of Bookbindings,* pp. 12–19. For frontispieces in Coptic manuscripts, see Cramer, *Koptische Buchmalerei,* and Leroy, *Les manuscrits coptes.*

27. Nordenfalk, "Miniatures of the Florence Diatessaron," 544.

28. Powell, "Binding [of the Stonyhurst Gospel]," in Battiscombe,

Relics of Saint Cuthbert, pp. 362–374, pl. 23. See also Ettinghausen, "Near Eastern Book Covers"; and Petersen, "Early Islamic Book-bindings."

29. Bruce-Mitford in T. D. Kendrick et al., *Evangeliorum quattuor Codex Lindisfarnensis,* Vol 1, facsimile, Vol 2, commentary (Olten and Lausanne, 1956, 1960), 2: 84–87 (hereafter cited as *Lindisfarnensis*).

30. Bober, "Glazier Codex," p. 43, figs. 13, 14. See also Gelfer-Jørgensen, "On Insular Miniatures."

31. See Needham, *Twelve Centuries of Bookbindings,* pp. 24–29, esp. 26; and Harrsen, *Central European Manuscripts,* pp. 6–10 and pls. 11, 12.

32. Grohmann in Arnold, *Islamic Book,* p. 32.

33. See Mahr, ed., *Christian Art in Ancient Ireland,* Vol. 2, pp. 115–119, pls. 115–118; and Metropolitan Museum of Art, *Treasures of Early Irish Art,* no. 66.

34. Bober, "Glazier Codex," fig. 1.

35. Alexander, *Insular Manuscripts,* p. 28, illus. 6. For a color reconstruction of this badly damaged page see *Lindisfarnensis,* 2: pl. 20.

36. For more on this aspect of book covers, see Kitzinger, "Pair of Silver Book Covers," and Nees, "Fifth-Century Book Cover," 5–6.

37. *Lindisfarnensis,* 2: 11–16. See also Henry's "Review" of the facsimile and text. She proposed the later dates. See also Backhouse, *Lindisfarne Gospels.*

38. For an important essay on the development of the decorative incipit page see Jantzen, "Das Wort als Bild."

39. One of the earliest surviving examples is in a sixth-century manuscript in Rome (Biblioteca Apostolica Vaticana, MS Vat. lat. 3806): see Grabar and Nordenfalk, *Early Medieval Painting,* p. 99 for a colorplate of this manuscript. For a full discussion of the development of the canon tables in early medieval manuscripts, see Nordenfalk, *Die Spätantiken Kanontafeln,* esp. pp. 208 ff. See also *Lindisfarnensis,* pp. 186–196, and Wright, "Italian Stimulus on English Art."

40. Bruce-Mitford, "Art of the Codex Amiatinus"; Alexander, *Insular Manuscripts,* pp. 32–35, with further bibliography

41. *Lindisfarnensis,* 2: 78.

42. *Ibid.,* 221–231. See also Swenson, "Symmetry Potentials."

43. For the icon, see Weitzmann, *Icon,* pl. 1; for the Monza covers, which are very similar to those in the Mount Sinai Icon, see Hurbert et al., *Europe of the Invasions,* fig. 241. Zimmermann, *Vorkarolingische Miniaturen,* 1: 115, noted the similarity of the Lindisfarne carpet pages to these book covers; Sweeney, *Irish Illuminated Manuscripts,* p. 21 suggested that they were related to Coptic book bindings.

44. *Lindisfarnensis,* 2: 147. See also Nordenfalk, "Corbie and Cassiodorus."

45. See primarily Alton and Meyer, *Evangeliorum quattuor Codex Cenannensis;* Powell, "Book of Kells"; Brown, "Northumbria"; Henry, *Book of Kells;* and Alexander, *Insular Manuscripts,* pp. 71–76 for a review of the arguments and further bibliography. Brown, *supra,* suggests eastern Scotland, and Nordenfalk, "Another Look at the Book of Kells," advocates Iona as the place of origin of the Book of Kells. For the pages not illustrated here, see colorplates in Henry, *supra.*

46. Quoted in Henry, *Book of Kells,* p. 165.

47. Friend, "Canon Tables of the Book of Kells."

48. See Kitzinger, "The Coffin-Reliquary," in Battiscombe, *Relics of St. Cuthbert*, 202–304; Werner, "Madonna and Child Miniature."

49. Metropolitan Museum of Art, *Treasures of Early Irish Art*, no. 57.

50. Although now bound in four separate volumes, the book originally appears to have been bound in one. See Powell, "Book of Kells," 3–12.

51. Henry, *Book of Kells*, p. 194. The closed book is referred to in Apoc. 5:1–3.

52. For various interpretations of this monogram see Henry, *Book of Kells*, p. 199; Mussetter, "Animal Miniature"; and Lewis, "Sacred Calligraphy."

53. St. Gall, Stiftsbibliothek (Cod. 51). This manuscript is thought to date from the first half of the eighth century. See Duft and Meyer, *Irish Miniatures*. See also *C.L.A.*, 7.

54. See Henry, *Book of Kells*, pls. 63–67; Nordenfalk, "Another look at the Book of Kells," 275–279; and Alexander, *Insular Manuscripts*, p. 73, for illustrations and discussions of these miniatures.

55. Alexander, *Insular Manuscripts*, pp. 72–74; Henry, *Book of Kells*, pp. 188–189, and 204. The only other narrative miniatures surviving in Insular Gospel books are in Durham A.II.17 (Crucifixion), the St. Gall Gospels (Crucifixion and Last Judgment), and the largely destroyed Turin Gospels (Biblioteca Nationale Cod. O.IV.20: Ascension and Second Coming).

Chapter 2. *The Carolingian Bible*

1. In addition to the monumental study, Koehler, *Die Karolingischen Miniaturen*, in which the Carolingian Bibles are discussed, the most recent thorough study is Kessler, *Illustrated Bibles*.

2. Koehler, *Die Karolingischen Miniaturen*, I¹: 209 ff., and Kessler, *Illustrated Bibles*, p. 5.

3. See Kessler, *Illustrated Bibles*, pp. 7–8 for a summary of the controversies concerning the S. Paolo Bible, and the studies by J. E. Gaehde in *Frühmittelalterliche Studien* 5 (1971): 359–400; 8 (1974): 351–404; and 9 (1975): 359–389.

4. Koehler, *Die Karolingischen Miniaturen*, I¹: 396–401 and pl. 77.

5. Kessler and Nordenfalk believe that the S. Paolo miniature may be closer to the lost prototype from a pre-Carolingian manuscript: Kessler, *Illustrated Bibles*, pp. 88–95; Nordenfalk, "Beiträge zur Geschichte," 297.

6. Koehler, *Die Karolingischen Miniaturen*, I²: 164 ff.; Kessler, *Illustrated Bibles*, pp. 13–35.

7. Kessler, *Illustrated Bibles*, pp. 59–68, and *idem*, "Traces of an Early Illustrated Pentateuch."

8. Kessler, *Illustrated Bibles*, pp. 98–99.

9. *Ibid.*, pp. 40–41.

10. *Ibid.*, pp. 55–56.

11. *Ibid.*, pp. 111–124.

12. *Ibid.*, p. 73.

13. *Ibid.*, pp. 76–77.

14. *Ibid.*, pp. 127–129.

15. The eleventh- and twelfth-century Bibles are thoroughly discussed by Cahn, *Romanesque Bible Illustration*.

Chapter 3. *The Imperial Gospel Book*

1. For a survey of the development of the Evangelist portrait, see A. M. Friend Jr., "Portraits of the Evangelists," *Art Studies* 5 (1927): 127 ff.; 7 (1929): 1 ff.

2. Vienna (Residenz Schatzkammer): Coronation Gospels of Charlemagne; Aachen (Dom, Schatzkammer): Coronation Gospels of Charlemagne; and Brussels (Bibliothèque Royale, MS 18723): Xanten Gospel Lectionary.

3. Gaehde and Mütherich, *Carolingian Painting*, pl. 14.

4. Cf. *ibid.*, pl. 5; and Grabar and Nordenfalk, *Early Medieval Painting*, p. 99.

5. For the full facsimile, see Leidinger, *Der Codex Aureus*.

6. Friend, "Carolingian Art."

7. Gaehde and Mütherich, *Carolingian Painting*, pp. 108–109.

8. *Ibid.*, pl. 5.

9. For the Lorsch Gospels (Vatican City, Biblioteca Apostolica Vaticana, MS Pal. lat. 50) and Alba Julia, Biblioteca Documentara Batthayneum, see the fascimile edition, Braunfels, *Lorsch Gospels*.

10. See Steenbock, *Der Kirchliche Prachteinband*, pp. 90–92 with additional literature, and Werkmeister, *Der Deckel des Codex Aureus*.

11. The Uta Codex (Munich, Bayerische Staatsbibliothek, Clm 13601, fol. 4). See Grabar and Nordenfalk, *Early Medieval Painting*, pp. 211, 213–214.

Chapter 4. *The Ottonian Evangelistary*

1. See Chapter 3, n. 9. This manuscript (Darmstadt, Hessische Landesbibliothek, MS 1948) has not been published in facsimile. See, however, *Karl der Grosse, Werk und Wirkung*, exhibition catalogue (Aachen, 1965): No. 473, pp. 291–292. It is usually thought to have been made for Archbishop Gero of Cologne between 969 and 996, but this view is contested by Dodwell and Turner in *Reichenau Reconsidered*.

2. For a full facsimile, see Dressler et al., *Das Evangeliar Ottos III*.

3. All of the principal pages and a representative sampling of text pages are published in Metz, *Golden Gospels of Echternach*. See also Kahsnitz and Rücker, *Das Goldene Evangelienbuch von Echternach*.

4. All of the miniatures are published in black and white and discussed in Leidinger, *Das Perikopenbuch*.

5. Reichenau has been contested as a major center of illumination. For this controversy, see Dodwell and Turner, *Reichenau Reconsidered*.

6. All thirteen sets of double-page miniatures (including the dedica-

tory verses and facing Coronation miniature) are painted on inserted bifolios without text on the reverse sides. Contrary to Leidinger, *Das Perikopenbuch,* pp. 4–5, only the miniature of Christ Calling Zacchaeus has an incipit initial painted on its verso. The other five single miniatures are on versos facing an initial, and are on folios containing text on their conjoint halves.

Chapter 5. *The Mass Book*

1. For a complete facsimile of the Drogo Sacramentary, see W. Koehler, *Drogo-Sakramentar.* The contents are detailed in Leroquais, *Les sacramentaires,* 1: 16; iconographical problems are discussed in Sonia Simon, "Studies on the Drogo Sacramentary"; and the liturgy in Unterkircher, *Zur Ikonographie.* For early Sacramentaries, see Gamber, *Sakramentartypen.*

2. "Yppopanti" stands for *Hypapante,* the meeting of the Holy Family and Simeon who recognizes Christ as the Messiah and prophesies his sacrifice. The account of the Presentation at the Temple in Luke (2:22–40) combines the presentation of Christ with the rite of Purification of his Mother forty days after birth; hence these two incidents are used interchangeably throughout much of medieval art. See Schiller, *Iconography of Christian Art,* 1: 90–94.

3. For an analysis of the texts appearing in the Drogo Sacramentary, see Wilson, *Gregorian Sacramentary,* and Pelt, *Etudes sur la cathédrale de Metz,* 1: 51–112. For a similar situation in another late Carolingian manuscript, see Plummer, *Liturgical Manuscripts,* pp. 11–12.

4. Steenbock, *Der kirchliche Prachteinband,* pp. 85–86; L. Weber, *Einbanddecken,* pp. 1–10; Bogler, "Österliche Szenen." I have followed Bogler's identification of the scenes.

5. See Mütherich, *Sakramentar von Metz.*

6. Swarzenski, *Berthold Missal,* pp. 22–23.

7. *Ibid.,* pls. 12, 13.

8. *Ibid.,* pls. 37, 38.

9. *Ibid.,* p. 38.

10. See Needham, *Twelve Centuries of Bookbindings,* pp. 39–41 for further discussion and bibliography.

11. For the Lombard Gradual and its relationship to Lombard art see Calkins, "Lombard Gradual at Cornell," and *idem,* "Master of the Franciscan Breviary."

12. Published in facsimile by Meiss and Kirsch, *Visconti Hours.*

13. *Ibid.,* LF 95v.

14. See Calkins, "Master of the Franciscan Breviary," 36n. 40.

15. See White, *Art and Architecture in Italy,* pl. 159; and Calkins, "Master of the Franciscan Breviary," 23.

16. Calkins, "Master of the Franciscan Breviary," 32–35. See also Levi d'Ancona, *Wildenstein Collection,* pp. 25–26; Canova, *Miniatura dell'Italia settentrionale,* nos. 77–81, pp. 39–44.

Chapter 6. *The Psalter*

1. For the Utrecht Psalter, see DeWald, *Illustrations of the Utrecht Psalter,* and the facsimile, Horst, *Utrecht-Psalter.*

2. Tikkanen, "Die Psalterillustration," and the useful summary by Kessler, "The Psalter," in Vikan, ed., *Illuminated Greek Manuscripts,* pp. 31–33. For examples of the monastic/theological psalters, see Vikan, 121–123.

3. Buchthal, *Miniatures of the Paris Psalter.*

4. Weitzmann, "Psalter Vatopedi 761."

5. Wormald et al., *St. Albans Psalter.*

6. Thomas, *Le psautier de Saint Louis;* and for other psalters in French collections, see Leroquais, *Les psautiers manuscrits latins.*

7. Egbert, *Tickhill Psalter.* For late 13th- and early 14th-century English psalters, also see Sandler, *Peterborough Psalter.* The first major discussion of the historian of the liturgical divisions is by Haseloff, *Die Psalterillustration.*

8. James, *Catalogue of the Manuscripts,* 1: no. 19, pp. 41–43; Verdier et al., *Art and the Courts,* 1: no. 26, pp. 97–98; and Bennett, "Windmill Psalter."

9. Cf. Millar, *Thirteenth Century York Psalter,* pl. 3. The York Psalter is now in the British Library, MS Add. 54179.

10. *Ibid.,* pl. 5, together with Christ Banishing the Devil.

11. *Ibid.,* pl. 7; both the Resurrection and the Salvation of Jonah are depicted.

12. *Ibid.,* pl. 11: the Coronation of the Virgin takes place above a representation of the Resurrected Christ approaching God the Father enthroned while the dove of the Holy Ghost hovers above.

13. Verdier et al., *Art and the Courts,* 1, 98.

Chapter 7. *Books for the Divine Office*

1. A basic introduction to the breviary and its contents may be found in Leroquais, *Les bréviaires manuscrits;* for the contents of the Belleville Breviary, see Vol. 3: 198–210.

2. *Ibid.,* 49–56.

3. Avril, *Manuscript Painting,* p. 112. See also Meiss, *French Painting,* 1: 160–161.

4. Avril, *Manuscript Painting,* p. 112; Sherman, *The Portraits of Charles V,* pp. 47–48.

5. For a full description see the notice of Sydney Cockerell in Thompson, *Descriptive Catalogue,* No. 83, pp. 55–74, and Miner, "Since De Ricci," 63–68 for additional bibliography.

6. Miner, "Since De Ricci," 68.

Chapter 8. *The Book of Hours*

1. Excellent introductions to the use and contents of Books of Hours may be found in the following: Leroquais, *Les livres d'heures,* esp. 1:

i–lxxxv; Delaissé, "Importance of Books of Hours," pp. 203–225; *idem* et al., *James A. De Rothschild Collection*; and Harthan, *Book of Hours.*

2. For some of these indications of usage see James, "Points To Be Observed in the Description and Collation of Manuscripts, Particularly Books of Hours," in *Catalogue of Illuminated Manuscripts*, pp. xix–xli; Madan, "Documents and Records: Hours of the Virgin Mary"; and *idem*, "Appendix: Hours of the Virgin, pp. 21–29. See also Leroquais, *Les livres d'heures* above. More complete charts of the variables are being prepared by James Marrow, but they have not yet been published.

3. Delaissé, "Importance of Books of Hours," pp. 204–207.

4. Now in the Cloisters, New York. For a partial facsimile of this manuscript see Rorimer, *Hours of Jeanne d'Evreux.*

5. Significant differences between the entries in the Calendar, Litany, and Suffrages in the Hours of Catherine of Cleves (New York, Pierpont Morgan Library, MSS M. 917 and 945) have been noted by Gorissen, *Das Stundenbuch der Katharina von Kleve*, pp. 158–159.

6. Webster, *Labors of the Months.*

7. See Leroquais, *Les livres d'heures*, 1: xlv–xlvi, as well as Harthan, *Book of Hours*, and James, cited in n. 2 above.

8. Leroquais, *Les livres d'heures*, 1: xlv.

9. For a virtual encyclopaedia of marginal figures in manuscripts of the period from the late thirteenth to the early fouteenth century, see Randall, *Images in the Margins of Gothic Manuscripts.*

10. For example, the *Belles Heures* of the duke of Berry, now in the Cloisters: see Meiss and Beatson, *Belles Heures.*

11. For the Hours of Engelbert of Nassau, see Alexander, *Master of Mary of Burgundy.* The Hennessy Hours is in the Bibliothèque Royale (MS II. 158).

12. Longnon and Cazelles, *Très Riches Heures of Jean, Duke of Berry*; Plummer, *Hours of Catherine of Cleves*; Meiss and Thomas *Rohan Master.*

13. (Bibliothèque Royale MS 11060–61). This artist was first discussed by Pächt, *Master of Mary of Burgundy.* See also Wixom, "Hours of Charles the Noble"; Meiss, *French Painting*, pp. 229–246; and *idem, Limbourgs*, p. 377. Concerning the identification of the Italian miniaturist, see also the important Brown, Review of Meiss, *French Painting.*

14. Calkins, "Italian in Paris."

15. Wixom, "Hours of Charles the Noble"; Calkins, "Italian in Paris."

16. Meiss, *French Painting*, p. 231.

17. See Meiss and Beatson, *Belles Heures*, fol. 30. The extraordinary page of the Annunciation in the *Belles Heures* may, however, be later than the London page and could even have been patterned after an Italian acanthus border by the Master of the Brussels Initials.

18. Meiss, *French Painting*, pp. 237–238.

19. *Ibid.*, p. 239 and figs. 808–811.

20. *Ibid.*, fig. 778.

21. Also in his Books of Hours in Parma, Madrid, and Oxford.

22. Meiss, *French Painting*, p. 232.

23. The Egerton Master is named after a Book of Hours he illuminated, now in London (British Library, MS Egerton 1070). For his con-

tributions to the Hours of Charles the Noble, see Wixom "Hours of Charles the Noble," 74–80, 83n. 46.

24. The Luçon Master is named after a pontifical of the bishop of Luçon (Paris, Bibliothèque Nationale, MS lat. 8886) which contains his miniatures: see Meiss, *French Painting*, p. 358, *passim*, pl. 743.

Chapter 9. *Other Types of Manuscripts*

1. For a full discussion of these books see Cahn, *Romanesque Bible Illustration*.

2. See p. 23 above.

3. Oakeshott, *Artists of the Winchester Bible*, and *idem*, *Two Winchester Bibles*.

4. Numerous examples are illustrated in Branner, *Manuscript Painting in Paris*.

5. Hindman, *Text and Image*.

6. For a facsimile edition of the Vienna manuscript, see Haussherr, *Bible moralisée*. The major publication of these mauscripts is Laborde, *La Bible moralisée illustrée*.

7. Schmidt, *Die Armenbibeln*. For an excellent introduction and facsimile of an early printed edition with illustrations and text carved on woodblocks (a so-called block book), see Soltèsz, *Biblia pauperum*.

8. Avery, *Exultet Rolls*.

9. Numerous examples are published in color in Williams, *Early Spanish Manuscript Illumination*.

10. The facsimile edition is Casanovas et al., *Sancti Beati*.

11. For the thirteenth-century Apocalypse manuscripts, see Delisle and Meyer, *L'Apocalypse en français*.

12. Temple, *Anglo-Saxon Manuscripts*, pp. 49–53.

13. Leroquais, *Les pontificaux manuscrits*.

14. For a facsimile of a Menologion in the Vatican Library see *Il Menologio di Basilio II*. For Western examples of the martyrology, rarely historiated, see Dubois, *Les martyrologes*.

Selected Bibliography

Ackroyd, P. R., and C. F. Evans, eds. *Cambridge History of the Bible.* Vol. 1: *From the Beginnings to Jerome.* Cambridge: Cambridge University Press, 1970.

Alexander, J. J. G. *The Decorated Lettter.* New York: George Braziller, 1978.

———. *Insular Manuscripts: Sixth to the Ninth Century.* A Survey of Manuscripts Illuminated in the British Isles. London: Harvey Miller, 1978.

———. *The Master of Mary of Burgundy: A Book of Hours for Engelbert of Nassau.* New York: George Braziller, 1970.

Allegro, J. M. *The Dead Sea Scrolls.* Harmondsworth: Penguin Books, 1959.

Alton, E. H., and P. Meyer. *Evangeliorum quattuor Codex Cenannensis.* 3 vols. Bern: Urs Graf Verlag, 1950–1951.

Arnold, Thomas W. *The Islamic Book: A Contribution to Its Art and History from the Seventh–Eighteenth Century.* Leipzig: Pegasus Press, 1929.

Avery, Myrtilla. *The Exultet Rolls of South Italy.* Princeton: Princeton University Press, 1936.

Avril, François. *Manuscript Painting at the Court of France: The Fourteenth Century (1310–1380).* New York: George Braziller, 1978.

Backhouse, Janet M. *The Lindisfarne Gospels.* Ithaca, N.Y.: Cornell University Press, 1981.

Bäumer, Suitbert. *Geschichte des Breviers.* Freiburg im Breisgau: Herder, 1895.

Battiscombe, C. F. *The Relics of Saint Cuthbert.* Oxford: University Press, 1956.

Beissel, Stephan. *Entstehung der Perikopen des römischen Messbuches. Zur Geschichte der Evangelienbücher in der ersten Hälfte des Mittelalters.* Freiburg im Breisgau: Herder, 1907.

———. *Geschichte der Evangelienbücher in der ersten Hälfte des Mittelalters.* Freiburg im Breisgau: Herder, 1906.

Bennett, Adelaide. "The Windmill Psalter: The Historiated Letter E of Psalm One." *Journal of the Warburg and Courtauld Institute* 43 (1980): 52–67.

Bibliothèque Nationale. *Byzance et la France médiévale: Manuscrits à peintures du II^e au XVI^e siècle*. Paris, 1958.

_____. *La librairie de Charles V*. Paris, 1968.

_____. *Le livre*. Paris, 1972.

_____. *Les manuscrits à peintures en France du VII^e au XII^e siècle*. Paris, 1954.

_____. *Les manuscrits à peintures du XIII^e au XVI^e siècle*. Paris, 1955.

Bober, Harry. "On the Illuminations of the Glazier Codex: A Contribution to Early Coptic Art and Its Relation to Hiberno-Saxon Interlace." In *Homage to a Bookman: Essays on Manuscripts, Books, and Printings for Hans P. Kraus on his Sixtieth Birthday, Oct. 12, 1967*, ed. H. Lehmann-Haupt, pp. 31–49. Berlin: Gebr. Mann Verlag, 1967.

Boeckler, Albert. "Die Reichenauer Buchmalerei—Die Kultur der Abtei Reichenau." In *Erinnerungschrift zur 1200. Wiederkehr des Gründungsjahres des Inselklosters*, vol. 2, pp. 956–998. Munich: 1925.

Bogler, P. T. "Österliche Szenen auf dem Elfenbeindeckel des Drogo-Sakramentars." *Paschatis Sollemnia (Festschrift J. A. Jungmann)*, ed. B. Fischer, pp. 108–119. Basel: Herder, 1959.

Branner, Robert. *Manuscript Painting in Paris during the Reign of Saint Louis*. Berkeley: University of California Press, 1977.

Braunfels, Wolfgang. *The Lorsch Gospels*. New York: George Braziller, 1967.

Brown, T. J. "Northumbria and the Book of Kells." *Anglo-Saxon England* 1 (1972): 219–246.

_____. Review of Millard Meiss, *French Painting in the Time of Jean de Berry: The Late Fourteenth Century and the Patronage of the Duke*. In *The Book Collector* 18 (1969): 470–488.

Bruce-Mitford, R. L. S. "The Art of the Codex Amiatinus." *Journal of the Archaeological Association* 32 (1969): 1–25.

_____. T. D. Kendrick, T. J. Brown, H. Roosen-Runge, A. C. S. Ross, E. G. Stanley, and A. E. A. Werner. *Evangeliorum quattuor Codex, Lindisfarnensis*. 2 vols., facsimile and commentary. Olten and Lausanne: Urs Graf Verlag, 1956–1960.

Buchthal, Hugo. *The Miniatures of the Paris Psalter: A Study in Middle Byzantine Painting*. London: Warburg Institute, 1938.

Cabrol, Fernand. *The Books of the Latin Liturgy*. London: Sands & Co., 1932.

_____. H. Leclercq, and H. I. Marrou. *Dictionnaire d'archéologie chrétienne et de liturgie*. 15 vols. Paris: Letouzey et Ané, 1913–1953.

Cahn, Walter. *Romanesque Bible Illustration*. Ithaca, N.Y.: Cornell University Press, 1982.

Calkins, Robert G. "An Italian in Paris. The Master of the Brussels Initials and His Participation in the French Book Industry." *Gesta* 20 (1981): 223–232.

_____. "A Lombard Gradual at Cornell." *Cornell Library Journal*, no. 6 (Autumn 1968): 1–48.

_____. "The Master of the Franciscan Breviary." *Arte Lombarda* 16 (1971): 17–36.

_____. "Stages of Execution: Procedures of Manuscript Illumination as Revealed in an Unfinished Book of Hours." *Gesta* 17 (1978): 61–70.

Canova, G. M. *Miniatura dell'Italia settentrionale nella Fondazione Giorgio Cini*. Venice: Neri Possa Editore, 1978.

Casanovas, J. M., C. E. Dubler, and W. Neuss. *Sancti Beati a Liebana in Apocalypsin: Codex Gerundensis*. Olten: Urs Graf Verlag, 1962.

Council of Europe. *Karl der Grosse, Werk und Wirkung*. Exhibition at Aachen, 1965 [Düsseldorf, 1965].

Cramer, Maria. *Koptische Buchmalerei*. Recklinghausen: Verlag Aurel Bongers, 1964.

Degering, Hermann, and A. Boeckler. *Die Quedlinburger Italafragmente*. Berlin: 1932.

Delaissé, L. M. J. "The Importance of Books of Hours for the History of the Medieval Book." In *Gatherings in Honor of Dorothy Miner*, ed. I. E. McCracken, L. M. C. Randall, and R. H. Randall, Jr., pp. 203–225. Baltimore: Walters Art Gallery, 1974.

——. James Marrow, and J. de Wit. *The James A. De Rothschild Collection at Waddesdon Manor: Illuminated Manuscripts*. Fribourg: Office du Livre, 1977.

Delisle, Léopold, and P. Meyer. *L'Apocalypse en français au XIIIᵉ siècle*. Paris: Firmin-Didot, 1901.

Destrée, Joseph. *Les Heures de Notre Dame dites de Hennessy*. Brussels: Société des bibliophiles et iconophiles de Belgique, 1923.

DeWald, Ernest T. *The Illustrations of the Utrecht Psalter*. Princeton: Princeton University Press, 1932.

Dodwell, Charles R. *Painting in Europe 800 to 1200*. Baltimore: Penguin Books, 1971.

——, and D. H. Turner. *Reichenau Reconsidered: A Reassessment of the Place of Reichenau in Ottonian Art*. Warburg Institute Surveys, 2. London: Warburg Institute, 1965.

Dressler, Fridolin, F. Mütherich, and H. Beauman. *Das Evangeliar Ottos III*. Frankfurt am Main: S. Fischer Verlag, 1973.

Dubois, Jacques. *Les martyrologes du moyen âge latin*. Typologie du moyen âge occidental, 26. Turnhout: Brepols, 1978.

Duchesne, Louis M. O. *Christian Worship: Its Origins and Evolution*. 5th ed. New York: Macmillan, 1919.

Dufrenne, Suzy. *Les illustrations du Psautier d'Utrecht. Problèmes des sources et de l'apport carolingien*. Paris: Ophyrs [1978].

Duft, Johannes, and P. Meyer. *The Irish Miniatures in the Cathedral Library of St. Gall*. Olten: Urs Graf Verlag, 1954.

Egbert, Donald D. *The Tickhill Psalter and Related Manuscripts*. New York: The New York Public Library and the Department of Art and Archaeology of Princeton University, 1940.

Engelbregt, J. H. A. *Het Utrechts Psalterium, een Eeuw Wettenschappelijke Bestudering (1860–1960)*. Utrecht: Haentjens Dekker and Gumbert, 1964.

Ettinghausen, Richard. "Near Eastern Book Covers and Their Influence on European Bindings." *Ars Orientalis* 3 (1959): 113–131.

Farquhar, James D. "The Manuscript as a Book." In J. D. Farquhar and Sandra Hindman, *Pen to Press: Illustrated Manuscripts and Printed Books in the First Century of Printing*, pp. 11–99. College Park, Md.: Art Department, University of Maryland, 1977.

Febvre, Lucien, and H. J. Martin. *L'apparition du livre.* Paris: Editions Albin Michel, 1958.

Fox, C. *Pattern and Purpose—A Survey of Early Celtic Art in Britain.* Cardiff: National Museum of Wales, 1958.

Fragmenta et picturae Vergiliana, cod. Vat. lat. 3225. 3d ed. Codices e Vaticanis selecti. Rome, 1945.

Frantz, M. A. "Byzantine Illuminated Ornament." *Art Bulletin* 16 (1934): 73–95.

Friend, A. M., Jr. "The Canon Tables of the Book of Kells." *Medieval Studies in Memory of A. Kingsley Porter*, ed. W. R. K. Koehler. Vol. 2, pp. 611–641. Cambridge, Mass.: Harvard University Press, 1939.

———. "Carolingian Art in the Abbey of St. Denis." *Art Studies* 1 (1923): 67 ff.

———. "The Portraits of the Evangelists in Greek and Latin Manuscripts." *Art Studies* 5 (1927): 115–147; 7 (1929): 3–29.

Gaehde, Joachim E., and F. Mütherich. *Carolingian Painting.* New York: George Braziller, 1976.

Gamber, Klaus. *Codices liturgici latini antiquores.* Spici Legii Friburgensis Subsidia, 1. 2d rev. ed., 2 vols. Fribourg: Universitätsverlag, 1968.

———. *Sakramentartypen: Versuch einer Gruppierung der Handschriften und Fragmente bis zur Jahrtausendwende.* Beuron, Hohenzollern: Beuronerkunstverlag: 1958.

Gelfer-Jørgensen, Mirjam. "On Insular Miniatures and Islamic Textiles." *Hafnia* 6 (1979): 50–80.

Gerstinger, Hans. *Dioscurides, Codex Vindobonensis Med gr. 1 der Österreichischen Nationalbibliothek.* Codices selecti, phototypice impressi, facsimile 12. Graz: Akademische Druck- u. Verlagsanstalt, 1970.

———. *Die Wiener Genesis.* Vienna: Dr. B. Filser, 1931.

Gorissen, Friedrich, *Das Stundenbuch der Katharina von Kleve. Analyse und Kommentar.* Berlin: Gebr. Mann Verlag, 1973.

Grabar, André. *Les peintures de l'Evangeliaire de Sinope.* Paris: Bibliothèque Nationale, 1948.

———, and Carl Nordenfalk. *Early Medieval Painting from the Fourth to the Eleventh Century.* Geneva: Skira, 1957.

Gutmann, Joseph. "The Jewish Origin of the Ashburnham Pentateuch Miniatures." *Jewish Quarterly Review* 44 (1953–54): 55–72.

Harrsen, Meta. *Central European Manuscripts in the Pierpont Morgan Library.* New York: Pierpont Morgan Library, 1958.

Harthan, John. *The Book of Hours.* New York: Thomas Y. Crowell, 1977.

Haseloff, Günther. *Die Psalterillustration im XIII.* [Kiel]: 1938.

Haussherr, Reiner. *Bible moralisée. Faksimile-Ausgabe im Originalformat des Codex Vindobonensis.* Graz: Akademische Drunk- u. Verlagsanstalt, 1973.

Henry, Françoise. *The Book of Kells.* New York: Alfred A. Knopf, 1974.

———. *Irish Art during the Viking Invasions (800–1020 A.D.).* Ithaca, N.Y.: Cornell University Press, 1967.

———. *Irish Art in the Early Christian Period (to 800 A.D.).* Ithaca, N.Y.: Cornell University Press, 1967.

_____. Review of *Evangeliorum Quattuor Codex Lindisfarnensis.* In *Antiquity* 37 (1963): 100–110.

Herbert, J. A. *Illuminated Manuscripts.* London: Methuen, 1911.

Hindman, Sandra. *Text and Image in Fifteenth-Century Illustrated Dutch Bibles.* Leiden: Brill, 1977.

Hinks, Roger. *Carolingian Art.* Reprint. Ann Arbor, Mich.: Ann Arbor Paperbacks, 1962.

Hopkin-James, Lemuel J. *The Celtic Gospels, Their Story and Their Text.* London: Oxford University Press, 1934.

Horst, Kurt van der. *Utrecht-Psalter.* Codices selecti 75. Graz: Akademische Druck- u. Verlagsanstalt, 1982.

Hubert, Jean, J. Porcher, and W. F. Volbach. *The Carolingian Renaissance.* The Arts of Mankind. New York: George Braziller, 1970.

_____. *Europe of the Invasions.* The Arts of Mankind. New York: George Braziller, 1969.

Hughes, Andrew. *Medieval Manuscripts for Mass and Office: A Guide to Their Organization and Terminology.* Toronto: University of Toronto Press, 1981.

James, Montague R. *Catalogue of Illuminated Manuscripts in the Fitzwilliam Museum, Cambridge.* Cambridge: Cambridge University Press, 1895.

_____. *Catalogue of the Manuscripts . . . of the Library of J. Pierpont Morgan.* 2 vols. London: Chiswick Press, 1906–1907.

Jantzen, Hans. *Ottonische Kunst.* Munich: Münchener Verlag, 1946.

_____. "Das Wort als Bild in der frühmittelalterlichen Buchmalerei." In *idem, Über den gotischen Kirchenraum und andere Aufsätze,* 53–60. Berlin: Gebr. Mann, 1951.

John, James. "Latin Paleography." In *Medieval Studies,* ed. J. M. Powell, pp. 1–68. Syracuse, N.Y.: Syracuse University Press, 1976.

Jones, Cheslyn, G. Wainwright, and E. Yarnold, eds. *The Study of Liturgy.* New York: Oxford University Press, 1980.

Kahsnitz, Rainer, and E. Rücker. *Das Goldene Evangelienbuch von Echternach.* Frankfurt am Main: S. Fischer Verlag, 1982.

Kendrick, T. D. *Anglo-Saxon Art to A.D. 900.* London: Methuen, 1938.

Kenyon, Frederick G. *The Chester Beatty Biblical Papyri.* 8 vols. London: E. Walker, 1933–1958.

_____. *Codex Alexandrinus.* London: British Museum, 1909.

_____. *The Story of the Bible.* 2d rev. ed. London: John Murray, 1964.

Kessler, Herbert L. *The Illustrated Bibles from Tours.* Princeton: Princeton University Press, 1977.

_____. "Traces of an Early Illustrated Pentateuch." *Journal of Jewish Art* 8 (1982): 20–27.

Kitzinger, Ernst. "A Pair of Silver Book Covers in the Sion Treasure." In *Gatherings in Honor of Dorothy E. Miner,* ed. I. E. McCracken, L. M. C. Randall, and R. H. Randall, Jr., pp. 3–17. Baltimore: Walters Art Gallery, 1974.

Koehler, Wilhelm. *Buchmalerei des frühen Mittelalters.* Munich: Prestel Verlag, 1972.

_____. *Drogo-Sakramentar: Manuscrit Latin 9428, Bibliothèque nationale Paris.* Codices selecti. Graz: Akademische Druck- u. Verlagsanstalt, 1974.

_____. *Die Karolingischen Miniaturen.* 7 vols. Berlin: Deutscher Verein für Kunstwissenschaft, 1930–1971.

Laborde, André de. *La Bible moralisée illustrée.* 5 vols. Paris: Société française des reproductions des manuscrits à peintures, 1911–1927.

Lampe, C. W. H., ed. *Cambridge History of the Bible,* Vol. 2: *The West from the Fathers to the Reformation.* Cambridge: Cambridge University Press, 1969.

Lawlor, H. J., and W. N. Lindsay. "The Cathach of St. Columba." *Proceedings of the Royal Irish Academy* (1916): 216 ff.

Leidinger, Georg. *Der Codex Aureus der Bayerischen Staatsbibliothek in München.* 6 vols. Munich: Hugo Schmidt, 1921–1925.

_____. *Das Perikopenbuch Kaiser Heinrichs II (Cod. Lat. 4452). Miniaturen aus Handschriften des Kgl. Hof- und Staatsbibliothek in München.* Heft 5. Munich: Rien and Tietze [1912].

Leroquais, Victor. *Les bréviaires manuscrits des bibliothèques publiques de France.* 5 vols. Paris and Mâcon: Protat Frères, 1934.

_____. *Les livres d'heures manuscrits de la Bibliothèque nationale.* 3 vols. and *Supplement.* Paris and Mâcon: Protat Frères, 1927–1943.

_____. *Les pontificaux manuscrits des bibliothèques publiques de France.* Paris: Protat Frères, 1937.

_____. *Les psautiers manuscrits latins des bibliothèques publiques de France.* 3 vols. Mâcon: Protat Frères, 1940–1941.

_____. *Les sacramentaires et les missels manuscrits des bibliothèques publiques de France.* 4 vols. Paris: Protat Frères, 1924.

Leroy, Jules. *Les manuscrits coptes et coptes-arabes illustrés.* Paris: Geuthner, 1974.

_____. *Les manuscrits syriaques à peintures conservés dans les bibliothèques de l'Europe et d'Orient.* Paris: Geuthner, 1964.

Levi d'Ancona, Mirella. *The Wildenstein Collection of Illuminations. The Lombard School.* Florence: Olschki, 1970.

Lewis, Susanne. "Sacred Calligraphy: The Chi Rho Page in the Book of Kells." *Traditio* 36 (1980): 139–159.

Lexikon für Theologie und Kirche. 2d ed. 10 vols. Freiburg im Breisgau: Herder, 1957–1965.

Longnon, Jean, and R. Cazelles. *The Très Riches Heures of Jean, Duke of Berry. Musée Condé, Chantilly.* New York: George Braziller, 1969.

Lowe, E. A. *Codices Latini Antiquores.* 11 vols. Oxford: Clarendon Press, 1934–1966.

_____. *Handwriting, Our Medieval Legacy.* Rome: Edizioni di Storia e Letteratura, 1969.

Luce, A. A., P. Meyer, G. O. Simmons, and L. Bieler. *Evangeliorum quattuor Codex Durmachensis.* 2 vols. Olten and Lausanne: Urs Graf Verlag, 1960.

Madan, Falconer. "Appendix: Hours of the Virgin (Tests for Localization)," in *Essays in History Presented to Reginald Lane Poole,* pp. 21–29. Reprint. Freeport, N.Y.: Books for Libraries Press, [1967].

_____. "Documents and Records: Hours of the Virgin Mary (Tests for Localization)." *Bodleian Quarterly Record* 3, no. 26 (1920): 40–44.

Mahr, Adolf. *Christian Art in Ancient Ireland.* 2 vols. Dublin: Stationery Office of Saorstát Eireann, 1932, 1941.

Masai, François. *Essai sur les origines de la miniature dite Irlandaise.* Brussels: Editions "Erasme," 1947.

McGurk, Patrick M. "The Irish Pocket Gospels." *Sacris Erudiri* 8 (1956): 249–270.

——. *Latin Gospel Books from A.D. 400 to A.D. 800.* (Les Publications de Scriptorium, 5). Brussels: Editions "Erasme" S.A., 1961.

——. "Two Notes on the Book of Kells and Its Relation to Other Insular Gospel Books." *Scriptorium* 9 (1955): 105–107.

Il Menologio di Basilio II. Codices e Vaticanis selecti 8. Turin, 1907.

Meiss, Millard. *The Boucicaut Master.* New York: Phaidon, 1969.

——. *French Painting in the Time of Jean de Berry: The Late Fourteenth Century and the Patronage of the Duke.* 2 vols. New York: Phaidon, 1967.

——. *The Limbourgs and Their Contemporaries.* 2 vols. New York: George Braziller, 1974.

——, "La mort et l'Office des Morts à l'époque du Maître de Boucicaut et des Limbourg." *Revue de l'art,* no. 1–2 (1968): 17–25.

——, and E. Beatson. *The Belles Heures of Jean, Duke of Berry.* New York: George Braziller, 1974.

——, and E. W. Kirsch. *The Visconti Hours.* New York: George Braziller, 1972.

——, and M. Thomas. *The Rohan Master, A Book of Hours.* New York: George Braziller, 1973.

Metropolitan Museum of Art. *The Age of Spirituality: Late Antique and Early Christian Art, Third to Seventh Century.* Princeton: Princeton University Press, 1979.

——. *Treasures of Early Irish Art 1500 B.C. to 1500 A.D. from the Collections of the National Museum of Ireland, Royal Irish Academy, Trinity College Dublin.* New York: Metropolitan Museum of Art, 1977.

Metz, Peter. *The Golden Gospels of Echternach: Codex Aureus Epternacensis.* New York: Frederick A. Praeger, 1957.

Micheli, G. L. *L'enluminure du hautu moyen âge et les influences irlandaises.* Brussels: Editions de la Connaissance, 1939.

Millar, Eric G. *The Lindisfarne Gospels.* Oxford: University Press, 1923.

——. *A Thirteenth-Century York Psalter: A Manuscript Written and Illuminated in the Diocese of York about A.D. 1250. Described by Eric George Millar.* Oxford: University Press, 1952.

Miner, Dorothy. "Since de Ricci—Western Illluminated Manuscripts Acquired since 1934. A Report in Two Parts. Part 2." *The Journal of the Walters Art Gallery* 31–32 (1968–1969): 41–115.

Morand, Kathleen. *Jean Pucelle.* Oxford: University Press, 1962.

Muñoz, Antonio. *Il codice purpureo di Rossano.* Rome: Danesi, 1907.

Mussetter, Sally. "An Animal Miniature on the Monogram Page of the Book of Kells." *Mediaevalia* 3 (1977): 119–130.

Mütherich, Florentine. *Sakramentar von Metz: Fragment.* Graz: Akademische Druck- u. Verlagsanstalt, 1972.

Mynors, R. A. B. *Durham Cathedral Manuscripts to the End of the Twelfth Century.* Oxford: University Press, 1939.

Needham, Paul. *Twelve Centuries of Bookbindings 400–1600.* New York: Pierpont Morgan Library, 1979.

Nees, Lawrence. "A Fifth-Century Book Cover and the Origin of the Four Evangelist Symbols Page in the Book of Durrow." *Gesta* 17 (1978): 3–8.

Nordenfalk, Carl. "Another Look at the Book of Kells." In *Festschrift Wolfgang Braunfels,* pp. 275–279. Tübingen: Wasmuth, 1977.

_____. "Before the Book of Durrow." *Acta Archaeologica* 18 (1947): 141–174.

_____. Beiträge zur Geschichte der Turonischen Buchmalerei." *Acta Archaeologica* 7 (1936): 281 ff.

_____. *Celtic and Anglo-Saxon Painting: Book Illumination in the British Isles 600–800.* New York: George Braziller, 1977.

_____. *Color of the Middle Ages: A Survey of Book Illumination Based on Color Facsimiles of Medieval Manuscripts.* Pittsburgh: University Art Gallery, 1976.

_____. "Corbie and Cassiodorus: A Pattern Page Bearing on the Early History of Bookbinding." *Pantheon* 32 (1974): 225–231.

_____. "The Diatessaron Miniatures Once More." *Art Bulletin* 55 (1973): 532–546.

_____. "Eastern Style Elements in the Book of Lindisfarne." *Acta Archaeologica* 13 (1942): 157–169.

_____. "An Illustrated Diatessaron." *Art Bulletin* 50 (1968): 119–140.

_____. *Die spätantiken Kanontafeln.* Goteborg: O. Isacsons, 1938.

_____. *Die spätantiken Zierbuchstaben.* Stockholm, 1970.

Oakeshott, Walter. *The Artists of the Winchester Bible.* London: Faber and Faber, 1945.

_____. *The Two Winchester Bibles.* New York: Oxford University Press, 1982.

Pächt, Otto. *The Master of Mary of Burgundy.* London: Faber and Faber, [1948].

Panofsky, Dorothy. "The Textual Basis of the Utrecht Psalter." *Art Bulletin* 25 (1943): 50–58.

Pattie, T. S. *Manuscripts of the Bible: Greek Bibles in the British Library.* London: British Library, 1979.

Pelt, J. B. *Etudes sur la cathédrale de Metz: La liturgie.* Vol. 1. Metz: Imprimerie Lorraine, 1937.

Petersen, T. C. "Early Islamic Bookbindings and Their Coptic Relations." *Ars Orientalis* 1 (1954): 41–64.

Pfaff, R. W. *Medieval Latin Liturgy: A Select Bibliography.* Toronto: University of Toronto Press, 1982.

Picturae ornamenta . . . codicis Vaticani latini 3867, qui codex Vergilii Romanus audit. Codices e Vaticanis selecti 2. Rome, 1902.

Plummer, John. *The Hours of Catherine of Cleves.* New York: George Braziller, 1966.

_____. *Liturgical Manuscripts for the Mass and Divine Office.* New York: Pierpont Morgan Library, 1964.

Powell, Roger. "The Book of Kells, the Book of Durrow, Comments on the Vellum and the Make-up, and Other Aspects." *Scriptorium* 10 (1956): 12–21.

Randall, Lilian M. C. *Images in the Margins of Gothic Manuscripts.* Berkeley: University of California Press, 1966.

Robb, David M. *The Art of the Illuminated Manuscript*. Cranbury, N.J.: A. S. Barnes, 1973.

Roberts, Colin H. "The Codex." *Proceedings of the British Academy* 40 (1954): 169–204.

Rorimer, John J. *The Hours of Jeanne d'Evreux at the Cloisters*. New York: Metropolitan Museum of Art, 1957.

Sandler, Lucy Freeman. *The Peterborough Psalter in Brussels and Other Fenland Manuscripts*. London: Harvey Miller, 1974.

Schapiro, Meyer. "The Place of Ireland in Hiberno-Saxon Art." *Gazette des beaux arts* 37 (1950): 134–138. Reprinted in *idem, Late Antique Early Christian and Medieval Art: Selected Papers*. Vol. I, pp. 225–241. New York: George Braziller, 1979.

_____. *Words and Pictures: On the Literal and Symbolic in the Illustration of a Text*. The Hague and Paris: Mouton, 1973.

_____, and seminar. "The Miniatures of the Florence Diatessaron." *Art Bulletin* 55 (1973): 494–531.

Schiller, Gertrud. *Iconography of Christian Art*. 2 vols. Greenwich, Conn.: New York Graphic Society, 1971.

Schmidt, Gerhard. *Die Armenbibeln des XIV. Jahrhunderts*. Graz: H. Bohlaus Nachf., 1959.

Sénécal, Julien. "Les occupations des mois dans l'iconographie du moyen âge." *Bulletin de la Société des antiquaires de Normandie* 35 (1921–1923): 104 ff.

Sherman, C. R. *The Portraits of Charles V of France (1338–1380)*. New York: New York University Press, 1969.

Simon, Sonia. "Studies on the Drogo Sacramentary: Eschatology and the Priest-King." Ph.D. dissertation. Boston University, 1975.

Soltèsz, Elizabeth. *Biblia pauperum*. Budapest: Corvina Press, 1967.

Staatsbibliothek Preussischer Kulturbesitz. *Das christliche Gebetbuch im Mittelalter*. Berlin, 1980.

Steenbok, Frauke. *Der kirchliche Prachteinband in frühen Mittelalter von den Anfängen bis zum Beginn der Gotik*. Berlin: Deutscher Verlag für Kunstwissenschaft, 1965.

Stiennon, Jacques. *Paléographie du moyen âge*. Paris: Armand Colin, 1973.

Swarzenski, Hanns. *The Berthold Missal (The Pierpont Morgan Library MS 710) and the Scriptorium of Weingarten Abbey*. New York: Pierpont Morgan Library, 1943.

_____. "The Xanten Purple Leaf and the Carolingian Renaissance. *Art Bulletin* 22 (1940): 7–24.

Sweeney, James J. *Irish Illuminated Mauscripts of the Early Christian Period*. New York: New American Library, 1965.

Swenson, I. C. "The Symmetry Potentials of the Ornamental Pages of the Lindisfarne Gospels." *Gesta* 17 (1978): 9–18.

Temple, Elzbieta. *Anglo-Saxon Manuscripts 900–1066*. A Survey of Manuscripts in the British Isles. London: Harvey Miller, 1976.

Thomas, Marcel. *The Golden Age: Manuscript Painting at the Time of Jean, Duke of Berry*. New York: George Braziller, 1979.

_____. "L'iconographie de Saint Louis dans les Heures de Jeanne de

Navarre." *Septième centenaire de la mort de Saint Louis, Actes des colloques de Royaumont et de Paris (May 21–27, 1970)*. Paris, 1976.

_____. *Le psautier de Saint Louis*. Codices selecti. Graz: Akademische Druck- u. Verlagsanstalt, 1970.

Tikkanen, Johan J. "Die Psalterillustration im Mittelalter." *Acta Societatis Scientiarum Fennicae* 31, no. 5 (1903).

Thompson, E. M. *An Introduction to Greek and Latin Palaeography*. Oxford: University Press, 1912.

Thompson, Henry Y. *A Descriptive Catalogue of Twenty Illuminated Manuscripts (Substitutes) in the Collection of Henry Yates Thompson*. Cambridge: Cambridge University Press, 1907.

Toesca, Pietro. *La pittura e la miniatura nella Lombardia*. Milan: Hoepli, 1912; reprint Einaudi, 1966.

Tselos, Dimitri T. *The Sources of the Utrecht Psalter Miniatures*. Minneapolis, 1955.

Turner, Eric G. *The Typology of the Early Codex*. Philadelphia: University of Pennsylvania Press, 1977.

Ullman, Berthold L. *Ancient Writing and Its Influence*. Cambridge, Mass.: M.I.T. Press, 1969.

Underwood, Paul. "The Fountain of Life in Manuscripts of the Gospels." *Dumbarton Oaks Papers* 5 (1950): 43–138.

Unterkircher, Franz. *Zur Ikonographie und Liturgie des Drogo-Sakramentars*. Interpretationes ad Codices, 1. Graz: Akademische Druck- u. Verlagsanstalt, 1977.

Valentine, Lucia M. *Ornament in Medieval Manuscripts*. London: Faber and Faber, 1965.

van Dijk, S. J. P., and J. H. Walker. *The Origins of the Modern Roman Liturgy*. Westminster, Md., 1960.

Verdier, Pierre, P. Brieger, and M.-F. Montpetit. *Art and the Courts: France and England from 1279 to 1328*. 2 vols. Ottawa: National Gallery of Canada, 1972.

Vikan, Gary. *Illuminated Greek Manuscripts from American Collections*. Princeton: Princeton University Press, 1973.

von Gebhardy, Otto. *The Miniatures of the Ashburnham Pentateuch*. London, 1883.

von Steiger, Christoph, and O. Homburger. *Physiologus Bernensis*. Basel: Alkuin Verlag, 1964.

Weber, Louis. *Einbanddecken, Elfenbeintafeln, Miniaturen, Schriftproben aus Metzer liturgischen Handschriften*. Strassburg: Elsass-Lothringische Druckerei und Lithographie-Anstalt, 1913.

Weber, Robert. *Le psautier romain et les autres anciens psautiers latins*. Rome: Abbaye Saint Jérôme, 1953.

Webster, J. C. *The Labors of the Months in Antique and Mediaeval Art*. Princeton: Princeton University Press, 1938.

Weitzmann, Kurt. *Ancient Book Illumination*. Cambridge, Mass.: Harvard University Press, 1959.

_____. "Book Illustration of the Fourth Century—Tradition and Innovation." *Akten des VII. internationalen Kongresses für Christliche Archäologie, Trier, 1965*. In *Studi di Antichità Cristiana* 27 (1969): 257–281.

———. *The Icon, Holy Images Sixth to Fourteenth Century*. New York: George Braziller, 1978.

———. *Illustrations in Roll and Codex: A Study of the Origin and Method of Text Illustration*. Studies in Manuscript Illumination, 2. 2d ed. Princeton: Princeton University Press, 1970.

———. *Late Antique and Early Christian Book Illlumination*. New York: George Braziller, 1977.

———. "Narration in Early Christendom." *Journal of Archaeology* 61 (1957): 83 ff.

———. "Observations on the Cotton Genesis Fragments." In *Late Classical and Mediaeval Studies in Honor of Albert Mathias Friend, Jr.*, pp. 112 ff. Princeton: Princeton University Press, 1955.

———. *The Place of Book Ilumination in Byzantine Art*. Princeton: Princeton University Press, 1975.

———. "The Psalter Vatopedi 761: Its Place in the Aristocratic Psalter Recension." *Journal of the Walters Art Gallery* 10 (1947): 20 ff.

Werckmeister, Otto K. *Der Deckel des Codex Aureus von St. Emmeram*. Studien zur deutschen Kunstgeschichte 332. Baden Baden and Strasbourg: Verlag Heitz Gmbh, 1963.

———. *Irisch-northumbrische Buchmalerei des VIII. Jahrhunderts und monastische Spiritualität*. Berlin: Walter de Gruyter, 1967.

Werner, Martin. "The Durrow Four Evangelist Symbols Page Once Again." *Gesta* 20 (1981): 23–33.

———. The Four Evangelist Symbols Page in the Book of Durrow." *Gesta* 8 (1969): 3–17.

———. "The Madonna and Child Miniature in the Book of Kells." *Art Bulletin* 54 (1972): 1–23, 129–139.

White, John. *Art and Architecture in Italy 1250–1400*. Baltimore: Penguin Books, 1966.

Willard, J. "The Occupations of the Months in Medieval Calendars." *Bodleian Quarterly Records* 7 (1932): 33–39.

Williams, John. *Early Spanish Manuscript Illumination*. New York: George Braziller, 1977.

Wilson, H. A. *The Gregorian Sacramentary under Charles the Great*. Henry Bradshaw Society, vol. 49. London: Harrison and Sons, 1915.

Wit, Johannes de. *Die Miniaturen des Vergilius Vaticanus*. Amsterdam: Swets and Zeitlinger, 1959.

Wixom, William. "The Hours of Charles the Noble." *Bulletin of the Cleveland Museum of Art* 52, no. 3 (March 1965): 50–83.

Wormald, Frances. *The Winchester Psalter*. London: Harvey Miller and Medcalf, 1973.

———, C. R. Dodwell, and O. Pächt. *The St. Albans Psalter (Albani Psalterium)*. London: Warburg Institute, 1960.

Wright, David H. "The Italian Stimulus on English Art around 700." In *Stil und Überlieferung in der Kunst des Abendlandes. Akten des 21. Internat. Kongresses für Kunstgeschichte, Bonn, 1964*. Vol. I, pp. 84–92. Berlin: Verlag Gebr. Mann, 1967.

Zimmermann, E. H. *Vorkarolingische Miniaturen*. 5 vols. Berlin: Deutsche Verein für Kunstwissenschaft, 1916–1918.

Index

Illustrations indicated by italics or by plate number.